i n s p i r e d

3D LIGHTING AND COMPOSITING

inspired

3D LIGHTING AND COMPOSITING

DAVID A. PARRISH

Publisher: Stacy L. Hiquet

Marketing Manager: Heather Hurley

Managing Editor: Sandy Doell

Acquisitions Editor: Kevin Harreld

Senior Project Editor: Heather Talbot

Development Editor: Kevin Harreld

Editorial Assistants: Margaret Bauer
Elizabeth Barrett

Technical Reviewer: David Santiago

Copyeditor: Jenny Davidson

Interior Layout: Bill Hartman

Cover Designer: Mike Tanamachi

Indexer: Sharon Shock

Alias|Wavefront, the Alias|Wavefront logo, 3December, the 3December logo, 3December.com, the Alias|Wavefront Education logo, AutoStudio, Can You Imagine, create>what's>next, DesignStudio, Studio, StudioTools, the StudioTools logo, SurfaceStudio and TryDesign are trademarks of Alias|Wavefront, a division of Silicon Graphics Limited.

Maya is a registered trademark and the Maya logo, Maya Complete, Maya Unlimited, Maya Fur, Maya Paint Effects, Maya Cloth, Maya F/X, Maya Artisan, A Taste of Maya, and The Art of Maya are trademarks of Silicon Graphics, Inc., exclusively used by Alias|Wavefront, a division of Silicon Graphics Limited.

SGI and the SGI logo are trademarks of Silicon Graphics, Inc.

HARRY POTTER AND THE SORCERER'S STONE © 2001 Warner Bros., a division of Time Warner Entertainment Company, L.P. All Rights Reserved.

"STUART LITTLE" © 2002 Columbia Pictures Industries, Inc. All Rights Reserved.

Universal images copyright © 2002 by Universal Studios. Courtesy of Universal Studios Publishing Rights, a Division of Universal Studios Licensing, Inc. All rights reserved.

Star Wars: Episode I – The Phantom Menace © Lucasfilm Ltd. & ™. All rights reserved.

Disney and Disney images © Disney Enterprises, Inc.

Pixar and Pixar images © Pixar Animation Studios.

"OSCAR®," "OSCARS®," "ACADEMY AWARD®," "ACADEMY AWARDS®," "A.M.P.A.S.®" and the "Oscar" design mark are trademarks and service marks of the Academy of Motion Picture Arts and Sciences.

All other trademarks are the property of their respective owners.

Important: Premier Press cannot provide software support. Please contact the appropriate software manufacturer's technical support line or Web site for assistance.

Premier Press and the author have attempted throughout this book to distinguish proprietary trademarks from descriptive terms by following the capitalization style used by the manufacturer.

Information contained in this book has been obtained by Premier Press from sources believed to be reliable. However, because of the possibility of human or mechanical error by our sources, Premier Press, or others, the Publisher does not guarantee the accuracy, adequacy, or completeness of any information and is not responsible for any errors or omissions or the results obtained from use of such information. Readers should be particularly aware of the fact that the Internet is an ever-changing entity. Some facts may have changed since this book went to press.

ISBN: 1-931841-49-7

Library of Congress Catalog Card Number: 2001098234

Printed in the United States of America

02 03 04 05 BA 10 9 8 7 6 5 4 3 2 1

Premier Press, a division of Course Technology
2645 Erie Avenue, Suite 41
Cincinnati, Ohio 45208

This book is dedicated to Mom and Dad for so much support and encouragement, and for telling me long ago that I could accomplish anything I wanted.

Foreword

Mark Stetson
Visual Effects Supervisor

Art history: mud, charcoal, sticks, brushes, pigments, oils, skins, papyrus, canvas, paper, silver nitrate, celluloid, carbon arc, acetate, tungsten, phosphor, silicon. As our tools have always shaped our art, so now is our artistic exploration with our latest digital tools redefining the motion picture medium within which we create.

As I write this, we are at the brink of another motion-picture industry paradigm shift. Digital cinematography is coming to the forefront, and digital projection will soon overtake film projection as the first run medium. Imagery will remain in digital form from capture or creation through to presentation to an audience. Digital cinematography and digital exhibition of a major motion picture has now been showcased by George Lucas in his pioneering work in *Star Wars: Episode II— Attack of the Clones*. More importantly, as the cost savings is exploited and the digital pipeline is enabled, digital cameras are shouldered by low-budget and independent moviemakers who complete editing, post-production, and visual effects on a personal computer. The work that has been done to enhance the resolution of digital video and export it to film (for theatrical presentation in the current paradigm) has brought even digital camcorder videography up to acceptable theatrical exhibition quality. In the extreme, Dogma disciples, such as Lars von Trier, have blazed a technological trail to theatrical release that even the more established and mainstream moviemakers are now exploring. As emerging moviemakers rise up the ranks to become tomorrow's mainstream directors and cinematographers, they'll bring along their experiences with, and preferences for, digital moviemaking.

Concurrently, digital distribution and exhibition is rushing into the forefront. It is likely that film will continue as a distribution medium for at least the next several years, but sooner than we think, new digital theater installations will overtake film installations. The cost savings to motion-picture distributors that is inherent in the change to digital distribution is evident. When the next generation of digital projectors hits, and the distributors and exhibitors agree on how to capitalize on the savings from digital distribution, a flood of new digital theater venues will emerge. Digital theaters will become the new premier motion-picture showcases, and inexorably, the conversion will march to the far corners of the movie world.

Have I made my argument that we should no longer call ourselves "filmmakers"? It's time to move beyond that soon-obsolete misnomer and rename ourselves "moviemakers."

Converging with the evolution of digital moviemaking is the changing tastes of the audience and the changing grammar of cinematic storytelling. The prime demographic audience for major motion-picture distributors is comprised of teenagers and young adults, who in this generation have grown up with VCRs, DVDs, and multiple TVs in the home. The small screen is king. VCRs have long since killed the drive-in theater. A double feature is no longer a Saturday matinee at the Cineplex, but rather a couple of video rentals from Blockbuster, watched three or four times. Twenty years of MTV has set the pace. Video games have evolved to replace many forms of once-popular entertainment, from slot cars to pinball to target shooting, and the evolution of the games medium is providing an immersive experience that is ever closer to photographic virtual reality. Habituated to playing video games on a small screen, kids' concepts of time, space, and motion in entertainment have been warped far beyond the physics of reality. We are now accustomed to, and have a taste for, moving impossibly fast through virtual space in the service of storytelling, or rushing through the streets and arenas of a game world. All this kinetic action is spilling over into feature-length moviemaking. Kids don't care about the concept of perceived image size. If it looks okay zipping around on the small screen, it'll look better blown-up to the big screen! Spiderman leaps through the streets of New York in thousand-foot swings, and we buy it because the quality of the image is so high. So we start with what Joel Silver called "heightened reality" and keep going up the scale from there.

The use of computer-generated imagery expanded relentlessly from experimental beginnings to become the first-choice solution for unfettered storytelling. The virtual camera of the digital medium frees the director and cinematographer to tell the story of the moment with total freedom. With our ability to create photorealistic imagery and present it in a way that no film camera could photograph it, the audience is treated to a new perspective and a new experience of the director's vision.

As we embrace and extend the use of digital cinematography and distribution, the integration of digital-effects imagery becomes ever more seamless and ubiquitous. With all of a movie existing in a digital workspace, more and more manipulation of

light, time, and space will be explored. As directors, cinematographers, and editors experiment with new looks, movies will become ever more varied in color spaces that are dynamic and unique. There will be a convergence of the work of editors and visual effects artists, as digital editing suites evolve to allow work to be performed in real time at higher and higher resolution. There will be a convergence of the work of colorists and visual effects artists, as well. As cinematographers explore the color space of a film in real time as it is prepared for release, last-minute changes to the overall color space will drift over into work that was formerly resting on the shoulders of the visual effects artist. Highlighting a face, changing a sky, creating the night look of a sequence shot day-for-night, all will be integrated into the color timing sessions. The tools are virtually the same, and it will be just a question of where and when the director chooses to address the question. Visual effects artists will be working even beyond the last minute, as moviemakers find they can refine a movie in streaming release in response to audience reaction. Directors, and even marketers, will ask that movies be modified during release to lure audiences back for a second or third version of a movie in its first run!

In this context, you are reading this book about compositing and lighting for visual effects. Part of the fun of our work is the trompe l'oeil. When we create a seamless, photo-realistic representation of a shot, lit consistently within the lighting space of the scene, integrated with the color space of the scene, conveyed with all the clues and nuance of light as it reflects around the boundaries of our frame and blends layer with layer, filtering among the subjects, hinting at the unseen, then we can help keep the audience engaged in the director's story and help the director trick the audience into believing his reality and following his story into the surreal or the fantastical. Lighting and compositing are all about matching and integration. When we offer a complete image to the audience that is true to the reality of the film, then we can manipulate it in impossible ways. We can manipulate our motion through a photo-realistic scene in a way that we could never see with an unaided eye, and take the audience along with us into the story.

Working in visual effects, we have all played a part in the evolution of the technology. The first digital paradigm shift occurred for us about ten years ago, when digital compositing replaced optical compositing virtually overnight. This happened once the technology of recording film from a digital image reached a level of quality that intercut with the rest of the photographed film, and thus allowed the obvious benefits of precise pixel manipulation to be applied to motion pictures. With digital compositing, we gained the freedom to explore much more complex shots at a much higher level of finish. Creativity in shot design and look development flourished.

The next major advances in cinematographic style will be based on manipulation of digitally captured images, not "filmed" images. Digital cinematography makes it easier for us to integrate our work into the whole movie, because the whole work will go down the same digital pipeline. It likewise opens up the whole movie to the possibility of visual effects enhancement. We will continue to push the quality of the images we create and apply our skills and disciplines to the creative exploration of our directors, our cinematographers, and ourselves. It will be up to us to maintain our perspective on our recorded images of reality—to continue to improve our capability to present a visually complete, realistic scene within a totally natural light and color space. From there, we will explore. We will dig down into the shadows and yank out the detail. We'll add, remove, brighten, darken, flash, fade, bleach, saturate, decontrast, punch it back up, stretch, and continually prowl the boundaries of reality. We will explore all the differences between a CCD capture and a photochemical exposure and exploit them to develop a new idiom for movie expression. We will be moviemakers.

About Mark Stetson

Mark Stetson began his film career building miniatures for *Star Trek: The Motion Picture*. He gained international recognition in 1982 for his miniature effects work in Ridley Scott's *Blade Runner*. He has since worked as a model shop, prop shop, and creature shop supervisor, as a designer/illustrator, as an effects facility proprietor, as a production designer, and as a visual effects supervisor. In 1985, he was nominated for an Academy Award for his work with Boss Film Corp. for Peter Hyams' *2010: The Year We Make Contact*. In 1997, he won a British Academy (BAFTA) Award for his visual effects work with Digital Domain for Luc Besson's *The Fifth Element*. In 2002, Mark won both the Academy Award and the British Academy Award for visual effects on *The Lord of the Rings: The Fellowship of the Ring*.

Acknowledgments

This book has been the result of a tremendous amount of collaboration and could not have happened without the help of many individuals and companies. First of all, thanks to Kyle Clark and Michael Ford for approaching me with the idea of writing a book. As the *Inspired* series editors, their initiative and foresight have made this book possible. Thanks also to the other authors involved in the *Inspired* series, Tom Capizzi and Alan Lehman, who contributed, among many other things, the articulated models used in this book.

The technical editor, David Santiago, deserves a great deal of credit for not only making sure this book's contents are technically accurate, but also for helping me to clearly convey my thoughts. A special thanks also to Michael Parrish, the hardware and software consultant, whose expertise and computer solutions made this book possible.

I would like to thank each of the interview contributors for offering their time and wisdom to the pages of this book. They are Melissa Saul Gamez, Jean-Claude Kalache, Dennis Muren, Mark Forker, and Jim Berney. In the time and wisdom department, thanks also to Heather Talbot and the editing crew at Premier Press for catching my mistakes and deciphering my sometimes cryptic thoughts. Thanks to Nagisa Yamamoto, Karen Hartquist, and Steven Argula for your professionalism and courtesy in dealing with my persistent questions and requests.

Many of the examples in this book are based upon a character developed through the artwork of Tom Capizzi and Jim Van Der Keyl. Additional artistry was provided by Lopsie Schwartz in the form of wonderfully painted textures. In the texture department, Travis Price also offered his expertise to the project. On the artist front, I've never met a finer one than Ron Woodall. He offered his photographic skills and has also provided me with many years of enjoyment through his unique views on this industry. Thank you also to Patra Meadows for her consistent support of whatever it is I decide to do.

In a category of his own is Kevin Harreld. He has been the driving force behind this series. He has been there at every obstacle to offer his knowledge, support, and hard work in seeing this project through to the end.

There is no possible way to thank all of those who have contributed to this book, but I am grateful to each of the incredibly creative and talented people I have had the honor to work with in the visual effects industry. I have learned so much from everyone I've worked with, and I am constantly encouraged and excited at the prospects of what imagination can and will do in the future.

About the Author

David Parrish started on the road to computer graphics as a boy who built a world out of Legos. As a young boy in Dallas, Texas, his dreams were of math, engineering, architecture, and doing whatever it took to turn those Lego dreams into real buildings. He entered the architectural undergraduate program at Texas A&M University and was introduced to his first taste of the computer world in AutoCAD class. After graduating in 1990, he went to work in a small architectural firm named Dickson Wells Architects in Dallas. The firm, at the time, was one of the few that did its construction drawings almost exclusively on the computer. He quickly became adept with AutoCAD, and began to explore its 3D capabilities. After a couple of years in the world of architecture, a long-time friend opened his eyes to a master's degree program that had sprung right in his old backyard at Texas A&M University. Housed in the very architecture building where he had studied as an undergraduate, a lab supporting a program called Visualization Sciences had begun shortly after he had received his undergraduate degree. The program was designed to blend in equal parts artistic composition and presentation with the technical skills of digital graphics programming. It sounded fantastic, and in 1992 he decided to leave architecture and enter the viz lab. The viz lab proved the ultimate training ground, with a strong faculty and a lab with the very same computers and software that were being used to create special effects for the movies. As a student, the dream was to move to California and work for Industrial Light & Magic. David was able to meet with the recruiter from ILM, and shortly before finishing up work on his thesis project, he received a call from them with a job offer. After finishing up his thesis and earning his Master of Science degree, David went straight to work for ILM. It turned out to be 5 years of feature film experience with credits on movies such as *Dragonheart*, *Return of the Jedi: Special Edition*, *The Lost World*, *Star Wars: Episode I—The Phantom Menace*, *Deep Blue Sea*, *Galaxy Quest*, and *The Perfect Storm*. After 5 years with ILM, he left for a computer graphics supervisor job with a startup company to create a full-length digital feature. Unfortunately, economic problems doomed the project before it could get off the ground, so David decided the next project that sounded interesting was *Harry Potter*. The timing worked out well, and Sony hired David as a senior technical director on *Harry Potter*.

Contents at a Glance

Contents

Introduction to *Inspired 3D Lighting and Compositing*

Since the dawn of moving pictures, lighting has played an integral role in the creation of fantastic stories and stunning environments. Directors learned early on that the success of their stories depended on how the lights brought life to their scenes. As computer graphics imagery has taken its hold, films, television commercials, video games, and music videos have embraced the freedom and imagination it has offered their respective media. Unfortunately, those who truly understand lighting are rarely found creating computer graphics imagery, and those who sit behind the computers rarely understand the subtleties of sculpting a scene with light. This book shares the knowledge of both worlds and shows how to combine them in making believable digital creations. Whether it's a stylized world or a photo-real character, the lighting and compositing will make or break the painstaking work that has gone into creating the computer graphics models and animation. Today's audiences have become increasingly sophisticated with regard to computer graphics characters and environments, and their expectations rise with each quality effect that is produced. The average audience may not know how to create visual effects, but it can definitely spot the bad ones in a heartbeat.

When the dinosaurs of *Jurassic Park* burst onto the scene in 1993, I was just beginning my graduate studies in computer graphics. I saw the T-Rex with his teeth and eyes glistening and the flashes of lightning revealing the awesome creature's realism, and I knew where I needed to be. I knew where, but I did not have the slightest idea of how to get there. I learned the software and the language of computer graphics, but the real key was in combining that knowledge with an understanding of light and shadow that artists had been using since the beginning. What the moviemakers understood was that the lighting and layering of a scene was not simply adding enough light to record an image onto film. Lighting offers a way to create the mood and enhance the story. With this realization, the goal for my graduate studies expanded to include the exploration of lighting scenes with the expertise and subtlety of movie storytellers. I continued my studies of photography, painting, and filmmaking, while developing skills of observation that had been established during my previous architectural studies. I soon realized that those successful in creating the dinosaurs of *Jurassic Park* had not only attained a great technical achievement, but also reached an incredible level of awareness for the subtleties of lighting and creating a three-dimensional scene on the two-dimensional screen of a movie theater. They developed a visual vocabulary and were able to apply it to every detail of every layer in the images.

As the tools for lighting and compositing computer graphics images grow more powerful and easy to use, the necessary skills for giving life to an image are often overlooked. The computing power is easy to obtain, but the knowledge for how to use it wisely is not found in any software manual. After years of working with film directors and visual effects supervisors with amazing skill and talent for lighting and composing a scene, as well as programmers and technical wizards who understand the computer code for simulating real-world lights in the digital environment, I have discovered many methods and techniques for combining the two sides of the equation. *Inspired 3D Lighting and Compositing* uncovers the sources for successful lighting and bridges the gap between the artistry of image making and the technical complexity of computer graphics.

Computer Graphics Primer

This primer is a short description of some technical aspects surrounding the world of computer graphics. The concepts discussed are the backbone for how 3D software works. A basic understanding of these elements will be crucial to navigating the CG environment.

The Basics

The structure of the worlds that we create within 3D are complex systems that can be a little overwhelming. Whether you are new to 3D or need a quick guide to refresh your memory, use this primer as a reference to the basic elements of computer graphics. By understanding the basics of your 3D software, you can take your first steps toward developing your skills in the fascinating world of computer graphics.

Cartesian Coordinate System

The three-dimensional (3D) world in computer graphics applications is visualized using the Cartesian Coordinate System.

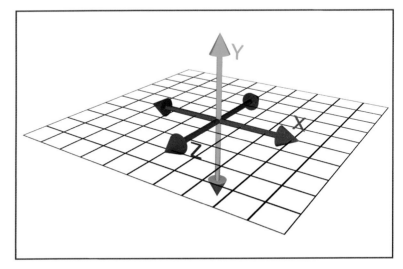

Figure I.1
The three components of the CCS system are X (width), Y (height), and Z (depth). The center of the 3D world (0, 0, 0) is referred to as the "origin."

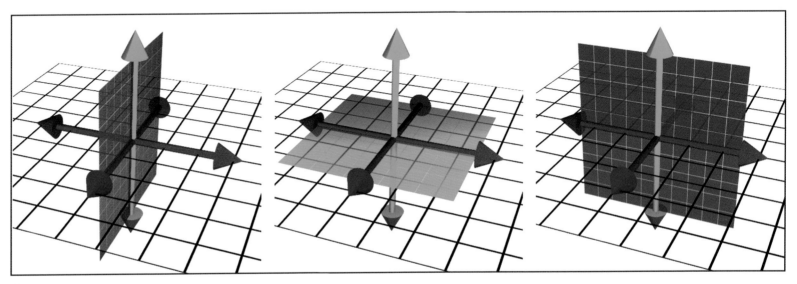

Figure I.2
The three major planes about the origin are the XY, XZ, and YZ.

Right- and Left-Handed Systems

The "hand" is a way to determine which direction of any component (x, y, or z) is positive or negative in relation to the others. To determine positive versus negative in either system, hold up the appropriate hand, palm toward your face. Stick your thumb out to the side; this represents positive X. Point your index finger straight up; this shows positive Y. Extend the middle finger toward your face; it's pointing out positive Z.

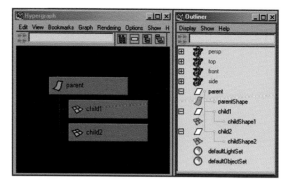

Figure I.4
A parent/child hierarchy.

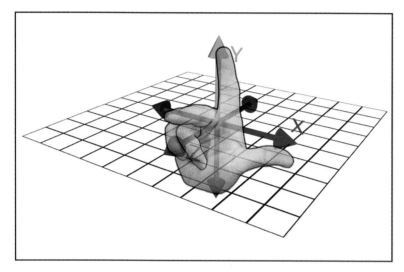

Figure I.3
Maya is a right-handed system.

Hierarchy

A hierarchy is a relationship of nodes to other nodes described in terms of parent, child, and sibling. By default, a child node will inherit what is done to its parent node, transforming along with it and maintaining the same spatial relationship.

Transformations (World, Local, Object, Gimbal)

The transform mode determines how you interactively manipulate nodes by changing what relationship you modify. **World space** manipulates an object with an axis of the same orientation as the world, regardless of the hierarchy. **Local space** is an alignment of the transform axis to the parent of the object. The transform channels of a node (rotate, translate, scale) are all stored in local space. **Object space** is the result of an object's transform in addition to the hierarchy above it.

Gimbal space is a breakdown of local space rotations. It displays each axis separately, showing you each rotation channel's actual orientation, rather than the accumulation of them as is shown in local space. Object rotation occurs one axis at a time. The **rotation order** (by default: x, y, z) specifies which axis rotates first, second, and third. Similar to a hierarchy built with the first axis on the bottom and last axis on top, the first axis inherits the rotation of the second and third. The second axis inherits the rotation of the third; the third axis inherits the rotations of the parent.

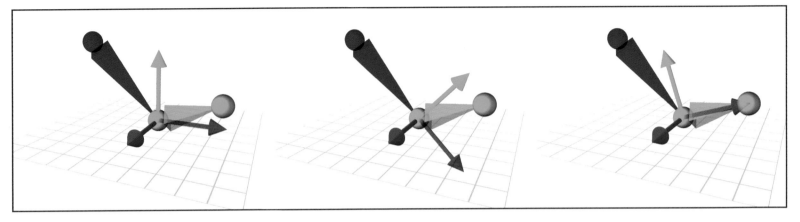

Figure I.5
World space, Local space, and Object space (from left to right).

Figure I.6
Displaying Gimbal: no rotations: x rotation; adding y rotation; adding z rotations.

Figure I.7
The resulting local rotation rings over the Gimbal rings.

chapter 1
A Little Bit of History

The computer graphics industry represents one of the fastest growing and most dynamic sectors in today's job market. Along with this growth has come the increased specialization of the many tasks required to bring computer graphics to life. Whereas in the past the programming, modeling, chaining, skinning, animating, lighting, and compositing might have been handled by a single person, this is rarely the case today. Depending upon the size of the studio and the complexity of the pipeline, these tasks can now be broken down into different areas of focus and completely different career paths. This, coupled with more user-friendly tools, has allowed a much broader range of backgrounds to enter into the field of high-end computer graphics. With that diversification and increased exposure, the competition has become fierce in this popular industry. This chapter will take a brief look at how computer graphics have grabbed a strong foothold in the film, television commercial, and video game industries, and how the computer graphics studio environment has evolved into what it is today.

From King Kong to T-Rex

It is common for people to take for granted the visual effects in today's movies, but it's only since 1980 or so that computer graphics have become prominent in films. Before computer graphics, the tools of choice for visual effects were optical compositing techniques. These techniques were the precursors to today's digital compositing software packages. Whereas optical compositing can trace its roots back to the mid-1800s and the creation of a single photographic print from many different negatives, it wasn't until the 1930s that optical compositing took on a prominent role in American cinematography. In 1933, *King Kong* burst onto the screen, in all of its stop-motion glory. The revolutionary idea behind this, and many other movies of the time, was that a creature need not be real or large to appear realistic and huge on–screen. In fact, the 50-foot ape was actually a 16-inch model that

was photographed before any of the backgrounds or human beings were filmed. By photographing a single frame of the miniature ape, then moving it slightly and photographing it again, the stop-motion animators were able to painstakingly create the motion of King Kong a single frame at a time.

Played at normal speed, the appearance is that of a moving creature. This animated version of the character created a layer to be used in the final film version. It's this type of layer that continues to be the basis for putting effects together today. The film version of *King Kong* was then combined with the background and live actors using two methods. One method involved projecting this footage of the miniature ape onto a rear projection screen, which was placed behind an actual movie set. The actors could then be shot in front of the animated character, giving the illusion that the ape and the humans existed in the same shot. The other method was the bluescreen technique. Still used frequently today, this technique involves shooting elements in front of a monochromatic screen (typically blue) and then replacing that color with a separate piece of filmed footage. The combination process at that time was accomplished optically, but it is the same technique that puts your favorite weatherman in front of a full-screen map.

These early stop-motion artists were responsible for many of the same tasks that today's lighting and compositing artists tackle. The director of the stop-motion shoot was in charge of setting up a lighting rig for this 16-inch creature to match the lighting of the live-action film footage. The challenge was how to light a small character in such a way that he would look large and fit in well with the actors. Because the two setups were completed separately, with little or no chance in each scenario to reference the other, the job was difficult. Due to the painstaking process of photographing and animating Kong, re-shooting a scene because of a

misplaced rim light or too much bounce light (refer to Chapter 5, "Tools of the Trade," for a breakdown of the different types of lights and their descriptions) was not a possibility.

The optical methods for compositing remained prominent in film effects for almost 50 years. The *Star Wars* movies, which first came onto the scene in 1977, took optical effects to a new level. With motion control cameras and sophisticated new methods developed for tracking and duplicating camera moves, George Lucas and his magicians at ILM were able to create effects in a quantity and with a level of quality that had never been seen before on the big screen. While computers were being used to track camera data and create simple effects for films, the level of interaction required for the computer to be a useful lighting and compositing tool had yet to be attained. Early forms of computer lighting involved a programmer spending hours of time writing code, setting off huge computational processes, and then recording directly to film before ever getting a visual clue as to what all those lines of code would actually look like to the human eye. Programming advances including graphical user interfaces helped provide a source for visualizing images on the computer screen before recording them onto film. Then computer graphics took a giant leap forward when the dinosaurs of *Jurassic Park* stormed onto the scene (see Figure 1.1).

Figure 1.1
The T-Rex from the 1993 film *Jurassic Park*. Copyright © 2002 by Universal Studios. Courtesy of Universal Studios Publishing Rights, a Division of Universal Studios Licensing, Inc. All rights reserved.

This not only opened up a whole new world for film effects but also paved the way for television commercials and video games. Never before had such realistic creatures occupied the same screen space as human actors. Many elements came together to make those dinosaurs look so convincing, not the least of which was the lighting and compositing. The models were fantastic, and the animation was believable, but without top-quality lighting, the viewer would have been no more convinced of the dinosaur's ferocity than they were of King Kong's. The interesting part is that, in many ways, the two movies served to produce the same level of innovation for their time. Whereas *King Kong* pioneered the optical compositing techniques and stop-motion animation, *Jurassic Park* brought computer graphics to the forefront. By bringing the original film footage into the digital realm, combining it with creatures and effects created in the computer, and recording it back out to film, a vast array of opportunities had been opened. Although *Jurassic Park* was not the first film to use these techniques, its popularity and quality made the viewing audience believe that these wondrous creatures possibly could exist. The way that the dinosaurs were combined with the live-action footage was so convincing that it was no longer thought of as an effect, and could therefore be used to enhance, rather than sensationalize, the film and its story.

Why is it that those dinosaurs seemed so different from the film creatures that had been seen before? Were they really that different from the *King Kong* or *Godzilla* movies we'd seen in the past? The answer, quite obviously, is yes. There are many differences, including modeling and animation, but this book emphasizes the way that textures were used to create believable surfaces, how light was used to sculpt the elements in the scene, and how the layers were integrated to make a cohesive composition. The basic concept behind every aspect of this book is the creation and combination of layers. After you've mastered the processes of creating quality layers and skillfully combining them into a composition, you're well on your way to a profession in lighting and compositing.

Learning the Fundamentals

So how do you go about making these quality layers? The road to creating quality layers and understanding how to combine them begins with studying the fundamentals of composing images. What better way to learn this than from those who have created the visual masterpieces you see in museums and in the history books. A closer look at the paintings, photographs, and films of the past can give you a much clearer understanding of how to begin putting together a successful computer graphics image.

Paintings

Now, maybe, creating photo-realistic lighting is not your goal, and I'm not by any means saying that this is the only way to go. However, if you want to learn to bend or even break the rules, it is imperative that you first understand those rules and get a feeling for why they are there. Before Picasso made the paintings he is famous for, he did some of the most amazingly realistic drawings and paintings I've ever seen. Picasso learned the rules and then moved beyond them to create his own style.

In Picasso's painting titled *The Couple* (see Figure 1.2), he displays both realism and the beginnings of his cubist style of composing an image. The painting shows tremendous attention to detail in the man's features and the light raking across the

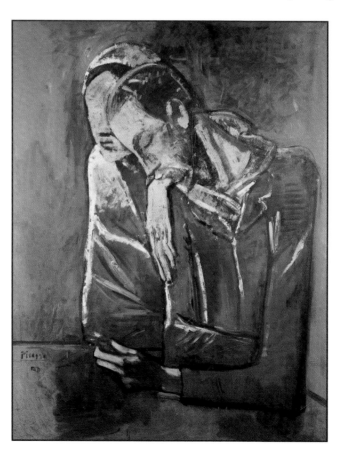

Figure 1.2
Pablo Picasso's painting titled *The Couple*. Picasso, Pablo (1881-1973) © 2002 Estate of Pablo Picasso/Artists Rights Society (ARS), New York.

subjects. The overall composition, however, simplifies the outlines of the forms. The elbow of the man is exaggerated to a harsh right angle, and the woman's elongated hand drapes over his shoulder following the same simplified form. The rectilinear shape of the two characters together offers clues as to how Picasso broke complex figures down into their simplest forms in his later works. Through his understanding of the pieces and parts that create the whole, he was able to break it back down into symbols that represented those pieces in a more simplistic way. In some ways, this is similar to the way the average person might draw a human's

face if you asked him to do so from memory. Odds are, he'd draw symbols to represent such features as the eyes, the nose, and the mouth. These symbols would probably lie somewhere between a cartoon drawing and a caricature, but the depth of understanding and interpretation in those symbols would most likely be missing. Picasso's understanding of the subjects of his paintings, of their proportions and interconnectedness, allowed him to break them down into their simplest forms on the canvas while maintaining the essence of what holds them together. Trying to light a scene without truly seeing and understanding how the light you

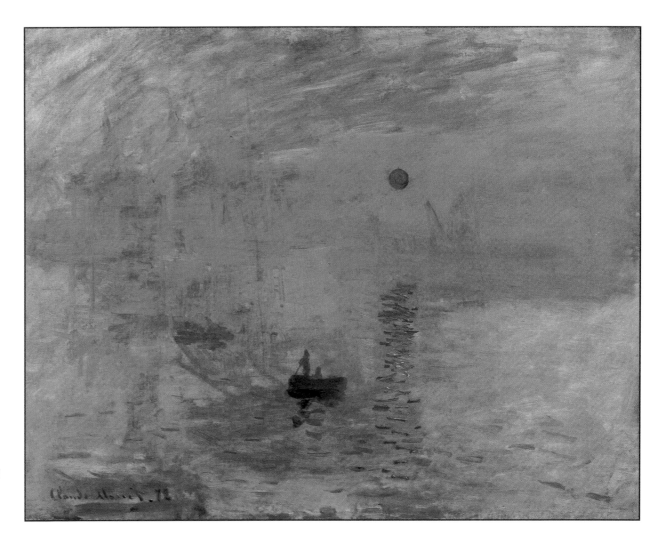

Figure 1.3
Claude Monet's study of light and color in his 1872 painting *Impression Sunrise*. Monet, Claude (1840-1926). Impression, Sunrise. 1872. Oil on canvas, 48 x 63 cm. Painted in Le Havre, France. Critics called Monet and his circle - at first ironically - "Impressionists" after the title of this work. Copyright Erich Lessing/Art Resource, NY. Musee Marmottan-Claude Monet, Paris, France.

experience every day reveals the world to you is like asking someone who's never studied the proportions of the human head to draw a portrait from memory. No matter how talented the artist, studying the subject matter is a must.

Paintings can also offer an excellent reference for interpretations of color and lighting. Many Impressionistic paintings break down the complex relationships between color and light, and how the human eye perceives them. Although much of Impressionistic painting was broken down into the scientific study of color perception, the point of focus for the original Impressionist was the experiential quality of the environment and the different qualities of light that could enhance that experience. Similarly, the computer graphics lighting artist can become bogged down in the science of lighting and lose track of the spectacle and brilliance of something as simple as a sunrise or a haystack (see Figures 1.3 and 1.4).

Closer inspection of Monet's paintings reveals that he carefully studied the effects of the quality of light at particular times of the day and in a wide variety of backdrops. The painting *Haystacks, Late Summer, Early Morning Effect* explores the complexities of light, shadow, and color in a seemingly simple composition of two haystacks in a field. Monet used this same composition for several paintings showing the differences in light quality not only at different times of the day but also in different seasons of the year. The *Impression Sunrise* shows incredible attention to detail, such as blending the colors of the sky with the horizon and the reflections of the sun in the water. (Refer to Chapter 5, "Tools of the Trade," for an explanation of color theory and compositional basics.) It also shows the elements of composition that lead the viewer's eye from one area of the painting to another and help the viewer to focus on the areas that Monet felt were important in the scene. The painting looks different than a photograph of the same scene would

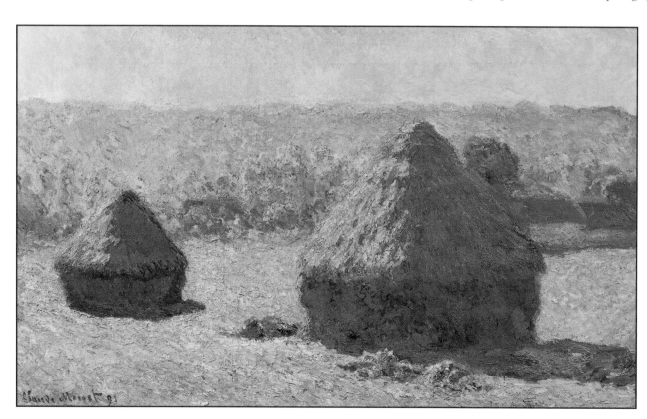

Figure 1.4
Claude Monet's simple subject matter but complex light and color study in his 1891 painting *Haystacks, Late Summer, Early Morning Effect*. Monet, Claude (1840-1926). Haystacks, Late Summer, Early Morning Effect. Musee d'Orsay, Paris, France. Copyright Giraudon/Art Resource, NY.

look; it represents a pushing or enhancing of particular elements. This same technique can be used in computer graphics, as well, when an element within a scene is enhanced in such a way to emphasize the point of the director. A flash of lightning may be added to reveal the forms of a dimly lit scene. A colored light may be added to adjust the mood of a particular scene. These are all examples of creating specific lighting effects that might never exist in the world that you study. Used with skill and awareness, they can tremendously enhance the final product.

Photographs

Paintings provide an excellent source of inspiration for the computer graphics artist, but many see more of a concrete connection with still photography. Films and television are, in essence, a series of individual images, strung together to simulate the motions of everyday life. Similar to a single frame of a film, photographs can give you clues on how to understand the subtleties of lighting and composition. The studies of light in terms of contrast are sometimes easier to see in black-and-white photography, and Ansel Adams provides some of the most amazing images ever exposed onto a negative. By studying his photographs, the lighting and compositing artist can learn volumes about dramatic lighting and how to place objects within a frame in a way that is both pleasing and intriguing. He went to incredible lengths to get exactly what he wanted from a shot, many times waiting for a particular hour on a particular day of the year to ensure that he would get the precise sun angle needed for the image he wanted to create.

Many of today's computer graphics artists use the concepts learned from black-and-white photography in their personal work. One example comes from Mark Forker, a visual effects supervisor with the visual effects company Digital Domain (see Chapter 13, "An Interview with Mark Forker"). In his photograph *No Skateboarding, 2000*, he uses many of the principles employed by Adams (see Figure 1.5). The viewer's eye is led directly to the head of the dinosaur because of the high contrast level between it and the tree. The elements in the background provide several layers of depth with the fence, the power line, and the distant hills all indicating the vast distance extending behind the foreground elements. The shot is precisely composed to frame the point of interest while still displaying the complexity and depth of the overall scene. This attention to detail is what sets apart the average computer graphics artist from the exceptional one.

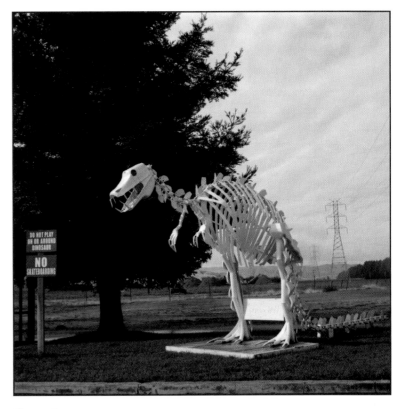

Figure 1.5
Mark Forker's photograph entitled *No Skateboarding, 2000*.

Films

Using many of the same concepts as Ansel Adams, Orson Welles displayed his visual artistry in the black-and-white film *Citizen Kane*. This 1941 film still stands today as one of the great motion picture accomplishments of all time. The stark, high-contrast style with which much of this movie was filmed, is studied by every student of movie lighting. Welles showed us how a single light could produce amazing drama and intensity within a scene. *Citizen Kane* is an excellent example to study, because the viewer can easily identify the placement and direction of the lights in many of the scenes. Several of the most successful photography tricks, such as silhouetting a foreground character to add drama and mystery to a scene, are adeptly used in this film (see Figure 1.6). An entire lighting course could be

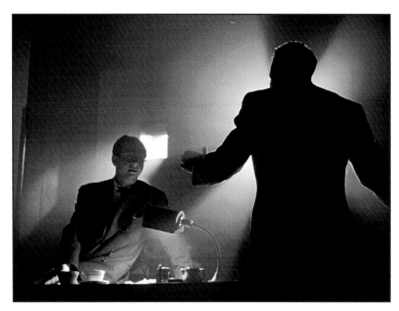

Figure 1.6
A scene from the 1941 film *Citizen Kane* showing Orson Welles' use of simple, harsh lighting schemes.

taught with this film as the subject, but for the purposes of this book, I'll just say that it is definitely worthy of study for those who want to understand the subtleties of lighting and compositing a scene.

As you can see, these tricks and tools of using light, color, and composition to convey thoughts and emotions have been through many iterations of expansion and revision through the years. Although there is a huge amount of film work in between *Citizen Kane* and *Jurassic Park* that is worthy of study for the lighting and compositing artist, I'll leave that to you to explore and discover. Try not to neglect the value of many of the early films and how those filmmakers shaped the craft of today's cinema. D.W. Griffith made many truly wonderful films. His 1916 classic, *Intolerance*, presents a striking montage of images from four completely different eras. Cecil B. DeMille is another legend in the film industry. In his classic 1923 film, *The Ten Commandments*, DeMille showed us grandeur through his staging and heartfelt emotion through his close-ups and framing. In 1956 when he

remade that film, he showed the movie world how powerful the use of color and special effects could be.

When you look to the great contributors to film history, it's also important to take note of those who are making history today. Many people in the film industry are continuing to place their mark. You may even have the opportunity to work with some of them. Whereas it's easy to recognize and respect the accomplishments of the Academy Award winning special effects supervisors, it might not be quite so obvious that you can learn from practically everyone who's spent a few years in the industry. Regardless of whether you're in the film, television commercial, music video, or video game arena, you'll most likely be working with someone who has a great deal more experience than you. When you get the chance, talk through your work with them and try as often as possible to start up a creative dialogue about your work. This can help you solve problems and gain a better understanding of the craft. Remember, the person providing direction has most likely done your job countless times. He can provide you with a wealth of information and guidance—but only if you ask. The keys to the entire learning process, of studying the world around you and studying visual works of the past and present, are to build a visual vocabulary and an ever-growing toolbox of methods and techniques for lighting and compositing a scene.

Hopefully, the examples provided here will whet your appetite for studying classic paintings, photographs, and films, as well as the world around you from which these images are always derived. The work you do on the computer is still representative of the world that you walk through every day. The difference is that you now have a new medium with which to work. Instead of a canvas or a negative, you have pixels and phosphors. What a computer lighting and compositing artist does is much the same in nature as what painters, photographers, and filmmakers did and continue to do today. You are given a world to work within, and you must learn all the nuances that make that world recognizable to you. You will study intensity and direction of light, the interactions of colors, the effects of light bouncing off objects and creatures, shade and shadow, depth cues and fading, fog and dispersal of light, and textures and how the light interacts with them. You'll study all these things and the cumulative effects they have on making something look real to you and to the audience.

Creating a Lighting and Compositing Artist

The desire to be a computer graphics artist and work on films, commercials, and music videos is what drives many people entering the computer graphics field today. Six years ago, that was my dream too, and it has been realized in a career path that has led me through three studios and eight major motion pictures. The process for me began with an education in architecture and eventually in computer graphics and visualization. Through working with some of the most talented and respected individuals in the visual effects business, I have gathered a wealth of knowledge and experience. That professional experience, as it pertains to lighting and compositing, is what I will share with you in this book.

It's almost impossible today to go to the movies without seeing some of the influence that computer graphics has had on the film medium. Even films that don't appear to have any computer graphics can be chock full of shots that went through some sort of digital process. One such example is *Forrest Gump*, which was one of the more effects-intensive films of its time. The effects were so seamless that few people noticed when Tom Hanks' face was superimposed over a stunt double that was carrying his best friend out of the forest, or when Lieutenant Dan was made to appear as if he'd lost both his legs. Forrest was placed into footage with former presidents and shown in front of a crowd of thousands at the mall in Washington, when in fact, there were barely 100 people there. As these types of seamless effects have grown more common, so too have huge special effects films. At the time of *Jurassic Park*, it was unusual for a film to have 100 digital shots. In this day and age, with films like *Star Wars: Episode I - The Phantom Menace*, a full 2,000 shots can be pushed through the digital world and then back out to film. Computer graphics characters have been pushed to fantastic, and sometimes grotesque, new levels in such films as *The Mummy* (see Figure 1.7). The decayed human form in this film is depicted with such amazing detail that it is both believable and frightening. Digital effects even pop up in places you'd least expect them, like a Coen Brothers film set in the Great Depression era with seemingly no call for computer

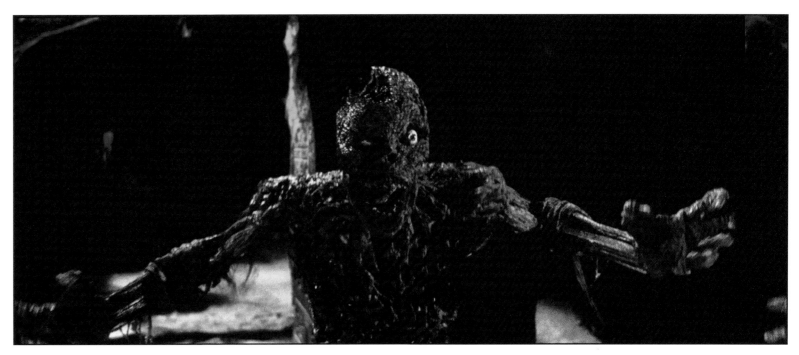

Figure 1.7
A scene from the 1999 film *The Mummy*. Copyright © 2002 by Universal Studios. Courtesy of Universal Studios Publishing Rights, a Division of Universal Studios Licensing, Inc. All rights reserved.

graphics. The audience doesn't necessarily recognize in such a film that every single frame was digitally processed to attain the color, composition, and feel that the directors had chosen for the film.

What the general viewer doesn't recognize is what the lighting and compositing artist is paid to create. That's how the director's vision finds its way onto the screen. Whether it's the ferocious roar of a terrible beast or a subtle twinkle in the eye of our hero, the lighting and compositing artist's job is to make sure that the director's vision comes to life. The basis for the set of tools required to accomplish that task can be found in the history of how computer graphics found its way into the production environment.

The early optical techniques eventually gave birth to the need for more precise control of how these images were to be combined. Not only did the artists want more control over the layering process, but they were beginning to demand more control over the look of the layers. While *Star Wars* was the major catalyst for fine-tuning how these pieces all came together in the optical world, *Jurassic Park* was the pioneer film for digital characters. With this film came the realization that believable creatures could be made in the digital environment with textures and lighting that was of a high-enough quality to convince an audience that these dinosaurs were alive. The steps that are taken to accomplish such a task are presented in this book. The process involves innumerable artists and programmers to turn the 1s and 0s that the computer sees into the spectacular creatures and effects that the audience sees. With the birth of computer graphics creatures and objects came the creation of an entirely new field of expertise in the effects industry. A lighting artist must understand how to sculpt an object or a creature with light and how to make the viewer believe the object or creature is real. That is the challenge a lighting artist faces every day—the challenge I have experienced and enjoyed during my time in the visual effects industry.

You'll see what sets professional-level lighting and compositing apart from simply pushing the buttons and following the tutorials. To understand how to achieve quality lighting, you first have to understand the world around you. The only real way to do that is to study it, and by studying it, I don't mean reading about vectors and luminance values in books. I mean get out into the world and start taking note of the things that go on around you. The average moviegoer has seen a person walk from shadow into bright sunlight hundreds of times, but can he tell you how

the specular interaction of the light varies from one lighting scenario to the next? Probably not, but I guarantee that he will notice within a second whether it looks right.

Making computer graphics appear believable depends on observation. The implementation of the knowledge gained from noticing the world around us depends on the intended audience. The audience could be movie-goers, television commercial viewers, or video game players. Each audience type requires a different application of the lighting and compositing tools and methods. It is rare to find a computer graphics company participating in film, television, and video game work, so it is necessary to choose an area of interest in the job market. The lighting and compositing tools and methods vary from company to company, as well as with the different output media. Chapter 2 describes many possible professional scenarios for a lighting and compositing artist and some of the pros and cons of each.

chapter 2
A Trip around the Industry

The popularity and appeal of computer graphics in movies, television commercials, and music videos has spawned the creation of companies around the globe to help meet the demand. Epic films with hundreds upon hundreds of computer graphics shots are put together all over the world. The opportunities in the game industry continue to grow as new platforms push the limits of the quality and complexity of visuals. Previously viewed as a simplistic and low-budget form of entertainment, music videos have now become a launching ground for promising new directors. Vivid imaginations and ever-increasing budgets have given this genre a new prominence in the world of computer graphics. Team all of that with the realization that a cutting-edge and distinctive television commercial can beef up the bottom line for a company, and the result is a plethora of viable options for gainful employment in computer graphics. The choices include large and small studios, creating feature film effects, digital feature, television commercial, music video, video game, and many combinations of those genres. With so many options, let's take a look at what it takes to earn a living in this industry.

Another Day, Another Dollar

Whether you've loved special effects since first seeing *Star Wars* or you're a college professor with a fluid dynamics background, who just happened to find a niche in the entertainment industry, you probably still depend on that regular paycheck for food, clothing, and shelter. Whereas it may seem like a game and a dream job to make pretty pictures and put them on the screen, the realities of the business world are still ever present. It's not the job, and most likely not the desire, of the computer graphics artist to understand the inner workings of how the money finds its way into the bank accounts. It can, however, help immensely to have a basic understanding of how the system works. The four distinct areas that are covered in this book—feature films, television commercials, music videos, and video games—are all very different in the way they operate and the way they are funded.

Large and Small Companies

The dynamic of a large company can be quite different from a small company. A larger company is insulated by its size and cash flow from many of the difficulties that the computer graphics industry can present. Shops can range in size from five or six people to hundreds of CG (computer graphics) artists. Whereas some companies are purely digital with just a few computers on-site to do a specific range of tasks, larger companies might have thousands of processors available and cover every task from bluescreen stage shoots to miniatures to film scanning and recording. Larger companies may offer a wider range of facilities, but they usually offer the individual artist a narrower range of tasks to perform. The price a large studio pays, literally, is the overhead of keeping the entire facility running. In downtimes, this is an irrecoverable expense. The larger companies need a more structured pipeline, which places the artist in somewhat of an assembly line type environment. Some may see this as a disadvantage, due to the possibility of getting stuck doing something repeatedly. Others see it as an opportunity to do what is most enjoyable without being bothered by other tasks that are less interesting or less suited to particular talents. If a huge special effects film needs 1,200 computer graphics shots, a small company is simply not able to provide the manpower or the computing power to accomplish such a feat within a reasonable time frame. Larger studios have the edge on bigger budget projects because the processes and machine power are already implemented to work through a large project. They can hire more people, supply them with more expensive machines, and plug them right into their system. The profit margin remains thin, but the large studios have a distinct advantage over smaller ones in terms of landing the high budget, blockbuster-type films. If a studio is going to invest tens of millions of dollars in their visual effects, they prefer to use a company with a proven track record for getting the job done.

There are also many practical benefits to working in a larger, more established studio. If a large studio has been in existence for quite a while, it has no doubt developed relationships with major studios. This often provides an inside track to bringing work into the studio, assuming the major studios have been pleased with its performance. A sequel to a successful film is often awarded to the studio that created the effects for the original film (see Figure 2.1). Relationships between directors and visual effects supervisors are important, and many times a director will specifically ask for an effects supervisor with whom he has worked previously. Such relationships can take years to develop but can mean a steady flow of work for a post-production computer graphics facility.

For many lighting and compositing artists, the lure of big budget films doesn't compare to the desire to learn every aspect of the business and have greater control over the many phases of computer graphics work. A smaller company can often offer that level of involvement for the CG artist. The smaller studios can't afford to hire as many people, and those that they do hire need to wear many hats. In a small studio, one person may handle a variety of different tasks, such as the camera matchmove, character set-up, texturing, animation, lighting, and compositing. Gaining proficiency in off-the-shelf software is common, because smaller companies can rarely afford to set up their own complex pipelines and write custom software. As a part of a smaller team, the individual artist takes on much greater

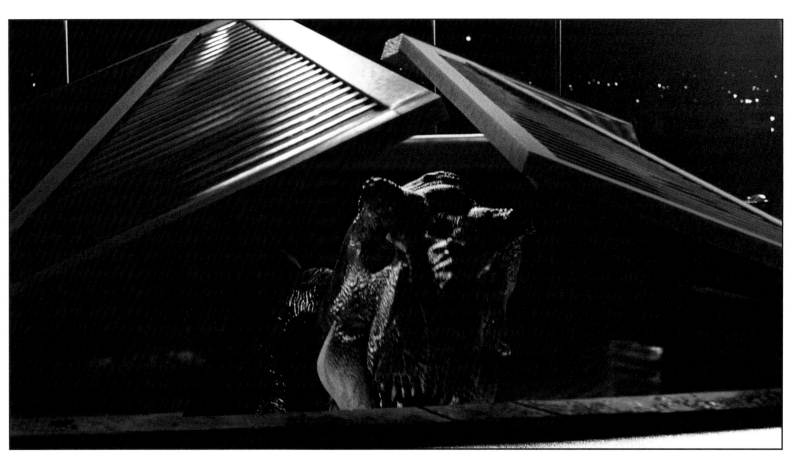

Figure 2.1
A scene from the 1997 film *Jurassic Park: The Lost World*, the sequel to *Jurassic Park*. Copyright © 2002 by Universal Studios. Courtesy of Universal Studios Publishing Rights, a Division of Universal Studios Licensing, Inc. All rights reserved.

responsibilities for the final look of the CG work and many times works longer hours for less pay. This can be a fantastic opportunity for breaking into the industry and can also offer opportunities down the line. All companies start out small, so if an individual can establish a certain quality of work, and the smaller company can attract other artists and programmers to expand and enhance the facility, he might just end up being in on the ground floor of the next Industrial Light & Magic.

After gaining valuable experience with a smaller company, the employment choices become more numerous. A thorough knowledge of a widely used software package greatly increases the artist's marketability. Smaller companies, and to a certain extent larger companies as well, hire experienced people on short contracts when work needs to be done on an extremely tight schedule. This can be a profitable position for the computer graphics artist, because the tighter the schedule, the more the studios are willing to pay people who know the software and production pipeline. In addition, a company typically pays higher rates for those working short contracts as opposed to the permanent staff employees, because contract workers don't receive benefits such as health care and 401k. It puts the responsibility completely on the employee to arrange for those types of benefits; some people prefer to have that kind of personal control over the choices of providers and investments. Many times, the decision between a large and a small company and between staff positions and per-project contract jobs comes down to how big of a risk-taker you are.

Stability versus Excitement

Whereas the excitement and intensity involved in creating professional-level visual computer graphics is tough to match, it also comes with a price. It is important to understand the project-based nature of this business. The specialization that has developed in this industry has resulted in difficulty for companies to maintain a full staff of employees when projects aren't as plentiful. If many people are hired for a specific task on a project, it is costly to keep those workers on the payroll when their portion of the project is completed. The film industry, for instance, is cyclical in nature. Projects come and go, and when the work is plentiful, the salaries are high and the jobs are easy to find. Typically, the biggest effects work for films is released in the summer blockbuster season. This puts the brunt of the digital postproduction work between the fall and spring. As the summer films are released, the studios wait to see how they fare before deciding whether to pump more money into next year's releases. This usually makes the summertime a lean time for film effects studios. While there are obviously exceptions, this may be a time when many talented artists are out looking for jobs, or may be taking a well-deserved vacation. Low demand and high supply works out to be a bad equation for the artist whose skill set is limited to a very specific task. Obviously, companies try to hold onto the most talented skilled people and hire the rest on a per-project basis. The hiring and layoff process can be brutal, but it is a reality of the business.

Projects are not the only things that come and go. A large number of special effects companies that were alive and well five years ago are no longer in existence today. The industry is unforgiving in terms of punishing those companies that are unable to manage their talent and finances properly. I speak from experience in saying that a project can have the most promising and experienced group of programmers and artists in the industry, as well as the content and facility to create cutting-edge, high-quality work, but still can fold in a matter of days. If investors decide the venture costs too much and presents too great a risk, you can quickly find yourself out on the streets with little or no notice. Obviously, there are many influences and indicators for such a cataclysmic occurrence, but they're not always easy or even possible for the computer artist to spot. As I said, it can be a brutal industry.

With that said, the nomadic nature of the business can also offer incredible opportunities. The beauty of a project-based industry is that there are constantly new challenges for the people working on those projects. There are many people who work their entire careers in one studio with excellent wages and incredible benefits. There are also people who work on a single project in a studio and move from company to company following the projects they want to work on the most. Some work nine months out of the year and spend the rest of the year traveling or with their families. When a project finishes, the artist has a great opportunity to evaluate what to work on next. It offers an opportunity to look back on the previous project and think about both the enjoyable and unpleasant parts of the job. Look at the type of project and the scope of your tasks, and consider whether you'd be comfortable doing that same type of work again. If the answer is yes and the studio was happy with your work, you'll most likely be in a great position to move on to another project at that same studio. If the answer is no, there are a number of options available.

One option is to look for appealing projects outside your current studio. After finishing my work on *The Perfect Storm*, the next big project on the horizon that was interesting to me was *Harry Potter and the Sorcerer's Stone*. At that point in my life, though, I also wanted to explore the possibilities of returning to school for an advanced degree in film. The place to do that was Los Angeles, so I moved from the San Francisco area to Los Angeles and began following a new path in the

computer graphics industry. Once in Los Angeles, *Harry Potter and the Sorcerer's Stone* was too big a project to pass by. With some work on my demo reel and phone calls to my industry contacts, I was able to land a job doing lighting and compositing on *Harry Potter and the Sorcerer's Stone*. (Refer to Chapter 3, "How Do I Open the Door?," for more about demo reels and making contacts.) With so many films, television commercials, and video games constantly on the horizon, the odds are good that there is a project to suit each person's fancy.

Another option is to look to your current company for training to improve your skills. If your specialties are applicable to the upcoming projects, the company may be willing to invest in training you for the work that it does have. A skilled lighting and compositing artist with a good eye and strong technical skills can be used in many ways in the production pipeline. If you can make a good case for why the company should train you and add to your toolkit of skills, then most companies will work with you. There are many tasks for which a skilled lighting artist can lend a hand, but the studio must be informed of the possibilities. A TD with a strong computer science and math background could help out writing shaders or with pipeline development. The next show may be in need of many complex water simulations, and you just happened to have been brushing up on your fluid dynamics. Maybe the upcoming show is heavy in difficult bluescreen composites, and you spent every spare moment on the previous show asking questions and learning as much as possible from the resident compositing supervisor with 10 years of bluescreen experience. The point here is to be prepared. If any of the other options are interesting, then use any downtime between projects to learn about them and expand your skill set. If lighting and compositing are the only things that truly interest you, do everything possible to gather more knowledge on those subjects. Before the current project finishes up, be ready to jump onto the next one, try something new, or move on to another studio. Try to expand your knowledge base and gain skills that will help you enjoy your career more. If you are asked to do something that you don't enjoy and won't help you get closer to your personal goals, maybe it's time to move on to another studio.

> TD, short for Technical Director, is a common title for the computer graphics lighting and compositing artist, and is used throughout this book. The term has different meanings at different studios, but for the purposes of this book, it is used interchangeably with "lighting and compositing artist."

The Studio Environment

The work environment in digital production is full of energy and enthusiasm. The closest parallel I can draw is my experience as an undergraduate student in architecture school. In the architectural studios, I worked many sleepless nights at the drafting table with my peers, cranking out drawings and building models. I developed camaraderie working with my peers for all those hours; in addition to the friendships, I also learned about design from my fellow students. Although each person had a different creative philosophy and was at a different skill and talent level, I was able to draw from the experiences and knowledge of those around me. Translating that into a digital production studio, you might be working next to a guy with 10 years of experience as a cameraman, or a woman with five years of experience lighting feature film shots. A situation like that is a gold mine of information, and the studio and project nature of the digital production world fosters that type of learning arena. That studio environment is one reason I chose digital production as my career and a major factor in why I still enjoy it to this day.

The imagination involved in this industry creates an energy and excitement that surrounds every project. This creative flow takes on a physical presence in the studio atmosphere. The workspaces range from sparse and efficient to cluttered and outrageous. The choice is largely that of the artist, but each studio has its own style of work environment. Some are set up as cubicles, some are larger studio-type rooms with several artists in each room, and some are in large warehouse-type spaces. Most larger studios are some combination of these variations (see Figures 2.2 and 2.3). The studio environment can be a bright, open environment with

Figure 2.2
A creative workspace at Industrial Light & Magic.

Figure 2.3
Several workspaces at Asylum Visual Effects.

anything from a DJ turntable, to a pinball machine, to a bubbling fountain decorating the space. You'll usually see framed posters of the films the studio has worked on, as well as a wide variety of posters at people's desks representing the movies that have influenced their careers.

The overriding theme of the workspace environment is determined by the people who run the company. They decide the image their facility will portray and make rules to guide things in that direction. It's important to realize that computer graphics is a big money industry with many millions of dollars spent on hardware, software, and talent. With that kind of money, some investors prefer to see a professional environment and know that their money is funding technologically advanced, ground-breaking visual effects. They might not want to pay for a group of 'kids' sitting around on couches, playing video games, and surfing the Web. Whereas some studios see the work environment as an extension of the creative forces that they expect to see in the work the studio produces, others see the work environment as simply a place to work, where diversions take away from the bottom line. Most studios see it as a mixture of the two, and the workspaces found in this industry are usually interesting and fun places. Along with the relaxed environment comes a casual style of dress. The concern is for the quality of the images put on the screen and not for the statement the artist's clothing makes. It would be a strange sight indeed if someone showed up to work wearing a coat and tie. Flip-flops and tank tops are much more likely.

The type of environment a studio portrays is a direct reflection of the way the studio operates. A crisp and clean workspace most likely translates into a nose to the grindstone kind of work environment. A chaotic, rambunctious workspace oftentimes translates into a wilder work style with crazy hours and many distractions. As I said before, most larger studios have some combination of both styles. The spaces vary with the personalities of the employees, and most companies give quite a bit of leeway in allowing the artists to make an area comfortable. You will spend a lot of time there, so it's in a studio's best interest to allow some freedom.

A lighting and compositing artist feels at home in a space where color and contrast can be accurately judged. Because the work is viewed on a monitor, which presents images with light, any additional light from the room will change the appearance of those images. With less light in the room, the lighting and compositing artist gets a closer approximation of the final output image. This need for darkness has created the common misconception that computer graphics artists enjoy working in very dark, cave-like rooms with only the glow of large monitors lighting their pale faces. Although some people do like to work this way, I've found that most people in this industry hate to work in the dark. Modelers and animators have no need for a dark room, because their work rarely depends on the precision of the color or contrast of the screen image. Many lighting and compositing artists, myself included, can't stand to work in a dark room for 50 to 70 hours per week. Artists fight for rooms with windows and do everything they can to brighten up their space. I prefer to work in a bright, open area with a light shield extending from the top and sides of the monitor. Some ambient light affects the monitor but if calibrated in that light, results are usually fairly accurate. There are always other monitors in a screening room to visually check fine color and contrast details. Although direct sunlight on a monitor is unwanted, it is still nice to have reflected sunlight in the workspace. Every facility I've been in provides both dark and light workspaces.

When considering the possible studio work environments, it's important to also realize the demanding nature of the job. As an integral part of the production pipeline, TDs will likely work long hours to meet demanding deadlines. Although the hours vary from studio to studio, a regular workweek of 50 hours is to be expected. In the digital production world, producers always want more work for less money, and they want it in less time. This provides a particularly difficult challenge for the lighting and compositing artists performing the last steps in the digital production process. The lighting cannot be completed until the modelers, animators, texture painters, and everyone else involved in the shots have completed their work. Likewise, the compositing of the layers cannot be finished until the lighting is completed. If the schedule is delayed anywhere up the line, it often means more hours at the end of the production for the TDs.

It's a tremendous amount of responsibility, but I wouldn't have it any other way. The TD gets all the pieces from the artists and puts them together. The compositing artist is the last person to touch the shot before it goes to its final output format. Whether that's the movie or television screen, the TD has the responsibility for making sure everyone else's work looks good and fits with the vision of the director.

Feature Film Work

The feature film arena is where I obtained most of my professional computer graphics experience. It has been both rewarding and challenging, and I am proud of the work that I've done. Feature films, in terms of computer graphics, can be broken down into two distinct categories: live-action effects films and full-length digital features. The first category holds such films as *Jurassic Park* and *Terminator 2*, whereas the second category is home to films such as *Toy Story* and *Final Fantasy*. They share many similarities, but also feature their own unique challenges.

Live-Action Films

In a live-action film shot including computer graphics, a great deal of research and reference has been compiled before the TD even begins work. By simply shooting the live-action plate, the director has provided a reference showing lighting directions, intensities, and color. (Refer to Chapter 8, "Analyzing Your Reference," for methods of breaking down a scene for lighting cues.) With this footage, the director defines the look and feel that he is after, and it is the job of the lighting and compositing artist to work within that vision (see Figure 2.4). Many times a lighting artist gets lost in a single shot and falls in love with his own work, forgetting to confirm whether the work fits in with the surrounding shots in the film. Working long and hard to make 48 frames (a mere two seconds of screen time) of film a beautiful, warmly lit, glowing masterpiece, first requires confirmation the shot is not cut into the film between two coldly lit, high-contrast scenes. It's surprising how often such inconsistencies can find their way through the cracks. It's part of the TD's responsibility to make sure that the color and feel of the shot matches those around it. The good news is there are plenty of eyes scouring the shots to help with this process.

Figure 2.4
A live-action movie set.

A TD's work is placed in front of many sets of eyes, but the ultimate goal is to please the director of the film. Depending on the project, and the director's level of experience with computer graphics, more or less of the final say on CG special effects shots is up to the visual effects supervisor. This is the person TDs answer to within the effects facility, and for all intents and purposes, whom the lighting and compositing artists are paid to please. There is also most likely a sequence supervisor over a particular portion of the film, and then a CG supervisor above him. It's important to please them all, but the TD must also correlate that with the common vision of the director and visual effects supervisor. The job goes more smoothly with an understanding and clear interpretation of what the visual effects supervisor is asking. It's much like preparing for a test that covers a vast amount of

material. It's impossible to memorize every detail of the subject matter, but gaining an understanding of the teacher's preferences helps in making an educated guess of areas to be emphasized on the test. Similarly, acquiring a good feel for what the visual effects supervisor is after in terms of the look, feel, and level of detail in the work improves chances of choosing the right type of lighting scheme. This method also reduces the risk of losing something in the translation from others in the chain of command.

It's important to realize that many shots end up on the cutting room floor. When first learning my craft of lighting and compositing on *Jurassic Park: The Lost World*, I completed one of the most difficult shots of my career. It involved the

T-Rex walking down a dock, coming in and out of pools of light in a parking lot, kicking cars, and walking under an electrical power stand as the focus racked to the foreground characters. Previously, in the opening shot of this sequence (see Figure 2.5), the T-Rex storms past his broken cage after arriving by boat in San Diego. I was responsible for the lighting and compositing of this opening shot of the sequence as well, and then moved on to work on the shot with the T-Rex on the dock. The shot was 583 frames, and to this day is the longest feature film shot I've ever completed. There were difficulties in the shot at every turn, with my work undergoing weeks of iterations to incorporate changes. When the shot was completed, I was proud of the work and relieved to get this shot through the pipeline and into the film. It was not until a screening of the film on opening night that I

Figure 2.5
A shot from the 1997 film *Jurassic Park: The Lost World*. Copyright © 2002 by Universal Studios. Courtesy of Universal Studios Publishing Rights, a Division of Universal Studios Licensing, Inc. All rights reserved.

found out the shot had been omitted from the film. It was decided at the last minute that the shot didn't work with the timing of the sequence, and just like that, the shot was gone. Although it is frustrating to work so many hours on a shot only to have it cut from the final presentation, try to look at it another way: When teaching seminars and classes on lighting and compositing, I can show a very special shot to the class that has never been shown in theaters. Ultimately, the lesson learned is to do the work to please yourself. I still have the fulfillment from accomplishing that shot, and the direction received from Dennis Muren and Steven Spielberg has shaped the lighting and compositing artist I am today.

Investing time in something ultimately not used in the final product is not unique to the feature film arena. Although it is where the phrase "on the cutting room floor" originated, work can just as easily be cut from any other format that computer graphics can take. Similarly, a common theme among all computer graphics presentations in the form of moving images is the tremendous amount of work required for a small amount of screen time. Because a single film image represents $1/24^{th}$ of a second of screen time ($1/30^{th}$ of a second for U.S. television or $1/25^{th}$ of a second for European television), it's not at all uncommon to spend two or three weeks working long hours on a shot appearing on the screen for two seconds. When considering that working 70 or 80 hours per week on these shots is common, the payoff in screen time seems relatively small. The upside is that the computer helps a lot, and much of the frame-by-frame processing is handled by the processing power of the machines. Still, it's the responsibility of the TD to ensure that every single frame is of the highest possible quality.

The ultimate fulfillment and enjoyment, at least for me, comes from taking pride in the quality and attention to detail in what is put on the screen. There are, however, some great additional perks that the film industry offers. One advantage is the opportunity to see screenings of certain films before the public has a chance to see them. Another benefit is having your name appear in the credits of a film. No matter how many times I told myself it wasn't a big deal, the first time I saw my name on the big screen, my heart beat fast and I grinned from ear to ear as my friends in the practically empty theater applauded loudly. Who knows, you might even go back to your 10-year high school reunion someday and win the prize for having the coolest job. Hey, it worked for me. Everyone wants that level of personal satisfaction in his work, but it's also kind of fun to impress your friends!

Digital Features

Digital features offer many of the same challenges as live-action effects films with one major difference: In a digital feature, there is little or no live-action footage used. Everything is created digitally, including backgrounds, landscapes, secondary characters, and anything else that would make up a scene. This makes for an incredible quantity of work that needs to be done. In order to achieve a full 75 minutes of completely digital work, a large studio can dedicate its entire facility and work force to a project for two or more full years. The goal of Pixar is to release one fully digital feature every 18 months, which is an ambitious goal for that amount of work. With that much digital work, there are endless opportunities for the lighting artist to shine. Depending on how the particular studio sets up its pipeline, there may not be as much of an opportunity on the compositing side of things. Because everything is digital, it can all be created with the same lighting. This gives the 3D artist control over all elements, whereas in a live-action effects film the TD would have control over only those pieces added to the shot. Even though it is all created digitally, it is still necessary in most cases to render elements separately and make adjustments to them later in the compositing stage.

With the box office success of films created by Pixar and Pacific Data Images, digital features have become a big money arena. These films will continue to be made, and more studios will be attempting to get their own original stories out in the form of a full-length digital feature. For the lighting artist, this presents an exciting opportunity. Because there is so much more to light, there are many additional areas of possible specialization for the lighting artist. Background objects, such as trees and landscapes, need to be created and lit. Interiors with walls, windows, carpets, furniture, and toys need to be created, offering another possible area of specialization. Odds are good for lighting a little bit of everything as the show runs its course. The key here is the TD has complete control over creating the director's vision within a fully digital scene. The look and feel of the scene with a color scheme, atmosphere, and any added effect will be created from scratch with no live-action film footage for reference. This means that the lighting artist depends upon color charts that map out the mood of the entire film. This progression of color palettes plots the tempo and the mood of the film. All films follow this type of pacing through overall color shifts in what is seen on the screen, but in live-action films color choices are generally governed by the director instead of with color charts. Digital features need something more concrete as a reference, because

many of the shots are being created simultaneously. With so much time and effort going into each digital shot, it's necessary to give the lighting artists a solid reference.

Specializations may occur when a lighting artist becomes proficient with one particular type of lighting. A single TD may be asked to light an entire sequence of shots that share a similar look. For instance, coming up with a great technique for creating a dappled sunlight look on the movie's characters creates the possibility of applying that technique to all the dappled sunlight shots in the film. An efficient assembly line is just as important, if not more so, in a digital feature as in a live-action effects film. Because every single shot of the film is created digitally, the process must be broken down into sets of tasks to be divided and handled in accordance with the production schedule. Falling behind on such a venture does not leave much room to catch up. If an effects company is already using the entire facility, falling behind and needing to double the output can become very expensive. To meet the deadline, it becomes necessary to purchase more processors, pay employees overtime wages, enlist the aid of other effects houses, or all of the above.

The lighting artist has an amazing opportunity for learning with a digital feature. It provides for long-term job security, because the projects may run for a couple of years. These projects also offer great variety in terms of lighting scenarios. For some people, working on a single project for that amount of time can become boring. For those, perhaps the pace of television commercials or music videos may be more suitable.

Television Commercials

Commercial productions share some similarities with film work, but the pace is faster, the budgets are tighter, the production crews are smaller, and the scope of the work is much narrower. For that reason, the commercial lighting artist is not able to dedicate as much time or produce as many iterations of tests as on a feature film. It is also much more likely that the lighting and compositing artist in the commercials arena will need to wear multiple hats during the projects. Commercial productions may require some modeling, camera moves, and animation in addition to the lighting and compositing of shots. This type of job can help hone the skills of a lighting and compositing artist and keep the TD up to date in the other areas of the digital production. If you like to do it all and want exposure to more facets of the production, commercials may be the place for you.

Because the commercial artist must be versatile, it's crucial to have a strong understanding of how shots are visually composed. Time is of the essence, and if the deadline is Wednesday, the commercial might air on Friday. There's not much room for error. Whereas a film project might last anywhere from a few months to a couple of years, a commercial production typically lasts six to nine weeks. This tight schedule means the TD must find tricks and shortcuts to output high-quality work quickly. For the lighting artist, this means truly understanding and realizing what every light in his scene is accomplishing. Because each light increases the render time for each frame, it's simply not feasible to throw in extra lights just to see what might happen. One thing that helps is the resolution of the final output. Compared to film, television commercial images are less than one-quarter the number of pixels for each rendered frame (see Figure 2.6). Less has to be more in this case, and it's necessary to get the most out of every light in a scene. For the compositor, it means knowing what each layering process is accomplishing, and understanding the concept behind what's going on with the work. There's no time to fish through all the different operators in a compositing software package just to see which one might work. It is necessary to know and understand the processes and be able to apply them quickly and efficiently. It's also vital to understand the trade-offs between rendering and compositing. When time is of the essence, the TD needs to know when to simplify the render and adjust something in the composite stage instead. Likewise, it helps to get a feel for how much time and effort might be wasted in the compositing stage trying to get a bad render to look good. This kind of feel for lighting and compositing comes with time and experience, and working on commercials offers plenty of both.

Because the commercial crews are smaller, each person has more responsibility. This means fewer supervisors and possibly not having a person specifically in charge of lighting and compositing. There are both advantages and disadvantages to this type of scenario. Because the supervisor might also be wearing multiple hats and giving direction on models, textures, animation, lighting, and compositing, there is less time to spend with individuals. TDs are often on their own and responsible for developing their own skills. Because the supervisor can't make every call, it gives more creative freedom and more opportunities to put shots together. Although you'll be working with a talented group of people, and it's important to get opinions and guidance from others, the ultimate goal is to please the director. However, with television commercials, an ad agency also must be pleased. In the fast-paced commercial world, be ready for spur of the moment changes and long hours to meet the deadline.

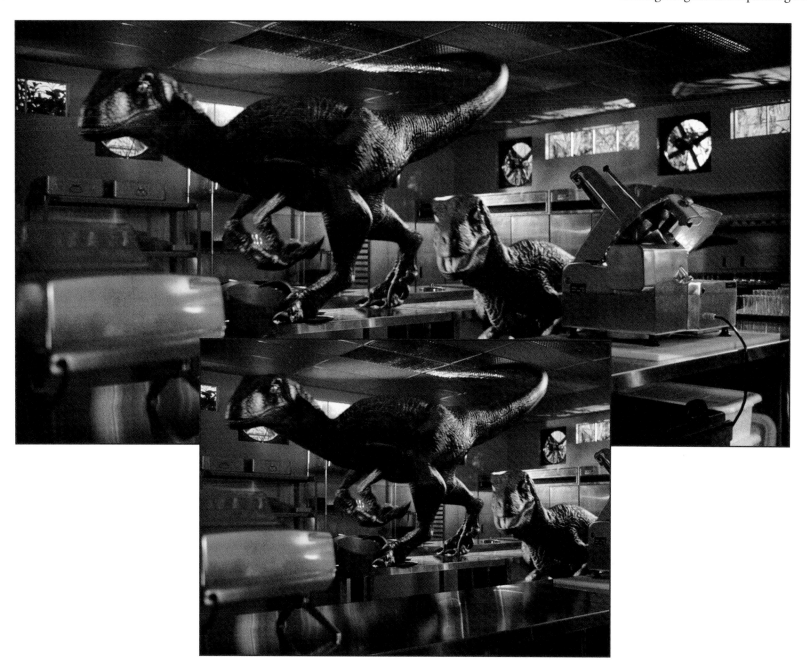

Figure 2.6
A relative size comparison between a film image and a television commercial image. Copyright © 2002 by Universal Studios. Courtesy of Universal Studios Publishing Rights, a Division of Universal Studios Licensing, Inc. All rights reserved.

2. A Trip around the Industry

These quick turnarounds also mean more projects per year. Whereas a TD might work on one or two projects in a single year on the film side of things, 10 or 12 commercials could be completed in that same time frame. For people who like the variety and thrive on pressure, the commercial field is the perfect place.

Music Videos

If the pace of commercials isn't quite fast enough, then music videos could offer the sprint you're looking for. Although the use of computer graphics is not as prevalent in music videos as it is in films or television commercials, it is definitely on the rise. Because they currently represent a smaller segment of the market, companies usually work on music videos in addition to other types of projects. With music videos, musical artists approach a production company with an idea for their video. Sometimes the idea is well developed; other times it is quite basic. The production company then develops the idea into storyboards that can be presented to visual effects companies for bidding. Many times, due to relationships or previous projects with the musical artists, the visual effects company is predetermined. In that case, the bidding is not for who gets the job, but simply for how much the overall price tag will be. It's the director's production company that spearheads this entire process, and it's the director who runs the show in terms of the video shoot and the final approval on effects.

Music videos often do not have big budgets, so the bidding process usually involves further refinement of the storyboards. Ambitious ideas need to be rethought if they are to be realized in the final product. Many times the music video effects are all done with 2D image processing, which is generally less expensive than full 3D visual effects. When this is the case, the digital effects company is often treated as a post-production service and might not have any involvement in the live-action shoot. If there are 3D effects, however, the effects studio's visual effects supervisor will become an integral part of the process. The visual effects supervisor and the director discuss how certain items need to be staged and shot so that the desired appearance is achieved. He develops a clear plan on how the scenes need to be shot in order for the effects work to be added efficiently and at a high level of quality. On the set, he makes sure things go according to plan and offers on the spot advice to the director on unplanned shots that might also need effects work. As in films and commercials, the visual effects supervisor is the primary link between the effects house and the live-action shoot. He acquires all the data necessary to do the effects work, such as survey information, reference photos, and camera information. Additionally, the visual effects supervisor may direct a second unit shoot to obtain footage of effects elements or reference. This could include things such as explosions, dust, sparks, crashes, or texture references.

The live-action shoot for a typical music video lasts two or three days. During this time, the effects house is doing its research and development (R&D). This is usually done only for 3D effects, but occasionally there is a need to research 2D image processing techniques. There is a total of about one week for the R&D to be completed. After the music video footage is shot, it takes a few days to get a working cut of the video to the effects house. Once that cut arrives, the clock starts ticking. Effects work for the average music video is completed in one or two weeks. That means one week of R&D and the remaining time to crank out the work. It's a tight schedule and often translates into round-the-clock work to meet the deadline.

The workflow for the lighting and compositing artists is similar to that described in the previous production scenarios, only much faster. Because the schedule is so tight, the 2D compositing techniques end up taking the brunt of the production burden, as opposed to the more time-consuming 3D effects. Whether the work on a music video is 2D or 3D, the TD in this scenario is presented with the added challenge of synchronizing everything precisely with the music. Because the music is the driving force, and the editor and director have already gotten together to make a cut of the action with the music, the lighting and compositing artist must maintain that synchronization with the additional elements to be added. Currently, it is unusual for a lighting artist to also do the compositing work in a music video. It is split up due to the time constraints and the need for high-speed, interactive compositing. Very fast and usually very costly compositing and image processing systems, such as Inferno, are used to keep the iteration/client feedback cycle moving. (Refer to Chapter 5, "Tools of the Trade," for a breakdown of the various types of compositing systems.) The great expense in maintaining these specialized systems and employing the highly trained operators prohibits using their time to create 3D elements. The 3D artists typically create and light the elements, possibly even animating them, and then hand them off to the 2D artists.

The accelerated schedule also presents a different type of interaction with the supervisors. The visual effects supervisor is usually the one a TD answers to directly in a production environment, but with music videos, the director himself may be at the computer workstation giving input. The creative process can't afford to have a misinterpretation with this type of schedule, so getting the word straight from the source is often necessary. You might think it would be better to get your instructions straight from the director, but directors are not always accustomed to describing their vision in terms familiar to a TD. Many times it's a blessing to have a visual effects supervisor as an intermediary.

Music videos are exciting and exhausting because of their short schedule. Because they explore so many topics, music videos provide a great variety of tasks and challenges. At a facility that also does features and commercials, the lighting and compositing artist may work on a music video, a commercial, and a film all at the same time. This is more common for the dedicated 2D artist than for the 3D artist, because he tends to work on several projects simultaneously. As budgets grow, more directors are becoming attracted to music videos; the opportunities for computer graphics in this genre will continue to be on the rise.

Video Games

Another option in the digital production world is the video-game industry. Video-game schedules typically last anywhere from nine months to two years. Whereas the time spent on a single project is comparable to that of a digital feature, the type of work for a lighting artist is very different. The lighting for video games is an exercise in making every pixel count. Video games require vast numbers of scenes and some type of user interaction within those scenes. This means that the audience's point of view, or the camera, is dynamically controlled. The interactive camera opens up an almost infinite number of ways to see the scene and the characters. Even with the simplest of characters or scenes, it can be a huge undertaking to try to make it look good from every angle.

When shooting a film with a camera, lighting rigs can be set up just to the right of the camera view, or a structure can be created without a roof because the camera never pans up to see the ceiling. In the video-game world, it is necessary to fill in all of those blank areas. With so many viewing options, even today's powerful processors cannot keep up with programming the level of detail into a video game that is seen in a film or on a television commercial. In a single scene from the film *Jurassic Park: The Lost World*, for instance, a dinosaur, known as a parasaurolophus, and the background are seen from one particular angle (see Figure 2.7). From that predetermined angle, the time it takes to render a single

Figure 2.7
A parasaurolophus from the 1997 film *Jurassic Park: The Lost World*. Copyright © 2002 by Universal Studios. Courtesy of Universal Studios Publishing Rights, a Division of Universal Studios Licensing, Inc. All rights reserved.

2. A Trip around the Industry

frame (remember, it takes 24 of those frames to add up to one second of screen time) can be an hour or longer, depending upon the size of the creature in the frame. By comparison, a single video-game scene can be viewed through a full 360-degree range of angles. If it takes one hour of processing time to make the parasaurolophus look that good for a single frame, from a single camera angle, you can begin to understand how difficult it is to make a video-game character look good from every angle. Because the geometry, textures, and lighting must all be greatly simplified in order to play out in an interactive game environment, the lighting artist is presented with the challenge of how to create the best looking scenes possible, with the least amount of overhead.

Video games also offer another approach to the initial design and development stages. Because many video games involve a complex story line with many levels of interaction, it is often necessary to develop a story or script to describe this new world. Hollywood scriptwriters are sometimes responsible for these stories, which describe in amazing detail the history, geography, and characters in a game. This type of treatment is then combined with concept art to provide the look and feel of an entire universe that might be created within the game. With all the options that are open to the game player, it is necessary to go to great lengths to ensure that the world he is exploring is cohesive and follows some type of underlying structure. More so than television commercials, music videos, or even feature films, this world must stand up to the scrutiny and exploration of the audience. The game playing community can be a pretty demanding audience, so it's no easy task to keep them interested and entertained. Along with impressive visuals, there must be some sort of world in which the players can submerge themselves. Creating this type of submersive environment is what many lighting artists crave.

The guidelines and restrictions that are provided by the live-action footage in an effects film come in a different format in video games. The game engine created by the programmers is what provides those guidelines. There may only be three lights that the lighting artist can use on a particular game, or possibly there won't be processing power to allow for specular highlights on any of the characters. The game engine, which is in essence a computer program that renders each frame to the screen, can be developed while the game is in production or can be purchased before the game production begins. If the engine is purchased, it is still necessary to have programmers who can add on to the basic engine and provide for specific requirements of the particular game. The game engine is written specifically for the type of platform upon which the game will be developed. This may be a PC, a

PlayStation, an Xbox, or any other dedicated gaming platform. The beauty of a dedicated game platform is that programmers have a very specific piece of hardware upon which to base their game engine. With a PC, on the other hand, a minimum platform requirement must be specified before the game development begins. Because there is such a wide range of processing and graphics capabilities in personal computers, the type of machine specified cannot be a top-of-the-line, cutting-edge machine. If it were, the audience would be too limited for the game to sell enough copies. Because of that, the game ends up being designed for a system that is technologically outdated and not designed specifically for video games. Obviously, PCs have a great deal of computer power, and amazing games are created for them; however, it's easy to see why a piece of hardware designed specifically for the requirements of video games has become the most popular way to get video games to the masses.

There is always a trade-off between what type of action is to be created in the game and what type of look the game will have. With other types of computer graphics, a better look usually comes from spending more time on each render. In a video game environment with each image created in real time on the screen, the luxury of spending more time per image does not exist. Who would want to play a great looking action game that takes several minutes to generate a single frame of the game? This type of trade-off means that the lighting artists and the engine programmers need to work together from the beginning.

Video games can offer an amazing opportunity for the lighting artist to utilize and develop artistic skills. Similar to the way Impressionist painters broke down the lighting in scenes to their simplest forms, the video-game lighting artist must use a simplified version of the full computer graphics palette. It becomes necessary to develop tricks and shortcuts that can gain the most visual benefit from a single light or a single, simplified texture. The lighting artist must maximize the use of artistic skills in order to create an appealing look in the video game realm.

Lighting for the Long Term

With the many career choices available in the entertainment industry, a long and prosperous career as a lighting and compositing artist is possible. Along with the opportunities, though, is a physical strain that should be considered. As noted before, the lighting and compositing phases are the last in the digital production line. This means long hours and high stress at the end of almost every production. Sitting at the computer for 10 to 15 hours per day may not seem like a physically

taxing position, but the hazards are there. Doing the same types of movements repeatedly, hour after hour, day after day, and year after year, can cause what is know as repetitive stress injury (RSI). Commonly referred to as carpal tunnel syndrome (which is actually a specific form of RSI), this type of injury can be serious and career threatening.

One thing all levels of computer graphics have in common is an intense level of concentration required to achieve results. I've often found myself tensed up and staring intently at the details on the screen, not even realizing that several hours might have passed. This type of intensity in mental concentration often translates into muscles becoming tense and eyes becoming strained. Without proper stretching and breaks from the strain, the muscles can tighten, blood flow can be reduced, scar tissue can form, range of motion can be reduced, and serious injuries can occur. This happens slowly but is exacerbated by insufficient recovery time. The body needs time to recuperate, and working 60 to 80 hours per week does not allow much time for recovery. Although the effort required to sit at a keyboard typing and moving a mouse around may not seem like much compared to other activities, it can still be damaging. I know many people in this industry whose careers have ended because they can no longer type or even sit at a computer without severe pain in their wrists, forearms, neck, or shoulders. Some of those people can't even use a pen to write a check. It's a very real problem, and if it takes years to build up, you can imagine how long it takes to recover.

With that said, these types of injuries can be prevented with proper understanding and guidance. Fortunately, most companies take a very proactive approach to addressing RSI concerns. Most facilities evaluate the ergonomics of each employee's work area and provide chairs, desks, special keyboards, and customized mice in order to address the possible physical problems. A conscientious company, along with an informed worker, addresses these problems before they start. The employee needs to set up reminders to take breaks, get up and walk around, stretch muscles, and give the eyes a chance to relax. If these precautions are taken, you can head off problems before they occur and enjoy a long and prosperous career in the digital production world.

Those are many of the realities of the computer graphics business. This industry offers many different sizes of companies as well as different genres. The project nature of the business and variety of studio environments create an exciting work atmosphere. The differences among live-action films, digital features, television commercials, music videos, and video games offer a wealth of career choices. There are risks, but the reward of on-screen glory is ever present. This industry offers incredible opportunities and a variety of tasks for the well-prepared lighting and compositing artist. We'll take a look at some ways to prepare for just such an opportunity in the next chapter.

chapter 3
How Do I Open the Door?

With such a rapid expansion of the computer graphics business, the number of schools and businesses that embrace CG has grown quickly over the past few years. In the past, a CG artist needed to study a variety of fields combining different disciplines to create an educational program. Now there are numerous specific programs designed to give the computer graphics artist the skills needed to survive and flourish in the ever-changing and ever-growing marketplace. These programs either offer the students an education leaning heavily on the technical and computer science areas or one leaning more toward the artistic and compositional side. Some programs blend the two together; others have gained the favor of specific studios due to their particular curriculum. The decision of where to learn about computer graphics has become almost as difficult as the decision of where to work in computer graphics. Both decisions will depend upon the choice of specialty area and overall career goals. In choosing both a scholastic environment and a work environment, it's important to take into account the people you'll be learning from. The professors at a school or a program as a whole always have strengths and weaknesses. Similarly, the choice of a studio may be based on a favorite film and the desire to learn from the person who was instrumental in bringing it to the screen. A huge factor in my decision was that I might get the chance to work with Dennis Muren, whom I knew had been instrumental in putting *The Abyss* and *Jurassic Park* on the screen.

Along with the people, the physical environment can play a huge roll in the decision-making process. If one of the keys to understanding lighting is getting out and experiencing the world, imagine if that world looked like some of the places in San Francisco (see Figure 3.1). With possibilities like that in your backyard, lighting research becomes a true pleasure.

In addition to geography, it's also important to take into account the type of interior space you might be working in. I'll review some of the factors that come into play in making these decisions and introduce a few of the possible options.

Education

As the number of jobs in the computer graphics industry grows, so too does the number of educational programs. When I attended graduate school, only two major programs in the United States combined artistic composition with computer graphics and programming. Since that time, more have popped up, and there are many schools that can help students break into the computer graphics industry. The problem in the past has been gaining access to expensive, high-end computer workstations that are running equally expensive 3D animation and rendering software. As the prices of computers continue to drop and the software becomes accessible on more platforms (such as Alias/Wavefront now offering their powerful Maya software on the Windows and Apple platforms), this becomes less of a problem. Having access to the software and being able to run it on a fast machine, however, doesn't provide all the tools needed to work on films, commercials, or video games. It will prove invaluable to have a knowledgeable instructor who can not only demonstrate how to use the software, but can also offer the tips that the manuals and tutorials won't have.

Training can start in high school, with a basic understanding of programming skills and artistic composition. In my case, I didn't start combining the technical skills with the artistic composition until after I had finished my undergraduate degree. There's no reason, though, that it can't start earlier. The first step is to identify the ultimate goal. Is it to work on films, video games, animation, modeling

Figure 3.1
A scene from one possible work locale in the San Francisco Bay area, home to such companies as Industrial Light & Magic, Pacific Data Images, and Pixar.

characters, or is it to be a part of the entire process? Many times it takes awhile to decide which task is most enjoyable for you. In some cases it's a good idea to attend a junior college or take a specific software training course to identify which areas are most interesting. It's not necessary to have a college degree to work in computer graphics, but the types of courses offered at most colleges offer a huge advantage to those who decide to pursue this career. The computer graphics industry as a whole does not put a great deal of emphasis on the degree or the college attended. As the competition increases, however, a degree helps distinguish desirable candidates from others applying for the same job.

Once the goal of lighting and compositing is chosen, the educational search can be narrowed. There are many things to look for, but the most important may be the credentials of the people teaching the courses. Check out the professors and look at the work they have done. Is it work that impresses you? Is it something you want to learn about? Can they help you to reach your goals? Look to see what types of visiting professors teach at the school. Are there lectures from people whose work you respect and admire? Many schools offer courses taught by people from the industry who are taking a break from the production life. I was part of a 10-week seminar that was taught jointly between Industrial Light & Magic and Texas A&M University. I spent a week lecturing (along with four other artists) and taking the students through a project that simulated a production shot from the industry. Because the seminar was conducted during the summer months, and there was a bit of downtime in the effects projects at that time, ILM was able to send each of us to teach without losing any production resources. It was a great experience to be able to share some of what I had learned about the industry with the visualization science students at Texas A&M (see Figure 3.2).

Figure 3.2
The computer visualization laboratory of Texas A&M University.

Connections with companies in the industry can also be important factors. Check to see whether appealing companies do recruiting at any schools. If a company has had good luck with students coming out of a particular program, they will invest time and resources into recruiting from such a school. Companies are looking for students with a good understanding of the basic concepts of the 3D computer graphics world; equally important, however, is a team player and fast learner. Those assets can be greatly developed in the right educational environment.

Speaking of dedication, it is important to see what the facilities of a school have to offer. A great deal of time will be spent at the computers learning the craft, and students need ample access to the machines and the software. See if the school offers 24-hour access to the computer lab, and find out what the student to computer ratio will be. Also check on how many licenses they have of the high-end software packages. (Refer to Chapter 5, "Tools of the Trade," for a description and uses of some of the more popular software packages.) A computer lab with 30 of the fastest machines around doesn't do much good if only 2 have Maya licenses. Also, inquire about their additional facilities. An interest in compositing can benefit from a stage area set up to shoot some bluescreens (see Figure 3.3). Access to high-quality video or digital cameras and facilities to edit the work is also important. It's nice to be able to record work on a portable medium. Transfers and editing can always be done elsewhere, but that can be a costly and time-consuming affair, particularly for a starving student just trying to show work to get a job.

A tremendous number of other options are available to people in the computer graphics field. I chose to go into film visual effects, but the field of computer graphics has opened new avenues of exploration in many other areas. Scientific visualization is making incredible strides in the surgical and medical research fields. Architects are creating virtual buildings to showcase designs in three dimensions before a foundation is even poured. Geologists run simulations to predict the effects of global warming on the earth's continent structure. Artists are using the digital medium to offer new conceptual and interactive gallery presentations. Practically every field of study can gain some benefit from the advancements in computer graphics, and any one may appeal to a student. This book draws from my personal experiences and describes many opportunities in the entertainment industries; but I don't want to discount the value or the possibilities in choosing a completely different area of interest. The options are out there, and they're definitely worth exploring.

Figure 3.3
Bluescreen stage at the visualization laboratory of Texas A&M University.

Local Projects

The number of opportunities available to the computer graphics artist can quickly translate into a college job. Almost any location in the country offers local projects from which excellent experience can be gained. Projects, such as a local television commercial or an architectural visualization, may be arranged through a school program. These jobs offer the novice the perfect opportunity to start working under the constraints of a project with a budget. The student learns what an individual's time is worth, what mistakes can cost, and how to deal with a client. At every level of the CG world and in every genre, a client with a specific vision is asking for specific details. If a client is paying money for computer graphics, he has the last word on how it should look. As a student, I was part of a team hired by the highway department to visualize the impact a new highway would have on the community it was to cut through. The job was to show the impact the highway would have on its surroundings and present it in a way that was visually easy to understand. This may not seem like a very glorious backdrop for someone aspiring to do great things in computer graphics lighting, but it offered many unexpected opportunities. The most important aspect of the project was that it was my first time working on a team project in computer graphics. Coming from an architectural background and having spent two years working in an architectural firm, I had worked on plenty of design and production teams—but this was an entirely different set of circumstances. The workflow was quite different, and it took all of us some time to learn each other's strengths and weaknesses. At that time, I honestly didn't know if I wanted to do modeling, animation, lighting, programming, or even if I was cut out for this type of work.

Fortunately for the group, we had competent leadership provided by a professor with many years of experience in the CG production world. Tasks were quickly assigned according to the strengths of the individuals working on the project. Each team member chose to work on his favorite aspect of the process, but ended up doing the tasks best suited to his individual talents. For me, that was lighting. The challenges of lighting a highway running through a neighborhood with an extremely simplified model were more than I imagined. Because the client was the department of highways, our job was to be accurate and also make the highway look appealing. As silly as it may sound, my job was to make a happy highway. For the presentation, the roadway was surrounded with vegetation, the entire surrounding neighborhood was brightly lit, and the highway was blended in as well as possible. I was even concerned with the contrast of the white dotted lines running down the highway relative to the grey of the concrete, not wanting the road to pop out too much to the viewer's eye. You may be thinking to yourself that my job was to mislead those who saw this visualization into thinking the highway would have less impact than it would in reality. Actually my job was to make it as accurate as I could, based on what I'd seen in real life. The most difficult part was the camera view chosen for the presentation. The highway was shown from a helicopter's overhead view, and from that angle a roadway always appears more prominent than it typically would at the level where humans would interact with it. The head of the department of highways had specific requests, and regardless of whether the team thought they looked good or bad, accurate or misleading, we were obliged to comply. It turned out to be great preparation for the work I do now. As Martin Scorsese put it, "The American filmmaker has always been more interested in creating fiction than revealing reality."

Another option is to look for situations where lighting and compositing work can be used in other, seemingly non-related areas. While in graduate school, I took a course on experimental music. For a final project, I combined the musical piece created in that class with a multi-layered composite of several scenes shot for a video class. CG elements were added here and there to enhance areas of the video. This introduced me to a new perspective on how live-action footage, computer graphics, and sound all work together to produce a product much greater than the sum of its parts. Unfortunately, my lack of experience contributed to the results of that particular project totaling up to be considerably less than the sum of its parts. Despite the look and sound of that final project (it was deemed by most as "interesting"), it did open my mind to new ways of thinking and new areas for exploration.

In addition to scholastic projects, it is often possible to find a local vendor who would love to add a little spice to some low-budget television commercials. This can provide an opportunity to work through the entire production pipeline, from storyboarding to editing the final cut. This arena may also allow more creative freedom, because the person contracting the work is most likely new to the world of computer graphics as well. Regardless of the apparent freedom, be aware that everyone has an opinion, and the person paying the bills usually has the strongest one. These types of projects can pop up in the least expected places, so always be on the lookout for possible work. Anyone who would consider putting a commercial on television will most likely consider adding something to jazz it up. Even a simple flying logo is an opportunity to start to fine-tune lighting and compositing skills and maybe even collect a bit of cash.

The Demo Reel

After fine-tuning those job skills, it's time to get them ready to show prospective employers. The way a lighting and compositing artist shows off his talents is with a demo reel. This little 3- to 5-minute bit of video is more important for landing a job than the resumé. In the digital production industry, the demo reel is how candidates are judged. It needs to be short and to the point and must grab the eye of whomever is watching it, whether that be a recruiter, a CG supervisor, or a director. The demo reel is representative of the artist's creativity and also the main avenue to getting a job, so artistic integrity must coexist with common sense and practicality. Perhaps a favorite personal project is a 12-minute short film with bits of outstanding computer graphics scattered throughout it. By taking the high road and refusing to break that piece up for the demo reel, most of the audience a demo reel is geared toward will be lost. No matter how good those 12 minutes are, odds are high that no one will have the time to get through the whole thing. In larger companies, recruiters look at hundreds of demo reels and simply do not have the time to sit through lengthy reels waiting for the pay-off. The assumption is that the best work is the first thing on the reel. If it starts out weak, the eject button is pressed rather than the fast-forward. If someone at a smaller company is reviewing a reel, it is likely that he'll have considerably less time to dedicate to watching demo reels than a full-time recruiter would—it's probably a person in charge of lighting 20 shots in 2 weeks. When it comes down to watching demo reels of perspective employees or making sure the work is done for the client, guess which one takes a back seat.

Considering the time constraints and your best work, you can put together a demo reel to sell you and your talents. The type of work appearing on the reel depends upon the type of job you are hoping to obtain. For consideration as a lighting and compositing artist, the best work in that category needs to be at the very beginning of the reel. Putting together a demo reel that starts out with 2 1/2 minutes of complex CG models shown spinning in a grey box with no colors or textures, followed with 30 seconds of nice lighting work, tells the person watching the tape that the candidate's strong point is computer modeling. Without enough completed work to fill a demo reel, there are a couple of options to help create additional content. One is to try some quick, small demonstrations of specific talents. Do a quick bluescreen composite, and concentrate on the quality rather than the length. Try lighting a complex scene with simple models but highly detailed textures and interesting lighting interaction. The important thing is to represent the quality you're capable of creating. Quantity is more a result of teamwork and having computer power and resources. Quality is the result of talent, hard work, and determination. Companies can buy the power, but they have to search through demo reels for the quality. The other option is to simply make the demo reel shorter. Having a short, high-quality demo reel is always better than having a long one with bits of brilliance scattered throughout.

To help choose which pieces are the most eye-catching, try not to depend completely on your own eyes. It's easy to fall in love with a certain project based on the amount of time put into it, or based on a fantastic new lighting technique. Show the work to others and see what they think about it. If everyone likes projects other than the one shown first on the reel, try to step back and look at it with their comments in mind. They might see things that you've been missing. It's important to study people's reactions as they watch the test cuts of a demo reel. Check to see how they react to certain things, and always listen for comments or exclamations that let you know something impressed them. Ask which part they thought was the strongest, and if it shows your best lighting and compositing work. It is also helpful to ask these types of questions in interview situations. It may be that an unsuccessful interview is specifically because of the demo reel. How will you know what to fix before the next interview unless you ask? Just remember that the demo reel represents the type of work that you want to use as the foundation for your career in computer graphics. Hopefully it is the type of work that is the most fun for you. Try to remember that when putting the demo reel together. Have fun with it, and treat it like the ultimate expression of your talents and capabilities.

Making Contacts

Regardless of talent and an eye-popping demo reel, a prospective employer must hire the candidate before the paychecks can begin. The old saying, "It's not what you know, it's who you know," holds true more than ever in the entertainment industry. The computer graphics industry is growing rapidly, but it's still amazing how frequently the same people cross paths while working in computer graphics studios. Each person has a unique way of making contacts and maintaining them, so I'll make this short and sweet. People remember two things about most people they've worked with. One is the quality of the work they produced and the other is how they worked within a team. In most cases, the second outweighs the first. I've seen some of the most talented people in the industry laid off from a company, simply because they were difficult to work with in a team environment. I've also seen people with average skills at lighting and compositing survive round after round of lay-offs, simply because everyone enjoyed working with them and they produced quality work. The people you work with will remember you, and one day your paths will likely cross again.

I've always established myself through a passion for the work and a determination to succeed. With that approach, and the constant willingness to learn and improve skills, the digital production industry can hold a wealth of opportunities. The right blend of education and experience, along with a demo reel that represents it, can open the doors to some of the most amazing worlds your imagination can create.

These first three chapters cover the basics of preparing for a job in the computer graphics entertainment industry and the expectations once a job is landed. With a strong educational background, a solid base of experience, and a demo reel that exhibits specific strong points, a path into this exciting and rewarding profession can be forged. The people working in this industry are some of the most incredible personalities and amazing minds you would ever hope to come in contact with. In many years in this business, the number of brilliant and talented people has never ceased to amaze me. Their energy and knowledge will hopefully rub off on you, leading to career advancement. The next chapter is an interview with a professional who has experienced and excelled in a wide variety of genres in the computer graphics industry.

chapter 4
An Interview with Melissa Saul Gamez

The individuals represented with interviews throughout this book offer a variety of opinions on how lighting and compositing are handled at the professional level. Each one has his or her own way of approaching this discipline, and each will offer another way to look at lighting scenes and compositing the layers together. I've included interviews with people working in many different types of companies and representing many different paths into the computer graphics industry. I hope these interviews are as entertaining and enlightening for you to read as they were for me to conduct.

A Brief Introduction

At the time of this interview, Melissa Saul Gamez was working as a computer artist at Westwood Studios in Las Vegas, Nevada. Melissa has a unique perspective on the computer graphics industry, stemming from her extensive and varied experiences. She has worked in the architecture field, the television commercial arena, and is now working on video games. Her achievements include a master's thesis involving nautical archaeology. In all of her endeavors, she has continued to utilize and enhance her lighting and compositing and other skills in the computer graphics world. In this interview, she discusses her various job experiences and how she approached the different challenges presented at each new company.

Interview

DAVID: *Could you give me a brief summary describing your path to the visual effects industry?*

MELISSA: I studied architecture in undergraduate school, and after graduating with a B.E.D. [Bachelor of Environmental Design] I decided that architecture wasn't really for me. So I was looking for something in the design field that was still creative, but not specifically architecture. Then along came the visualization program at Texas A&M University, where I had received my undergraduate degree. I thought it looked interesting, looked like something new, and I thought I'd give it a try. It wasn't like a lifelong goal or anything. It was just sort of being in the right place at the right time. You know what I mean? Actually, didn't I talk you into getting into the viz lab?

DAVID: *Yes, as a matter of fact, you did. In a way, this interview is happening because of what you did back then.*

MELISSA: Full circle. [Laughing] This is payback.

DAVID: *So that's how you got started at the visualization laboratory. What happened next?*

MELISSA: My thesis project involved collaboration with a professor in the Nautical Archaeology program at TAMU to reconstruct a 17th-century Dutch passenger ferry that the professor was digging up and studying at that time (see Figure 4.1). The reconstruction was used as a means to determine the functionality and applicability of using visualization and computer graphics in the field of nautical archaeology. It sounds quite ordinary now, but at the time not many people were using CG in that field because of its newness and cost.

> My thesis project involved collaboration with a professor in the Nautical Archaeology program at TAMU to reconstruct a 17th-century Dutch passenger ferry that the professor was digging up and studying at that time.

Figure 4.1
Images from Melissa's master's of science in Visualization Sciences thesis project.

After I finished the master's of science program in the visualization lab, I went to work for an architecture firm in Germany that was doing computer animation and 3D graphics at the time. I wouldn't say it was my dream job or what I had been going through the [Texas A&M] program thinking I would get a job as, but it was such a great opportunity to live abroad and experience a new culture and have some fun.

DAVID: *How do you think traveling and working abroad changed or established your perspective on the computer graphics field?*

MELISSA: Well, back then things were so different. It was quite different what they were doing in Europe at the time, because computers, both hardware and software, were so much more expensive in Europe then. They paid such a high tax to import the stuff, so they were quite a few years behind what was happening in the United States. Very few people were using the same hardware and software, to the same caliber and extent that they were in America, because of the cost. It was very prohibitive, so, if anything, that was probably the biggest impact on the work that we did. It was a little frustrating coming from the states and working over there, but at the same time, computer graphics is international. They're doing the same stuff everywhere and it's not specific to any culture (see Figure 4.2).

> **It was a little frustrating coming from the states and working over there, but at the same time, computer graphics is international.**

DAVID: *So the content is basically the same?*

MELISSA: I think what influenced me more, the reason I only did it for a few years and I became bored, is that in an architecture office, when you're working in a large firm, most of your clients are bankers and they're very conservative. Therefore, the products you're producing are very conservative. You don't get as much freedom and you can't be as crazy or creative as you'd like to because you're presenting to a banker who may not appreciate what you're doing.

Figure 4.2
Examples of Melissa's work with the German architectural firm Kahlen & Partners.

DAVID: *Your clients were bankers because of the way things were set up specifically in Germany?*

MELISSA: Mainly because of the scope of the projects. The architecture firm that I worked at did very large office complexes and worked with developers and bankers. It wasn't like we were doing domestic architecture or houses or anything like that. The firm wouldn't have been able to afford to be able to use the computers if they were doing small projects. It was these large projects that afforded us the use of the computers. The work was challenging for a while, but I became a bit bored with it because, first of all, it was German [corporate] architecture which is very clean and austere. And secondly, we couldn't do anything really interesting or creative or different with our presentations, because our clients were usually very conservative. It was fun work, but after about three years, it became somewhat monotonous. It was a little stifling. I would read in the journals and magazines and online about all these new tools that they were coming out with and new effects, but they were things that I could never use or try with our presentations because it wasn't appropriate for what we were doing.

DAVID: *So what pulled you away from Germany?*

MELISSA: Well, like I said, I worked in Germany for about three years and I really just became bored with the scope of the work. I didn't feel like I was being challenged anymore. I had sort of stagnated in terms of what I could learn from them. So I decided to come back to the states, and I wanted to just try something new. I still wanted to work in computer graphics, but another field in computer graphics, specifically entertainment, mainly because that's where most of the jobs were at that time. I was just about to start looking for jobs when I got a call from Will Vinton Studios. Some friends who were directors there found out that I was back in the states and offered me a job to come work as a technical director at Will Vinton, and I said okay.

DAVID: *So they hired you based on previous contact with you rather than on a demo reel?*

MELISSA: Yes. Contacts are very important. You know, as big as it's become now, it's still a very small industry. Word of mouth is more important than anything. If you burn your bridge in one place, it will stay with you forever. People don't forget.

DAVID: *You went to Will Vinton and made the move to the entertainment side of things. Will Vinton Studios are widely known for their expertise in stop-motion animation, especially claymation [an animation process in which clay models are built, posed, and shot one frame at a time to produce character movement]. Did you have any experience with that when you went to work there?*

MELISSA: No, I didn't. Will Vinton was a really great environment at that time, in that they allowed you, if you were interested, to study and pursue animating or technical directing or directing in the stop-motion environment if that's what interested you and you showed a talent for it. They would try to put you in production in that new area, and that was really nice. We got to do a little bit of dabbling on the stop-motion side, but there was so much on the computer side that I was more interested in and felt my strengths were in, that I chose to work in that area. I worked with so many talented, stop-motion animators; I couldn't even hold a candle to them. I mean these people were just really amazing. We had a few people at Vinton who worked on both stop-motion and CG, and it took a very specific personality and mindset because they required a completely different skill set as far as patience and thought process. With the computer, we did it over and over and over, and in stop-motion you had to plan everything ahead of time, and you got one shot. Sometimes you could shoot it again, but the schedule usually didn't allow for that. You really had to think differently about the way you would approach something. One thing I did like is that a lot of the projects we did were mixed media, so it was a little bit of stop-motion mixed with CG, and those were a lot of fun. It was really rewarding when we brought those two worlds together.

> **We got to do a little bit of dabbling on the stop-motion side, but there was so much on the computer side that I was more interested in and felt my strengths were in, that I chose to work in that area.**

DAVID: *What did you work on primarily at Will Vinton?*

MELISSA: Will Vinton's meat and potatoes is television commercials, and that's what I primarily worked on. They have also done television shows, movies, and a 3D animated film for the M&M's store here in Las Vegas. That one was sort of interesting. It was the first time our company had gone into that arena. We all had a big learning curve that we had to get on really quickly, because working in 3D just brought up a whole new set of problems and issues. It was interesting, though. It was new challenges that we had to face, and we all learned a lot. It was another way to expand your knowledge base.

DAVID: *Can you tell us about the process of creating a television commercial?*

MELISSA: At Will Vinton I was a senior technical director, so I can tell you the process from that perspective. Our company would bid on jobs from advertising agencies for specific commercials…well, basically, the ad agency would pitch an idea to the client and we would put together an animatic [a rough animation using simple graphics and drawings to visualize the storyboards in motion] to bid on a project. If it was accepted by the agency then our producers and directors would get together with the creatives at the ad agency to come up with a more fine-tuned animatic as to what the spot would look like. We would put together a team that was usually a director [at Will Vinton Studios a "director" fulfills the vfx supervisor and animation director roles other studios may employ], a producer, a few animators, and a technical director.

The typical schedule for a 30, and by that I mean a 30-second commercial, is anywhere from 6 to 15 weeks. It depends on how much money you have, the client, the turnaround, and things like that. If it's a new client, then you've got a lot of concept work. You have to work out a new logo, a new character…it depends on what it is you're doing for that company. Will Vinton primarily was a character animation house, so people came to us to create a character or spokesperson for their product, such as the M&M's, the Clorox guys, the Domino's Noid, and things like that. So a lot of times the first part of a process for the commercial would be creating that new character who's going to be your spokesperson.

> **…a lot of times the first part of a process for the commercial would be creating that new character who's going to be your spokesperson.**

Then you would start modeling your characters or your environments, and if the CG was going to be married with live action you would have a shoot somewhere. The technical director would go with the director and producer and get all of the information needed at the shoot, so we could marry our CG with the plate. We'd track lighting, camera focal lengths, distance… things like that. You'd come back from the shoot, where you'd continue getting ready for the project, whether it required modeling or figuring out a new character setup, etc. You'd get your background plates and have your first edit, and then the first thing you'd do is roto the plates [Will Vinton Studios has generalized the term rotoscope to include the process of matching the live-action camera with a computer graphics camera, not the frame-by-frame creation of mattes typically meant by roto or rotoscope], and put your character in them and hand off scenes to your animators. Then the animators would start animating the character and the TD would start working on lighting, effects, etc. At that point you'd start having dailies. Once a week you'd send your tape off to the client, get feedback the next week, make your changes, and keep animating until they were happy. After final renders, depending on whether or not the composite was going to happen in-house or somewhere else, you'd composite everything together and hopefully have a happy client.

One thing I liked about working at Will Vinton was that as a technical director, I got to do a lot of different tasks because we were a small company. You got to go to the live shoots, handle lighting, rotoscoping, modeling, texturing, rendering, script writing, and compositing. We got to do everything that wasn't handled by the animators or the director. So it was a fun role in that we didn't get bored doing the same things over and over and over, and we constantly got to play with new tools, learn, and be exposed to new things, which was a lot of fun and very stimulating. The downside is that working in that environment, as you know, is very stressful. You have very short deadlines and it's not always a friendly environment.

> **…we constantly got to play with new tools, learn, and be exposed to new things, which was a lot of fun and very stimulating.**

Competition is fun, and that's where you learn things. It's really rewarding working on a collaborative team putting something together, and it's challenging and you learn a lot. But after a while, when you're working 60-, 70-, and 80-hour weeks, week after week after week, it starts to get to you…especially at a smaller company, where you're not compensated as you would be at larger companies. You're not paid hourly, you don't get overtime, and there's no perks. You kind of start to feel like you're being abused because possibly the project wasn't being managed as well as it could be by the producers or something else. Some big companies take advantage of their employees like small companies, but at least you feel like you're going to be financially compensated. If you love the work, and if you just crave what you're doing, then it probably doesn't matter. I got to where I came home at the end of the day and I said, you know what, I'm making commercials that sell foot powder. Is it worth putting in the 80 hours a week? No, I'm not saving the world. My time and my sanity are worth more than this.

Another good thing about working at a small company, and this opportunity was afforded me at Will Vinton, is that I had absolutely no commercial production experience before I went there. I think you might have a better chance at a smaller company to be exposed [to all the aspects of the business], learn the ropes, and let them train you for a particular job better than at a big company where you might need experience to get in the door. I could be wrong, because I haven't worked for a giant company, like ILM, but that's the impression that I get.

DAVID: *Did you enjoy the size of the teams of people that you worked with at Will Vinton?*

MELISSA: Yes. They were usually 3 to 12 people, and Will Vinton had a bunch of really nice people to work with. When I first started there it was a real sort of family environment. Everybody knew everyone, everyone took care of each other, and we all helped out on each other's projects. I really enjoyed the scale of that. As the company grew, and we took on the P.J.'s, we hired around 150 people. We went from 60 people to around 250 people, and it became a lot more corporate, a lot more impersonal, and you didn't know everybody that was walking around in the hallways. It affected the way we treated each other and it affected the environment. I didn't enjoy it as much, but at the same time, you had a greater pool of talented people to pick from who could work on your project. So there are pros and cons to both.

DAVID: *Was the animation the only external input you received in terms of putting shots together as a technical director?*

MELISSA: No, we did a little bit of everything. Technical directors also did some animating, but it was mainly effects animation. Everything, of course, was under the direction of the director. Everything we were doing was coming from the director who wanted this certain look or this camera angle. Most of the work we did at Vinton was CG mixed with live action, so a lot of that was dictated by the plate. We did very few commercials that were all CG. What was nice at Vinton, too, is that a lot of times, depending on the director you were working with, they gave you a lot of

> **I think you might have a better chance at a smaller company to be exposed [to all the aspects of the business], learn the ropes, and let them train you for a particular job better than at a big company where you might need experience to get in the door.**

> **What was nice at Vinton, too, is that a lot of times, depending on the director you were working with, they gave you a lot of carte blanche as to how to approach something or how you'd like something to look.**

> **It got to the point where we had done those characters so many times, that we'd ironed out all of the bugs as far as the modeling, the character setup, etc.**

carte blanche as to how to approach something or how you'd like something to look. They had very specific ideas (and some directors had a lot more specific ideas than others), but also if you tried something and it looked great and it worked for the shot, then a lot of times they would use it. That was a lot of fun. That was really nice. There's a lot more freedom at a smaller company than at a big company, I would say.

DAVID: *Did you find yourself setting up new scripts or rigs for each shot or each new project, or did you frequently use things over and over?*

MELISSA: I would say both. We did so many M&M's commercials. They were one of the largest accounts that Will Vinton had. It got to the point where we had done those characters so many times, that we'd ironed out all of the bugs as far as the modeling, the character setup, etc. Every year or couple of years we'd re-do their skeletons, just because new tools would come out, with better IK tools [Inverse Kinematics is a common method used to calculate multiple joint positions and rotations based on animating a single joint] or better skinning tools or something like that. We were constantly updating these guys [M&M's], but I would say we used the same basic scripts, the same basic tools, but we would upgrade them with the tools that were available to us on the software side for sure. We couldn't change too much because when you have a character like the M&M's, they have a specific personality and look and feel to them that people come to know, and they expect them to look and move and feel this certain way. You can only change them so much, because if they start to go against character, then people start to go, "Wait a minute, that's not Red [M&M]. That's funny, he looks funny

now." But we definitely would re-use some of the same tools over and over, just hopefully improving them each year as the software and hardware improved.

DAVID: *Was that trademark look to the characters as much in lighting, reflections, and color as it was in animation?*

MELISSA: Yes, oh exactly. And it's funny when people who see the commercials, who didn't work on them, probably wouldn't catch this…but I can look at old spots and I can tell sometimes which animator animated which character, because each animator had a certain way that they had the characters move, in the early shots especially. It's kind of interesting, because the people have put their own little touch on the commercials. But toward the end, we'd done so many of them that they really all looked the same. Red had a specific character, had a specific look, his shell had a certain shininess to it, his eyes and lips only moved a certain way, his walk had a specific gait to it, and all of these things contributed to giving him that sense of character, that sense of identity, that I think made it such a popular campaign. So you really needed to make sure that you stuck to that look and that feel when you were lighting, when you were compositing, and when the animator was animating. Things like that were all really important to help them stay in character. It is kind of interesting when you think about something that doesn't exist for real, having that much personality and character. It's the same as when you guys work in your movies, and you have one of the characters from *Star Wars*, and he has to have the same look and feel across hundreds and hundreds of shots. We maybe only did 25 shots for a 30; sometimes 20 or 15. You had hundreds, and it's the same thing. He had to stay in character and have the same look and feel and remain consistent through all those shots.

> It's kind of interesting, because the people have put their own little touch on the commercials.

DAVID: *That sounds like a pretty good overview of the commercials world. And now you're working on video games. How did you make the move to that area?*

MELISSA: Well, like I said, I kind of got burned out working on television commercials, because of the pace and the hours. My husband

> I decided it was time to try something new. I've done architecture; I've done nautical archaeology; I've done commercials; let's try video games.

took a job in another city, and there was nothing happening in my field in that particular city other than a video-game company, so I decided to apply for a job there. I decided it was time to try something new. I've done architecture; I've done nautical archaeology; I've done commercials; let's try video games. So I accepted a job, and now I'm working in the video-game industry.

DAVID: *In the video-game industry, what is it like to do lighting and compositing?*

MELISSA: It's really interesting, Dave. Coming to the video-game industry from high-end computer graphics, I was very skeptical. I had always sort of pooh-poohed the work I had seen in games before. I thought it was very low tech. I thought it looked bad. I have to say, I have a whole new appreciation for what happens in the video-game world now after working in it. There is a completely different skill set that you need to have developed to be a good artist in the video-game world. You use the tools completely differently. It's very challenging. I would say first off, your basic artistic skills are so much more important, because your poly count is so low. This is changing with PS2 and the GameCube and all that, but traditionally, because the number of textures you can have and the number of polygons you can have is so low, every pixel has to count. Every polygon has to count, and you really have to be smart about maximizing what you've got. I've used my basic drawing and painting skills so much more working in a video-game company than I ever did working in commercials or architecture. It amazes me how much. It was almost like I had forgotten how to draw.

> There is a completely different skill set that you need to have developed to be a good artist in the video-game world. You use the tools completely differently. It's very challenging.

Compositing depends on the platform you're working for, because if you're creating a game for PC, for PS2, or for a Game Boy, the type of products you're going to produce are going to be completely different. The games that I've been working on here have been for the PC and for the Internet. For these games, there isn't any compositing per se, in a way that we would understand it coming from entertainment like commercials or film. Everything we create is a three-dimensional object that lives together in this world we have created. The compositing really comes

from the programmers who write the code that lets all this stuff exist together in the engine. So, I have to say, since I've been working on video games, I haven't done any traditional compositing.

As for lighting, again this depends on the engine you're using for your game. Basically your lighting has to be built into your character. You have to bake it into the texture map, because you don't get all these different passes and materials that you can apply to your character or your environment. You usually get one small texture map that's for everything. Your character has one pass, and depending on your programmers and your engine, it's very limited. For example, you may not have any specular in your world, because the engine can't afford to. So that changes everything. There are all of these things that you have to deal with. Sometimes the characters will respond to real-world lighting, but usually we're baking those lights into the map itself. We'll paint in highlights. We'll paint in shadow areas. So it's not always accurate, but it gives that character more dimensionality and realism, I think. It's also very challenging because so much of your lighting comes from the programmers. It depends on your engine. They may say, okay, we can afford to have a sun in our world, and maybe these other five lights that characters are going to react to, and that's it. It's rarely real.

In one of the games that I worked on here at Westwood, we decided to use Lightscape, which is a program that calculates real-time lighting and calculates actual volumetric lighting and shadows. We would take an environment that we had created for the game, run a light simulation and calculation, and render out what the lights and shadows would look like, and then those would be baked back into the texture maps. It was this crazy and amazing process that we went through. The lighting wasn't dynamic. It wouldn't change, as in if a ceiling fan blade was turning, the shadow that it cast on the floor would not turn… only in specific areas if a programmer told it to, but at least we baked in shadows, highlights, reflected light, reflected color in our environment, and we would paint that into the texture map. Now the downside is it doesn't change when your lights change,

> **Basically your lighting has to be built into your character. You have to bake it into the texture map, because you don't get all these different passes and materials that you can apply to your character or your environment.**

but that takes a tremendous amount of hardware and engine power to be able to calculate something like that. It will happen in the future. It's coming. There's a couple of places where they're already doing it, but it's just too expensive right now. Usually, your game would crawl.

DAVID: *With my experience in films, I would typically work on 8 to 10 shots for a film, which might total 15 to 20 seconds of screen time. Is there a comparable way to quantify how much work you might do on a video game?*

MELISSA: Well, it's completely different in video games. In one of the games I worked on for the PC, we were creating environments where the characters would play and run around for the entire game, so in a sense, you were creating "shots" for the entire game. I guess the big difference is that it isn't linear in the same way a film is. Someone created the characters, someone created the vehicles, someone created the weapons, someone created the trees, someone created the environment, and then the programmer would write a tool that would put all these things together in the same world. Some of the things needed to move and some didn't—the things that could move that the player could control, and the things that could move that the game could control. So it was different.

> **I guess the big difference is that it isn't linear in the same way a film is.**

Now, that said, there are some people who work on specific shots, like in a film, because most of these games have what are called cinematics. Those are the movies that are in the game. Now it used to be all of the games had pre-rendered cinematics, so you'd be playing the game, it stops, and then it cuts to this little film that plays. Now, since game engines and computers are getting more powerful, you're having more in-game cinematics. This means you're using your actual environments and characters to play little movies. They are called run-time cinematics or real-time cinematics. That's the trend. That's what most games are moving toward, because the computers are fast enough now and the frame rate's good enough where they can handle that many polys on the screen at one time. But some games we've been working on still have pre-rendered cinematics. It's

> **They are called run-time cinematics or real-time cinematics. That's the trend. That's what most games are moving toward.**

3D Lighting and Compositing

kind of like doing small films. They may be working on 10 or 15 minutes total of all CG cinematics for a game. It's got to be rendered and it's supposed to look photo-realistic; they've got storyboards for it; they've got an editor; it's got sound—it's just like a little mini movie. But that trend is going away.

DAVID: *A great deal of what you create depends on the programmers. What is your work relationship like with the programmers?*

MELISSA: I can't speak for all game companies, but at our company, work production is broken down into three specific areas: programmers, who write the engine that drives the game; designers, who come up with the game play itself, how characters are going to act, and write scripts for how things act and react; and then the art team, which produces all of the 3D and 2D graphics for that game. And then of course, you have a producer and a lead or a director for your project.

DAVID: *How many people are on a team that's putting together a video game?*

MELISSA: I work at a fairly large company and our teams are pretty big. In the game that I'm working on right now, I'd say we have maybe 8 artists and 1 lead artist, 2 concept artists, and then you have a team of programmers—that might be another 10, 20 people, and then you have a team of designers and that might be another 10, 15 people. Now, that said, I don't know if the size of our teams are typical for other game companies. I think we happen to be on the large side and tend to throw a lot of people at these games. Most games have a much smaller staff. You might have 4 or 5 artists, 4 or 5 programmers, and 4 or 5 designers. It depends on the scope of your game and your budget.

DAVID: *It's quite a different world from film and television commercials.*

MELISSA: Yes, it is. If you're creating cinematics for a video game, then your role as an artist is very similar to a technical director in the film or commercial side, because you're modeling, texturing, lighting, camera matching, and rendering just like you would for a commercial or for a film. If you're creating art for the game, then it's a completely different skill set, which I've found to be very interesting, and I have a whole new respect for people who work in the game

> **I have a whole new respect for people who work in the game industry who do good work. You've really got to make every single pixel, polygon, and vertex count.**

industry who do good work. You've really got to make every single pixel, polygon, and vertex count; it's just amazing. You know, when I started in this field, it took me three months before I felt like I was usefully contributing to my team. At the same time, I was incredibly frustrated. A downside to working in the game world is that you don't get to use all the cool new tools that have come out with the software packages these days, because, chances are, your game engine can't handle it. Anything that's done effects-wise is going to be done by programmers, so I feel that one side of my talent has really grown and my knowledge base has expanded in this new realm, but at the same time I have used such a narrow slice of what I know now. It's very small and very specific. For example, my modeling skills have stagnated because my characters can only be 200 polygons, maybe. You can only do so much with 200 polygons. You're not going to use any of the fancy new modeling tools that are out there. You know what I mean? So, it's the same with lighting, the same with all the new hair renderers, smoke, things like that, but at the same time, my painting skills and the way I problem solve has really changed and improved. So, it's a trade-off.

DAVID: *It sounds like it's been a great new challenge for you. Speaking of challenges, what is it like to be a woman in this industry?*

MELISSA: Oh, good question. Very interesting. At Westwood, which has over 200 people, I am one of 14 female employees. I am the only female artist in the entire company. We have one female programmer. We have one female designer, and I think the rest of the women are secretaries and administrative assistants and HR people. At Vinton, it was a predominantly male environment also, but not as bad as

> **It's not the ideal environment to work in as a woman. A lot of times I don't feel like there are a lot of people that I have much in common with.**

a game company. Vinton had only one or two female technical directors while I was there. Most of the women in the company were producers and assistant producers. We also had some women directors. That said, at Westwood, being the only female has a lot of pros and cons. I've found, and I don't know if this is because the industry has so many men in it, or if it's the particular company I work in, or it's

because of the type of products that we produce as games, but it's a very machismo-heavy, locker room environment to work in. You have to be a very laid-back woman, and not let every look or comment offend you. It's not the ideal

4. An Interview with Melissa Saul Gamez

environment to work in as a woman. A lot of times I don't feel like there are a lot of people that I have much in common with. I don't want to talk about the latest copy of *Playboy* or download the latest naked woman, but it's been interesting. The game industry is definitely a young person's environment, and it's definitely a boy's environment. I think it would probably depend on the company you work at and what kind of product you produce that would affect your environment. I have heard that Westwood is supposed to be, actually, a lot better than most companies. I don't have anything to base this on. They treat me very well there as a woman. I feel like my needs are always listened to. If I have concerns, there's someone I can bring them to and they're dealt with. But I wish we could hire some more women. We really need some more estrogen around that office. It's a great opportunity for women, and I think women bring something different to any job than a man does. We just look at things differently.

DAVID: *Do you have any recommendations for someone just starting out in computer graphics? Maybe you have some encouragement or some horror stories for our fledgling lighting and compositing artists out there?*

MELISSA: I think the field of computer graphics is a fabulous opportunity for anyone, a man or a woman, because there are so many opportunities out there today in so many fields. You can do science, you can do litigation, entertainment, education, architecture. I mean the possibilities are literally limitless. Computer graphics is being used everywhere these days, so it's a fabulous skill set to have. Also [it's great] if you're a creative person who wants to have the opportunity to play. Not many jobs let you have so much freedom in such fun, creative environments.

> **Not many jobs let you have so much freedom in such fun, creative environments.**

The downside is that a lot of these jobs are going to suck the life out of you, because they want you to work 80 hours a week, and you have to decide if it's worth it. Is making a piece of candy talk, or is selling toilet bowl cleaner worth your life? What's the trade-off? That's the big question, because you can make a lot of money, but at the end of the day when you go home, are you proud of what you've done? Have you made the amazing effects for this really crappy movie that sucked? Was it worth it? Was it worth putting all those hours in? And, you know, only you can answer that, but at least you have the choice, which is good. It's better than a lot of fields.

Another thing I would say, looking back now, which I didn't do when I first started off, is to make sure you speak up for yourself. Don't be afraid to speak up for yourself, because a lot of what we do is so unhealthy, and I know so many people who have health problems now because of this industry. You really need to make sure you work in an environment where they're proactive about your ergonomics and the number of hours you spend in front of your computer, because it's not worth the use of your hands. Nothing's worth that.

chapter 5
Tools of the Trade

The perspective of the seasoned professional in the previous chapter and knowledge of the state of the digital production industry lays the groundwork for exploration of elements used to create professional-level lighting and compositing. In this section, the basic concepts involved in presenting a three-dimensional world in a two-dimensional medium and the tools a lighting artist uses in 3D computer graphics software are presented. Whereas the tools and concepts presented here can be used with virtually any 3D graphics software package, the examples in this book use Alias/Wavefront's Maya. We'll step through the variety of lights available, the ways to manipulate them, and how to make computer graphics creations both convincing and impressive.

Compositional Basics

The basics of two-dimensional composition are outlined in Chapter 1, "A Little Bit of History." In studying film, photography, and paintings, the concept of a picture plane is essential. In each of these media and in computer graphics as well, the three-dimensional world must be translated into a two-dimensional presentation format. For films it is the screen of a theater, for photography it is the paper of a print, and for traditional paintings it is the canvas. The two-dimensional layer onto which this three-dimensional world is being projected is known as a picture plane. The picture plane for a photographer or filmmaker is defined by the view through the chosen lens. The picture plane for a painter is more flexible, because the painter can distort the plane or include things a normal camera could never see in a single frame. With a camera, the picture plane is only distorted by using different lenses. A fisheye lens enables the picture plane to encompass a full 180 degrees of view, whereas a normal lens only provides for a view of about 45 to 70 degrees (see Figures 5.1 and 5.2). No matter the type of lens used, though, there are rules for how lights interact with objects based on the physics of the real world that everyone recognizes. These rules help people relate the two-dimensional film images they see back to the world with which they are familiar. Of course the rules can be bent, but as stated in Chapter 1, "A Little Bit of History," with reference to Pablo Picasso, it is first necessary to learn the rules.

The Picture Plane and Framing

The picture plane is a powerful concept and deserves additional explanation. Imagine walking around outside carrying a big, flat piece of cardboard with a rectangle cut out of the middle. Nothing is visible around the outside and the only view of the world is through that cutout. What is seen through the cutout is the picture plane. A single moment frozen in time of what is visible on the picture plane would be a photograph. If you were filming, that would be a single frame of the running footage shot. Suppose you are stopped and looking through the piece of cardboard held at arm's length. In the view, there is a body of water with some other elements to the lower right of the frame (see Figure 5.3). With relation to an image, elements are defined as objects or layers within the frame. In computer graphics, these elements can include character animation, live-action film footage, video footage, bluescreen elements, particles, and anything else that serves as a layer for the composition. The framing in Figure 5.3 provides the impression that there is some type of bridge or walkway at the bottom of the frame, and a tree just to the right of the frame. There are also some hazy white and gray forms in the background at the top of the frame, but it is difficult to identify what they are.

Figure 5.1
A photo taken with a standard 50mm lens.

Figure 5.2
Another photo taken from exactly the same location with a fisheye lens.

Bringing the cardboard picture plane closer to your eyes reveals a wider view and clarifies that the gray and white forms are actually mountains in the distance with the lake nestled in among them. There is also a bridge between you and the lake, and a large tree between you and the bridge (see Figure 5.4). If you pull the cardboard still closer, you see the tree has broken off at the top, and there is an indication of something very close to the camera at the top left corner of the frame (see Figure 5.5). From this framing, it appears that the shot was taken from a location floating out above the ravine where the tree is located. Moving the cardboard even closer reveals that the shot was actually taken from just off the side of the road. The road sign identifying the "Narrow Bridge" is now completely revealed and the two sides of the road that the bridge connects are now clearly visible (see Figure 5.6). This movement of the picture plane is a simple way of representing the changing of focal length in a camera's lens. The point here is not to explain all of the details of shooting with different lenses; rather, the point is to show how multiple framings of the exact same scene can create an entirely different feel and provide the viewer with a whole new set of visual clues within the two-dimensional picture plane.

Understanding the concept of framing is essential for anyone who wants to make an effective 2D presentation. The four different images of the mountain lake all emphasize something different. The 200mm shot emphasized the lake, whereas the 50mm shot is much more about the bridge in the midground. Why is this the case? Both shots are from exactly the same angle, at the same time of day, with the same lighting, and with the lake in the very center of the frame. Obviously, the size of the lake in the frame has some effect on how important it is in the composition. Also, the size and dominance of the bridge in the midground makes it seem more important. The point here is that the way a shot is framed can make a significant difference in how an audience perceives the subject matter.

There are many ways to visually emphasize an idea by using a few simple rules of composition. For instance, to make a character within a scene appear ominous, the placement of that character within the frame could help a great deal. A character that exceeds the boundaries of the frame can appear large and menacing (see Figure 5.7). Another compositional factor to consider is how objects meet or approach the edge of the frame. Elements close to the edge of the frame, but not quite reaching the edge, typically create tension in the composition. Along with

Figure 5.3
A view of a mountain lake shot using a 200mm lens.

Figure 5.5
A view of a mountain lake shot using a 50mm lens.

Figure 5.4
A view of a mountain lake shot using a 100mm lens.

Figure 5.6
A view of a mountain lake shot using a 28mm lens.

5. Tools of the Trade

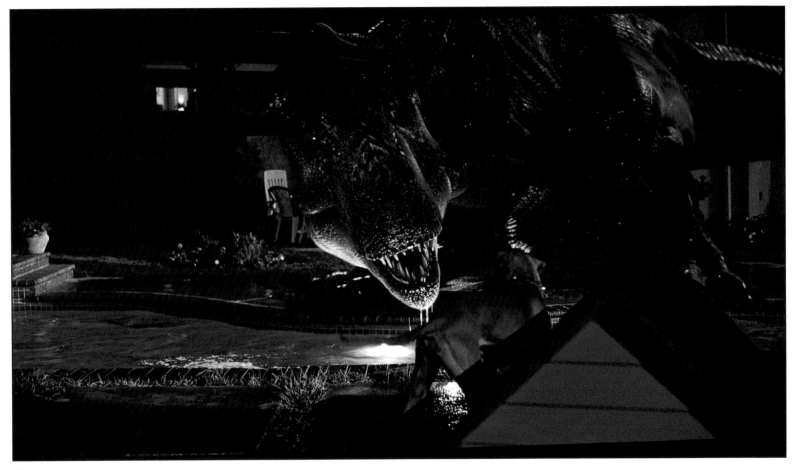

Figure 5.7
A shot of the T-Rex, from the 1997 film *Jurassic Park: The Lost World*, where he is so large and intimidating that he can't be contained within the frame. Copyright © 2002 by Universal Studios. Courtesy of Universal Studios Publishing Rights, a Division of Universal Studios Licensing, Inc. All rights reserved.

how elements interact with the edges of the frame, it is equally important to consider how they interact with each other in the shot. Two elements within a frame that come very close to each other without touching can also cause a sense of tension. This provides a small sample of the compositional practices that can make or break a two-dimensional presentation. To gain a better understanding of composition through framing, take some time to look at your favorite paintings, photographs, or films, and pay careful attention to the way their creator chose to frame the objects within the given picture plane.

Motion and Lines of Influence

The previous examples dealt with still images as opposed to the moving images found in a film or a television commercial. The addition of movement is yet another way to affect how an audience perceives the elements presented to them. The viewer's eye can be led from one side of the frame to the other by simply moving an object across the frame. This can add chaos if many movements occur in different directions at the same time. The viewer can quickly become confused or overwhelmed in such a situation and miss details that might be important. Be

aware of how much activity is put onto the screen before it begins to detract from the intended visual emphasis. These concepts are difficult to represent in still images, but imagine a city scene in which so many things are happening that it becomes difficult to determine the intended emphasis of the shot (see Figure 5.8). The many lines of influence leading your eyes around the image in Figure 5.8 are disorienting. A still frame can be studied or analyzed, but a sequence of images that flies by at 24 or 30 frames per second is more likely to be confusing. Of course, if the intent is to present a confusing and disorienting scene, this is exactly the type of composition you want. Entire books have been written on composition, and a director of photography makes a career out of choosing the proper framing to convey the emotions and story of a film's director. As with paintings and photographs, films offer a wealth of information on how to successfully frame a shot. Go back and watch some of your favorite films taking note of how important the framing is to how the story is told and the visual impressions that the film makes. Just as important, note the shots that seem to fail or fall short compositionally.

Figure 5.8
A city shot where it is difficult to discern the intended area of focus for the viewer.

Layers and Depth of Field

In addition to placement within the frame, it is also important to determine in which layer the particular element resides. Is the element meant to be in the foreground, the midground, or the background? Is it meant to be behind the tree or in front of it? If we're compressing the three-dimensional world into two dimensions, what indicates which things are in front of or behind other things? It seems a simple enough question, but some of the most common mistakes found in computer graphics are due to a poor understanding of the visual clues used by the human eye to perceive the third dimension (depth).

When shooting with a camera, the depth of field is one of several ways to help indicate which layer of a scene an element occupies. The depth of field is defined as the range of space both in front of and behind the primary focus plane that remains in apparent focus. The way to affect the depth of field within a camera is with the aperture setting. The aperture (also known as the f-stop) defines the size of the opening in the lens through which light passes. (The film aperture is divided by f-stop. Refer to the Appendix for a technical explanation of camera lenses.) The larger the f-stop number, the smaller the light opening but the greater the depth of field. Because the light opening is smaller, in order to gain a greater depth of field within a photo, it is necessary to have more light. With a small depth of field (a lower f-stop number), there is a very limited range of space that appears in focus for the shot. In return for a narrower depth of field, though, not as much light is needed to take the shot. Conversely, with a large depth of field (a higher f-stop number), there is a much greater range of space that appears in focus. The three images shown here looking down a hallway demonstrate how different the emphasis of a shot can be from exactly the same camera position but with three different depth of field settings (see Figures 5.9, 5.10, and 5.11).

In the top image (see Figure 5.9), a set of headphones is very near to the camera, but because the depth of field is narrow and the focus is set so close to the camera, it is difficult to discern any other details about the scene. This shot is obviously emphasizing the headphones in the foreground.

In the next image (see Figure 5.10), the headphones are now out of focus, and our focus is set much farther from the camera. The depth of field is still narrow, because there is only a very small range in focus. As the focus point gets farther away from the camera, the depth of field, even with the same aperture settings, becomes larger. If you didn't already know there were headphones in the foreground, it would be difficult to identify the objects that are close to the camera. In this shot, the emphasis is on the ladder and paint bucket in the midground.

Figure 5.9
A scene shot with a very narrow depth of field and the focus on the extreme foreground.

Figure 5.11
A scene shot with the focus on the background, creating a wider depth of field.

Figure 5.10
A scene shot with a narrow depth of field and the focus on the midground.

In the last version (see Figure 5.11), the focus is centered on the wall in the background, and the poster of young wolves is now clear. Even though the aperture setting is the same in all three photos, the depth of field is different. As you can see, these are three very different shots that create different effects, yet the camera has not moved one bit.

The depth of field discussion also relates back to the topic of framing a shot. Elements very close to the camera are often used to change the shape of the viewing area, thereby adjusting where the viewer's eye is led in the shot. With both sides of the frame blocked off, as by the doorways in Figures 5.10 and 5.11, the horizontal format of the image plane takes on a vertical emphasis. Reshaping the viewing area in order to manipulate the area of interest is a common technique used in all types of two-dimensional compositions. The key to all presentations is communicating your point. The ability to hold the viewer's attention and guide his eyes to the chosen subject is a basic skill essential to successful visual communication.

Depth Cues

There are many components closely related to depth of field in a two-dimensional composition that give the viewer additional clues to understanding the layers in a scene. People are very sensitive to the visual cues they have seen many times before. The average moviegoer may not be able to tell you specifically what makes a shot in a film look wrong, but she can definitely recognize if something doesn't look right. The way a computer graphics artist layers a shot together has a great deal to do with whether it looks correct. Contrast and brightness of elements within a scene contribute a great deal to how they should be layered. Elements in a scene with little contrast and muted colors typically occupy a layer far from the viewer. Conversely, the objects closest to the camera appear to have the most

vibrant colors and the highest contrast. Objects closer to the camera don't necessarily have greater contrast or more intensity of color, but they appear that way due to resolution. A camera lens, much like the human eye, is able to resolve closer objects with more detail than those farther away. There are also factors, such as atmosphere and haze, that affect the amount of detail seen, but for now just consider the effects of resolution on how elements are perceived. When presenting the three-dimensional world on a two-dimensional picture plane, the objects closer to the lens generally occupy more of the picture plane, and thereby have more pixels to help define their surfaces.

Pixels and Resolution

Pixels are the building blocks of computer graphics images. The more pixels you have, the greater the resolution. Think of pixels as rectangular dots that come together to form an image. Each pixel has its own color and intensity. If there are not enough pixels, the image is not as clearly defined. The photograph in Figure 5.12 of a beach sunset with a variety of plants in the foreground, has a fairly high resolution (many pixels). The forms of the greenery, the tire tracks in the sand, the breaking of the waves, and the clouds surrounding the sun can be clearly seen. In

Figure 5.13, however, things are not as clear. There are far fewer pixels, and the details are no longer discernible. Notice the rectangular shapes at the ends of the leaves on the plant at the right of the frame. Because pixels are rectangular, it takes many of them to simulate a curve. The leaves at the right of the frame cannot appear curved with the small number of pixels available in Figure 5.13. There is simply not enough pixel density to display the details of the scene. (Refer to the Appendix for the typical image resolutions used in film and television.)

The resolution discussion points out one of several attributes that helps identify the distance of an element from the viewer. The greater the resolution or clarity of an element, the more likely the viewer is to perceive it as closer to the camera. If something appears to have higher contrast and more saturated colors, it pops out in the frame and, therefore, appears to be closer. If a subject has little contrast and less saturated colors, it tends to drop into the background. Of course, there are many other considerations, such as the color scheme of the subject, the color and contrast levels of the surrounding environment, and the movement of the element. These simplified explanations of the layering concepts and techniques are explored in more detail in Part III, "Practical Application."

Figure 5.12
A scene with small pixels and a high resolution.

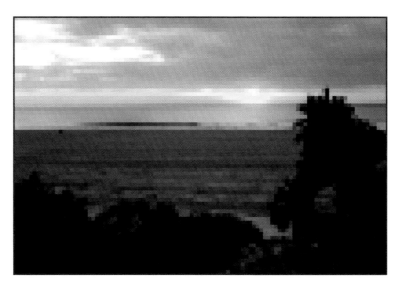

Figure 5.13
A scene with large pixels and a low resolution.

5. Tools of the Trade

Color and Mood

In addition to shot framing and depth cues, such as contrast and shading, the amount and types of colors within a shot have a tremendous impact on the composition. A single, blue light in a scene can completely change the mood and the emphasis. Likewise, a brilliant red object within a scene can grab your attention. Color, much like contrast, can be used to differentiate elements within a scene. The interaction of colors within a scene, however, is a much more complex process than the simple contrast between light and dark. Objects within the scene have characteristic color attributes that, when illuminated by various light sources, produce the luminance captured by the camera. When the colored layers of a scene are assembled, the interaction of the objects' colors can produce an unexpected result. The layering process that this book emphasizes is of vital importance when dealing with color. Lights can change or create the mood within a scene, and understanding how they interact with the subject is vital to controlling the intended look.

Figure 5.14
A blue rectangle on a predominately orange background.

Emphasis versus Blending

As a simple example, look at the image of a blue rectangle on an orange background (see Figure 5.14). Although a blue shape typically stands out against the complementary orange color, here it is integrated somewhat with the background. The blue of the rectangle is desaturated and shifted to a color closer in tone to the orange of the background. Also notice in this composition that there are many objects criss-crossing the frame. With these added components, and with the rectangle's diffused color, it is difficult in a still frame to distinguish a primary point of interest for this image. Nothing stands out as being more or less important than anything else, and the many diagonal lines that cut through the composition add to the confusion. If the rectangle were moving from screen left to screen right, however, its motion would identify it as the emphasis of the shot. For the purposes of this discussion, though, assume the presentation is just a still frame. One way to make a blue character or object pop out from the background is to make the blue color more vibrant. A simplified example shows how a vibrant blue color on an orange background creates an area of interest in the frame (see Figure 5.15, left). Notice also that it's not simply the color's difference from the background, but also the isolated appearance of that color within the image. If there are many blue shapes spread throughout the image with the same vibrant coloring, the effect loses its impact (see Figure 5.15, right).

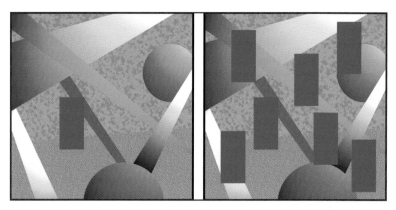

Figure 5.15
A vibrant blue rectangle on an orange background (left), and several blue rectangles on an orange background (right).

Mood and Time of Day

In addition to adding emphasis to a particular element, color can create a mood within an entire scene. Instead of changing the color of an individual object, colors of the lights illuminating the scene can be changed to affect the final product. Shifting the overall color scheme of a photograph illustrates this concept. The original photograph is of the Hoover Dam on a normal, sunny day (see Figure 5.16). By shifting the colors of the scene toward blue, it can appear more calm and tranquil (see Figure 5.17). It actually appears to be later in the day, and the weather seems nice and cool. By shifting the original scene more to an orange tint, the scene now appears much harsher (see Figure 5.18). This image now has a desert feel to it—a very warm place with the summer sun beating down upon it. In all three images, the contrast levels are maintained, and only a shift in color creates the three completely different moods. This same effect can easily be created in the computer graphics world by changing the color of one or all of the lights. It is a powerful tool, and even a subtle change in the color of a single light can have a noticeable effect on the final image. There is much published research on how the use of color affects humans psychologically. I leave it to you, once again, to look at films, paintings, and photographs to discover how the colors used contribute or detract from the mood and the subject.

Figure 5.17
A scene with its colors shifted toward blue.

Figure 5.16
A scene with its original colors.

Figure 5.18
A scene with its colors shifted toward orange.

5. Tools of the Trade

Be aware, also, that absence of color can completely change the mood. A scene with few bright colors, low contrast levels, and an overall gray tone can feel dreary or monotonous. This color scheme has been used to represent mundane work environments or depict hopeless imprisonment. Consider an image of an environment with dull colors, low contrast, and a fairly even distribution of light (see Figure 5.19). The room is uninteresting and doesn't exactly look like the type of place you would like to visit. By adding more color in the lights and to the surfaces of the objects, the feel of the room has changed (see Figure 5.20). The overall effect, although not as dreary, is still ordinary and not terribly interesting. A third approach maintains the vibrancy of the colors, but also increases the contrast among the various lights (see Figure 5.21). As you can see, the feel of the scene is more dramatic with the dark and light areas adding a hint of mystery to the scene, resulting in a more visually intriguing space. With the basic concepts of composition, layering, and color under your belt, you can now move on to setting up lights within a 3D computer graphics environment.

Figure 5.20
A room with high color intensity and brightly colored lights.

Figure 5.19
A room with low contrast, low color intensity, and neutral lighting.

Figure 5.21
A room with high color intensity and high contrast lighting.

Lighting Basics

Lighting a scene can be as complicated or simple as you want it to be. A solid understanding of how scenes are lit on live-action sets or in theatrical productions provides an excellent starting point for setting up lighting. To break it down, there are three basic lights with which most scenes begin. Those lights are a key light, a fill light, and a rim light (also known as a backlight). The key light, as its name would suggest, is the primary source of illumination for the scene (see Figure 5.22). If the scene is outdoors, the sun is usually the key light. In a room, the key light source may be a ceiling-mounted light fixture. Sometimes there is only a key light and other times there is no key light at all. For the time being, though, I will concentrate on the basic three-light setup, including the key, fill, and rim lights.

Figure 5.22
A character with only a single key light contributing illumination.

Key Light

The key light typically produces diffuse and specular illumination as well as casting the dominant shadows. Frequently in computer graphics, you may hear someone refer to either the diffuse or the specular component of a light. In reality, diffuse and specular components are characteristics of a surface and the incidence of light upon it. Diffuse refers to the light reflected in many directions by a surface. If you strip away the reflections and the highlights, what you have left is the diffuse component. Think of it as the base layer of illumination on a surface. The specular component refers to the light reflected directly into the camera from a surface, producing a highlight. With most lights in computer graphics it is possible to control the diffuse and specular contributions individually, but this is a cheat to avoid making lighting models that obey the computationally expensive reality of physics. For now, consider the lights as simply sources of illumination, as in the real world, with no separate controls over how they illuminate objects.

Fill Light

The fill light helps to fill in the areas where the key leaves off. There can be many fill lights in a scene, and they can have many different names. You might have a top fill aimed from above the scene, or a left and a right fill to try to fill in from the sides of the frame. In the basic three-light setup, however, the fill light is placed roughly opposite the key light in order to fill in the dark areas on a character or an object (see Figure 5.23). These are the areas that the key light does not reach. Without a fill light opposite the key, the contrast is at its highest, but there is no additional illumination to reveal object details. The brightness of the fill light is usually set far lower than that of the key light. The ratio between these two lights, known as the key to fill ratio, gives you a basic idea of the contrast level within a scene. A high key to fill ratio means a high contrast scene, whereas a low key to fill ratio creates a more evenly lit scene.

Rim Light

The third light in our basic setup is the rim light (also know as the backlight). This type of light helps directors outline the actors on stage or screen, thereby separating them from the background and giving the scene more depth. Placing a bright light behind the scene creates a bright edge, or rim, around the subject. The rim

Figure 5.23
A character with only a single fill light contributing illumination.

Figure 5.24
A character with only a single rim light contributing illumination.

light is invaluable in computer graphics for outlining a shot's emphasis. In every feature film I've worked on, this has been one of the most talked about and requested lighting features added to a shot. If money is being spent to add a computer graphics character into a scene, the director wants to clearly see what all that money is being spent on. The rim light is placed behind the character with its illumination just creeping around enough to be visible along the edges (see Figure 5.24). The placement of the rim light in computer graphics can be one of the trickiest and most time-consuming lighting effects. Directors frequently ask to broaden the rim, tighten the rim, or have it affect both sides of the character. Because the rim light usually produces a very fine detail on the character, it must be tested at a high resolution to determine whether it is producing the desired effect. For this reason, it can be difficult and time-consuming to tweak. With practice, though, placing rim lights will become second nature.

Once all three lights are included, the basic lighting for the character is established. In Figure 5.25 the key to fill ratio is 8:1, so there is a fairly high level of contrast in the lighting. The rim is placed above and to the opposite side of the key to help define the edge of the character against the darker background. The three-light setup is an excellent starting point for many lighting scenarios. There are limitations and exceptions, but proper control of this basic setup can help light almost

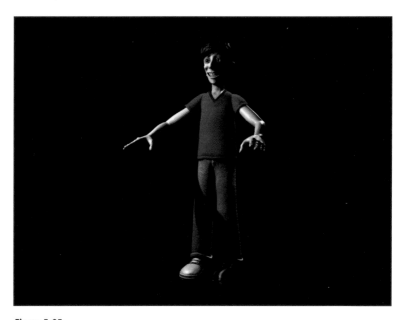

Figure 5.25
A character with a key light, a fill light, and a rim light contributing illumination.

any scene. It is important to note that in all lighting it is vital for the lighting artist to know exactly what each light is contributing to the scene. Rendering a test of each light alone clarifies the end result after the lights are all turned on and rendered together. As the number of lights in a scene grows, it becomes easier to forget how each light is contributing to the shot. It is good practice to save a rendered image of each light's contribution to a scene to avoid duplicating or wiping out the effect of a light put in earlier. Understanding what each light contributes individually gives the lighting artist much greater control over sculpting a scene. Chapter 14, "Lighting a Production Shot," steps through using the three-light setup to begin lighting a scene, and then expands upon it to achieve the desired results.

The Digital Approximations

So now you know to position a key light, a fill light, and a rim light to illuminate a scene. The only problem is, how does the computer know the type of light you want to use? Do you want a soft white light bulb, a floodlight, an overall glow, or direct sunlight? When rendering, the computer must figure out how much illumination from a source reaches each point visible to the camera to be captured as a pixel. The affected surfaces are illuminated by one light at a time, and each light's contribution is added to get the final resulting color and luminance value for the pixel. How is the illumination by these lights modeled in the computer and what kinds of lights are available to fill these roles? The five basic lights found (or in some way implementable) in most software packages are the ambient light, point light, directional light, spotlight, and area light. The icons for these lights, as they appear in the software package Maya, are shown in Figure 5.26.

Ambient Lights

The ambient light is a directionless light source that illuminates equally in all directions. It is intended to simulate the contribution of scattered light over the entire scene. In practice, its color and brightness serve simply as a multiplier of the object's surface color attributes. This product is the ambient light's contribution to the illumination of the scene. Because it is directionless, the ambient light casts no shadows, and changing the position of the light has no effect. Only the color and brightness of the ambient light affect the scene, which makes it a computationally inexpensive light. Typically, use of ambient lights is avoided, because it is an unnatural illumination. Its use is reserved as a possible cheat later in the lighting process. Due to the glowing, unnatural feel it produces, I have never included an ambient light in any of the feature film work I have done.

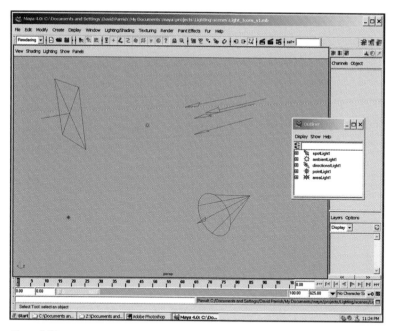

Figure 5.26
Typical representations of different types of lights in a 3D software package.

Directional Lights

The directional (also called infinite) light is infinite in size and casts light in one direction. It is used to represent a distant light source of which all the incoming rays are parallel and of uniform brightness. The directional light is often used to simulate the sun, which, at a local level, illuminates the earth uniformly. The directional light can cast shadows, which is very handy because we tend to notice that the sunlight falling upon trees and houses creates shadows. Of course, as with all lights, the color and brightness of the directional light can be set and even animated.

Point Lights

The point light is an omni-directional light source emitted radially from a point. It can be used to simulate a light bulb, the sun in a planetary system, or a fire. The point light may cast shadows if the option is selected, and its brightness can be attenuated over a selectable distance. This allows the light from a desk lamp to

illuminate an area on the desk that dims with distance from the bulb. Point lights are commonly used because they can inexpensively provide directionality, attenuation, and shadows. They can be placed in the scene, like the lights on a set.

Area Lights

Another common light, and the most expensive one discussed in this book, is the area light. It simulates a skylight window or large light fixture. It is like the directional light except that there is a limit to its cross-sectional dimensions. On the set, a light fixture called a softbox is often used. A softbox is essentially a rectangular box painted white inside to reflect the light of the many light bulbs wired inside the box. The open side of the box is covered with a diffusing material to produce an even light. The area light can cast shadows, support attenuation, and can have softened-edge control similar to the cone-angle delta of the spotlight. (Maya's default area light does not.) Basically, it projects a rectangular (sometimes circular) beam of light with even brightness across its cross-section. Advanced software features may allow for control of the area light's angular beam spread. Just from the few features described here, you can probably begin to understand why this light is computationally expensive to use.

Spotlights

To simulate the lights most commonly used on sets, the spotlight (or conelight) is used. It projects light similar to a parabolic, fresnel, or other lensed movie light. It can be described as a point light over which a shade or cone is placed to restrict illumination to a conical beam. Spotlights not only offer options for casting shadows and controlling the attenuation of the beam, but also for adjusting the cone angle to define the spread of the beam, and the cone-angle delta to define the width over which the beam edge falls to darkness. The basic attributes of a spotlight allow the user to create most common lighting setups without using more complex (and expensive) lights. It is possible to light any scene I have ever worked on by utilizing the advanced features available on spotlights in most software packages.

Because spotlights are such powerful and commonly used tools in computer graphics, understanding and controlling them is necessary for creating quality lighting. The many options make spotlights seem complex, but once mastered, using other computer graphics lights is simple. The basic functions of spotlights are the same in most 3D computer graphics software packages. The descriptions here are from Alias/Wavefront's Maya software package; however, the types of controls apply to other packages as well. The Maya interface, which controls the attributes of the spotlight, is shown in Figure 5.27, along with a sample wireframe image pointing out some of the controls. This figure depicts the wireframe representations of a spotlight's point of origin, cone angle, penumbra angle, and center of interest. These parameters are explained in the following examples.

Intensity and Color

The basic controls for spotlights, along with most other computer graphics lights, start with the intensity and color fields. The intensity is simply the brightness control for the light. Think of it as a dimmer with a high number of increments. As this value increases, the light becomes brighter. The color field, as its name suggests, allows for control over the color of the light and is comparable to placing a colored gel over a practical stage light. Most software packages provide an interface for interactively choosing a color. In Maya, clicking over the white rectangle next to the word "color" brings up such a window (see Figure 5.28). The color

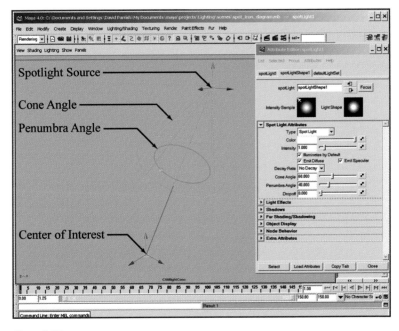

Figure 5.27
3D graphics software representation of a spotlight.

Figure 5.28
Typical color picking interface.

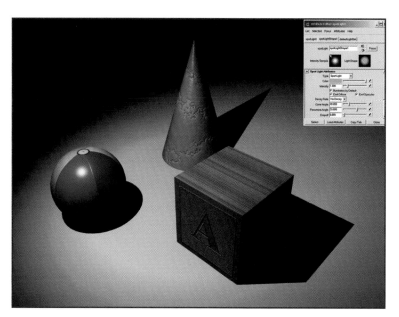

Figure 5.29
Spotlight with its color set to blue.

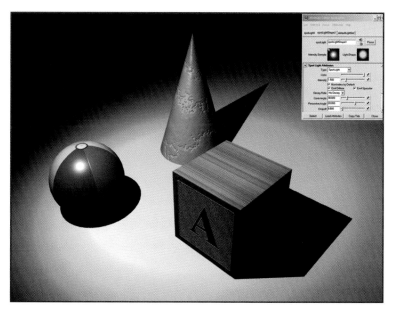

Figure 5.30
Spotlight with its color set to orange.

can be chosen by clicking within the color wheel or by inputting numerical values. The colors can be represented in the HSV or RGB color modes. The HSV color model represents colors as hue, saturation, and value (see the left color picker in Figure 5.28). The hue reference number identifies the color's location in the spectrum or on a color wheel. Saturation is the quantity or concentration of color. More saturated colors are more vibrant, whereas less saturated colors are paler. A saturation reference number of zero yields a gray tone. The value represents the brightness or darkness of a color. Whereas a low value creates a dark color, a high value produces a bright color. Another color model, RGB, breaks all colors down into their red, green, and blue components (see the right color picker in Figure 5.28). This is how the colors are most commonly represented in the computer, and any color can be displayed as a combination of some ratio of red, green, and blue. For some, the HSV model is more intuitive; for others, the RGB method offers more direct control over color. Most color picking tools offer a choice, and experimentation with each is the only way to know which is more comfortable for you. To simulate a blue gel placed over a light, the color is set to any value of blue, and the resulting light illuminates with a blue tint (see Figure 5.29). Likewise, an orange color can be chosen to create a warm light, and the result is a light producing orange illumination (see Figure 5.30). Be aware that this color value directly affects the intensity. The darker the color value, the more it reduces the

intensity of the light. If the color is set to black, it is the equivalent of placing a black card over a light, in which case no amount of intensity in the light will provide illumination for the scene.

Diffuse and Specular

The Maya interface also offers checkboxes to control whether a light emits diffuse and/or specular components. In real life, there is no such control over a light, but in computer graphics lighting, it is often useful to have control over these variables. If both the diffuse and specular boxes are checked, the light acts as a normal light would. If only diffuse is checked, though, the light no longer creates specular highlights. If only specular is checked, the light provides only specular illumination. It is sometimes useful to render the specular pass separately, thus offering more control over adjustments to the highlights during the compositing stage. Figure 5.31 shows a spotlight with the specular component turned off, leaving only the diffuse component. Notice that the specular highlights are now missing from the image. Figure 5.32 illustrates a spotlight with only its specular component visible. The bright highlight on the ball is obvious, but when the diffuse and specular shading are combined, the specular highlights on the cone are more subtle. Separating the elements of a light, as with isolating individual lights in a complex scene, can reveal clues about a light's contribution that might otherwise have gone unnoticed. Methods for separating light components and combining them in the compositing stage are discussed in Chapter 15, "Compositing a Production Shot."

Cone Angle

Another common control in a spotlight is the cone angle. This value is measured in degrees and indicates the size of the cone that defines the area a spotlight illuminates. Imagine a cone with its point (apex) at the location of the spotlight and the volume of that cone containing the emitted light. A spotlight with a cone angle of 40 degrees creates a cone of illumination that measures a total of 40 degrees from side to side (see Figure 5.33). A spotlight with a cone angle of 80 degrees illuminates a much larger area by creating a cone of light spanning 80 degrees (see Figure 5.34). A large cone angle covers more area without moving the light farther from its point of interest. A small cone angle allows the lighting artist to pinpoint the area of illumination for the light, but can also make the edges of the light's illumination visible in the scene. This may or may not be acceptable, but there are ways to soften the edge of a spotlight's cone to make the edges less noticeable.

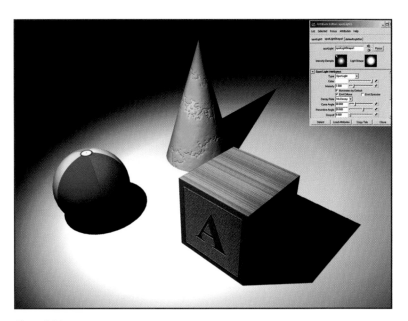

Figure 5.31
Spotlight with only the diffuse component enabled.

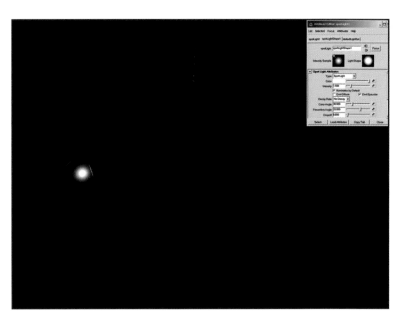

Figure 5.32
Spotlight with only the specular component enabled.

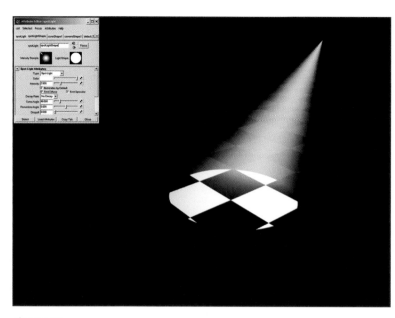

Figure 5.33
Spotlight with a cone angle of 40 degrees.

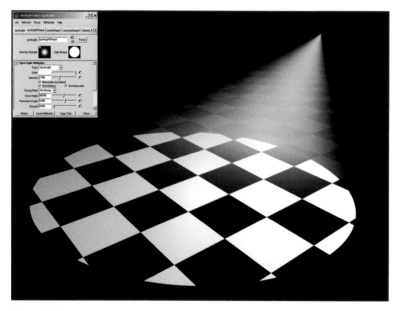

Figure 5.34
Spotlight with a cone angle of 80 degrees.

Softening the Edge

Hard-edged spotlights offer a simple representation for diagramming how spotlights work, but they are rarely useful in creating believable computer graphics lighting. Maya provides two options for softening the way the light falls off at the edge of the cone. Those two options are penumbra angle and dropoff. These terms are not universal among 3D software packages, and they are frequently controlled by a single variable. The name of this variable is not consistent among software packages, but it is often called softness, spread, or falloff. Check the software documentation to see which light parameter controls how the light's intensity drops off from the center of interest to the edge of the cone. In some packages, it is controlled by a single, normalized (range from zero to one) value indicating a percentage distance between the center of interest and the cone's edge at which the light is attenuated. In Maya, the penumbra angle defines the additional angle from the edge of the spotlight's beam over which the intensity falls off linearly to zero. If the penumbra is set to zero, the dropoff begins and ends at the cone angle, resulting in a hard-edged spotlight (see Figure 5.35). Setting the penumbra to 20 degrees effectively increases the spread of the spotlight's original 40-degree cone out to 80 degrees (see Figure 5.36). The extra 20 degrees of illumination fades off linearly to zero, beginning at the original cone edge and extending out according to the value specified in the penumbra angle field. This creates 20 additional degrees around the cone, which totals 80 degrees of illumination. The penumbra value can also be negative. Setting the penumbra angle to negative 20 (using the same 40-degree cone angle spotlight) creates light that fades off from 0 degrees (the center of the cone) to the cone's edge (see Figure 5.37). Notice how both the positive and negative penumbra settings soften the edge of the cone and create a much more realistic lighting effect.

Similar to the penumbra angle, the dropoff can also soften the harsh edge of a spotlight. Dropoff controls the rate at which the spotlight's intensity drops off from the center to the edge of the cone. The higher this number, the quicker the light's intensity falls off starting from the center of the spotlight's beam. Whereas the penumbra angle is defined relative to the edge of the spotlight's cone, the dropoff begins at the center of the cone and defines a rate of falloff to the cone's edge. A value of 40 creates a soft-light effect and greatly reduces the harshness of the cone edge on the ground (see Figure 5.38). The dropoff only has an affect within the original angle of the cone, unlike the penumbra angle, which can extend beyond the spotlight beam's original edge (see Figure 5.39).

5. Tools of the Trade

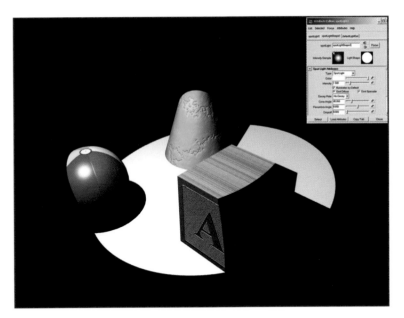

Figure 5.35
Spotlight with penumbra set to zero.

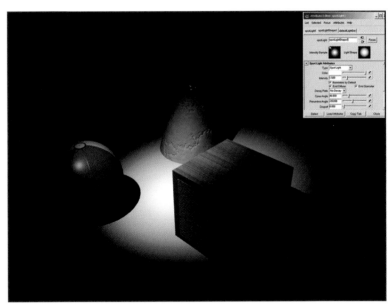

Figure 5.37
Spotlight with penumbra set to negative 20.

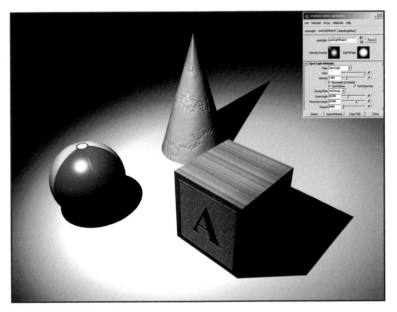

Figure 5.36
Spotlight with penumbra set to positive 20.

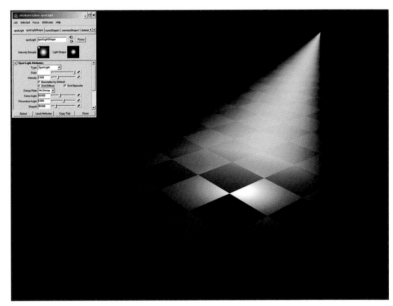

Figure 5.38
Spotlight with dropoff set to 40.

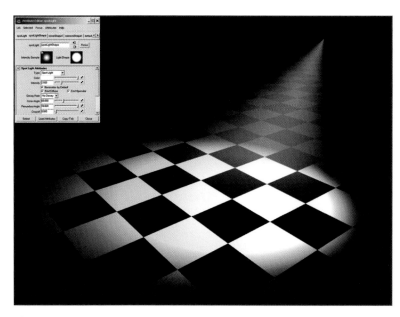

Figure 5.39
Spotlight with penumbra set to positive 10.

Attenuation

The last spotlight control discussed here is the decay rate. In real-world lighting, the intensity of light falls off over distance due to its radiation pattern and atmospheric attenuation. A flashlight is brighter on a hand placed six inches in front of it than it is on a door 20 feet away; this is due to the decay rate of the light beam's intensity. Computer graphics lights, however, do not necessarily have a decay rate. The default light in most 3D software packages has the decay rate set to none or zero, which means the light maintains the exact same intensity all the way to infinity. This can be useful in some situations, but in most cases it offers a vivid clue to the viewer that something is wrong with the scene. The decay of a light is typically calculated linearly or quadratically (following the inverse square law), although other attenuation rules can be used. Linear falloff means that for every unit of

distance away from the light source, the intensity of the light is divided by that distance. For instance, if a light's intensity is 1 at its source, and an object is 10 units away, then with linear falloff of the light's intensity will be 1/10 as much once it reaches the object. Inverse square falloff is a much closer approximation of real-world lights, and it produces a much faster falloff than the linear method. Inverse square falloff means that if a light's intensity is 1 at its source, and an object is 10 units away, then the light's intensity will be divided by the distance squared, which in this case is 1/100. Because the light values attenuate so quickly with the inverse square falloff method, it is usually necessary to greatly increase the intensity value of the light to provide useful illumination for a scene. Figure 5.40 shows an example of a spotlight with linear decay rate enabled. To produce a similar level of lighting, the intensity of the light has been increased to 10 from the 1.5 value used in the previous examples. Figure 5.41 shows the inverse square method of calculating the decay rate with the light's intensity increased to 100. Notice the increased brightness at the top of the ball and the cube, but the quick falloff by the time the light reaches the ground. The inverse square method creates a greater contrast in the image, because the high intensity creates extremely bright areas, and the quick falloff creates dark areas within the scene behind those highlights.

This chapter has covered some of the basics involved in composition, layering, depth of field, and color. The groundwork has been laid for creating computer graphics elements and layering them together in a two-dimensional presentation format. Equipped with this knowledge, and the computer graphics approximations of lights, you can now take the next step and begin setting up scenes to imitate specific occurrences in the real world.

Chapter 6 looks at lighting scenes in bright sunlight, in overcast conditions, in a lightning storm, and even underwater. The key, fill, and rim lights are a starting point, but it is now necessary to explore additional lights used to complement them and add the subtleties necessary to create convincing computer graphics imagery.

5. Tools of the Trade

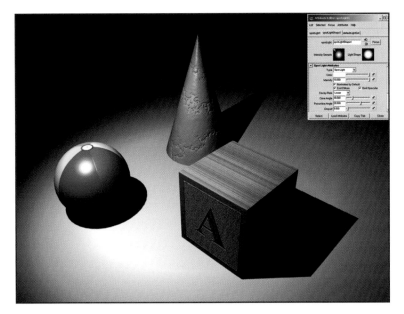

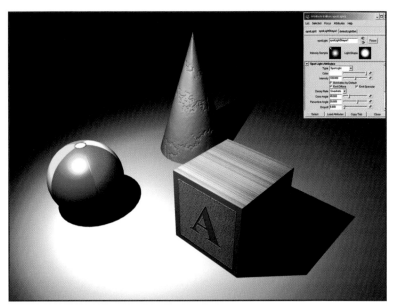

Figure 5.40
Spotlight with linear decay rate and intensity of 10.

Figure 5.41
Spotlight with inverse square (quadratic) falloff and intensity of 100.

chapter 6
If You Can See It, You Can Light It

The key to lighting, as simple as it may sound, is to use your eyes. This does not mean reading the manuals and looking at all the buttons on the monitor. It also does not mean to stare at a screen for hours on end, shifting colors and adding every type of light the software offers just to try to make something look cool. First you learn the rules, and then you take that next step allowing you to break the rules and possibly even create something beautiful. The great thing about learning the rules of lighting and compositing is that the best way to do so does not involve books or formulas. The best way to learn is by experience, and that is exactly how you can begin to understand the ways of the lighting world. Everyday occurrences teach how light interacts with objects, people, and animals in the world. When taking note of the surroundings, a confusing shadow or an unexpected refraction of light through glass warrants closer inspection. Still photography provides an excellent resource for this study. I am almost never without my camera in my car, and I often stop to photograph things that are interesting or perplexing. This not only provides something to study later, but also automatically converts a three-dimensional scene into a two-dimensional format. Whether simply taking the time to notice the surroundings, taking photographs, sketching, painting, or shooting video, the key is to use the eyes and train them to notice what makes the car look red, the window reflective, or the woman bright and happy.

There are many ways to approach the lighting of any scene, and each artist has his own style and methods. The similarities in these methods are that they all start with an understanding of how the eye perceives the world through light. This chapter steps through a variety of different lighting scenarios, describes how they look in reality, and presents methods for translating them into a computer graphics environment.

Direct Light

With a flashlight or a desk lamp it is easy to simulate a light source, such as the sun, and start to gain an understanding of what happens when light strikes an object. Shine a light on a ball, and observe that the ball is brightest where the light hits it (see Figure 6.1). That's pretty basic, but notice how the light falls off over the surface and what it is about the surface that indicates the location of the light. Assume the picture plane for that ball does not provide the luxury of seeing the light source. The only thing in view is the ball. In this computer graphics example, the ball is floating in the air, so there is no shadow cast onto a surface (an excellent indication of light direction is covered in the next section) to find the light. Because the surface material of the ball is a bit shiny, a nice bright highlight appears, helping to locate the light. Shooting a ray directly from the camera into the middle of the highlight and tracing the direction it deflects off the sphere leads directly to the light source. The distance from the light to the ball is not clear, but the direction from the light to the ball with respect to the camera can definitely be determined. Broken down into its simplest terms, the light is projecting rays at the surface of the ball, the ball is reflecting those rays, and the camera uses the reflected light to create the image of a ball. Without the light, quite obviously, no ball is seen.

What if the light is still shining in exactly the same direction and the camera is still looking at the same spot, but there is no ball? Nothing is seen unless something is present to reflect the light. In the real world, shining a light into a space would most likely illuminate atmospheric components, such as dust, that would reflect light indicating the presence of a light source. In the computer graphics environment, though, particulates in the air do not exist unless put there.

Figure 6.1
A spotlight aimed directly at a shiny sphere.

Figure 6.2
A spotlight aimed directly at a dull sphere.

Suppose a different ball is placed in the scene. The ball is the same size as the previous one, but its material is much less shiny. In fact, the surface is completely dull (flat or matte) with no specular highlights at all (see Figure 6.2). The only information to be gained about the light is from the diffuse illumination of the surface. In Chapter 5, "Tools of the Trade," the *diffuse component* of a material is defined as the reflection of light in many directions, and the *specular component* is defined as the light reflected directly back into the camera. Stripping away the specular highlight makes the placement of the light more difficult to determine. There are still enough clues, however, to find the light location. The main source of information still lies in where the light reflected to the camera is the brightest, and how it falls off (*attenuates*) around the sphere. Notice that although the bright highlight is no longer present, there is still an area of the ball that is brighter than the rest. The bright area fades off toward the bottom of the sphere and from left to right, as well. Enough clues are present to know the light is placed high and to the left of the scene.

Because of the light cues it provides, a sphere in the middle of a scene is an excellent tool for deducing the placement of lights. In fact, on most movie and television commercial sets, reference footage is shot with a neutral gray sphere placed in the middle of the scene to identify light locations for postproduction computer graphics (see Figure 6.3). A chrome sphere is also typically shot as a scene reference (see Figure 6.4). Reflections in the mirrored surface show where everything on the set is located, which is extremely valuable for reproducing stage lighting setups. A chrome sphere provides such detailed information about the location and brightness of lights in a scene that methods have been developed (some automatic) to create, place, and set the brightness and color levels for every light in a scene by using a single image of a chrome sphere. Of course, due to some of the approximations and limitations involved in the computer graphics representations of lights, the illumination of the resulting lighting setup is not a perfect reproduction. At least an excellent starting point is provided, particularly for extremely complex lighting scenarios.

Figure 6.3
A gray sphere shot for reference in a scene.

Shadow Side and Cast Shadows

One of the most important things to notice about lighting is what happens in the areas where the light does not reach. As noted with the sphere in the previous example, the way the light falls off around the sphere is important to understanding the light striking the surface. The side of an object that does not receive direct light is the shadow side of the object. That does not mean a shadow is apparent. The shadow side can receive fill light or light bouncing off other objects around it, but it is generally darker than the area of direct illumination. A shadow, although related, is different, and understanding the distinction between the two is very important. A shadow is produced when an object prevents a light from striking another object. The object, such as a cone, may occlude light from reaching the surface it rests upon (see Figure 6.5). The outline of the cone, as viewed from the light source, prevents light from reaching the ground plane. Viewing the light source from behind the object presents a silhouetted image of the cone. The silhouette appears to be cast onto the surface from the light to the ground.

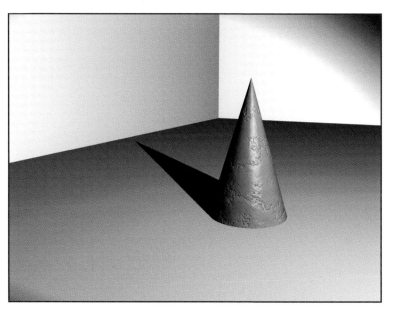

Figure 6.5
A cone with a single light source casting a shadow.

Figure 6.4
A chrome sphere shot for reference in a scene.

Information from Cast Shadows

The cast shadow, much like the chrome sphere, can pinpoint the precise location of a light source. With a little triangulation, a line can be drawn from the point of the cone in the cast shadow back to the point of the actual cone and eventually leading directly to the contributing light source. In addition to giving a clear indication of the casting light's location, the cast shadow also provides information about the rest of the scene. Cast shadows indicate changes in elevation (such as stair steps), they help quantify the amount of texture on ground planes, and they define shapes that might otherwise be confusing.

In another simple example, several cylinders have been placed in a scene with a single light illuminating them and the background (see Figure 6.6). The image shows five yellow cylinders over a blue background. There is no indication of a ground plane, and no way to tell whether the cylinders are floating in space or resting on a surface. However, there are clues to the direction and placement of the light. The cylinder at the top left of the frame has a thin illuminated portion on its left. The cylinder at the bottom left has an even thinner edge that just barely catches rays from the light source. It is clear from these clues that the light is to

the left of the frame and slightly behind the cylinders. One additional clue, which may be deceiving, is the light that appears to spill into the top of each cylinder. If this were a live-action scene with real cylinders, this would indicate that the light is above the cylinders. In this computer graphics scene, however, the lack of shadows has allowed the light to pass through one side of the cylinder and light up the inside of the cylinder. A light with no shadows, which could never exist in the real world, can create unexpected and unwanted results in computer graphics.

Many things simply cannot be determined from the scene, however, because of the missing shadows. Once the shadows are included, a whole new set of visual clues is added to help decipher the details of the scene (see Figure 6.7). Now it is clear that the cylinders are not floating in space but resting on the blue surface. That blue surface has also been revealed to be not a single flat plane, but a surface with steps leading down to the right side of the frame. The shadows also reveal some hidden columns that were not evident in the previous shadowless render. The taller column at the middle right of the frame is hiding a shorter column directly behind it. The hidden column, along with its height, is now revealed by its shadow. Notice also how the shadows interact with the steps to the right. The offset sections of the

Figure 6.6
A single light source illuminating several cylinders, but with no cast shadows.

Figure 6.7
A single light source illuminating several cylinders with cast shadows included.

shadow indicate the height of each step. Two additional columns that are not framed within the image are revealed by the shadows stepping down at the top right of the frame. These shadows reveal that two tall, previously hidden columns are just out of the camera's view. In addition to providing a wealth of new information about the scene, the shadows have completely changed the visual composition. The horizontal lines of the shadows have broken up the simple vertical lines of the shadowless render. The empty spaces in the middle of the image have now been filled with the strong lines of well-defined shadows. Even in this simple example it is still easy to see the impact shadows can have on the overall composition of any scene.

The examples in Figures 6.5 and 6.7 show a single light producing cast shadows. In most lighting scenarios, the circumstances are considerably more complex. There are typically more lights, more objects, more cast shadows, and a great deal of interaction among the elements. You will explore the way these multiple layers of light and shadow come together to form a complete image in Part III, "Practical Application."

Outdoors and Bright Sunlight

Now it's time to step outside and see what is involved in setting up a CG lighting environment representing bright sunlight. The first step, as with any lighting scenario, is to observe. Studying sunlight outdoors will offer innumerable clues on how to represent it in computer graphics. At first glance, a lighting artist might look at creating outdoor lighting as a simple adaptation in computer graphics. It is actually one of the more difficult lighting scenarios to reproduce. A major contributor to the lighting created on a bright, sunny day (in addition to the sun) is the light scattered from all the other objects in the environment (bounce light). *Bounce light* is any light in a scene that reaches a subject by bouncing off of another surface; it is therefore an indirect light source. In computer graphics it is possible to create interactive lighting scenes in which the rays from lights can bounce off multiple objects within a scene (known as *ray tracing*), but it is computationally very expensive to do accurately. In reality, light is scattered by everything and provides additional levels of illumination and color to a scene. Outdoors, the sunlight is extremely bright and bounces off many subjects; this makes it difficult to accurately reproduce in computer graphics. The key, as with all lighting, is to study the type of environment being lit. A walk outside on a sunny day is an important part of the research process. The things to look for are not only the way sunlight directly strikes surfaces and creates highlights, but also how the illumination and colors of objects are affected by light bouncing off of everything.

Bounce Light Characteristics

The complexity of bounce lighting is an often overlooked aspect of computer graphics lighting. This oversight can quickly give a CG scene away as being a simulation of reality. As light strikes any surface, a certain amount is absorbed by that surface, and a certain amount is reflected. If the surface is extremely shiny, as with a mirror, the majority of light is reflected and very little is absorbed. If the surface is very dull, a great deal of light is absorbed or randomly scattered by the surface. If the surface is broken up with texture, as with a gravel road or deeply grooved tree bark, the light is dispersed, or broken up, and the resulting bounce light is much less intense. Light rays bounce from one object to another, losing intensity and becoming more dispersed with each surface they strike. This is mathematically complex to re-create accurately, so approximations are used to simulate the effects of bounce lights.

Because the light bouncing off objects decreases with each bounce (attenuation due to absorption by the atmosphere and the object's surface), it is possible to add a small number of bounce lights to a scene and still have a fairly realistic representation. The trick is placing a light as if it is the surface producing the bounce light. If a character is standing outside in the grass on a bright, sunny day, the grass should provide a great deal of bounce light for the character. Without bounce light, the key, fill, and rim lights are not enough to integrate the character with the grassy surface (see Figure 6.8). The light bounces off the grass and

Figure 6.8
A character standing on a grass surface in bright sunlight without any bounce light.

illuminates the character from below. In addition to providing illumination, the bounce light will also provide a color contribution. Because the grass has a green color, that color is included in the bounce light. The grass also serves to disperse the light, because each blade of grass reflects the light in a different direction. The surface is not uniform, and is certainly not a polished mirror, so a great deal of the light's intensity is lost. Also, because the light has been dispersed in many directions, the quality of light bouncing off the grass is much softer than that of direct sunlight. Soft light is a general term for illumination with faint, fuzzy, or completely nonexistent cast shadows, which fades off gently. Harsh light is the opposite, and it produces a high-contrast scene with harsh, well-defined shadows. Bounce light, in general, provides a softer light than direct light. Because the light is dispersed in so many directions, it serves almost as a glow emanating from the bounce surface.

Simulating Bounce Light

The way to imitate light bouncing off the ground is to place a light below the ground plane in the computer graphics scene and aim it up at the subject. Usually, the light must be placed well below ground level to uniformly illuminate a large area. The problem is that a light placed directly below the ground plane, and

aimed straight upward, will not reach much more than the soles of the character's feet. To get useful illumination, another variable must be taken into account when placing a bounce light. The camera view determines where the effects of a bounce light are visible and, therefore, helps determine bounce light placement. Because it is difficult to simulate light bouncing in all directions from a surface, two or more bounce lights are often used. Two lights strategically placed in the scene to the left and right of the character (relative to the view from the camera) illuminate the majority of the view. It might seem that a single bounce light placed directly below the line of view from the camera would be a simpler option, but that is a common pitfall in computer graphics lighting. Lighting from the camera direction is almost always detrimental to the look of a shot. The reason is that such a light tends to flatten out the subject. Shadows and varied illumination values, as illustrated with the preceding cylinder example, provide a great deal of information about a scene. A light shining from the direction of the camera does not cast any visible shadows. Also, the same rays the light uses to illuminate the subject are only seen by the camera if reflected directly back. This is one of the quickest ways to lose definition and contrast in an object and make a scene's lighting look flat and uninteresting. With that said, the bounce light is placed to the left of the character. In this scene,

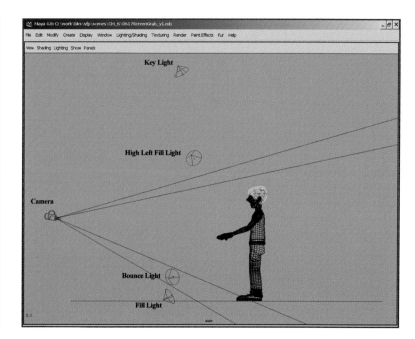

Figure 6.9
Top and side views of the light placement.

the key light is above and to the left, the fill light is low (still above the ground plane) and to the right, and the rim light is behind and to the right (see Figure 6.9). The bounce light is below the ground plane, in front and to the left of the character. This placement allows for bounce light to reach the left side and the majority of the front of the character. In order to simulate the color contribution from the grass, the light has been given a color similar to that of the grass. The light is also attenuated so that its illumination only reaches about half-way up the character's body. This is to simulate the dispersion and absorption of the light by the grass, which reduces the brightness of the light. If the bounce light's contribution to the character is isolated, its contribution can be more clearly illustrated (see Figure 6.10).

Combining Fill and Bounce

The next logical question is: How does the right side of the character receive bounce light? There are a couple of ways to tackle this. One is to use the fill light from the right side of the scene to serve as both a fill and a bounce light. This solution is the most elegant, because avoiding the addition of another light saves render time. Each light added to a scene can greatly increase the amount of time it takes to render a frame, so it is important to be judicious with the placement and addition of light sources. The less elegant solution of adding a second bounce light

from the right side of the frame may be necessary depending on the desired look for the shot. The first solution, using the fill light, makes sense on several levels. The only direct light source in this scene is the sun, so every other light is in some way simulating an indirect light source. There may be illumination on the shadow side of the character, but there is not an actual light there like the fill light in the computer graphics scene. Because this fill light is simulating some portion of the scene's ambient contribution, it makes sense that it would also take on some of the characteristics of the light bouncing off the grass. By adding some green color to it, the right side of the character now has an element of bounce light (see Figure 6.11). The fill light is not quite as green as the bounce light, because it is also being used to simulate light from other sources in the scene. By differentiating the amount of bounce light, as well as the angle from which it is projected, on each side of the frame, the shot becomes less uniform. It is very easy to fall into the trap of adding lights of similar intensities and angles to a computer graphics scene only to realize that such uniform lighting almost never exists in the real world. The organic quality of light and the way it interacts with objects is an important factor to keep in mind. Because every approximation in computer graphics is based on a mathematical equation, there is always the danger of the final image appearing too structured.

Figure 6.10
A character with a single bounce light providing illumination.

Figure 6.11
A character with a single fill light providing illumination.

Computer graphics lighting is a series of mathematical functions. These functions are based on patterns, such as a sine wave, and are easily picked up on by the human eye. Due to this inherent structure, the lighting artist must constantly be aware of possible signs of structure or pattern in his work that gives it away as computer-generated. If consistent patterns are followed in the setup and adjustment of lights, as with using the same key to fill ratios consistently or the same brightness levels for each type of light, then the inherent patterns found in the lighting software can become even more pronounced. Take note of the organic quality of light in the real world, and always be aware of consistent patterns that can quickly give away a scene as a computer graphics shortcut. Computers are wonderful tools for precision and creating patterns, but the human eye is also adept at spotting them and identifying them as signs that something is merely a simulation of the real world.

Once the key light, fill light, rim light, and bounce light are added to the scene, the character fits in reasonably well with the environment (see Figure 6.12). Because the sun is so bright, a high key to fill ratio (8:1) is used in the scene. The placement of the key light depends either on the art direction given for the shot or, in the case of fitting a creature into a piece of film or television footage, on where the sun is actually located.

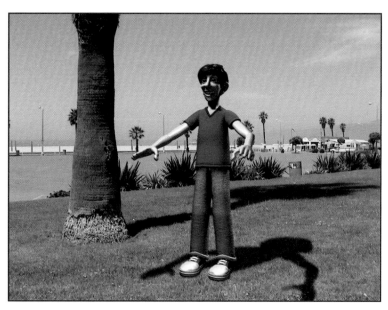

Figure 6.12
A character with a key light, fill light, rim light, and bounce light providing illumination.

Background Clues

When a background plate is provided, as with adding a character into a live-action film scene, there are many clues provided by the scene that can make setting up the basic three lights fairly straightforward. In an outdoor scene I worked on for *Star Wars: Episode I—The Phantom Menace*, the challenge was to insert the character Watto into a scene in which he was carrying on a conversation with the live-action character Qui-Gon, played by Liam Neeson (see Figure 6.13). This scene offers an abundance of clues for the lighting artist in both the background and foreground characters. By studying the highlights and the shadows in the scene, it becomes apparent that the sun is high in the sky and slightly behind the characters. Look at the way the light creates a rim around Qui-Gon's hair, and observe the highlights on his forehead and the shoulders of his robe. Also take note of the highlights on the dome of the top of R2-D2, as well as the contrast between the highlight areas and the fill areas of the characters. These clues were all taken into account when setting up the basic lighting rig for Watto. Notice how his head catches a similar highlight to that of Qui-Gon, and how the sunlight spills over and creates brighter areas where his eyebrow and mouth protrude from his head. Look also at the bright rim created on Watto's pointing hand and arm, which not only helps to outline the character and make him stand out from the background, but also draws the viewer's attention to the action of the scene.

If given the freedom to move the sun around the character, take note of how his shadow changes the composition and feel of the shot. If the sun is behind the character, how does that change the role of the fill and bounce lights? If the sun is directly above the character, how does this affect the shadow on his face and his overall appearance? These are all questions that can be addressed as you practice creating scenes, moving lights, and noticing the effect it has on the composition and mood of a shot.

Overcast Days

Step one for creating overcast lighting conditions in a scene is to take note of every lighting detail while walking around on overcast days. Important things to note are the differences between bright, sunny days and overcast days. Depending on the cloud density and the time of day, the shadows on an overcast day will be considerably less defined or possibly non-existent. The overall level of contrast is less with the key to fill ratio being much closer to one. People and objects appear less vibrant on an overcast day, and the feel of an overcast scene is typically more subdued than its sunny day counterpart. An overcast day produces a more constant level of light with the light filtered and refracted through the clouds spread more

Figure 6.13
Integrating the character Watto into a bright sunlight situation in the 1999 film *Star Wars: Episode I—The Phantom Menace*. COURTESY OF LUCASFILM LTD. Star Wars: Episode I—The Phantom Menace © Lucasfilm Ltd. & ™. All rights reserved. Used under authorization. Unauthorized duplication is a violation of applicable law.

evenly across a scene. The bright yellows and reds reaching the ground through direct sunlight are, to a large extent, blocked by cloud cover. The result is an overall tone tending toward the blue end of the spectrum.

With this in mind, let's reevaluate the basic three-light setup and see how appropriate it is for an overcast day. The basic premise behind the three-light setup is that a strong light source (the key light) is illuminating the scene from a single direction. This works well for bright sunlight or an interior shot with a primary light source such as a light bulb. For a scene where the intensity and direction of the light are less specific, some modifications can be made to the three-light setup. First of all, identify the emphasis of the shot and determine whether things blend in seamlessly or a particular element of the shot needs to stand out. If shot on location, additional light may be added from above or beside the character in order to differentiate his illumination from other parts of the scene. If pushed too far and these additional lights are extremely bright or colored too differently from everything

else in the shot, the character will not only stand out but also not appear to fit correctly within the scene. There is a fine line between emphasis and alienation of a character in a scene.

Subtle Lighting Direction Clues

The primary point of interest of the following example scene is the character. On an overcast day, the sun is still at a certain point in the sky, so the key light is placed accordingly. If integrating the character into a live-action scene, it is more difficult to precisely locate the sun in the scene. Shadows are an important clue for locating the direction of the key light, but an overcast day may offer little help in the way of shadows. There are, however, other indicators in almost every case. Look to see which sides of objects in the scene appear the brightest, and look at the sky or the background for a brighter side to the scene. If the scene is truly uniformly lit offering no visual clues for the location of the key light (an unlikely occurrence), the placement will depend on the art direction and the context of

surrounding scenes. For this fully CG example, the sun is fairly high in the sky to the right side of the frame and slightly in front of the character (see Figure 6.14). The brightness of the key light is much less than in the bright sunlight example. Also note that the cast shadow on the ground is much lighter and less defined than the cast shadow from the previous example (see Figure 6.12).

The next additions are the fill and bounce lights. These lights can be placed similarly to the bright sunlight example. The difference in this case is that each of them will be much closer in brightness to the key light. For this example, the key to fill ratio is down to 2:1 making for much less contrast in the scene. In addition, the colors of the fill and bounce lights may need to be adjusted. As mentioned earlier, an overcast day typically will be shifted more to the blue side of the color spectrum. The yellow used in the bounce and fill lights may need to be adjusted more toward blue. These lights still need to reflect the yellow color of the sand, but with less saturation (see Figure 6.15). If the fill lights are taken all the way to blue, then it is difficult to make the character fit well in the scene (see Figure 6.16). The key and top-left fill (formerly the rim) lights are placed high above the character, whereas the fill and bounce lights are placed low and on either side of the character.

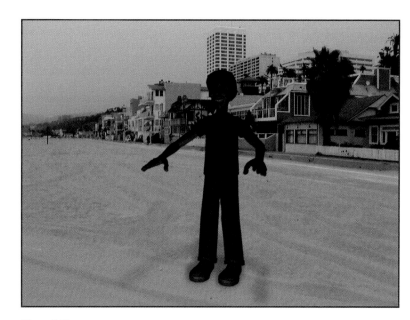

Figure 6.15
A character lit with only a low fill and a bounce light, and with a desaturated yellow tint added to each light.

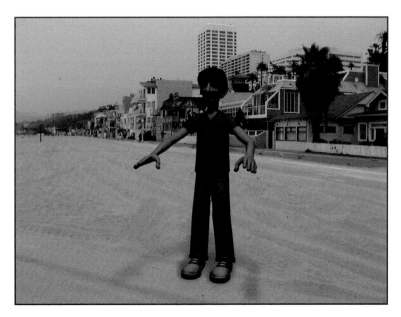

Figure 6.14
A character lit with only a key light on an overcast day.

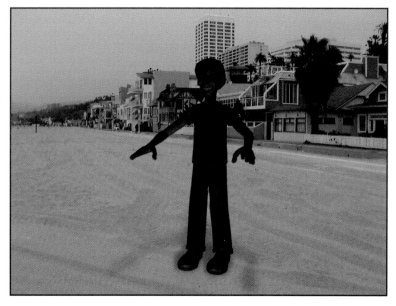

Figure 6.16
A character lit with only a fill and bounce light, and with a blue tint added to each light.

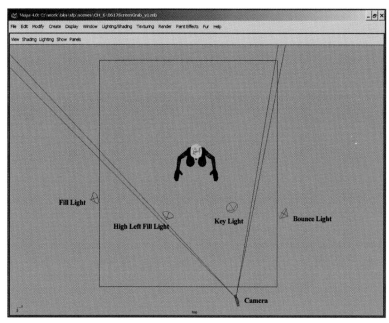

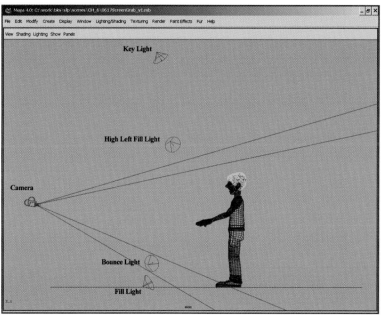

Figure 6.17
Top and side views of the light placement.

Rim or High Fill?

The rim light in an overcast day presents an interesting question. Does the character need to stand out from the background or blend in as much as possible? If the answer is stand out, then the rim light is still necessary. If the answer is blend in, then the rim light may not be necessary. Without the rim light, the character does not have a bright edge to separate him from the background and draw the viewer's attention. For this example, assume the art direction calls for the character to blend in with the background. Because a defining edge for the character is no longer required, the rim light can become an additional fill light. It is placed on the opposite side of the key and higher up to more evenly light the character. By changing the rim light to a high-left fill light, the overall lighting set-up is more symmetrical in its layout (see Figures 6.17 and 6.18).

The high-left fill representing the light dispersed by cloud cover is similar in color to the key light. The key light has a bit more yellow and the high-left fill light has a slight blue tint simulating the key originating from the sun and the fill from the sky and the clouds. The end result is a character that blends in well with the surroundings (see Figure 6.19). Minor color tweaks to each light can create major differences in the perception of the character and the scene. The point at which the

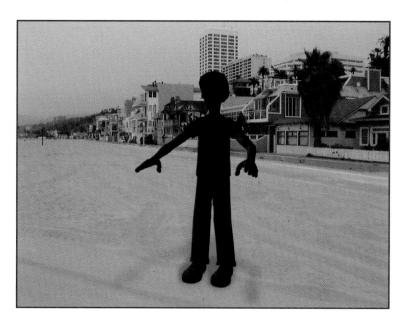

Figure 6.18
A character lit with only a high-left fill light.

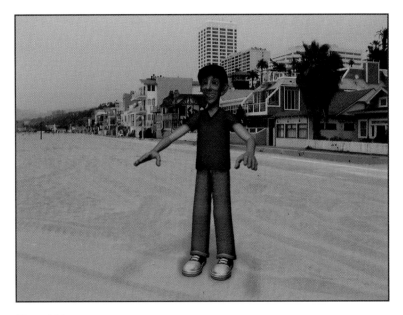

Figure 6.19
A scene with a key light, a bounce light, and two fill lights providing illumination.

scene changes from "cool" to "warm" is difficult to specify precisely. The overall "temperature" of a scene depends on light placement, brightness levels and colors, as well as the color and placement of the objects that they illuminate. The best way to understand these nuances is to break an image down to the contributions of each light and visually study and analyze the effect the individual lights are having on the final rendered image. I make it a practice in my daily work to render an image of each light's contribution alone, and save the images for future reference. When the parts are seen clearly, it is much easier to understand the whole. It is also possible to add the individual light renders together in a compositing software package and make brightness and color adjustments to view the effects each light has on the overall feel and mood of the composition (refer to Chapter 12, "Compositing Techniques and Methods," for explanations of compositing functions).

Dangers of Symmetry

Continue to be aware, particularly as the layout of the lights approaches complete symmetry, of the dangers of precise, algorithmic placement and adjustment of the lights. If the top-left fill light is an exact mirror of the key light, and the RGB values of the fill and bounce lights are exactly the same, then the rendered image reveals evenly balanced illumination. Because the lights used in computer graphics are already simplified versions of reality, it is imperative that the lighting artist not emphasize the problems working with computers can present. Consistency, precision, and lifelessness are all inherent aspects of most computer programs. The goal of the lighting artist is to use the tools in the most creative way possible in order to simulate the organic qualities of light in the real world. Imagine a lighting artist as one who sculpts with light. It is a delicate process, and if the input of the lighting artist is absolutely consistent and symmetrical, it's similar to using a jackhammer to shape a porcelain figurine. The result is usually not pretty.

Outdoor lighting has many more variations than simply bright sunlight and overcast days. There are as many different lighting scenarios outdoors as there are outdoor places to visit. The desert has a particular type of light as does a snowy mountain, a grassy valley, and an ocean cliff. Each place has a distinct feel to the lighting because of the atmosphere, the surrounding features that provide bounce light, and the weather conditions. A rainstorm obviously presents some interesting lighting challenges and possibly the task of creating computer graphics simulations of pouring rain. An interesting note on rainstorms is the increased level of reflected light, which is inherent to wet objects. An old movie trick is to get out the fire hoses and wet down entire streets where scenes are about to be shot. This greatly increases the overall lighting level of the scene by providing reflected light off the water sheen on the street surface. With the cost of setting up lights for a film shoot, any free light is good light. Along with rainstorms, nighttime is another variation of outdoor lighting. It is important to realize some common tricks for lighting an outdoor scene at nighttime. One method is to shift the color of the lights toward blue. Blue lights give a soft, cool feel to a scene, whereas red and yellow lights give more of a vibrant, warm feel, which is generally associated with sunlight and daytime. If you light an outdoor nighttime scene with red lights, it is possible to make it seem dark and mysterious, but it is difficult to avoid the burning in hell feel of a fire-lit cave. An overall blue lighting scheme with small touches of yellow or red light for emphasis can help a character stand out in a nighttime scene.

Each outdoor scenario is complex and requires observation and research. For example, look at the following four images (see Figures 6.20, 6.21, 6.22, and 6.23). Each image uses exactly the same lights with only the colors and intensities adjusted. Notice how the feel of the shot changes as the lighting scheme goes from neutral to warm to cool. Also note how the overall brightness of the scene creates a feeling of daytime and reduces the glowing eye effect (see Figure 6.23) that contributes to the nighttime feel shown in the other renders. Before moving on to the indoor lighting section, practice making a simple scene with perhaps a wall, a ground plane, and a character, and change only the colors and intensities of the lights to adjust the time of day or the mood of the scene.

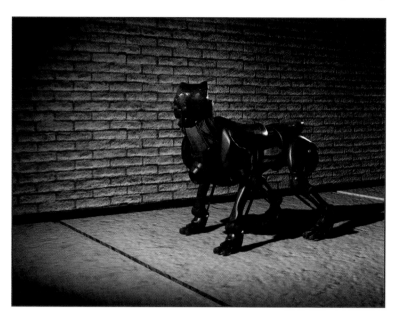

Figure 6.20
A scene with neutral lighting colors.

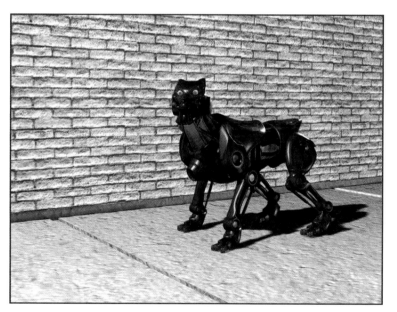

Figure 6.22
A scene with cool lighting colors.

Figure 6.21
A scene with warm lighting colors.

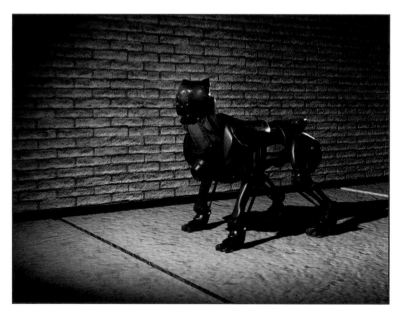

Figure 6.23
A scene with bright, neutral lighting.

6. If You Can See It, You Can Light It

81

Indoors

The many possible variations of indoor lighting present numerous challenges. Light sources in indoor scenes can be directional, as with a desk lamp, omni-directional, as with an uncovered light bulb, or indirect, as with a floor lamp bouncing illumination off the ceiling. The variety of indoor lights available provides many opportunities for establishing mood and identifying the emphasis of the shot. Characters walk in and out of the light, dark corners hide details, and interior surfaces provide an almost infinite number of ways for light to bounce and reflect. The first step is identifying the emphasis of the shot and applying many of the concepts used in the previous outdoor lighting examples. The types of lights may be different, but the three-light setup remains an excellent starting point.

For interior lighting, the spotlight makes sense in many situations. It provides control for the cone of light, as with light from the top or bottom of a lampshade, or from most types of desk lamps or floor lamps. The spotlight allows adjustment to the softness of light as it reaches the outer edge of the cone, and it provides the subtle controls needed for lighting interiors. In certain cases, as with an uncovered light bulb, it is appropriate to use a point light source, which sends light in all directions. My suggestion is to begin with spotlights, because they offer the greatest amount of control, and after gaining a solid understanding of their operation, you can begin to wrap additional light types into lighting setups.

Underwater

Lighting a scene underwater presents a major difficulty with regard to the first step of lighting a scene. Walking outdoors to experience bright sunlight is simple, but diving underwater to see how lighting works is another story. Reference is still vital, and although it may be difficult to get first-hand experience, there are many documentaries of underwater explorations. In studying underwater footage, the first step is identifying what makes the scene look underwater. What is the difference between a dark scene with light filtering down through fog and an underwater scene? What clues are there to help the viewer recognize that the camera is looking through water instead of air?

Particulates and Haze

Upon closer inspection of underwater reference footage, it becomes apparent there are several details that differentiate how cameras see through water as opposed to air. With moving footage, the camera typically floats with the current of the water. Additionally, there are bits and pieces of matter that float around in the water and follow its current. These can be referred to as particulates and are simply non-descript fragments of plant life—small organisms or debris that float around in the water. It is straightforward to simulate particles floating and following some type of current and then layer them into an underwater computer graphics scene (see Figure 6.24). Another clue identifying an underwater scene is haze from fine dust and small particles suspended in the water. It is much like fog in the way it can absorb light from any source and display shafts and shadows.

Figure 6.24
A simulated particle layer that can be used to represent floating underwater particulates.

Vegetation and Texture

The vegetation as well as the textures found underwater can also help to indicate that a scene is underwater. Underwater plant life has a different look and feel than the greenery found above the water's surface. Plants take on the same current-induced floating as the particulate, but they are typically rooted to the bottom. The slow waving motion of the plants helps give the scene a heavier-than-air feel. With any underwater scene, it is important to consider that the resistance of the water slows any motion through it. With underwater plant life, observation and research plays a vital role. Choosing the correct vegetation requires study. In addition to the plant life, the textures found underwater can give a viewer clues as to the location of a scene. Anything that stays underwater for any period of time gets a distinctively distressed texture. The water is teeming with life, and it shows up on almost every visible surface. Barnacles are attached to many surfaces, coral is jagged and deeply grooved, and rock formations are often covered with any number of underwater residue or plant life. The abundance of matter and particles in the water creates a world rich in surface textures.

Caustics

If the scene to be lit is near the surface of the water, caustic patterns are a consideration. When lighting sharks just beneath the surface for the film *Deep Blue Sea*, a pattern was included on the tops of the sharks to imitate the sunlight striking them through the water. A caustic is technically the junction at which the light's incident behavior on the water changes from refraction to reflection. Because the water surface is ever-changing, so too are these caustic boundaries. The patterns of bright lines among the darker areas where the sunlight is reflected are often referred to as caustics. There are several ways to approach simulating caustic patterns in computer graphics. One method is to create a large, gray-scaled texture and use it as an animated slide map within a light (see Figure 6.25). A slide map is simply a texture placed in front of a light, with the dark areas of the texture causing occlusion of the light. By animating this slide map, the impression of the light passing through water is approximated. (Animated slide maps for lights are covered in more detail in Chapter 11,"Dead Give-Aways: Real World versus the CG World.") Another method is to create a piece of geometry textured with a caustic pattern. Maya offers a water texture that can be used for this method. Within the attribute editor, it is also possible to animate the water texture over time. By moving the water texture across the surface and shining the light through that animated texture, the resulting illumination simulates light shining through a water surface.

Figure 6.25
A caustic pattern that can be animated in front of a light.

Many of the techniques listed here take advantage of motion to give the viewer clues that the scene is underwater. In a still frame, it is more difficult to differentiate an underwater shot from a shot in dense fog. The particulates floating around in the water are one of the clearest indicators within a still frame (see Figure 6.26). The plant life and textures can also provide clues, but it never hurts to include a few silhouetted fish to make the point crystal clear. Take into account the things that will help in moving footage, such as the current in the particulates and the movement of the camera, but also realize what will not be seen during the motion. Depending upon the speed of the camera motion, it can be difficult to make out the level of detail on the underwater surfaces. As with any CG scene, invest your time where it counts the most. Do not work for days on extremely high-resolution textures for the underwater surfaces if the camera flies by so fast that all the viewer will see is a blurry mass. Instead, spend time on creating believable camera motion, particulates, and haze that enhance the underwater feel.

Figure 6.26
An underwater scene from the film *Star Wars: Episode I—The Phantom Menace*. COURTESY OF LUCASFILM LTD. Star Wars: Episode I—The Phantom Menace © Lucasfilm Ltd. & ™. All rights reserved. Used under authorization. Unauthorized duplication is a violation of applicable law.

On *Star Wars: Episode I—The Phantom Menace*, it was particularly important to give attention to the effect of haze on the illumination of the scenes. The haze not only plays an important role in creating a believable underwater environment, but also adds to the story by concealing monsters within the murk of the scene. As the camera moves through the underwater haze, the dangerous creatures are obscured until ultimately encountered. The creatures' quick emergence from previously indiscernible outlines enhances the suspense and surprise in the story.

Lightning

Many action and suspense films utilize lightning storms in their story line because of the intensity of this natural phenomenon. The dark mysterious lighting of an overcast or nighttime scene, combined with the quick, revealing flashes of lightning, provides an excellent opportunity for hiding danger and startling the audience. Quick flashes of lightning reveal the details of a scene, whereas longer periods of darkness present action in silhouette. The tension builds as the

audience, along with the characters, struggles to see how the situation is developing between lightning strikes. Although the illumination from the lightning may last only a few frames, a great deal of detail and story development can be revealed in that short span of screen time. A lightning storm is tailor-made for Hollywood creature or horror films, and is a common effect asked of digital effects houses.

Real-Life Reference

Step one for successfully lighting a scene with lightning, as I hope you've guessed by now, is to check out some reference. If possible, the best option is to go outside and witness a lightning storm firsthand (without holding anything conductive in your hands, of course). If not, there is plenty of reference available in films or television programs. Be cautious of non-documentary reference, however, so that inaccuracies in the portrayal of reality are not propagated unintentionally. The best source of information is an actual lightning storm. Take note of the different ways lightning illuminates a scene. Often in computer graphics, the artists create only a

one- or two-frame hit of intensely bright light. Repeating these quick hits of illumination without variation in the intensity of the light creates a strobe effect rather than the desired lightning effect. The light produced from a bolt of lightning is rarely as simple as a single burst of uniform intensity light turning on for one or two frames and then turning off. I've seen many lightning shots created using that poor technique. The result is a noticeable strobing instead of the subtle varied flashing of lightning.

Types of Bolts

The primary considerations when creating a CG lightning storm are the bolts of lightning themselves and the illumination they create. If the scene includes visible bolts of lightning, study as much reference as possible to get clues on the wide variety of forms lightning assumes. The most common types of lightning are sheet lightning, bolt lightning, and ball lightning. (There are many varieties of lightning that extend beyond the lighting scenarios covered in this book; these subcategories include bead lightning, silent lightning, black lightning, ribbon lightning, colored lightning, tubular lightning, meandering lightning, cloud-to-air lightning, stratospheric lightning, red sprites, blue jets, elves, and so on.) Lightning bolts often appear as single shafts stretched straight down toward the ground (see Figure 6.27), as a series of bolts branching out in several directions (see Figure 6.28), or as multiple strikes jumping across the sky from cloud to cloud. Variety is the key, and the old saying that "lightning never strikes the same place twice," can be extrapolated to CG by saying, "no two bolts of lightning ever look the same." The fact that the lightning bolts will only appear on the screen for a few frames helps the cause, but their brightness makes them the center of the viewer's attention.

Timing and Intensity

Because lightning often strikes several times in a short span of time, the illumination produced has several layers of intensity and direction. A large bolt of lightning is often followed almost immediately by several smaller bolts that provide less intense illumination. Rendering multiple passes of bolts with differing lightning intensities and layering them together in the composite provides excellent control for later adjustments. While working on *Harry Potter and the Sorcerer's Stone*, I was presented with a scene in which a troll was to be lit in a castle bathroom, with lightning flashing in from the clerestory windows, as well as a window in the wall. The background plate provided me with reference for when the lightning strikes were to occur and of what intensity, but the key was to allow for quick and easy adjustments to the brightness of the troll. The visual effects supervisor and the

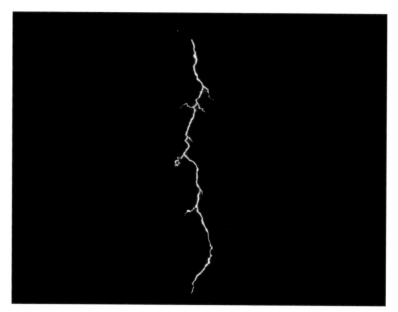

Figure 6.27
A computer-generated element for a bolt of lightning.

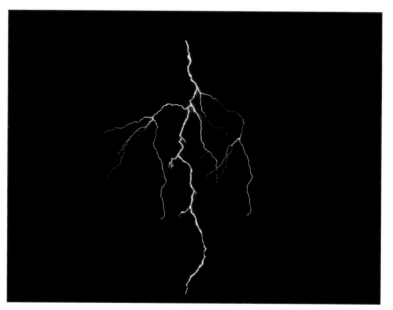

Figure 6.28
A computer-generated element for a multi-branch bolt of lightning.

6. If You Can See It, You Can Light It

director frequently asked for a little more bounce on the lightning frames or a more intense rim light in the brightest lightning frames.

One method used in creating lightning in a scene is placing lights specifically for lightning and then animating the intensities for the appropriate frames. This method, however, makes adjustments a nightmare; it involves adjusting the light intensity animation, and then re-rendering the entire sequence to see whether it will look correct.

The Troll in the Bathroom

There is a much more elegant solution to the problem that allows for precise control as well as fast turn-around in creating iterations. For the scene with the troll, the entire sequence of the troll was rendered with a base level of illumination (see Figure 6.29), and then additional times for the lightning illumination components. These different passes could then be mixed in the composite. The timing and intensity could easily be changed because there was a full set of passes for the

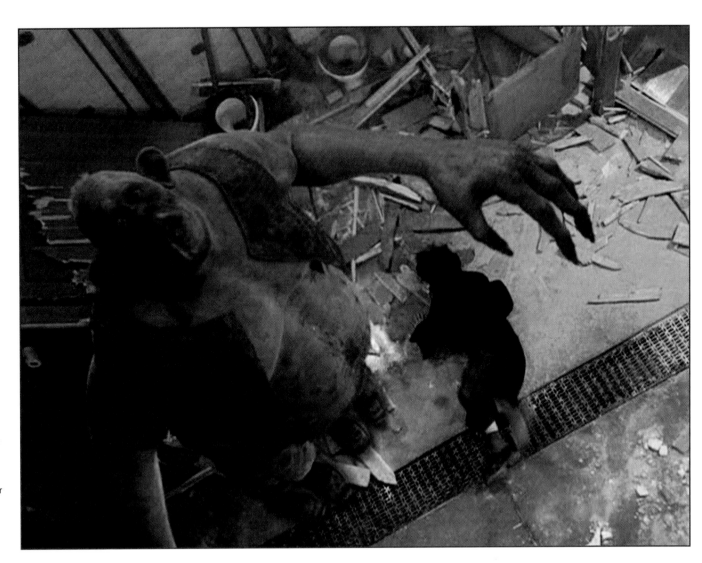

Figure 6.29
The base level of illumination on the troll from the 2001 film *Harry Potter and the Sorcerer's Stone.* HARRY POTTER AND THE SORCERER'S STONE © 2001 Warner Bros., a division of Time Warner Entertainment Company, L.P. All Rights Reserved.

entire shot. There are several different ways to break down the illumination provided by the lightning for the scene pictured in Figure 6.29. One method is to break it out into types of illumination created by the lightning. In the troll bathroom sequence, the lightning illumination is broken down into three different components. One is the bright overhead component simulating the lightning entering the scene through the clerestory windows. Depending on the camera angle and the position of the troll in the space, this light could be either blasting the front of the troll or providing an intense rim light from just behind him. In this particular

scene (see Figure 6.30), the troll is looking up, and this source blasts the front of the character. The second component in this scene is the illumination from the lightning bounced from the floor of the bathroom. This source is simulated by placing lights below and to each side of the character, which basically fills the character with light from below. The third component is a subtle light coming from a window just off the left side of the screen. The angle of this light is more horizontal, and it provides a raking illumination from the side that the other two components are missing. These are the lightning passes rendered separately to provide

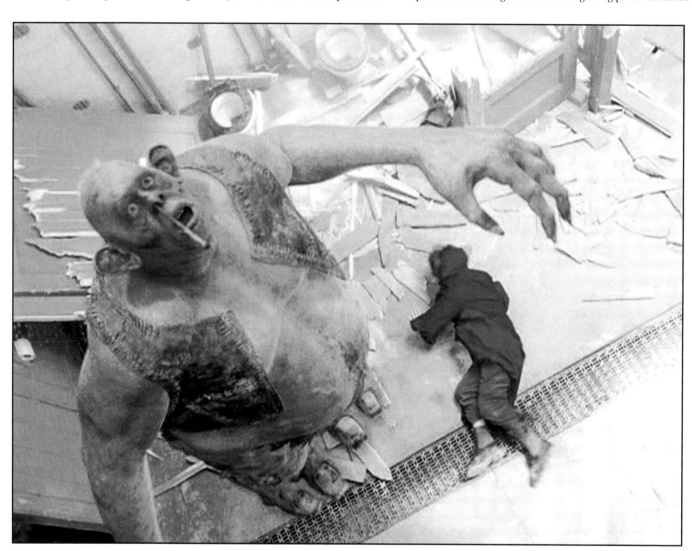

Figure 6.30
Additional layers of lightning illumination added to the troll from the 2001 film *Harry Potter and the Sorcerer's Stone*. HARRY POTTER AND THE SORCERER'S STONE © 2001 Warner Bros., a division of Time Warner Entertainment Company, L.P. All Rights Reserved.

three distinct renders of the same sequence to be combined with the original base render in the composite. The method for combining the layers is basically an "add" composite function, which adds the illumination of one layer to the other. Each rendered layer can be added to the original base-level illumination render (just as a lightning bolt would add illumination to a scene in the real world) in any percentage the artist desires (see Figure 6.30). The beauty of this method is that the brightest lightning layer can be made brighter either by adding in percentages of the other lightning passes or by adjusting the brightness of the rendered layers in the comp. The layers can be mixed in an infinite number of variations, and the intensities can be animated as the scene requires. Because the computationally intensive process of rendering the frames has already been completed, the compositing of the frames with the simple "add" process takes very little time and allows for creating multiple iterations quickly. Supervisors like fast turnaround times and this method allows for many variations to be completed in a matter of minutes.

In Figure 6.31 you see the intensity animation curves for the different passes added to the base layer. What is important here is not the intensity of the curves, but the way they overlap. Notice there are points, usually for just a single frame, in which all three lightning components are added to the base layer. Notice also there is a roll off or gradual fading of the three lightning passes from their initial level of intensity. Lightning bolts quickly ramp up to full intensity, but due to the following smaller hits, the lightning illumination typically ramps down over a few frames. During this ramp-down period (a total of maybe 36 frames, or one and a half seconds from beginning to end), there can also be small spikes of lightning intensity to simulate smaller bolts. These additional hits are usually of less intensity than the original strike, but another large and intensely bright lightning bolt can strike during this time, as well. If the scene requires multiple lightning strikes, then variety is essential.

The best test is to set up the curves, composite the sequence, and see it in motion. Studies of reference footage or observation of an actual lightning storm will train the eye to spot what looks right and what looks wrong. Something often will look or feel incorrect while watching a computer graphics lightning test, but you can't identify a specific problem. In that case it is helpful to try breaking down the elements of the lightning hits in order to isolate the problem. Running several tests that experiment with brightness levels, rate of falloff, and various combinations of the multiple lightning passes will help to gain a clear understanding of what looks like real lightning and what does not.

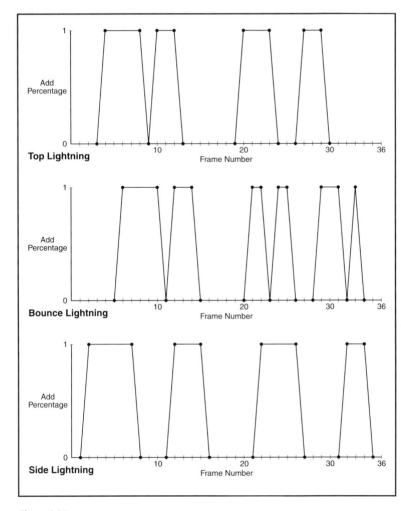

Figure 6.31
An example of multiple curves controlling percentages of three lightning layers in a composite.

Space

When many people think about special effects, the first thing that comes to mind is the *Star Wars* series. In 1977, the original *Star Wars* took its cinematic predecessors' techniques (such as model miniatures supported by strings in front of black sheets with backlit pinholes for stars) and brought them to a new level of respectability. Suddenly spacecrafts were as large as shopping malls, space battles were intense and believable, and the planets and stars actually did seem as expansive as the galaxy. The camera and the spacecraft model motion play an important role in these effects, but the lighting and layering of elements is equally important.

The problem with lighting an outer-space scene similar to that of lighting an underwater scene is the difficulty obtaining first-hand reference. Compounding the problem is the fact that much of what audiences expect from outer-space lighting is inaccurate when compared with actual footage from space. Through years of outer-space movie effects, audiences have been "educated" as to what space looks like. Although the look is not entirely accurate, it is often necessary to partly emulate the misperception of space to cinematically guide the audience. Because there is no atmosphere in space, the normal depth cues that help a lighting and compositing artist in visually explaining the three-dimensional space are no longer available. There is no hazing as elements get closer to the horizon. In fact there is no horizon to help orient the viewer.

Lack of Depth Cues

Without atmosphere, the problem is the opposite of that faced with underwater lighting. Instead of adding elements into the scene (such as particulates or haze) to create an underwater environment, the lighting artist is presented with the challenge of creating a realistic scene without the visual clues provided by atmospheric elements. The lighting in space is intense and the edges are crisp, because there is very little in the way to absorb or deflect the light. The concept of bounce lighting does little good in this environment, because there are no ground planes or walls from which to bounce the light. There may be planets or the occasional meteor, but overall it is a stark environment. With high-contrast lighting and sharp edges, it is difficult to provide the viewer with the necessary clues for understanding the three-dimensional qualities of the scene. For this reason, the camera is often used to help with the layering process. By using a much longer lens, and thereby decreasing the depth of field, the camera provides depth cues by exaggerating the range of focus. A spacecraft passing by the camera may be shot using a 200mm lens, thereby causing the end of the ship farthest from the camera to appear out of focus (see Figure 6.32). This simulates the depth of field cues occurring in the

Figure 6.32
A spaceship element shot with a 200mm lens, thereby creating a narrow range of focus.

Earth's atmosphere, but forces them into a much smaller range. The viewer now has a clue helping to identify what is close and what is far from the camera.

The problem with using a long lens, though, arises when adding more distant elements to the scene. For instance, if the Earth were shot beyond the spacecraft using the same 200mm lens, it would be so blurry that it would be indistinguishable (see Figure 6.33). The solution is to render the background planets as a different pass, with a different camera lens, to produce a recognizable element (see Figure 6.34). Once you begin to cheat, a lot more cheating is required. The difficulty arises when many elements appear in a space scene at varying distances from the camera. Such a scene often requires each element or layer to be rendered separately with a different camera lens in each scene. This can become difficult when trying to remember which layers belong on top of others. On the positive side, separating the elements offers more opportunities for precise control in the compositing stage. If the Earth layer is rendered too sharply, then it can be softened in the compositing stage without affecting the foreground spacecraft or the other elements in the scene.

Star Fields

The spaceships and planets require a backdrop, and the element of choice is a star field. There may be galaxy formations, nebulae, and meteor belts, but the first step for a background in space is a field of stars. There are a variety of ways to create a star field, and the method depends on the type of camera move and the level of realism a shot requires. A common method is to place the stars on the inside of a very large sphere. The stars themselves can either be painted in the form of a texture or created with a particle system and placed randomly on the sphere. With the particle system method, the particles are usually small spheres varying in size, color, and brightness (see Figure 6.35). Depending upon the art direction of the shot, distant stars often have a tint of color and are not all pure white. Stars may have a blue, red, or yellow tint, and can be grouped in clusters of like colors to add a sense of organization to the star field. The density and placement of the stars depends on the direction and the level of realism desired. The stars can be modeled after the actual constellations in the sky or can be randomly placed to simulate space far from planet Earth.

Figure 6.33
Spaceship and Earth elements, both shot with a 200mm lens.

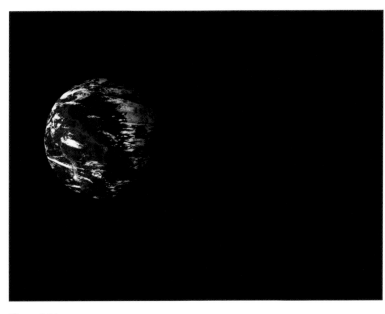

Figure 6.34
Earth element shot with a 50mm lens.

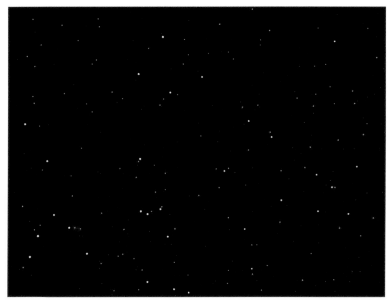

Figure 6.35
A star field created with particles spread randomly over a sphere's surface.

To create some type of midground between the spaceship and the star field, it is useful to add an additional layer of planets, nebulae, or meteors. This layer can be an environment sphere, like the star field, only smaller. By creating a smaller inner sphere, camera movement creates parallax between the distant stars on the large, outer sphere and anything placed on the inner sphere. This inner sphere can be populated the same way as the outer one, but it may need more detail in the textures. Once again, it can be a single painted texture or rendered particles distributed over the surface of the sphere (see Figure 6.36). The example shown here for the inner sphere is a painted texture, with the dark areas having an alpha value of zero to reveal the outer sphere element. The example also shows that the texture and particle techniques can be mixed if desired, or the same method can be used for both spheres. Additional spheres can also be added to provide more layers.

Figure 6.36
Planets and nebulae created with a texture applied to a sphere.

Planet Details

When planets are close to the camera, it is often necessary to add several additional levels of detail to make them believable. The planet Earth is often seen in films, and it is typically created with several layers. The layers are mentioned here, and the techniques for combining them will be explained in detail in Chapter 12, "Compositing Techniques and Methods." These layers often include water, continents, and clouds. The cloud layer is offset and darkened to create cloud shadows. There is also the Earth's atmosphere, which is simulated by adding a general haze pass over the entire planet. The edge of the Earth always catches the viewer's eye, particularly if it is not handled properly. The edge needs to represent the atmosphere trailing off into space. In this example, the alpha of the Earth is dilated and a smoke pattern is placed within it. This creates an outer edge helping the viewer recognize the fading atmosphere (see Figure 6.37). Once these elements are all layered together, a convincing space scene is created that will be successful in a still frame as well as through a camera move (see Figure 6.38).

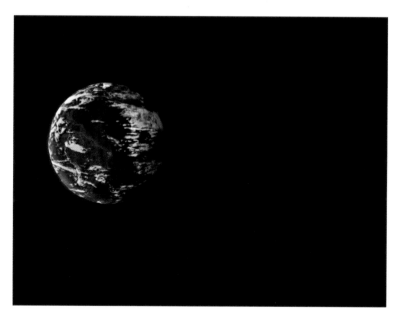

Figure 6.37
Several layers combined to create the planet Earth.

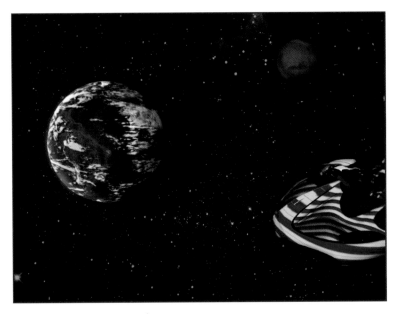

Figure 6.38
Spaceship, Earth, and inner and outer star fields composited together.

This chapter has presented several common lighting scenarios a lighting artist might be asked to create during a digital production. These scenarios only begin to scratch the surface of the many varieties and subtleties an accomplished lighting artist has under his belt for tackling difficult lighting tasks. As with any discipline, practice brings improvement and one of the best forms of practice is to pay attention to the world we live in. If this chapter has shown nothing else, I hope it has driven home the importance of observation and the knowledge it brings. Research is important, and in the world of a computer graphics lighting artist, having visual reference constantly accessible is vital.

chapter 7
An Interview with Jean-Claude Kalache

A Brief Introduction

Jean-Claude Kalache is a lighting supervisor for Pixar Studios in Emeryville, California. Jean-Claude was born and raised in Lebanon and came to the United States to study architecture at Franklin College in Boston, Massachusetts. Although Jean-Claude's native tongue is Lebanese, he was educated primarily in French and then learned to speak English fluently upon his arrival in the United States. After transferring to Texas A&M University, Jean-Claude finished his work on a bachelor's degree in architecture. Taking a slight detour from architecture to explore the computer graphics world, Jean-Claude continued his education in the visualization sciences program at Texas A&M. After completing his master's thesis, he joined Pixar in February of 1997. His first project at Pixar was the Academy Award winning animated short film, *Geri's Game*. Since then Jean-Claude has worked on the feature films *A Bug's Life*, *Toy Story 2*, and *Monsters, Inc.* while progressing to his current position of lighting supervisor.

Interview

DAVID: *Could you give me a brief summary describing how you entered the computer graphics field?*

JEAN-CLAUDE: Yes; absolutely. I grew up in Lebanon and by the time I was ready to go to college (architectural school), I couldn't because of the war. It was on the other side of the demarcation line, so my only option was to go to another school that happened to be an English system school. My education was French, so I thought I could do it, but unfortunately they didn't have an architectural program. I thought the closest thing to a design field might be mechanical engineering (clueless right there). So I went in as a mechanical engineer, and a year later the war was just getting worse and worse. I remember I had a brand new car that my family bought me and I had it for two weeks. During one of the street wars, someone was practicing—I guess target practicing—and decided that my car looked nice and shiny, so he went after it. He blew it to pieces. I remember telling my family—that's

Figure 7.1
Jean-Claude's analysis of the *Inscription House* by Yasumitsu Matsunaga.

it, I want to do something more useful in my life. I was skipping school because they couldn't open all the time due to the war. I told them I just wanted to go somewhere else. I happened to have a friend in the U.S. who was from Lebanon. He was in Boston, so I decided to apply to a small college in Boston. It's Franklin College, which is a small private college. I applied for architecture, and I got in. Within a couple of months I left Lebanon, still barely speaking English. I knew Sue [now Jean-Claude's wife, who spoke English], so that was great to practice a lot. My English was really very, very basic. I came to the U.S., started architecture in Boston, and then found out through a friend, of a friend, of a friend about [Texas] A&M. The big decision for me going to A&M was it was a great place to study, was very safe, and cheap. It was a lot cheaper than Franklin College, and since my family was supporting me, that's when I decided to go to A&M. That's how it all started; someone messed with my car [laughing]. When you look back, you know it's all metal (referring to the car I lost). Sometimes we laugh, as long as no one got hurt in one's family, that's the most important [thing], and the rest is all replaceable.

I got my undergraduate degree in ENDS [Environment Design] at Texas A&M, and I decided to get my master's degree in architecture. I remember at the time my advisor, Rodney Hill (awesome guy), came to me and said you know, it's probably going to be the same work and even longer nights [in graduate school] and you're welcome to do that, but there's this new lab thing happening in our building you might want to go investigate. It's funny, because I'd already started my master's program and signed up for all my classes. I went to the viz lab [visualization laboratory at Texas A&M University] just to ask, and they said, "yeah you can apply, but the chances are slim." They used to only take ten people [per year]. They said we need a portfolio and the deadline is in 10 days. So I stopped going to all my classes, and I tried to put all that stuff together in 10 days. I tried to buy a lot of equipment and set up a table at home. It was like my studio table for shooting all my models. I had stuff done, but it just wasn't the quality [I thought] they were expecting.

Figure 7.2
Jean-Claude's analysis of the *Jacobs House* by Frank Lloyd Wright.

considered computers. I was always going after architecture, the craft of it, and just the manual work most of the time. So I got in, and I remember my first class (I wanted to sign up for the most basic classes) was a multimedia class. How hard could that be? Of course, now I say that, but it was all on Macintoshes, and I was so overwhelmed that I went and talked to the teacher and said I might have to drop this class. Here I am overwhelmed by Macintoshes, not knowing what was waiting for me in the other classes. Soon enough, with all the other students in the lab, I picked it up pretty fast. It wasn't as scary as I thought it was going to be.

> **Soon enough, with all the other students in the lab, I picked it up pretty fast. It wasn't as scary as I thought it was going to be.**

Figure 7.3
Sections of Jean-Claude's design for an artist's residence.

Before I knew it, I got in. And a funny thing, when I got in, I honestly did not have any previous computer experience. I didn't know what e-mail was. We never had a computer at home growing up. I think we'd had one tiny computer, called Spectrum, and all it did was teach you how to write a program to figure out the square root of a number. That was as far as I could go with it … and I played chess on that computer a whole lot. But other than that, I'd never even

> **I played chess on that computer a whole lot. But other than that, I'd never even considered computers.**

Honestly, I went into the lab thinking, I'm just going to keep on doing architecture, but this time it's going to be on the computer. It's a new thing. It's a new flavor. Quickly I realized that the companies that were coming and hiring people weren't really interested in my architectural details and my beautiful designs. They wanted people that were well-rounded and knew about the whole process of filmmaking. I quickly realized I was either in the wrong program, or if I wanted to stay I had to shift focus from architecture. So I did and just started this whole new experience, and it's been great so far.

7. An Interview with Jean-Claude Kalache

Figure 7.4
Plan and model photographs of Jean-Claude's design for an artist's residence.

DAVID: *How do you think your education and previous work experience prepared you for your job in the digital production environment?*

JEAN-CLAUDE: The only previous experience was a job on campus with T.T.I. [Texas Transportation Institute]. They did highway transportation. It was an assistantship. The best thing about them is what I found out when I got into this computer business—no one had a specific set of rules on how to do things. In architecture they had phase one where you research, phase two you explore, etc. It's been in the making for thousands of years. In this field, I never had answers. Of course, I had tutorials, but that was pretty much it. So I found myself doing a lot of problem-solving myself. Just understanding what they wanted and how to get to that image was a big challenge for me because there were 50 ways to do it. The challenge was, what was the best way to do it, what was the cheapest way, and what was the most creative way to do it? There was plenty of exploration for doing that. Being at the viz lab and being surrounded by 10 or 20 super-talented people, it pushes you to work with them, learn from them, and share with them as much as you can. Then you apply it to your own work as much as you can, too. I think it definitely prepared me in terms of teamwork, being at the viz lab. It definitely prepared me—being surrounded by people who would always critique my work. Working at T.T.I. gave me a

> **I think it definitely prepared me in terms of teamwork, being at the viz lab.**

way of understanding what happens in the real world, but I wasn't responsible for deadlines or budgets. I was getting an idea of what happens in the real world, where clients are coming from and what they expect, and going back to

the viz lab and realizing that I might have spent a day trying to get a highlight on a character; and then going back to work and finding out the client really wants to see something a lot more simple than my beautiful highlight. It's a give and take situation, so you are always fighting these two things. How can I be creative, but then be cost efficient? This is always a problem. You don't want them to be married together, but they are in some ways.

DAVID: *How did you end up working at Pixar?*

JEAN-CLAUDE: It was the usual cycle. When companies came to A&M, they interviewed a bunch of us, and then if they liked your work, they flew you out here. I got lucky because Pixar and PDI [Pacific Data Images] flew me out here, and it was nice because they're sort of close [physically]. ILM [Industrial Light & Magic] as well, so it was three companies in one trip. I interviewed with all three companies, and when I went back, interviewed with a couple of other companies like Blue Sky. My interview had a lot to do with what really attracted me to Pixar. That interview was probably the longest out of the three. Within a very short period that day I got to meet a lot of people and we clicked immediately. I noticed most of them were my age, and even the older generation was acting my age, which was really nice. I just felt very comfortable at Pixar. I only did a little bit of research. This is going back in time a little bit, but this is really a funny story. When I joined the viz lab, I met a fella that you know very well, Jason Rosson. We were in that multimedia class and I got to know him. He plays tennis, and we started playing tennis, and one time he made a comment and said, "When I

> **My interview had a lot to do with what really attracted me to Pixar.**

finish this program, I want to go to Pixar." I said, "What's Pixar?" I had no idea. He started telling me about Pixar and what they did and said let's go rent these videos. They did this short and that short and little did I know that eventually I was going to finish school and go to Pixar. That was a funny coincidence.

Figure 7.5
Modeling examples from Jean-Claude's master's of science in visualization sciences thesis project.

7. An Interview with Jean-Claude Kalache

DAVID: *Did you find any difficulties in making the transition from school to the professional world?*

JEAN-CLAUDE: Absolutely not. You know, one thing that is amazing about the viz program is that when I was there, I sort of complained a little bit about the structure of the program. I was never exposed to the real world, other than T.T.I. Even at T.T.I., I was a specialist. I was just doing lighting and modeling. When I came out here to Pixar, I realized that everything I had learned was applicable at Pixar. They have this great open policy of: "We'll put you on a project, and you can do whatever you want (of course, if we need a lighter, we'll ask you to light first)." You can move and change and try different things. They encourage people to do that, even if you're completely out of the loop in some domain and you just want to learn about it. I think what made the transition pretty easy is P.U., Pixar University. It's a ten-week program, and they just take you through the process. You do a mini-movie in that university. It's not a mini-movie really, but it's a few shots. They take you through the production cycle in the ten weeks. Again, because you're in a class, you are surrounded by maybe 10 or 12 people. Stephen King from the viz lab was also in that class. Within a week we were best buddies, all of us, and we were sharing knowledge and learning from each other. They made it really, really easy. In fact, they made it so easy that for a while at P.U., we would do the assignment, and (because, again, I think we were so well trained at the viz lab) we would finish it early, and then we'd do extracurricular activities at Pixar all the time. We became really good at Ping-Pong and foosball, just because the whole atmosphere seemed to rhyme well with the viz lab atmosphere. So the transition, I think, was really very smooth.

> **I think what made the transition pretty easy is P.U., Pixar University. It's a ten-week program, and they just take you through the process.**

DAVID: *What is the team environment like at Pixar, both in terms of your entry-level position and your current role as a supervisor?*

JEAN-CLAUDE: As soon as I finished P.U. at Pixar, I heard about a short movie, *Geri's Game*. I was hired at Pixar as a modeler, but my back-up strength was lighting. I'd done quite a bit of lighting. They wanted someone to light on *Geri's Game*, and because they didn't have any lighters, I signed up to do it. In the beginning it was a little bit overwhelming, but within a week or two I was assigned a technical lead that I would interact with every single day. Dave Haumann is his name. Every day he would guide me through the small details of how the production was set up. In P.U. you're working on this one example and everyone else is working on it. Everyone has done it before, so you can ask questions and you'll immediately get answers. In this production, every day is a discovery day, and not just for you. Your leads and everyone are learning things as they go. What is really nice about that experience is, on a weekly basis, I would interact with the director. Here I am straight out of school sitting down with an eventual Oscar winner, Jan Pinkava. Sitting down with him and learning what he wanted, and teaching him in some way what we could do with the technology and trying to bridge that gap between the two of us. It was so nice to try to teach and learn from him at the same time. It was really nice and rewarding. The great thing about working on a short is that you get to interact with a very small team. Not only do you interact with a small team and you know them well and become very familiar with their styles and how they work, but you also find yourself doing a lot more than one task. It's a small team. We were probably ten technical directors, ten animators and artists, and the director himself. Before I knew it, I wasn't just doing lighting. I was doing camera layout and anything that I could put my hands on. People would encourage me to just go and experiment with that. If I couldn't find any help, then I would just read documents, and there were tons of them.

> **In this production, every day is a discovery day, and not just for you. Your leads and everyone are learning things as they go.**

> **Before I knew it, I wasn't just doing lighting. I was doing camera layout and anything that I could put my hands on.**

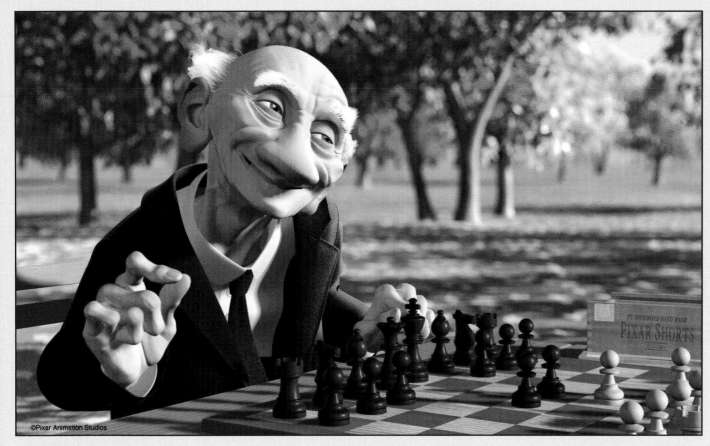
©Pixar Animation Studios

Figure 7.6
A shot from Pixar's animated short *Geri's Game*. © Pixar Animation Studios.

It really shaped me for the next big project, which was *A Bug's Life*. When I transitioned into *A Bug's Life*, it was a much bigger team. It was almost overwhelmingly bigger, but I found myself within a very short period ramping up and doing work equal to the other people working on *A Bug's Life*. Within a short period after that, I was teaching those guys (the *A Bug's Life* lighting team) things and tricks that I'd learned on the short production. Working on shorts and working with a smaller team helped me develop really fast. Working on *A Bug's Life*, I had a much smaller

> **Within a short period after that, I was teaching those guys (the *A Bug's Life* lighting team) things and tricks that I'd learned on the short production.**

role. I was solely a lighting T.D., and I would only interact with the D.P. [Director of Photography], sometimes on a daily basis, sometimes every couple of days, but that was my major role. I didn't do any camera work, and I didn't venture outside lighting. It was great because now that I knew the technology and the tools and the proprietary software, and now that I had a director of photography whose vision needed to be developed and was guiding me (Sharon Calahan) every day, the process was really smooth. I would meet with her ten minutes on average a day, get a

99

Figure 7.7
A shot from the 1998 animated feature film *A Bug's Life*. © DISNEY ENTERPRISES, INC./Pixar Animation Studios.

download, show her my work, go back and forth and talk about the goal and the vision, and she would leave and I'd go back to work and then the next day do the same thing. Eventually, as I progressed, she felt that I could do a little bit more than shot lighting. I moved on into master lighting, which involves set lighting and working with the art director and the director of photography a little bit closer than with shot lighting. I enjoyed that, too. Toward the end I was master lighting and leading sequences. I found myself master lighting shots, but then going to other people's offices and trying to help them, most of the time on the technical side. I wasn't giving any creative feedback, since that was the D.P.'s job.

After that, I moved on to *Toy Story 2* and *Monsters, Inc.* in a supervisor's role. On *Toy Story 2*, it was more of a technical supervisor role and Sharon was the D.P. In that role I was interacting with the team. We had a large team of people that I interacted with, and on a daily basis I would do walk-throughs with every single individual and try to answer any questions they had. Sometimes they were questions like, "The D.P. wanted this, where do I start?". It was more of a creative technical decision. Sometimes it was, "This is not working; my shot is failing; what's going on?". So I became the point person for the lighting department on *Toy Story 2* and was regularly meeting with other people in the production and learning from them. Eventually, on *Monsters, Inc.* we didn't have a D.P., so I took on more creative responsibility. I covered the technical planning, a little bit of management, and had a lot of creative influence on the lighting department. The nice thing about the structure was I was the supervisor, but we had two creative leads. So between the three of us, we managed to work with a large team and get the movie done. The team was exceptional. We had quite a few new people and we worked out a system where the old people worked with the new people and they taught them.

We created an amazing environment, and the sense of a lighting team was awesome on *Monsters, Inc.* We worked with the new director and the producer, and the whole team was working in harmony. The one thing I omitted is that the typical direction comes from a production designer, art director, and the director. You sit down with them and they basically have a vision. Your job is

We created an amazing environment, and the sense of a lighting team was awesome on *Monsters, Inc.*

Your job is to translate this vision into this new world and in doing so you always have obstacles. You're like the negotiator.

to execute this vision. Your job is to translate this vision into this new world and in doing so you always have obstacles. You're like the negotiator. I know this is what you are trying to achieve, but I can give you this slightly different variation of what you want. Are you happy with it or not? For technical reasons this is why we can or can't do it and for creative reasons this why we can or can't.

Figure 7.8
A shot from the 1999 animated feature film *Toy Story 2*. © DISNEY ENTERPRISES, INC./Pixar Animation Studios.

7. An Interview with Jean-Claude Kalache

Sometimes you suggest a lot of new, fresh ideas that they can add to their direction, so it worked out really well.

DAVID: *How do you approach a shot in terms of analyzing the computer graphics lighting setup and then actually creating the lighting for the scene?*

JEAN-CLAUDE: I haven't done any shot lighting [lately]. It's funny. On *A Bug's Life* I averaged like 140 shots in 6 months. On *Monsters, Inc.*, I had four shots. The typical thing I tell people, and I try to do myself, is when you're dealing with a shot you have to go through a few phases. There's the technical phase of understanding how to do it, and then there's the creative phase. Then there's the exploration and discovery phase and the delivery. I usually start with the story, actually. I should go back a little bit. You know Pixar is very big on story. Almost every department was built to help story, and lighting is a great place to help story, because with no animation, with no shading, with no acting, and with nothing in the scene, you can tell a story with lighting, depending on how you set up your scene. Typically, when we get a shot, the first thing we want to know about is the story. The story is about the shot and its context, not just a stand-alone shot. We want to learn from the director and, if I'm a supervisor, I will convey that message to the shot lighter. This is what the emotional goal is of the shot. This is what the mood is supposed to convey. We basically, for several minutes, talk about the story. This is what's happening, and if it's a key point about the character and the character is sad and then the character becomes happy—okay, how do you help it with lighting? So we start analyzing how lighting is going to help. We know that there are practical lights coming from a ceiling, coming from the window, or from the morning sun, but that's the practical world. How can we stylize it? How can we change it to serve the story? We figure out a formula for where we want to go, and then, when you're lighting shots, you have to work from the outside in. You have to look at the whole sequence and who else worked on that sequence and see where your scene will fit in that sequence. You sort of work backward too, from the inside out. Start with your [shot] if you're beginning on the sequence and see how you want to develop it so that it grows and matches all of the other shots. Once we figure out an aesthetic plan, and how we want to tackle this (usually the most challenging part), the rest is easy. It becomes a little bit more technical. Okay, how do we want to set

> **...with no animation, with no shading, with no acting, and with nothing in the scene, you can tell a story with lighting.**

this up? How do we want to optimize this? Now you're thinking of efficiency versus creativity and that usually takes quite a bit of time to adjust because, like I mentioned earlier, there's no one set of rules on how to make a shot faster or render faster. There are so many ways you can do it. Do I composite or do I let it all work in the three-dimensional world? There's a lot of decision-making at this point. Once we figure out the technique of the technical way and how to achieve that, then it's just a matter of doing hands-on work and exploring that process. We're not there yet today, and I don't think the industry is there yet today, but in the very near future I would love to see us doing a lot less technical work, worrying about how to optimize the shot, or how to make if faster, and have the computer and the system take care of that. Then have us just completely worry about the look of the movie, and explore a lot more than what we usually do right now. It's happening and I see it changing as we speak.

DAVID: *Do you prefer when you are supervising people on shots to nail things down in the three-dimensional render, or to get the renders out and then make tweaks in the two-dimensional compositing stage, or is it some combination of the two?*

JEAN-CLAUDE: I think it's a combination of the two. It's a big dilemma, always, because you can work in a full 3D world and, of course, it's going to take a long time to render. Or you can composite everything and it will render a lot faster, but it will take you a lot longer to set up, because now you're responsible for ten layers instead of one layer. I think sometimes what drives the decision is really the look of the shot. There are things that you can achieve in both rendering the whole environment or in compositing, but in terms of a super-stylized look, sometimes compositing gives you a lot more leeway than rendering. We are trying to mimic some physical laws, where sometimes it's the opposite, and sometimes you want a more realistic way. Even in the rendered scene you might have specialized lights that you couldn't have in live action, but with CG you can do them and shape them and attach them to characters and have them follow in a way that is a lot faster than doing it by compositing several objects or characters in the scene that are interacting with each other. So I think it really is a combination of both. At Pixar today, we talk about 2D lighting and 3D lighting and how both of them are really important. The final image is 2D and we should sort of light it 2D, or paint with lights as they say, but the initial

> **At Pixar today, we talk about 2D lighting and 3D lighting and how both of them are really important.**

product is 3D in some way, too. You're always going back and forth between the two and I think it's usually up to the technical director, the person working on the shot, to make that decision. That decision, of course, is driven by a lot of factors. If you're pressed for time, and you have to work on three shots, sometimes you just don't composite. You go and just let it render and look at it the next day and make that decision. If you're not pressed for time, you can from day one go in and say I'm going to have a really systematic approach with this shot. I'm going to break it into five layers, this is what's going to happen and set up the rules. So there's a lot of decision-making in this process. I think in the end there is a vision of what he [the director] expects from your shot. Whether you composite or whether you render is not that important. It's important in terms of budgeting and time and all that, but it's not as important as fulfilling that vision. There are always work-arounds. If you come in late [behind schedule] for a couple of days, then the week after we make sure that you get a simpler packet of shots so you can cut shots. Or if you came up behind on a week, there are always people that have simpler packets and shots to make up for those numbers. So we're not really worried about the numbers a whole lot. We push TDs to worry about the final look of the image, and whether compositing or rendering serves the purpose, we'll just go for it.

DAVID: *What are packets?*

JEAN-CLAUDE: Packets are basically a series of shots that for continuity purposes are assigned to one person. Let's say you're sitting in a living room and the camera is basically looking at you, and then in other shots the camera is looking at the opposite view at the TV. We have two people working on this sequence of you watching TV, and we keep cutting back and forth between the two camera angles. We basically pick all of the shots that are looking at you, and we call them a packet and we assign them to one person. It's just an efficient way to work. Rather than saying shots 1 through 10 go to this person and 11 to 20 go to another person, we're a lot more efficient. We do it like location scouting. We look at the most logical location where a person can work efficiently and for continuity purposes not have too many issues with their work. A good example would be, if there are three same-as shots, or similar shots, it just doesn't make sense to give them to anyone else except you. So we create what we call a packet—a series of shots.

DAVID: *How differently do you approach lighting hero characters as opposed to lighting background elements?*

JEAN-CLAUDE: Not that differently. I may be sounding a little bit redundant, but every scene has a story. If it happens that the story is about the background elements, we will pay equal attention to them compared to the foreground or hero characters. Hero characters, most of the time, are right in front of the camera and we do pay quite a bit of attention to them. If the focus of the audience is to go in the back in the blurred background since there's something happening with that background character, then we'll definitely work on that character. If that character transitions from the background to the foreground, the attention will be paid to that character in equal terms compared to hero characters. We do, however, in the early phases, spend a lot of time learning about hero characters and what makes them who they are. In the preproduction phase, we take our hero characters and we ask animators to animate them, move them, and then we put them in different lighting environments and we learn about them. We learn about what makes them look good, what makes them look sad, and what makes them scary. You'd be surprised at how much information you get from very simple tests. Very simple lighting tests reveal so much about characters. We do give more attention [on heroes] compared to background elements or characters in that way.

> We learn about what makes them look good, what makes them look sad, and what makes them scary. You'd be surprised at how much information you get from very simple tests. Very simple lighting tests reveal so much about characters.

DAVID: *Are there any particular shots or sequences you've worked on at Pixar that you were extremely pleased with or that you thought stood out above some of your other work?*

JEAN-CLAUDE: You know, it's funny, because when I finished working on *A Bug's Life*, I decided I was going to take my favorite shots and for my own repertoire just print a couple of pictures and leave them in my office. I ended up printing probably 40 or 50 images. I think the reason I'm proud of everything (and it's not just my

work, it's work of people I worked with) is because every shot is special. This sounds funny, but when you buy furniture, you can go to the store and buy a piece of furniture and put it in your house and it will stay there forever. It won't mean the same, though, as if you got a piece of furniture from grandma who got it from great-great-grandpa. It's just that it has history. You look at a piece of wood and all of a sudden you feel good and you remember so many things about it. There are a lot of shots at Pixar I've worked on and a lot of sequences that at the end really paid off. Through the stress and all that, you look at the final product and you go back in history and you remember every single thing that you did on this shot and you are really, really proud of it. What makes us even prouder at Pixar is when you look at the final product. When you're lighting your [work is] out of context. You're lighting on shots, but you just can't see the whole movie. Very few people can see the whole movie in their head. The director and probably the editor can. When you go to the premiere and all of a sudden you see your work and everyone else's work combined with sound and effects, the whole atmosphere just lights up in the premiere and you are really proud of your work. It's not any more about a specific shot or sequence, but it's about the whole movie. I definitely have my favorite shots and my favorite sequences in each movie, but it's about the work as a whole.

> **Through the stress and all that, you look at the final product and you go back in history and you remember every single thing that you did on this shot and you are really, really proud of it.**

Back to *Geri's Game*, and just a quick thing about that. It was not about look development in terms of lighting. We had the lighting tools, but *A Bug's Life* was underway and they did a lot of work. *Geri's Game* was about exploring hair and learning about cloth simulation—the problems that we had to learn about along the way. Some things we learned not to do, but there are key shots in *Geri's Game* that I still have today on my desktop. I look at this old character, and it's just a great, great feeling. There's something about this old man that you can associate with, because we all had grandfathers or knew older people, and it just makes me happy. It makes me really proud. So it's not just the lighting that I'm looking at in *Geri's Game* (it was very basic lighting), but it's the final product. It's the moment captured in that image—the animation, the lighting, the layout, the story, and it's all very rewarding. It's good stuff.

DAVID: *Can you share some tips or advice you might give on setting up particular computer graphics lighting scenarios, such as bright sunlight, or interiors, or changing mood through lighting?*

JEAN-CLAUDE: Absolutely. There's a lot of ways we do this. If it's bright sunlight, I'll walk with [the TDs] outside and we'll start to look at things. If it's an interior we'll go inside offices or we'll go in some pod. Wherever we have to go, we'll try to explore the environment around us. Nature gives it to you for free, so why waste too much money elsewhere? The first thing I tell them is to observe. Observation. We take a lot of things for granted around us every day. When you're in the lighting department, all of a sudden you start realizing things because you're working on them manually, but you've never really seen them before. We all know that eye highlights are very important. The eyes are the window to the soul and that's what John [Lasseter] says every time. So we pay a lot of attention to eye highlights. All of a sudden you realize that every lighter you talk to is just watching you in a very strange way, and it's almost a creepy way, but you realize they're trying to figure out what's happening to your eyes, and where the highlight is falling, and what makes the eye look this way or that way. So I always tell people the first thing you have to do is just look around and see how much you can learn from the environment around you. Other tips we give, since we've done a couple of movies and tons of shorts, is ask if there's anything we're faced with right now that we could relate to in previous movies, either technically or creatively. If yes, then we'll look at our libraries and ask how they did it. Why reinvent the wheel? Why not just try to figure out how they did it and try to implement it. If that doesn't work, then it's time to explore. It's time to discover. The only answer I could give them then is let's try it three different ways. Maybe the character is walking into this room and we want to make him happy, but evil. So we start experimenting and looking at some reference footage. We always go to the art department with questions. On *Monsters, Inc.*, Boo's hair was very tricky. It looks real, but it's stylized. If you take that same hair and you put it in real life and light it, you cannot achieve what we achieved, because it was done in a very special way. To do this, we wanted references, so we went to

> **Wherever we have to go, we'll try to explore the environment around us. Nature gives it to you for free, so why waste too much money elsewhere?**

the art department with someone [who] was learning about Boo and so we said, okay, let's try a couple of things. Let's try to get art references. We got a wig with a head that you could put it on, and we got flashlights and started experimenting with these things and learning about what we could get from nature, and what the director wanted, and how we could achieve these things. Then you go back to the drawing table and you either rewrite a couple of things or you use some technology in a different way that you haven't thought of before. I think the biggest hint or the biggest tip I tell people is just look around you and observe, because that's what I do most of the time.

DAVID: *What differences do you think there are between full digital shots and effects work that adds computer graphics into live-action scenes shot on film or video?*

JEAN-CLAUDE: I think the major difference with commercials and television and feature film (like what ILM does) is having background plates. It's half the equation. It gives you a lot of information, but when you put your work with that background plate, there's some magic that happens to our eyes (if it's done well) that just allows it to blend seamlessly and the eye becomes a lot more forgiving. It's something that I haven't seen yet in a full CG world. The level of realism with Pixar movies, or with the full CG movies I've worked on so far, is a representation of what the world could be; of what that fantasy world or real world should be. It's almost like a painting. It's not about reproducing the same exact world. It's about an interpretation. It's very stylized and that's where I think the big difference between the two is. I don't think there's any goal at Pixar to make our movies look realistic. I mean there's always interesting effects that you want to add. If you're doing something about water, it's nice that the water looks like water and not like mud. If we become extremely realistic, you sort of lose the purpose of who

> **The level of realism with Pixar movies, or with the full CG movies I've worked on so far, is a representation of what the world could be; of what that fantasy world or real world should be. It's almost like a painting.**

we are, and actually you'd probably spend a lot more time doing it that way than shooting live action. It might be cheaper. CG movies are expensive. In that sense, and in working with the limitations of the technology, I think the CG world is very different than in film and television commercials that combine CG and live plates. I've yet to see a full CG piece that intentionally or unintentionally I don't recognize as a full CG piece. I've seen still images, of course, but it sort of stops at that. I think it's great when you have separation between the two, and if they become identical, it's kind of weird. Some of my favorite cartoons were Bugs Bunny and Tom and Jerry. If you look at those two, they had no lighting, they had no shadows, they had none of the fancy stuff that we have, but they're eternal. If today you had a Tom and Jerry that look so real that I couldn't tell the difference (of course except that they're acting) I think it would have a different impact on me than the original series. It's just truer to the art. It's like looking at a classic car and a brand new car. A brand new car offers you a lot of features and comfort and all that. The classic car doesn't offer you as much in terms of comfort, but there's something true to their form and true to the people who created them. In my opinion, if it changes, they lose their impact. I think the same thing is true with full CG movies. Right now they live in this world that is very magical and the commercial and film worlds are magical on that side, but I think they're two separate worlds. I've only worked on the full CG side of things, but I have to say, many times I wonder what happens on the other side. You're really dissecting your scene in full CG movies. If you put a light here, you have to understand what that means—what does it hit next, how does it interact with the room and the characters and all that? You can only do it in a very simple way, because lighting is a very, very complex thing in life and we've barely scratched the surface about the theory of lighting and color. It's just a huge thing, so it's a complex process, and I believe what you guys did at ILM, which is amazing, is a slightly different process because you have this background reference that you try to analyze and try to fit in your environment.

> **Some of my favorite cartoons were Bugs Bunny and Tom and Jerry. If you look at those two, they had no lighting, they had no shadows, they had none of the fancy stuff that we have, but they're eternal.**

DAVID: *What are some of the technical and creative challenges for you in your current position?*

JEAN-CLAUDE: Every movie you work on, every new project you work on, has its technical challenges, and they're the usual suspects. This is what the director wants and if it happens to be smoke, then it's a technical challenge and we have to figure out how to do that. If it happens to be some other effect, then we'll figure out how to do these things. For me today, working on a new project, the biggest technical challenge is the user experience, and how do they interact with tools to get to their image. In the beginning when I was at Pixar, I never questioned that. Now, four or five years later, to me it's about experience and how they do things and how they contribute. The nice thing about Pixar is that they have a lot of on-going classes, so I took a pastel class a couple of years ago. One of the coolest things about it, and sort of ironic when compared to computers, is with pastels you just sit, you look in front of you, you pick up the pastel, and you work. That's it. That's all that you have to do. Computers, on the other hand (and this is very funny because they were designed and created to make us work less), require a lot more work to achieve that same look. So I started thinking about, you know, that this doesn't make sense. These things are just super fast, yet when I work with my pastels I'm a lot faster and a lot more creative. So now I'm actually working with the tools department and we're thinking about ideas and prototyping ideas about how to make the user experience, from a technical standpoint, a much better experience. We think in an abstract way. Do we want to light, or do we want to paint with lights like artists and call that lighting? Right now we call it lighting because we have to put lights in places, and move them, and play with their colors and their different dimensions, but do we want to do it completely differently and maybe not call it lighting but call it painting or whatever we want? So we're exploring that as a technical challenge. As a creative challenge, every movie is creative in its own way. It could be stylized, it could be more realistic than other movies, but it really is about research. We do a lot of research and we talk about observation. Going back to smoke, if there's smoke in a movie, there's so much to learn about smoke. When I worked on *Monsters, Inc.* there was a lot of smoke and driving every day to work there are a couple of refineries in Point Richmond that are doing nothing but

> **For me today, working on a new project, the biggest technical challenge is the user experience, and how do they interact with tools to get to their image.**

putting smoke in the air (I think it's safe smoke). So day in and day out I would watch the smoke, and it's amazing how much you learn from just watching and observing these things. Creatively the new project has a lot of these things that we see around us and we just want to learn about a little bit more. Some of them are very abstract and different and stylized, and we just have to explore as much as we can.

DAVID: *Do you have any advice for someone who might want to choose a career path similar to yours?*

JEAN-CLAUDE: Yes, I'll say observe, observe, observe. There's nothing better than just observing and exploring if you can do that at work and if you have the tools to explore. I think once you stop exploring, you just stop learning. When you stop learning, you're only going to get good at something and then you plateau. The more you explore, the more creative you will become. Maybe it's a simple thing like moonlight coming through a window. You can show me five different ways of looking at moonlight in a room and they could be very, very different from each other. This is where it becomes very interesting and intriguing. What is moonlight? Well, we don't know what moonlight is. If you ask people some will tell you it's blue light, some others will tell you it's white light, and some people think of it as a warm light. It's just a way I encourage people in what I'm doing to explore as much as you can. Because we're in the computer business, you have to do a lot of problem-solving, too. One time, I went back to do recruiting at A&M, and we were in the auditorium and one guy asked, what makes a good TD? I said, first of all, you have to have a good Lebanese-French accent [laughing]. Second of all, I told him, you have to be a good problem-solver, because on a daily basis you're given tasks and very few of them are repetitive. Most of them are new, which is what really

> **Right now we call it lighting because we have to put lights in places, and move them, and play with their colors and their different dimensions, but do we want to do it completely differently and maybe not call it lighting but call it painting or whatever we want?**

> **I think once you stop exploring, you just stop learning.**

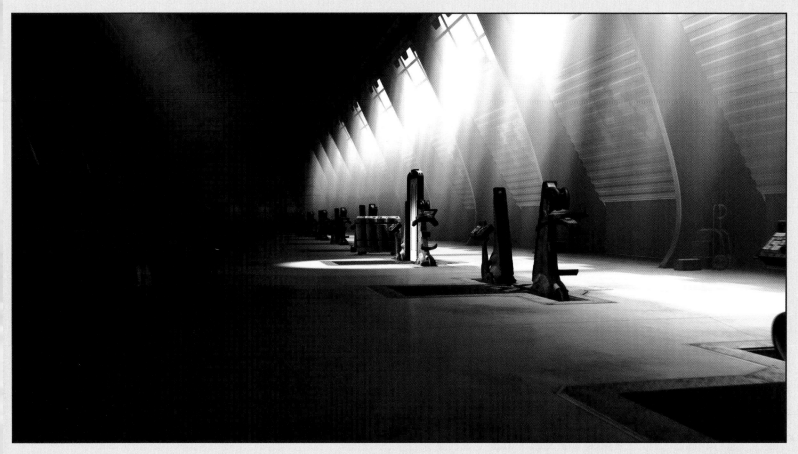

Figure 7.9
A shot from the 2001 animated feature film *Monsters, Inc.* © DISNEY ENTERPRISES, INC./Pixar Animation Studios.

makes our jobs very exciting. With new jobs you just have to figure out a way. Like I said, there is no documentation or a very set way. You have to watch your shot and in a couple of minutes figure out what the aesthetic needs are and in another couple of minutes figure out how to light it. You have to be ready, you have to be smart about these things, and it's a big, big challenge for everyone in this department. Usually we say with art you don't want to place constraints, because creativity does not operate with constraints. But because of computers and because there's this intermediate

> **Anywhere you work in the world, if they see you working at something and you really exude passion, they will notice.**

magic box that is working for you, there are constraints. We're not at a state today where you just say, "Make movie," and it happens. So there are a lot of in-between processes that you have to make decisions on how this machine is going to operate for you. In my supervisor role, I would say if you have a true passion for what you are doing, things happen magically. There is no secret recipe about it. Anywhere you work in the world, if they see you working at something and you really exude passion, they will notice. It rarely will go unnoticed. The biggest challenge for me

7. An Interview with Jean-Claude Kalache

supervising a team is that you have to deal with two things: making beautiful images and dealing with people. It's always a challenge, and just dealing with people to me is almost a full-time job. Then you have that other job of getting the images. Every day I learn something new, and every movie I learn something new about my role. On every movie I look back and I write long, long papers on what went wrong, what worked, and how we should do it differently. We're always
changing our career path. Even if it's the same title for a long time, there's still so much to learn.

chapter 8
Analyzing Your Reference

Observation is the key to creating believable computer graphics imagery, but unfortunately, not everyone has a photographic memory. In my teaching experience, failing to maintain focus on the subject is the most common mistake committed by students in introductory drawing classes—often looking at the subject only once every few minutes. Without supervision, the students spend the majority of their drawing time looking down at the piece of paper. It's tough to draw something if you rarely look at it. The mind begins to insert symbols (representative features) for things the eyes are not seeing, which rarely match the complex interactions of light and shadow comprising the subject matter. To see a clear example of this, give someone a piece of paper and ask him to draw a picture of you. The person will typically draw symbols for every feature on the face. The eyes, nose, and mouth are usually representations of the actual features, and the drawing will most likely look like a third grader's drawing. It's not a coincidence that most people's drawing skills progress little after grade school. At that point in the educational process, analytical symbols such as the alphabet, numbers, and mathematics begin to push aside the creative observation skills needed for drawing, coloring, building, and so on. (See *Drawing on the Right Side of the Brain* by Betty Edwards for more on this topic.) As the eyes and the mind are drawn away from observation of the outside world and into interpretation of symbols, the focus on visual reality is shifted and often ignored.

What does all this mean in terms of computer graphics lighting and compositing? It means that staring at the computer screen for hours on end is just like staring at a piece of paper. Instead of referring to the subject matter being produced, the computer graphics artist has only the software interface and text shells for visual reference. Without frequent looks at reference in the form of photographs, film footage,

maquettes, or completed CG shots, a computer graphics scene can quickly lose touch with reality. The symbols learned in school are at the very heart of the programming code that is computer graphics, but this code is an abstraction of real-world lighting and graphic composition, and only representative of the image we want to create. It's up to the artist to ensure that the symbolic representation, when interpreted by the computer, creates the desired final image. A lack of reference on which to base those computer instructions can cause a computer graphics scene to look like... well, computer graphics.

This chapter steps through references in many formats and describes the essentials for using references in the digital production environment. Reference from film sets is the basis for the discussion, because it provides a great deal of valuable information about the scene to be digitally enhanced. The cameras and lighting setups used in film shoots translate well into the format of most 3D computer graphics software programs. As long as the proper references are obtained and integrated, the shots reap the benefits of these observations.

Pipeline Requirements and Analysis

To understand how and why shot and reference data are collected, stored, and utilized, it helps to have a concept of the overall computer graphics studio pipeline. This is the system for taking a visual effects shot from concept to completion (see Figure 8.1). Each phase represented in Figure 8.1 receives input from many sources, but the connections between boxes here represent only the required contributors and a general workflow. The flowchart shows how every aspect of the computer graphics pipeline eventually funnels into the lighting and compositing stages of production. For the lighting and compositing artists, there

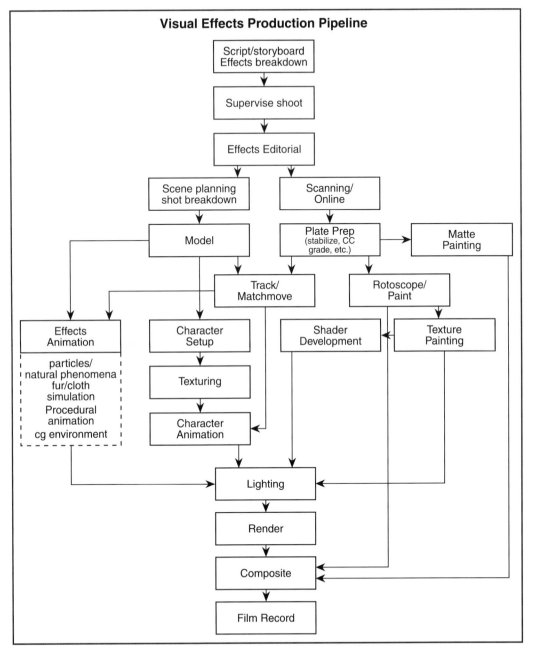

Figure 8.1
A flowchart of a typical digital production pipeline.

are both positive and negative repercussions to this workflow. On the positive side, collecting input from other artists and programmers to produce the final output offers the lighting and compositing artist control over the final look of every image. Each person involved in the process provides valuable input, but he who puts the layers together adds the finishing strokes. This puts the lighting and compositing artists in a crucial position in the production pipeline.

With this responsibility comes a tremendous amount of pressure, which inspires ingenuity. Problems must be solved quickly, because input is coming from all sides. Communication is vital, because the lighting and compositing artist receives data from every other phase of the production. Working at the end of the digital pipeline, the lighting and compositing artists are often faced with making up for lost time. Many times deadlines are missed or delayed in previous stages, but the final delivery date for the project rarely changes. This can mean long hours and long workweeks, particularly during the final stages of a project. The payoff is huge, though, because the lighting and compositing artists have the final input for achieving the ultimate vision of the imagery. In the feature film effects environment, the lighting and compositing artists are the last people in the digital world to touch the shot before it goes to the big screen.

Planning and Live Action

To reach that stage, however, many tasks must be accomplished. The pipeline starts with an evaluation of the written script and storyboards to determine what digital work needs to be done (see Figure 8.2). The shots that need CG are planned in detail (hopefully) with the required information shared between the effects house and the director. These early stages are crucial to the success of the visual effects to be

often helpful to place brightly colored objects, such as tennis balls or Ping-Pong balls, throughout a scene. These can provide excellent reference points for accurately tracking camera motion and can later be digitally removed from the final scene. On-set supervisors also frequently take photographs and/or video footage to provide additional reference of the live-action set.

Conversion to Digital

When filming is complete, the process of transferring the film data into the computer begins. The footage is managed and organized by the effects editorial department, which categorizes each of the live-action elements and plates. This is the stage in which it is decided what will be brought online (into the computer systems) for visual effects work. The film negative is scanned to convert it into a digital format, much the same as images are scanned on a flatbed scanner. At this point, the footage is typically evaluated to define the required processes for each shot. It is preliminarily decided how the shots are to be put together in the digital production studio. The layers of each shot are identified for additional shooting of effects elements or assignment to the various artists. The shot is now born into its digital post-production life.

Figure 8.2
Storyboard artwork.

added, because this is often when it is decided what can and cannot be accomplished. This takes into account technology, talent, existing pipeline capabilities, time, and money. With a solid plan in hand, the effects house visual effects supervisor and/or additional supervisors accompany the director on the live-action shoot. In addition to advising how a shot is best filmed for effects, they collect data to use in the digital production process. Their responsibilities are ensuring that the camera data is properly recorded, the lighting is appropriate for the required effects, and the proper markers and locators are included within the scene. It is

Camera Tracking

The shots now pass into the *tracking*, or *matchmoving*, stage. This is the first point in the production pipeline in which the real world is described in the computer graphics environment. The computer graphics scene is set up with a camera to match, or track, the original motion of the live-action camera. Any moving objects in the scene requiring effects need to be tracked as well. This is where the camera data collected from the shoot is extremely helpful. The lens information

and surveyed reference can be input into the 3D computer software and provide a head start in duplicating the view of the scene as recorded through the camera. Due to distortions and lens variations, this stage requires adjustments in order to precisely match the original camera move. A variety of tools are in place, many included in 3D and compositing software packages, as well as a variety of proprietary software solutions that have been designed to help reproduce the camera in the computer's world. This process also involves creating a basic 3D scene, with simple geometry being constructed to duplicate items in the shot, such as a ground plane.

Models

Several stages in the digital production pipeline can occur before or during the matchmoving process. Creating the computer graphics *models* is one of these. The models can be created independently of the input processes mentioned, but usually they are created in the very early stages of a production. Models can be created from scratch within a 3D software package or from the digitization of a physical model. Sculptors often create maquettes of complex creatures with tremendous attention to detail and proportion. 3D scanning methods transfer these into computer graphics models to provide an excellent starting point for creating a particular character or creature. Different digital models may be created at different resolutions or in different poses as needed by animation, effects, matchmoving, and so on.

Character Setup

Closely connected with the modeling process is the *character setup* stage. This portion of digital production involves fitting models that need to be animated with skeletons and controls. This extremely involved process combines a variety of disciplines and background knowledge, and is vital for creating believable motion. Premier Press's *Inspired 3D Character Setup* book steps through the methods for creating skeletal systems, deformers, manipulators, and controllers in a variety of computer graphics characters and creatures. This process can be lengthy, particularly for characters or creatures with unusual movements, but once a successful skeletal system has been established, the methods and techniques can be transferred to many other models and characters.

Painting and Shaders

Matte paintings can be started even before film footage is brought online. A matte painting is a piece of artwork that serves as a backdrop or extension for a scene (see Figure 8.3). The black cut-outs in the CG matte painting are for 3D computer graphics placement. Matte paintings are less convincing when close to the camera, because any camera movement quickly informs the viewer that he is looking at a 2D painting as opposed to an actual 3D scene.

Additional production categories capable of progression without the use of the digital camera are *shader development* (a computer program to describe the physical behavior or appearance of an entity, such as light, surface, volume, and so on) and *texture painting*. Whereas each of these categories benefits with evaluation from the point of view of the camera, they can be developed to a great extent without the matchmove scene file. The shaders (also called materials) and textures are typically tested on the models as they are being developed. The lighting for such a

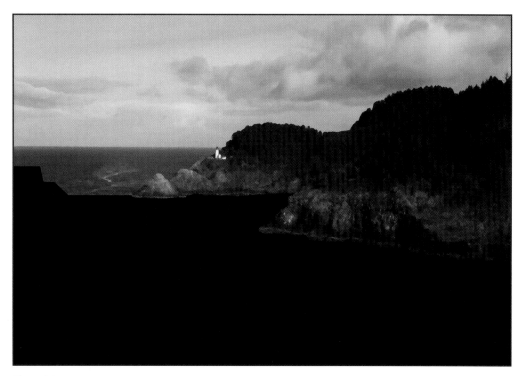

Figure 8.3
Background matte painting.

scene is basic, with little more than a key and one or two fill lights. The lights are white, so textures can be evaluated on the model in their purest form. A textured test of the model is frequently composited over a representative live-action frame to determine whether the color palette is suitable for the intended background.

Shader development is crucial in establishing the ultimate look of computer graphics elements. Whereas 3D software packages come with ready-to-use shaders and textures, advanced and custom shaders and textures differentiate professional quality computer graphics from the average. As with lighting and compositing, reference and observation are vital in this stage, because shader writers attempt to faithfully re-create real-world materials. Photographs, particularly of objects with similar qualities to those of the CG models, offer visual clues to how the shaders will approximate the surfaces. The way lights interact with surfaces, reflections, refractions, and surface-texture details is controlled by shaders. Painted textures are placed on the model surfaces according to the shader code instructions. Shaders are combined to create various looks, and most studios develop libraries of shaders for commonly used materials. Shader writers work closely with texture artists, modelers, and lighting artists to ensure achievement of the CG elements requested by the director.

The images containing the color and appearance of materials used to cover digital objects when rendered are created by texture painters. The texture painters provide texture maps, bump maps, displacement maps, specular maps, and any other artistic rendition required to enhance the look of an object (see Figures 8.4 and 8.5). These maps vary greatly in size and resolution and can be created from scratch in 2D and 3D paint programs or adapted from scanned photographic reference. Shaders, textures, and how they work together are described in Chapter 9, "Computer Representations of Lights and Surfaces."

The reference provided to the lighting artist is not always comprehensive or sufficient to provide a solid understanding of the desired look. Each of the aforementioned job disciplines utilizes some type of reference for a task, and all the elements find their way into the lighting artist's scene. For this reason, it is sometimes valuable for lighters to visit the other departments to view the shot reference used in earlier stages. It is also often valuable to gain other artists' input on the factors affecting the look of the element in the scene. Each person in the production pipeline has talent and insight and is usually eager to discuss the shot to help it come together in the lighting and compositing stages.

Figure 8.4
Texture map created by Tom Capizzi.

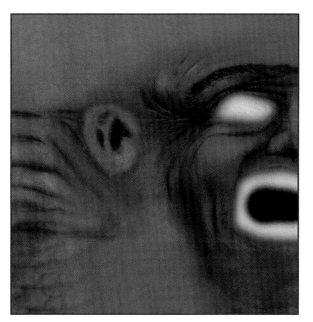

Figure 8.5
Specular map created by Tom Capizzi.

Effects and Animation

After the camera scene is set up and models are created and attached to skeletal systems, these parts are integrated so that the scene can pass to the *effects* and *animation* stages. As you would think, the animation stage involves animation of characters and objects in the scene. The effects stage encompasses the creation of everything else necessary to complete the scene. This could be crumbling buildings, smoke and dust, rivers and oceans, clothing and ropes, fire and lava, and so on.

Lighting and Compositing

Finally, after passing through all those departments and the hands of so many people, the shot arrives at the desk of the lighting artist. The lighting scene file is an integration of all the work previously done on the shot. All that's left is to add some lights, render the necessary layers, composite them together, and scan the shot back to film. Of course, this is all in a perfect world, and if you've ever worked with computers, you know that things do not always go that smoothly. Sometimes film footage is unusable or shot poorly, computers crash, cameras don't match, animation is off, geometry renders strangely, and so on.

With all the possible problems, it is extremely helpful if the technical director possesses enough knowledge of the pipeline and contributing disciplines to correct minor mistakes when they arise. If a TD is forced to constantly return the elements of a scene to other artists for minor fixes, the shot is likely to miss its deadline. A TD well versed in quick paint fixes, modifying equations, adjusting animation curves, and changing material shaders has a huge advantage in completing a shot on time. Also, being able to make those modifications provides the TD with the ability to ensure every element of the shot works together.

Lighting Diagrams and Set Measurements

A lighting diagram of the live-action film set (see Figure 8.6) is an incredibly valuable piece of information available to the lighting artist. The diagram indicates the basic position and

orientation of the lighting setup and identifies each light by type and intensity. Additionally, the locations of characters and the camera and art flats (artwork painted on a large canvas or board to simulate areas beyond a movie set, such as outside a window or door) may be included.

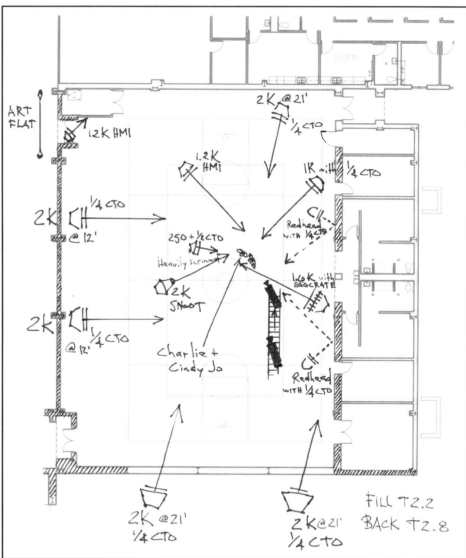

Figure 8.6
A movie set lighting diagram.

Intensity

It is not necessary to understand every technical aspect of movie lighting equipment and the accompanying jargon, but a basic knowledge of lighting terms enables the lighting artist to decipher a lighting diagram. By placing the computer lights in roughly the same locations with the same parameters as those on the movie set, the lighting artist has a head start on matching the look of the background scene. The basic terms used in most lighting diagrams start with a description of the intensity of the light. A light labeled as 2K produces 2,000 watts of illumination. Lights come in various shapes and sizes, such as a standard Fresnel lens light or a zip light, but each has an illumination value associated with it (see Figure 8.7). A Fresnel lens is a glass lens with concentric ripples casting a soft, even illumination across the light's beam. A zip light is a 2,000-watt soft light (with no lens) used to provide broad, diffused lighting. Another light type found in Figure 8.6 is called a redhead, which is an open-faced (no lens), 1,000-watt fixture. The metal flaps attached to the sides, top, and bottom of the top light in Figure 8.7 are called barn doors. Each barn door is hinged to allow for more precise control of direction and spread of the light. Some spotlights in computer graphics software include barn doors for additional control. There are many more practical light types (with confusing nicknames) than those listed here, but each one can be simulated in the computer.

Color and Attenuation

The color of the lights in the scene is determined in large part by the type of gel placed in front of them. *Gels* are simply sheets of acetate that come in a wide range of colors. A gel is usually attached to the front of a light with clothespins (C-47 is the jargon for clothespin, given by a production manager in an attempt to provide a more technical title for the mundane article). A common abbreviation found on lighting diagrams is CTO, denoting color temperature orange. This designation specifies a particular spectral transmission, in this case a specific orange. An abbreviation of CTB denotes color temperature blue. These labels are valuable for establishing the different lighting colors contributing to the illumination of the scene. Unfortunately, setting the computer light's color to that of the gel doesn't usually work. As the color reaches the subject, it is affected by the wattage of the light, the atmosphere on the set (smoke or fog), the ambient light in the scene, and even the type of film used.

Figure 8.7
A 500-watt Fresnel lens light on the top and a 1,000-watt zip light on the bottom.

In addition to intensity and color, lights are also frequently labeled to identify how they are diffused or attenuated. To decrease the light's contribution to the scene, one or more scrims can be placed over it. A *scrim* is a small, wire mesh used to cut the intensity of a light without greatly scattering it. A single scrim is designed to reduce the light's contribution by approximately one stop, which is a 50% reduction. Two scrims layered on top of each other, known as a double mesh, reduce the light by approximately two stops, which is 50% of 50% (or 25%), which is then added to the original 50%, to achieve a 75% reduction.

Lighting Details

The lighting diagram may also contain general notes identifying values for specific types of lighting contribution with a letter and number combination (for example, T2 or T2.8). A designation such as T2.8 refers to the amount of lighting required for proper film exposure using a camera lens with an aperture setting of 2.8. With the same lens, a measurement such as 2 would represent lighting one stop below the base lighting level for that lens. The numbers correspond to the common aperture setting on cameras, which are 1, 1.4, 2, 2.8, 4, 5.6, 8, 11, 16, 22, 32, 45, 64, and 90. The letter T is similar to the letter F used by 35-millimeter cameras but takes into account the loss of light within the lens before reaching the film.

Lights are often labeled with a height, but rarely show coordinates to locate them precisely in the scene. Notes are taken quickly on the set, and information is sometimes left out or even recorded incorrectly. The lights are usually drawn in their approximate locations. They are definitely helpful, but by no means precise. Keep in mind that even a perfect lighting diagram faithfully transferred into the computer does not produce lighting to match the live-action scene. Computer graphics lights serve as approximations for real-world lights and are not exact replicas. The lighting artist must have the technical skill and visual acuity to reproduce complex lighting schemes with the tools provided in 3D lighting and rendering packages.

Camera Information

Camera information collected from a live-action shoot, particularly one that later involves computer graphics elements, is generally much more precise and complete than the information gathered in the lighting diagrams. An accurate reproduction of the camera and its movements is absolutely vital to successfully integrating computer graphics elements with a live-action scene. The camera report is a record of data about the camera, the film, and the scene (see Figure 8.8). The sheet identifies the production and scene, along with the key players in charge of the shoot. The camera report also provides information on each camera used to film the scene, because different cameras are frequently used to capture different angles. Additional cameras may also utilize different lenses, filters, and film to provide options in depth of field, framing, contrast, and so on. For each camera, the lens, focal length, position, and orientation are noted. The focal length of the lens can be input directly into a computer graphics camera to begin matching the camera. Real camera lenses usually introduce some level of distortion in the image. Lenses are often tested (characterized) so that the distortion can be removed or included in the computer's camera. Additional information on the camera report includes film speed (24 frames per second is standard for film), lens filters, and shutter angle (size).

Because cameras often move through a scene, the camera report may only provide a starting point for the camera. In order to accurately match this movement, markers (like the tennis or Ping-Pong balls mentioned earlier) are often tracked through computer graphics programs. The locations of these markers are

Camera Information			
PRODUCTION: CHARLIE'S JOURNEY	DIRECTOR OF PHOTOGRAPHY: BOBBY LENSMAN, ASC, ACS	VISUAL EFFECTS SUPERVISOR: JOE CIESITALL	SLATE: 79 / Scene: 79 / Date: 31st December, 1999
Roll: B312	Cameraman: Camera A	Cameraman: Camera B	Cameraman: Camera C
Stock and Code No.: 5274	Lens f/l: 19mm	Lens f/l: 40mm	Lens f/l: VARIOUS
	Stop: 2.8	Stop: 2.8	Stop: 2.8
	Speed: 24	Speed: 24	Speed: 24
	Filter: 81A	Filter: 81A	Filter: 81A
Scene Description: Charlie and Cindy Jo meet in the gym at sunset.	Shutter: 180°	Shutter: 180°	Shutter: 180°
	Camera height: 3'6"	Camera height: 3'	Camera height:
	Distance: 20'	Distance: 12'	Distance:
	Tilt: 5°	Tilt: 10°	Tilt:
	Dutch: N/A	Dutch: N/A	Dutch:

Figure 8.8
A visual effects camera report.

accurately surveyed. Using sufficient surveyed marker data and the images, tracking software can re-create the camera's position, rotation, and lens settings for each frame.

The report provides a specific identification of the type of film used and the batch to which it belongs. Each batch of film is produced to be consistent across every roll. This allows filmmakers to purchase film within a single batch and obtain a consistent look for their film. Different batches of film have different characteristics, and although the color range and grain variations between batches may be slight, they are definitely noticeable when cutting shots together. After the film shots are transferred into the digital environment, these characteristics can be identified and matched consistently for each computer graphics element included with that particular film stock. Hopefully the stock number is consistent across all footage for a particular film, but it is always helpful to check those numbers and make sure the computer graphics elements being added match the characteristics of the film.

Reference Spheres

Quite possibly the most valuable references for the lighting artist collected from a live-action shoot are the reference sphere shots. A reference sphere is placed at the point of interest in a scene, typically in the location where the CG character or elements are to be added and filmed under the exact same lighting conditions as the shot itself. You may be asking, "Why is a sphere so valuable as a reference?" The answer is twofold, and begins with the simplicity and purity of the shape. A sphere provides valuable information because it offers a continuous range of angles of incidence as viewed from a single vantage point. Whereas a flat plane only shows light reflecting away from the plane, a sphere shows the light reflecting at an infinite number of angles viewable from the camera. This curvature offers a tremendous amount of information about light sources, their intensity, and the level of diffusion.

Two commonly used reference spheres are the gray sphere and chrome sphere. The gray sphere is typically a matte finish with a neutral gray color (see Figure 8.9). The matte finish provides information on the diffuse contributions of the scene's light sources. The chrome sphere is a reflective surface (like a mirror) and offers a more literal interpretation of the film set lighting. Its mirrored surface shows a full 180-degree view of the scene relative to the camera (see Figure 8.10). The chrome sphere shows the locations of light sources as well as bounce cards (flat, usually white surfaces used to reflect additional illumination from existing light sources into a scene) and other set pieces beyond the view of the camera.

Figure 8.9
A gray reference sphere.

Figure 8.10
A chrome reference sphere.

8. Analyzing Your Reference

117

The reflections in a chrome sphere record the brightness of lights and often reveal smaller, less intense light sources that may have gone unnoticed in the gray sphere or unrecorded in the lighting plot.

Creating a CG Sphere

Now, to answer the second part of the question of why a sphere is so valuable as a reference: In any 3D software package, creating a sphere with a basic gray surface is a simple task. The matte finish material of the real sphere can be easily matched with a simple CG material. The size of the ball can also be matched to that of the real reference sphere, and once the CG camera is created, the ball can be placed in the scene to match the position of the ball on the set. Once this is done, the lighting artist can then begin lighting the sphere in an attempt to match the reference images shot on film. It may sound like a straightforward task, but lighting a sphere to precisely match a film reference sphere is not easy. The rate of falloff, the ambient contributions, the bounce light, and the atmosphere in the live-action scene all offer challenges to the CG lighting artist. A close visual match between the CG sphere and the live-action sphere is a great starting point in building the basic lighting rig for illuminating the CG elements.

Maquette Reference

Although spheres are helpful, wouldn't it also be great to see a version of the creature or object intended for the scene in the live-action environment? Often this is possible, in a small way, by shooting reference footage of a previously created maquette. A reference model of the soon to be created computer graphics element can be placed at its intended location in the scene. Because the maquette is usually much smaller than the ultimate size of the element, this reference is not an exact representation but still provides clues for how the light will interact with the surfaces and colors of the element. Placing the maquette closer to the camera to simulate a larger size provides information on how the element will fit in the frame and which parts of the scene are occluded. Because lighting varies drastically outside the intended area of interest, the lighting on the maquette is likely to be completely different when closer to the camera.

The combined information gathered from sphere lighting references and maquette shots can contribute to a very accurate reproduction of the live-action scene lighting. The bits and pieces of information still missing are filled in by the lighter's experience and sensibilities. The CG elements added to the scene may also require special additions beyond the on-set lighting. Adjustments to accentuate certain CG

elements, such as intense rim lights and special eye lights for CG characters, are commonly required in a shot. Keep in mind that realizing the reference spheres is a starting point, but not necessarily the ultimate lighting goal.

Set Photographs and Video

The on-set supervisor for the effects company often takes photographs or shoots video of the set as an additional reference. With a seasoned visual effects professional providing this footage, details of the scene are revealed that are not evident in the lighting diagrams or the gray and chrome sphere reference images. Many lights on a live-action set are easily hidden from the view provided by the chrome sphere reference. The on-set documentary footage also captures changes in the lighting setup made after the reference spheres are shot. Motion picture film shoots are on tight schedules and budgets, so the crew shuts down the lights and moves on to the next scene as soon as possible. This makes it difficult to shoot lighting reference after filming, although that is the optimum time to obtain the most accurate information.

On-set video documentary footage provides not only additional shot reference but also an excellent opportunity to learn the details of life on a live-action set. The sounds and images of the director, director of photography, and the film crew are a window on the collaborative process of filmmaking. Both photographs and digital video record the colors and contrast of the scene differently than the motion picture film camera, offering a variation on the lighting reference provided by the film footage.

The set photographs and video are only useful if the lighting artist has access to them. Many studios make this reference available to the crew by storing it in a digital database with background footage and other data. A lighting artist evaluates all of this information (plates, diagrams, set stills, video, and so on) while incorporating the requests of the director and visual effects supervisor. All of the reference offers insight and clues to successfully blending the computer graphics elements with the live-action footage.

Similar Shots

The previous reference types are all collected from the live-action environment. Just as important is the look of approved shots in the sequence, which ultimately must match each other. Often a single shot in a sequence is chosen as the representative shot in which the initial lighting rig is built. This first shot is refined until the director is pleased with the look of the lighting and composition. The shot is

then used as the template and reference for other similar shots in the sequence. The lighting for these shots is typically set up by a supervisor or lighting artist with many years of experience. It is often helpful to study the techniques used to set up the lighting rig. The setup file may include lighting constraint systems (lights can be attached to or automatically pointed at objects or characters within a scene to follow their movement) and other features you must be familiar with to light the scene. It is best to take a few minutes to sit down with the lighting lead and talk through the goals, strategies, and solutions for lighting the sequence. Studying his lighting setup file is helpful, but an understanding of the reasons behind his decisions can be applied to future lighting scenarios.

Team Lighting

The template shot is important, but do not forget the work of your peers lighting on the sequence as well. Each person approaches lighting differently, and may have added something valuable to the original setup. The team concept is important, because the sequence is only as strong as the weakest shot. An audience will stay caught up in the story and consistent shots may go unnoticed, but a shot that snaps them out of their willing suspension of disbelief is remembered. Working closely with the other lighting artists and frequently comparing shots is educational and improves the shots. You may find another lighter achieving similar results with far fewer lights and much faster render times. Another lighter may have added a flickering rim light to one element of the scene that the director thinks is the best thing since *Citizen Kane*. The point is, in the digital effects industry, the visual process is a collaborative art with input provided from a wide range of supervisors and fellow workers.

Supervisors and External Examples

Supervisors and directors often have a particular look in mind for a shot or a sequence based on something they have seen before. While working with Dennis Muren on *Star Wars: Episode I—The Phantom Menace*, I was responsible for choreographing an army of Gungans as they emerged onto the battlefield. Dennis Muren offered several specific film references for how he envisioned troops making their way onto the battlefield. He and I sat down to watch a videotape of reference and discussed the type of imagery he was envisioning. The visuals gave me a new direction to explore and eventually led to a shot that pleased both Dennis Muren and George Lucas. Since then, I have made it a point to ask supervisors for sample shots from previous films. A specific film reference is suggested in almost every instance, which not only provides an applicable piece of reference but also the chance to watch a film as research for work. Not many jobs include watching movies as a part of the job description! While studying the specific reference pointed out by the supervisor, additional lighting elements or ideas may become evident. Certain visuals stand out in a director's or visual effects supervisor's memory as striking or successful. The details of the shot, however, may not be included in that memory. It can pay dividends in later lighting scenarios to carefully analyze why the specified shot is successful and how these features can be applied to a shot, an entire sequence, or future projects.

When several shots in a sequence are in the lighting stage simultaneously, it is helpful to compare individual frames or an entire sequence cut together. Seeing shots side by side or cut together in sequence often shows the lighting artist areas that require more or less attention. For instance, when looking at another shot, it may become apparent that the color adjustment you've made in the lights is causing your shots to stand out. On its own, this color change looks nice and produces a visually successful image. With the other shots, it stands out as different, and therefore a mistake. If the change in color is important to the feel of the shot and you feel it improves the look, show it to the supervisor in comparison with the other colors. Maybe the other artists will be asked to match the new color, or maybe it will be determined that the newly colored lights are not successful with the overall look of the scene. Without direct comparison to the other shots, this kind of subtle difference can go unnoticed during much of the production. Continuity is a key to creating believable computer graphics imagery, and direct comparisons are one of the best ways to ensure a high level of consistency.

Similar shots, along with lighting diagrams, camera information, reference spheres, and set photographs or video can provide the lighting artist with all the tools necessary to create a believable computer graphics shot. Collecting this data is necessary, but utilizing it appropriately is the key. The hard work of collecting wonderful reference imagery, analyzing it, and establishing a solid lighting plan is lost if the visual contact with those references is not maintained throughout the production life of a shot. The greatest reference in the world does not make a computer graphics shot beautiful. Quality reference can go to waste without attention to detail and the collaborative work of a lighting artist to adapt it into a harmonious image.

chapter 9
Computer Representations of Lights and Surfaces

L ighting and compositing technical directors are typically not responsible for creating the textures, materials, or shaders they use. The TD receives a scene file containing textured objects with their associated shaders. The TD then places and adjusts the lights and shader settings to render the final image or element.

This chapter provides a brief and simplified explanation of how the computer applies the shaders and lighting to render the objects in the scene. Of course, a complete explanation of rendering and shaders is beyond the scope of this book, but this basic introduction offers sufficient information for most lighting TDs.

Coordinate Systems and Texture Spaces

First, I'll provide a lesson in the space and geometry of computer graphics. An object placed in a scene has a position in space and a shape, which the computer must store in some way. Typically, positions are recorded in a Cartesian coordinate system, which uses X, Y, and Z axes to define three-dimensional space. Each position in space is defined by an X, Y, and Z coordinate set. Each vertex or control point of a piece of modeled geometry stores its position in this way. Additionally, each point on the surface of the object can be located by a coordinate set interpolated from the curves (splines or lines) that define the object. Each vertex of the geometry often also carries texture coordinates and other point attributes for use during rendering.

Texturing is the assignment of additional coordinates to the geometry with respect to a different coordinate system. The geometry's spatial (X, Y, Z) coordinates are used in the render, but it is useful to define additional coordinates to better identify the surface or volume being rendered. Surface texture coordinates are typically

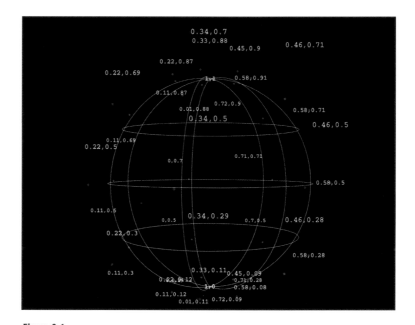

Figure 9.1
A Cartesian coordinate system with a surface-textured sphere.

defined as if the surface were stretched flat and then a 2D coordinate system were assigned. This texture coordinate system uses U and V to define the axes. Therefore, each U, V pair defines a point on the surface of the object. Texture coordinates are usually normalized, which means their range is from zero to one. Using texture coordinates, a texture (image) can be mapped onto the object by specifying the bottom-left corner of the image as (0,0) and the top-right corner as

(1,1) in UV texture space—or a 3D texture (0,0,0) to (1,1,1). The sphere of Figure 9.1 has texture coordinates defined such that the image of the Earth in Figure 9.2 wraps the globe completely. Figure 9.1 shows that the U-texture coordinate values on the sphere increase from zero to one around the circumference and the V-texture coordinate values vary from zero to one vertically. It should be noted that the sphere in the figures is a NURBS surface, so the control vertices which are assigned the texture coordinates are not necessarily on the sphere's surface, but their attributes are associated with the area of the sphere they influence. This is a common texturing operation called polar or spherical mapping, and it is designed to allow textures for spheres to be painted in two dimensions.

Other common texture operations that most 3D software packages provide are cylindrical mapping and orthographic mapping. Cylindrical mapping textures an object as if it were a cylinder unrolled to be flat. The texture coordinates are applied in a rectangular grid from left to right, bottom to top. Orthographic mapping looks at an object from one direction as if it were flat and again assigns texture coordinates from left to right, bottom to top. Therefore, an orthographically texture-mapped sphere has the same texture coordinate values on both halves. There is no limit to the ways texture coordinates can be assigned. Sometimes, they are even animated to produce certain effects, such as flowing lava. A volumetric texture coordinate system uses U, V, and W to define the three dimensions aligned with the coordinate system of the object's bounding box (see Figure 9.3). An object may be textured with multiple texture coordinate systems to support the application of different shaders and textures as necessary. See the *Inspired 3D Modeling and Texture Mapping* book in this series for more about texturing.

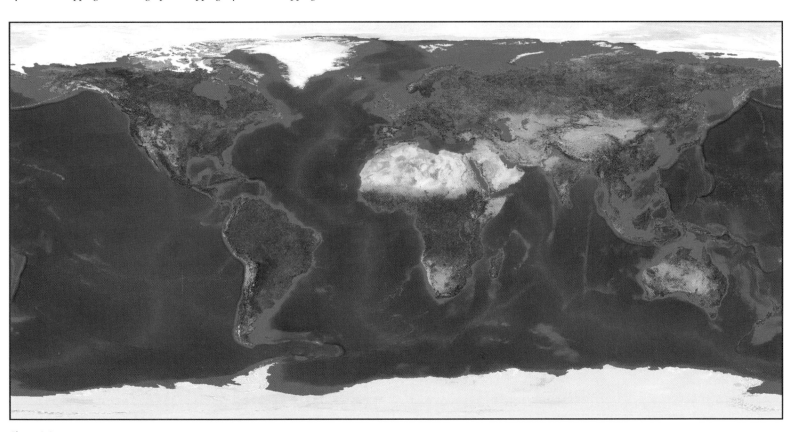

Figure 9.2
A texture map designed to be mapped onto a sphere.

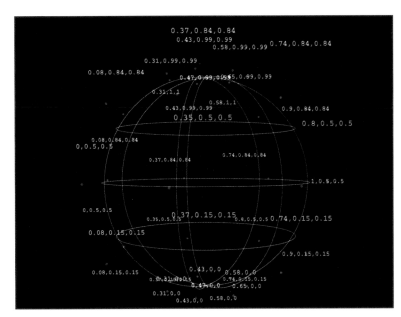

Figure 9.3
Volumetric texture coordinates on a sphere with values based on the sphere's bounding box.

Rendering

Rendering is the process of calculating the values for each pixel of a computer-generated image. The results of these calculations can include the red, green, blue, alpha, and Z-depth values for the pixel. (The Z-depth channel stores a normalized distance from the camera that can be used to layer elements properly in a composite.) These calculations are based upon what objects occupy the pixel, which lights illuminate it, and the viewing properties of the camera. There are several different rendering strategies, but they basically boil down to scan-line or ray-trace rendering. The difference between renderers (software or hardware) is the way in which these basic strategies are implemented, optimized, or approximated for quality and efficiency. A scan-line renderer works its way across the image plane evaluating a section at a time to determine the color of the pixels from the objects and lights in the scene. A ray tracer shoots rays into the scene from the camera and records the objects the rays hit and what happens to the rays as they travel through space. The rays may bounce off reflective surfaces and pass through translucent materials.

The first thing a scan-line renderer does is decide what geometry is in the camera's view for a particular frame. Anything not in view can be ignored. Next, the objects in view need to be split into smaller pieces of a user-determined maximum size. These pieces are then diced into smaller pieces, usually about a pixel in size. Any pieces not in the camera's view can now be ignored.

The scan-line renderer projects all this onto the two-dimensional image plane. For each pixel of the image plane, the pieces in view are sampled (see Figures 9.4 and 9.5). Sampling can save time and memory by choosing a representative portion of the data for analysis. (Higher sampling results in greater accuracy at greater computational expense.) The renderer (as prescribed by the shaders) considers the direct illumination contributed by each light to each sample. This results in a color and intensity value for each sample in the pixel. In Figure 9.5, assume the samples are at the corners of each pixel. Because a final rendered pixel has only a single color, a filtering algorithm averages the color contributions of each sample. Additionally, in a later step during the render, an anti-aliasing filter algorithm averages the pixels at object edges with surrounding pixels to prevent jagged edges and artifacts. Reflections, refractions, and shadows need to be simulated using mapping techniques to be discussed later.

Figure 9.4
A view of a camera, light, and objects in a scene.

Figure 9.5
The view through the camera with exaggerated size pixels indicated by the grid (top) and an enlargement of the view through an individual pixel (bottom).

A ray-tracing renderer evaluates each pixel by tracing rays from the camera to the object surfaces and then to the light sources. In addition to the direct illumination that a scan-line renderer computes, this method includes lighting contributions due to reflections and refractions. Rays bouncing from or transmitting through objects to the pixel being shaded create a more accurate representation of real-world lighting. These more accurate calculations do come at additional computational cost (time and memory). For example, geometry not in view of the camera cannot be ignored, because it may reflect upon objects that are in view. At the geometry encountered, the vectors (rays) are allowed to reflect from or transmit through the object's surface in search of lights. If those continuing rays encounter another surface, they reflect or refract again. If a light is encountered, the geometry in the pixel receives that illumination. Quality and render time are partly controlled by limiting the number of interactions (reflections and refractions) allowed between each ray and the surfaces encountered. More interactions result in more accuracy, but with more computational expense.

Another ray-tracing rendering technique called final gathering (also called *photon mapping*) actually projects a predetermined number of rays from light sources and allows them to bounce around the scene until their intensity is reduced to a certain level or the maximum number of allowed bounces is reached. The addition of this technique to a render increases the accuracy of the contributions due to ambient lighting, reflections, and refractions.

Yet another common rendering technique called *radiosity* calculates the diffuse reflections of surfaces in a scene. This diffuse lighting solution is independent of viewing angle and needs to be calculated only once per scene as long as light sources provide continuous (non-animated) illumination. Specular, reflective, and refractive contributions need to be calculated or simulated otherwise with ray tracing or scan-line techniques.

All these rendering techniques start with the mathematics of basic optics (reflections and refractions) and then include more features and complex algorithms to generate better results and provide user controls. Figure 9.6 shows a ray emanating from a light source and illuminating a surface. Basic optics dictates that the angle of reflection of a light ray is equal to the angle of incidence. This angle is measured with respect to the surface normal at the point of incidence. The camera or the eye only sees objects as the light they reflect, transmit, or emit. Therefore, the camera or viewer must be located at an angle of reflection for the particular

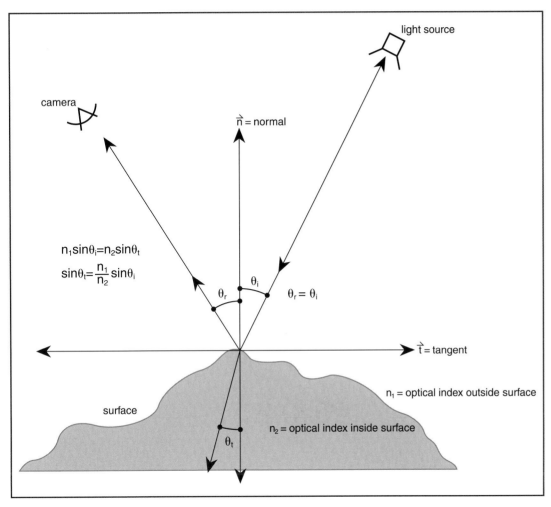

Figure 9.6
A diagram showing the incident light ray reflecting about the surface normal and transmitting at the refraction angle.

(less irregular), it becomes more reflective. Fewer rays are scattered about and they bounce more tightly together. This tight reflection of light is the specular reflection. The renderer's specular reflection function used in shaders has a roughness attribute that determines how broad the specular highlight appears. The greater the roughness value, the more the specular contribution looks like a diffuse contribution. The lower the roughness, the more the surface behaves as a mirror.

Light rays incident upon a transmissive or translucent surface or material are refracted (path is bent) through it. Snell's law ($n_1\sin\theta_1 = n_2\sin\theta_2$, where n_1 and n_2 are the indices of refraction for each medium, and θ_1, and θ_2 are the angles of incidence and transmission) applies to refraction. Besides refracting the light, a material usually attenuates it. A ray-tracing renderer can calculate the reflections, refractions, and shadows based on the actual rays, whereas a scan-line renderer must use rendering tricks.

Shaders

Shaders are computer programs that describe the physical behavior or appearance of an entity used in a render, such as a light, surface, volume, and so on. Some 3D packages have items called materials, which are actually shaders by a different name. The shaders must be written in the programming language understood by the renderer, and each renderer supports different sets of shaders with different capabilities and functions. Pixar's PhotoRealistic Renderman, a scan-line renderer, supports displacement shaders, light shaders, surface shaders, volume shaders, and image shaders. Mental Images' Mental Ray, a ray-tracing renderer, supports material shaders, volume shaders, light shaders, shadow shaders, environment shaders, photon shaders, photon emitter shaders, texture shaders, displacement shaders,

incoming rays. This means that the normal must point to the viewer's side of the surface. Diffuse surfaces scatter light in many directions due to their irregularity. This irregularity means the surface normals point in many directions providing a broad illumination of the surface. Because modeling or defining such surface detail is computationally expensive, a diffuse lighting approximation is used to provide this broad illumination for diffuse surfaces. As a surface becomes smoother

9. Computer Representations of Lights and Surfaces

geometry shaders, contour shaders, lens shaders, and output shaders. As an advanced ray tracer using scan-line and final gathering, Mental Ray organizes its features in a large assortment of shaders available to the user to control the render. Renderman's elegant time-tested rendering algorithm has only a few shader types to house all its features.

Whatever the shaders, they all work together in the rendering process. A displacement shader reshapes the object's surface before the surface shader begins its process of coloring it. To find the particular color of a point on an object, the surface shader must call the light shader to determine how much illumination there is. A volume or atmosphere shader might be called to find out whether the light is attenuated before hitting the object or entering the camera's view. In the next section, I discuss some of these shaders and how they work together to create an image.

Light Shaders

Light shaders describe how light is projected from a particular source. I have already spoken of ambient, diffuse, and specular lighting, but how are these represented in the language of shaders? An ambient light shader illuminates every point in the scene identically. Therefore, the output of an ambient light shader, to be supplied to the surface shader, need only be color and intensity values. A purely diffuse light shader considers the position of the light with respect to the object receiving its illumination. This direct illumination is uniform but may be occluded by other objects and attenuate over distance. A purely specular light shader uses the basic optics of reflection to calculate which illumination striking the object is reflected to the camera. A point light shader may combine ambient, diffuse, and specular lighting with control parameters for color, intensity, and attenuation. A basic spotlight shader may additionally provide controls previously mentioned for spotlights: color, intensity, attenuation, cone angle, cone falloff, and so on.

The lights in a 3D package are interfaces to light shaders containing basic and more advanced parameters such as the possible addition of cukaloris or filter. There are also usually methods for applying custom shaders to lights.

Shadows

A ray tracer automatically calculates shadows accurately because occlusions of one object by another are included in the illumination calculations. Ray tracing can result in realistic shadows and penumbra. A scan-line renderer must add shadows in a different way, because lights are unimpeded by objects in their paths. Shadow maps must be rendered from the point of view of each shadow casting light in the scene before the scene is rendered. A shadow map is a Z-depth render, which, when reapplied to the light, defines the point where the light's beam does not reach. In this way, illumination is prevented on certain surfaces, thereby creating shadows. The shadow map controls in a light shader offer many options for adjusting the look of the shadow including blur and anti-aliasing filters. Shadow maps are used as an input to a light shader. If the lights and objects in the scene do not move, then only a single shadow map needs to be calculated for each light. If there is animation, a shadow map must be rendered for each light for each frame of the shot. If the shadow is going to be soft (blurred), the shadow map image can be small to save disk space and render time. Sharper shadows require larger, more detailed shadow map renders.

Surface Shaders

A surface shader describes a surface's appearance. In photo-real rendering, the programming code is an attempt to simulate how certain materials react to light so that the rendered result is perceived to be composed of the desired substance. In non-photo-real renders, the goal is to create a material that is believable within the context of the scene. The shader can include the contribution of lights or make the surface self-illuminated. When called by the renderer, the surface shader calculates the color at a certain point on an object. This calculation is based upon the surface attributes defined for the point and the lights illuminating it. The surface attributes may be assigned to a certain point using the point's texture coordinates, local Cartesian coordinates, global Cartesian coordinates, and a number of other coordinate systems. If an object's color is affected by its position in space, for example, the global coordinates of each point on the object may be appropriate indices for applying colors and textures.

A shader typically has a control interface containing the various adjustable parameters. Common parameters are level of transparency and the percentages of ambient, diffuse, and specular illumination desired. Additionally, options may be available to provide simulated refractions or reflections. If a shader requires textures as inputs, a file browser is usually available in the interface to select the images. Variables and controls required for any adjustable procedural algorithms are also included.

Although shader writing is beyond the scope of this book, it can be stated here that the basic approach to shader writing is as follows. Use reference and observe how the desired substance reacts to light; separate the features into layers; and then program each of the aspects of the surface one layer at a time.

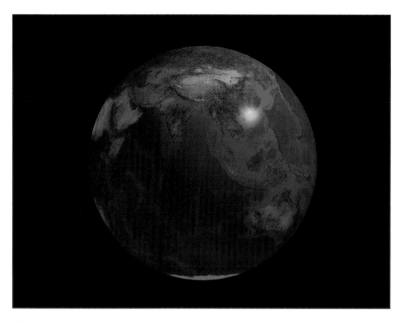

Figure 9.7
The texture map from Figure 9.2 on a sphere.

Painted and Procedural Textures

These layers of the shader often use texture maps to apply painted textures or photographs to the object being shaded. A soda can label can be photographed or painted and then simply applied to a cylinder with a surface shader. Of course, the cylinder must have texture coordinates that wrap around it for the label applied to the can's side and a different set of texture coordinates and shaders to apply the top and bottom textures. On the other hand, many shaders use procedural computer algorithms to simulate the look of a material. The example above mentioned an object that changes color as it moves through space. Assigning the position in space of the whole object or each point to the red, green, and blue channels accomplishes the task (the position values would have to be normalized since RGB color values are usually in the range of zero to one).

A simple example of procedural versus texture is a checkerboard tile floor. A picture of a section of floor could be photographed (see Figure 9.8) and, in the shader, copied and offset to cover the CG surface at the appropriate scale. If the camera dips down close to the floor, details such as scratches and stains should be

Figure 9.8
A texture map of a section of tile floor (top) and the texture map rendered to create a complete floor (bottom).

revealed. To do this with a texture, the photograph or painting must be of high enough resolution to capture such detail at a close distance. If, additionally, the camera travels along the floor for some distance, the repeated textures are noticed as the same stain appears over and over again.

In the procedural tile floor shader, a series of black and white tiles can be described with instructions to alternate coloring certain patches of the surface black or white. This base layer can be enhanced by a random scratch layer and random stain layer to avoid repetition (see Figure 9.9). Procedural textures often use noise functions to simulate the randomness of nature and the real world. Many types of noise functions and algorithms are available in shaders to produce random but also continuous and repeatable patterns. No matter how far the camera travels along the floor, the tile can be made to look slightly different or exactly the same, depending on parameters supplied to the shader.

Figure 9.9
A procedural tile floor shader including random scratches and staining.

Projection Maps

Projection maps are texture maps projected from a camera or a light. The 3D object inherits the colors projected upon it. Using projection maps avoids the necessity to apply texture coordinates to an object and then come up with a texture map to fit those coordinates. The appropriate texture coordinates are automatically applied to the geometry by the shader. These work best when applied to flat surfaces, because curves cause texture stretching that is apparent when not viewed from the projection camera or light. The top image of Figure 9.10 shows a sphere projection mapped from the viewing camera with the texture of Figure 9.2. The result looks like a circle cut out of the center of the texture map. The bottom image of Figure 9.10 shows the same projection mapped sphere viewed from the side. Notice that the texture is stretched on the side of the sphere and then repeats on the other side because the projection assigns texture coordinates all the way through the sphere.

Environment Maps

Environment maps are textures created to simulate the surroundings of CG elements. It could be a spherical, cylindrical, or cube map that surrounds the object. The spherical map textures a sphere; the cylindrical map textures a cylinder; and the cube map textures the six faces of a cube. By using the environment map to project onto the CG objects, reflections of the world are simulated. This is the scan-line renderer's main solution for simulating reflections, but ray-trace and other renderers provide environment mapping, as well. The environment mapping shader looks from the center of the object being shaded outward radially through the object to the environment map. The corresponding map color is returned for that point on the object and can be added as a reflection.

Reflections can also be simulated by simply projecting a texture onto a surface from the appropriate angle. The shader can access many texture maps and apply them many ways to produce an object's appearance. Reflections on flat surfaces, such as mirrors or floors, can be created by transforming the scene across the reflection plane in the shader. This creates the mirror image of the scene, which is then placed in the reflecting surface.

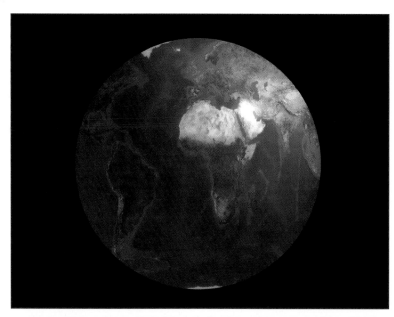

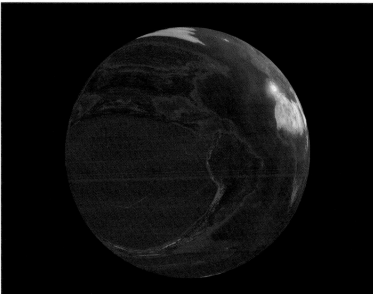

Bump Maps

Bump mapping, whether with a painted texture or procedural algorithm, is the manipulation of the surface normals in a surface shader to simulate the appearance of surface displacement. Now what does that mean? As mentioned above, the light incident on a surface is only visible to a viewer (the camera) if the surface normal faces the viewer. Additionally, specular reflections obey the reflection angle rule about the normal. This means that by adjusting the surface normals in the surface shader calculations, the surface can be made to look irregular without moving the points in the surface. Bump maps can be painted, photographed, or computer-generated images. Often, they are monochrome images to define the amount the normal is rotated in some direction (usually away from the camera). Using color (RGB) bump maps, the vector (X=R, Y=G, Z=B) can be used to set the normal. Bump mapping can also be completely procedural using noise functions and other algorithms to break up the surface. Remember, bump mapping varies only the color intensity on the object based on the normal and does not actually perturb the surface position. The object does not change shape, so don't expect a purely bump mapped sphere (no displacement) to cast irregular shadows. The top image of Figure 9.11 shows a texture mapped onto a sphere. This texture can be used as a bump map in a shader that has inputs for the Earth texture and a bump map texture. The bottom image of Figure 9.11 is fake bump mapping created by multiplying the rendered Earth of Figure 9.7 by the grayscale noise image at the top of Figure 9.11.

The real bump mapped Earth is in Figure 9.12. The top right portion of the sphere shows how the bump map breaks up the specular highlight with what appears to be undulations in the sphere. Notice the apparent shadowing in northern Asia. The lower middle of the sphere shows some render artifacts possible if care is not taken with the bump mapping shader. Due to the low resolution of the sphere and low sampling rate during render, the sphere is not bump mapped smoothly and areas receive the same bump value, causing the raised polygon look. Imagine a square area in which only one point is sampled. All the points in the area receive the same new normal calculated from the bump map. Therefore, they all respond to the illumination in the same way.

Figure 9.10
A projection mapped sphere viewed from the projection camera (top) and the same sphere viewed from the side (bottom).

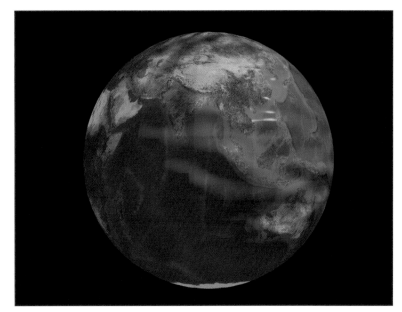

Figure 9.12
A bump mapped Earth showing render artifacts.

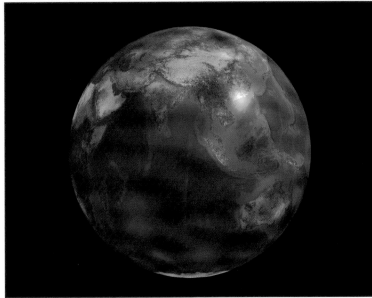

Figure 9.11
A bump map texture on the sphere (top) and its use on the Earth (bottom).

Displacement Shaders

Displacement shaders physically (in the computer) deform the object's surface in space. This deformation to the geometry occurs before the surface shader step in the render. Basic displacement shaders move the geometry along its surface normal. This is the case in Figure 9.13 where the texture from the top of Figure 9.11 is used as the displacement map. The intensity of a painted monochrome displacement map defines the distance the point is translated. Just as a bump map uses a color image to alter normals, an RGB image can be used to encode vectors for the normals before displacement of the surface. The surface can be displaced along those vectors, keeping the normals the same, or the normals can be perturbed and the displacement performed along that normal. In either of those cases, the resulting surface normals can be maintained or recalculated after displacement. The resulting surface normals after displacement shading are the ones sent to the surface shader for surface calculation. This is a little confusing, but it is important to consider when writing displacement shaders. Also important to understand is how this displacement is calculated in the renderer. Because a renderer works on a

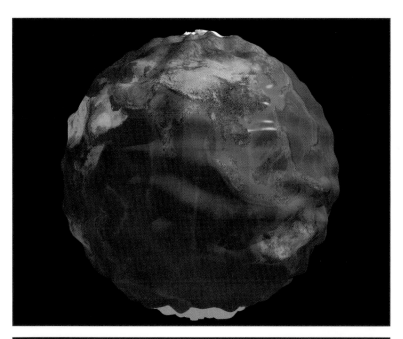

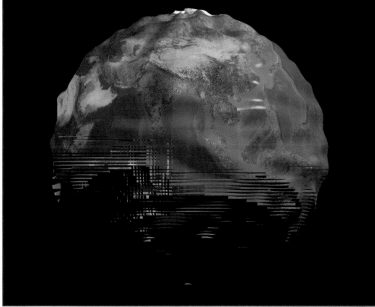

section at a time, it tries to allocate the resources it needs to efficiently process that section. A volume is chosen to bound all calculations with respect to the section. If displacement causes part or all of the geometry in that section to leave the bounding volume, the renderer won't know where those pieces are. The bottom image of Figure 9.13 shows this render error. The user needs to adjust the displacement bounds parameter to be just large enough to contain any displacement, but not so large as to make the renderer perform calculations on a volume of space containing nothing.

Volume Shaders

Volume shaders affect light as it passes through a medium such as smoke or haze. A basic atmosphere shader obscures objects as they move away from the camera by calculating an appropriate degradation as a function of position. A smoke or haze volume shader typically uses noise functions to simulate cloud-like semi-transparent viewing obstacles, as shown in Figure 9.14. In addition to obscuring objects, their interaction with light reveals the 3D procedural smoke texture.

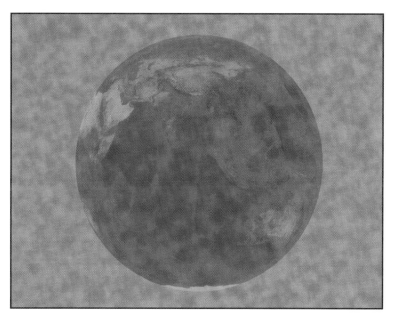

Figure 9.14
A volumetric cloud shader surrounding the texture-mapped Earth.

Figure 9.13
The same bump map used as a displacement map on the sphere (top) and errors caused by improper displacement bounds (bottom).

Those are the basic types of shaders most renderers support by one name or another. The other types of shaders mentioned earlier are simply additional programs to control more aspects of the render. For example, in Mental Ray, the photon shader controls the released photons for final gathering and the geometry shader actually creates or manipulates geometry. There is no need to go into more detail about them here because their purpose and details are particular to the renderer.

Understanding the basics behind rendering and shaders is important because they are a big part of the lighting process. This introduction should help when choosing techniques for a project. More shader techniques are discussed in Chapter 11, "Dead Give-Aways: Real World versus the CG World," but now let's step away from the technical discussions of computer graphics and hear from an important figure in visual effects history.

chapter 10
An Interview with Dennis Muren

A Brief Introduction

If you know about computer graphics special effects, then you know the name Dennis Muren. During his years with Industrial Light & Magic, he has played an integral role in some of the most influential and ground-breaking special effects films ever created. Dennis has worked on special-effects films from the very dawn of the digital age. His efforts have not only been recognized with outstanding box office support but also recognized by the Academy of Motion Pictures Arts and Sciences, with eight Oscars for Best Achievement in Visual Effects. The award-winning films (*Indiana Jones and the Temple of Doom*, *Inner Space*, *The Empire Strikes Back*, *The Abyss*, *E.T.: The Extra-Terrestrial*, *Terminator 2: Judgment Day*, *Return of the Jedi*, and *Jurassic Park*) represent a wide range of achievements in effects work. Dennis was the 2nd cameraman on the original *Star Wars* movie, became a director of photography after that, and then found his niche as a visual effects supervisor in 1981. He's been providing us with amazing visuals ever since, and he was kind enough to share with me some of his secrets to success in the world of computer graphics.

Dennis Muren drives home many of the points I've made in the previous chapters, and ties them in with specific film examples. It's no coincidence that his views are similar to mine, since I worked with him early in my lighting and compositing career and learned a great deal from him. In working with Dennis, I soon realized that he has a way of appealing to the child inside of us, who can look at the screen with the wonder and awe of seeing something for the very first time. Along with that ability, he is also able to appeal to an ever-increasing visual sophistication that the digital age has instilled in his audience. His creative energy and genuine excitement for the craft he has chosen continues to this day to be a driving force at Industrial Light & Magic.

Interview

DAVID: *You have a long history in the film industry. Could you tell me a little bit about how you got started in the computer graphics side of the industry?*

DENNIS: I've been doing the traditional work since I was a kid, so effects is just something that's in me. I was aware of the work that was going on in the late 1970s and very early 1980s. At ILM, we actually saw a test that had been done in 1980 … by Triple-I [Information International, Inc.], of a computer graphics X-Wing flying along. As we had just finished *Empire* and had a difficult time with doing motion control work, this was really enlightening to see what they could do as far as the motions of the spaceships. They weren't encumbered by any of the hardware [motion controlled cameras with physical models and mechanical processes for moving those cameras and models] problems. It didn't look photographically real, but it was pretty promising. When Pixar came in, they were developing tools for us, and I became interested since it showed incredible promise to be able to do work in a free way. It was much more liberating from the hardware. It was really exciting, so I jumped in that department when I could with projects, to see if the technology was actually useful. To that point, there hadn't been anything done that was photographically real. I wasn't actually interested in computer graphics, since I've always concentrated on just the end result. The end result had never been real, but I always wondered, "Could I make it real by just specifying what was wrong with it?" That was it, and that's where the opportunities were. After Pixar was

> When Pixar came in, they were developing tools for us and I became interested since it showed incredible promise to be able to do work in a free way.

> The end result had never been real, but I always wondered, "Could I make it real by just specifying what was wrong with it?" That was it, and that's where the opportunities were.

sold [Pixar was spun off from ILM in 1986, when they were purchased by Steve Jobs, co-founder of Apple Computer, Inc.], we really had a chance to fly on our own, because we had our own agenda. At that time, it was a big step forward. That's when we did *The Abyss* and *T2*.

DAVID: *What were some of the challenges when you made that transition over from the live-action world to the CG world?*

DENNIS: From my point of view, being a traditional effects person, I had a really clear idea of what looked real and what looked fake; but I had to know how you can manipulate the tools around to get the stuff to look real, because that's what I was accustomed to doing traditionally. It was really hard in the beginning when we were doing *Young Sherlock Holmes* in 1985. It took us six months to do seven shots because it was very slow to animate, render, and determine the final look. It was very similar to what I'd been doing before, but very, very slow. You're given incredible tools, but with certain restrictions. It's as if you're a cameraman, and they deliver to you all the lights, the models, the camera, and the stage, but then you only have one arm and one leg to do the shot. It was so hard to do anything, but the results were just great. When *The Abyss* came along, there was a great opportunity since we could actually budget that show. We did 16 shots and we were able to stick to the schedule. We also completed it for the budgeted amount of money, which was a breakthrough. To accomplish this, we required our output scanner to be predictable. We previously didn't have ways to reliably input or output the work [transfer the original film footage digitally into the computer, and then back out onto film], so we needed that capability to do these shows. Both *Sherlock*

> It was really hard in the beginning when we were doing *Young Sherlock Holmes* in 1985. It took us six months to do seven shots because it was very slow to animate, render, and determine the final look.

> Both *Sherlock* and *The Abyss* required consistent scanning techniques. Both films had transparent characters, so we had to be able to input the background to make it work.

and *The Abyss* required consistent scanning techniques. Both films had transparent characters, so we had to be able to input the background to make it work. That was one of the things I kept pushing for—reliably inputting and outputting the digital work, because this was important to the ultimate shot looking good. To me, it was not just the CG, but the compositing that was equally important.

I think the test that deGraf/Wahrmann had done for *The Abyss* was pretty good. They did it differently, with an approach that was in some ways simpler than the path we ultimately took. I think the technology was there. When we heard that Jim Cameron was coming up to ILM, we did a really quick, overnight test. We wanted to show him a look, at least with a plastic character, of how a water snake would look rippling and moving along through space. Jim saw our test and realized how much we wanted to do the show. We had done a lot of work, and we did really want to do it. John Knoll supervised most of the work and it went through smoothly. It was really hard and things seemed like they should be easier than they were. I took a year off at that point and bought that big Foley and van Dam computer graphics book [*Computer Graphics: Principles and Practice* by Foley, van Dam, Feiner, and Hughes]. For one year, I read an hour a day. I learned it without all of the entrapment of being at ILM. The way to do it was learn it myself from the bottom up, and that's what I did during that period.

> When we heard that Jim Cameron was coming up to ILM, we did a really quick, overnight test. We wanted to show him a look, at least with a plastic character, of how a water snake would look rippling and moving along through space.

DAVID: *That's a great way to learn the technology. I had no idea that you'd gone about it that way.*

DENNIS: I understood how it worked, but the tools were not anything that I was comfortable with. This time away gave me an understanding of the difference between specular and diffuse [lighting], how you put those together, and the vocabulary of it all. I could see all of those independent things in my mind's eye and how they could look together. John Knoll gave me an alpha copy of Photoshop. I got a Mac and began looking at the idea of doing digital compositing with Photoshop and realized we could do it. We got some clips, John set me up with a macro, and we could push one button and do a bluescreen composite. We could stand back and

10. An Interview with Dennis Muren

look at the screen doing it all by itself, and it was flawless. It was one of the most shocking things I'd ever seen after so many years of struggling with traditional optical methods. We had a flawless composite on a machine that you could buy as a consumer product. It was revolutionary. I started bringing my tests in to ILM during my year off and I set up a secondary compositing system to get the supervisors and everybody comfortable with the technology. One of the hurdles was just getting used to looking at a monitor. That was so foreign to many of us. We had to realize the monitor is not going to be the final quality, or the final image, but more of a way to keep it in your mind's eye. We experimented with it on *Rocketeer* and a bunch of shows we were doing around that time. There was *The Invisible Man* and then along came *T2*, in which we could put everything together. All of the CG stuff that the guys had been doing was great, and we had just put the digital compositing into place. I remember finding the output scanner. We had an input device that ILM had been working on with Kodak, and it worked pretty well. They could never figure out what the specifications should be for the file sizes, but at least it worked. They didn't really have an output device, so I tracked down a management graphic business slide film recorder that people said would never work. They said you could use it with business slides and bar charts, but you could never film out a photographic image on this equipment. You know, I tried it, and it worked. We bought two of those, and now we had our output device, the input device, and the people to do everything, so we did all of *T2* digital. That was it, and it was the most exciting thing I've ever done and probably ever will do.

> **We had a flawless composite on a machine that you could buy as a consumer product. It was revolutionary.**

> **They said you could use it with business slides and bar charts, but you could never film out a photographic image on this equipment. You know, I tried it and it worked.**

DAVID: *One of the most valuable things that I know I learned from you was how to choose what to focus on when working on a shot. Could you tell me a little bit about how you look at a shot and determine what's important?*

DENNIS: The first thing you need to do is to not think that the shot you're working on is going to be in isolation. It's one of 2,000 shots for a movie. A shot is there to tell a story, and the question is, what's the story that needs to be told for that two seconds or five seconds or ten seconds? That's all there is to it, and it's really that simple. There are a lot of elements in any one shot. There is a character, or maybe two or three, a background, some action, and some dialogue. But what's important about the shot? It's necessary to be able to distance yourself mentally from the shot and see it as though you've never seen it before. And I just do that. I can turn on this little switch, as though I'm seeing something for the first time, but I know what the intent of the shot is. If I don't see it, then I have to figure out what the problem is. It may be that the camera is in the wrong position, it needs to focus on a different part of the scene, or the shot is just too complicated. The lighting plays a big role, since it can be lit in such a way that it can pull your eye to where you want to tell the story. Filmmakers do this all the time, but the audience doesn't realize it. People don't talk about it, but that's really what we're doing when we set up a shot. When a DP is lighting a scene, he's lighting it so that the audience knows where to look. Also, something I've always used, because our cuts here are so short, is a little formula. The audience should be able to see what the shot is within a half a second. Too many things on the screen can easily confuse the audience, so if we can follow that formula, then we're way ahead. That comes with the composition, lens choice, where the character's facing, how he's posed, and the lighting.

> **A shot is there to tell a story, and the question is, what's the story that needs to be told for that two seconds or five seconds or ten seconds?**

> **The audience should be able to see what the shot is within a half a second. Too many things on the screen can easily confuse the audience, so if we can follow that formula, then we're way ahead.**

DAVID: *What advice would you give a lighting artist on how to make a shot look right in these different scenarios: bright sunlight, underwater, and a lightning storm?*

DENNIS: With bright sunlight it is best to first start by walking outside and looking at what's going on in the real world. Not just reading about it, but actually looking and figuring it out. Our light source, the sun, is very, very small and very, very far away. There's not much light falloff going on since the sun is 93 million miles away. The other side has to be lit by some sort of ambient skylight or bounce light off of something nearby. This ambient light has either no shadows or very faint shadows on the fill side. Your key light, which is very strong, and maybe 5 stops underneath that (a stop is half the light) is how bright the fill side is. The color of that space also plays a role in determining what the ambient light sources contribute. In combining the CG with the background, your lighting must be from roughly the same point of view as in the background plate. If the shadow needs to follow the contour of something the character's walking by or the ship is flying over, that needs to be there, too. The shadow also needs to have all the same characteristics as the fill side of the character. It has color that's based on the environment, but without the sun. It is important to be attentive to those things. I spend a lot of time just looking outside at how the world acts and works. This is one of the important things that I've done. There are books on the subject, but it sure doesn't hurt to go out and look at the world. Also look at paintings. Impressionistic paintings are really good because of the methods used for studying light.

> **When looking at those paintings, you can see what you can get away with and still have shots look good or even better than if you did it technically correct.**

When looking at those paintings, you can see what you can get away with and still have shots look good or even better than if you did it technically correct. First you've got be able to get it to look real. If it's appropriate, you can cheat it to look better than real and pull your attention to the character. In *Jurassic*, in that first shot of the Apatosaurus when it walks up to the tree and starts eating the leaves, we cheated the backlight on it (see Figure 10.1). The plate is shot very top lit, which means that the whole top of the dinosaur would have been lit up all the way down his shoulders and his underbelly would have been dark. When we did that, it just didn't look very good. I knew since most of the other stuff was so small in the frame, we could cheat the light back and give it more of an edge light. That edge light made it stand out and look much better. These sorts of cheats are okay as long as the audience doesn't know what's going on or see it as fake. It's good to try those things, but you have to know when you can get away with it.

DENNIS: For underwater lighting, a good example is the underwater sequence in *Episode I*. We didn't want the underwater scenes to look like they were in outer space. One of the ways to prevent this is to make sure things are kind of hazy. It's important to have sort of a fog effect so that things fade off into the murky distance. The trick is how much murk, because you've still got a story to tell. It is important to balance it so you can at least see the setting, but not have it look like outer space or crystal clear air. Another way to do it, as well as having the murk, so it doesn't look like it's in fog, is to add little particulates floating around like little bits of debris in water currents. It's nice if that stuff actually has a current to it, with direction. It's not just floating, but it's moving, so you get a concept of a large ocean current moving it. It makes everything look a lot more realistic. In addition, you can put little caustic type rippling effects if you're not too deep in the water.

> **Something as simple as just adding a roll to the camera can make a big difference.**

This helps remind you that you're in the water since you see the water ripples on everything. Another thing you can do is have your camera be like a hand-held type camera. Include a little panning and tilting, because most of the underwater footage we see, probably 99% of it, is shot handheld. This means you've got a little panning and tilting going on, but you also have camera roll happening all the time. By introducing those three things into it, you will help tremendously in giving the audience the feeling that they're seeing something that's shot underwater. Something as simple as just adding a roll to the camera can make a big difference.

If you're doing something that's at nighttime and dark, then you need to establish some sort of light to start out with. It may be the moonlight coming through clouds, because with a storm, it's probably very cloudy. It's always nice in nighttime scenes to edge light something with a rim light, so you can identify

> **It's always nice in nighttime scenes to edge light something with a rim light, so you can identify the edges of the subject.**

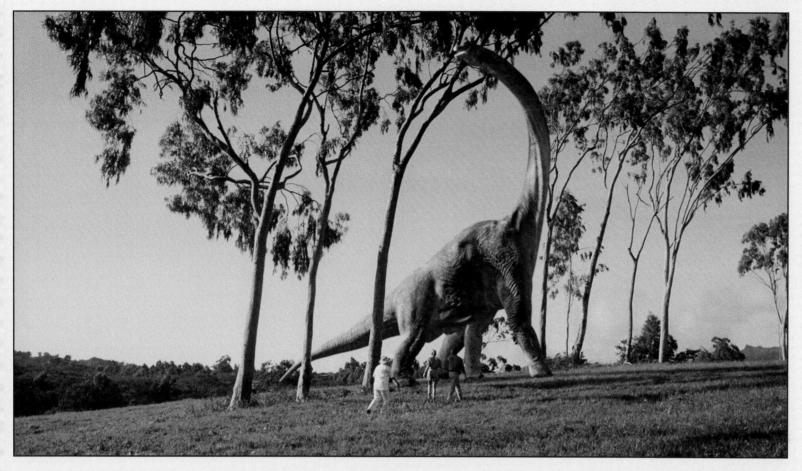

Figure 10.1
A dinosaur with light coming from behind to better identify its outline in the 1993 film *Jurassic Park*. Copyright © 2002 by Universal Studios. Courtesy of Universal Studios Publishing Rights, a Division of Universal Studios Licensing, Inc. All rights reserved.

the edges of the subject. The front of it can be pretty dark and pretty mysterious. Some of the shots with the T-Rex breaking through the gate and roaring in *Jurassic* are good examples. There are mainly two things going on in those shots. One thing is there's a little edge light on it, with the front side being really dark and mysterious.

The second thing is there are a couple of eye lights in there to get his eyes to show up. These are only lighting up the

The audience isn't even aware that they are seeing a light, but their eyes are drawn to the danger, which is the teeth and the jaws.

eyes and not the rest of the model. When the dinosaur roared, we put a little light in its mouth (see Figure 10.2). It was a very weak light. The audience isn't even aware that they are seeing a light, but their eyes are drawn to the danger, which is the teeth and the jaws. That's what you want to emphasize. There's a weak little light source in there all the way through *Lost World* to make those nighttime scenes look really scary.

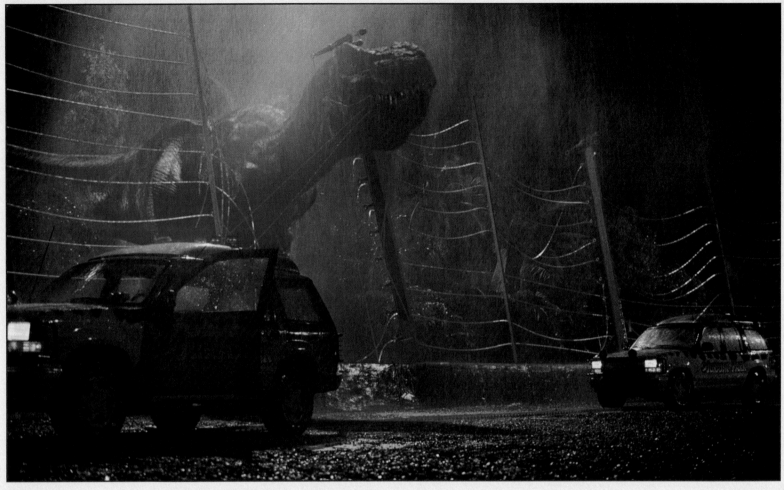

Figure 10.2
Eye lights used in the 1993 film *Jurassic Park*. Copyright © 2002 by Universal Studios. Courtesy of Universal Studios Publishing Rights, a Division of Universal Studios Licensing, Inc. All rights reserved.

DENNIS: The eye lights were used in both *Jurassic Park* and *Lost World*, but the mouth lights didn't come along until *Lost World*. The lighting scheme that Janusz [Kaminski, cinematographer on *The Lost World*] set up on *Lost World* was more radical, and it offered more opportunities. The eye and mouth lights are a really good trick. Again, you don't want the audience to think about it, and if you light it dimly enough, they will see it and not to be conscious of it.

When you've got something that's kind of sketchy, you can add in the lightning flashes. They can be used sparingly but appropriately to highlight the drama of the scene. They will also fill in the side of the character that is normally dark in the shot. The part of the subject facing the camera could be dark with a little edge light, but then when the lightning hits you see all the muscles and detail. You really get a good chance to see the face, claws, and everything like that. And then it's gone in a third of second, and you can use that as a great dramatic tool. What I

like to do is keep shots sketchy so that by the end of it, you want to see more. It's what I call playing peek-a-boo with the cameras. As a shot goes on, you can actually direct the audience's eye from one point of the frame to another point, to another point, and so on. You can do that with lighting, performance, camera moves, or anything. With lightning, you can do it in an even more obvious way and it can be really, really effective. By picking the place that you put the light for the lightning flashes and deciding how many there are, you can get the details of the creature's flexing muscles to show up and look really frightening.

DAVID: *What kinds of details do you look for in the way light interacts with surfaces of CG creatures and objects that tells you if it's working well or not?*

DENNIS: I try to have a reference. I always have a reference that's made, an actual object, because otherwise your mind will trick you. The more you work on anything, the more your mind will tell you it's looking better. This can be a big mistake, because the audience only sees it once. You have to remember what the thing really looks like that you're trying to do. For *The Abyss*, we sculpted a pseudo pod character, cast it in clear resin, and had it there all the time. We knew what a clear object would look like and how it refracted light. We had a real object for studying the highlights along with every other detail. We did that for *Jurassic*, as well. We made the dinosaur models, and the TDs would have them on their desk. We also had film of them that we shot out on the set. We're always referencing back to what is real, and not what you think two weeks into a shot is real. You'll really be fooled if you do that, as you fall in love with your own work, even though it's wrong. There are a million things to look at, but if you start with reality and can make a little set of it somehow, like with a maquette or reference photos, then your questions answer themselves. That way you know for sure if the glints are too bright or too wide, or if you can see too many shadows, or if the fill side is not lighting up correctly. One problem is if the skin of the animal makes it look like plastic or rubber. It may not look like CG, but it looks like a fake object instead of a creature. We

> **What I like to do is keep shots sketchy so that by the end of it, you want to see more.**

> **I always have a reference that's made, an actual object, because otherwise your mind will trick you.**

> **There are a million things to look at, but if you start with reality and can make a little set of it somehow, like with a maquette or reference photos, then your questions answers themselves.**

> **Once you know the reality of the world, how light reacts to an object, how objects light each other, and how camera angles accentuate, then you can help your single shot fit into a whole film.**

had to figure out what real dinosaur skin looked like. We went to a local zoo and shot lots of footage of elephants and had all our guys go up and touch elephants so they could see just how much sheen was on it, how dusty they were, and how much detail was on it also (see Figure 10.3). This is what you need to do. Don't trust your memory. It's one of the most important things.

DAVID: *So if you're looking at something and it does look rubbery, how do you encourage and motivate the artist, while still telling them their work does not look good?*

DENNIS: Everybody wants to do good work. Hopefully what's going on is that they think they've got it, but they don't quite have it yet and they're not going to give up. What I'll try to do is just sort of prove it to them. The way to prove it to them, if you can, is to have the reference, or to shoot a reference, or take them and show them something in person. We walk out in the light so they can see what's going on. A lot of the artists really want to do it right, but they just have never had to dig this deep into their own mind to figure it out. Often when they get there, they're going to look and say, "Okay, now I know what's going on." Before, they would see it much simpler than it really is, but now they understand how to do it the next time they're starting at that point. After doing that for a few years, they've got this great tool chest and can start getting artistic with it. Once you know the reality of the world, how light reacts to an object, how objects light each other, and how camera angles accentuate, then you can help your single shot fit into a whole film. Once you know all of that and you're comfortable with doing it, then you can start really creating something in a different way. You're creating another level in the detail of the scene.

10. An Interview with Dennis Muren

Figure 10.3
Dinosaurs benefiting from elephant skin reference, in the 1997 film *Jurassic Park: The Lost World*. Copyright © 2002 by Universal Studios. Courtesy of Universal Studios Publishing Rights, a Division of Universal Studios Licensing, Inc. All rights reserved.

DAVID: *So when you're getting elements, or when a TD is generating elements you've requested, do you rely heavily on 2D techniques to make those things better? Or do you prefer that the elements are lit and rendered as they will be in the final shot?*

DENNIS: It can kind of go either way. I think it's sort of based on what the shot is. The comping tools are so great and the people are so good doing comping nowadays that you can almost shoot in any lighting and cheat it in the comp to get it right. I still try to shoot real elements as much as possible if we can get them to look good. Rain is a good example, since you can shoot that so easily. We've got a good library of real rain, but other things, like

> **The important thing in the shot is that the plane's crashing, not that it's smoking out the back. You don't want spend half your budget making the smoke.**

complex contrails behind crashing airplanes, you can never really shoot correctly. Those need to be CG. I'd say that if you're in strong sunlight or if there's a really dominant light source, then you need to customize it to the shot. If it's a more general thing, though, you can be a lot sloppier with it to comp it in. That's pretty much a judgment call as to what you can get away with. It'd be nice to do everything custom, but it's probably going to be too expensive. A lot of the things that we're talking about are actually very insignificant to the shot. The important thing in the shot is that the plane's crashing, not that it's smoking out the back. You don't want to spend half your budget making the smoke. If there's some way that you can do that cheaper,

even if it's not quite correct but still looks real, then you sort of owe it to all of the other shots to not get bogged down on that one little detail in the shot.

DAVID: *So when you work on a film, how do you go about identifying your audience? Is it other people in the CG industry, you personally, your children? Who are you trying to please with these shots?*

DENNIS: I'm primarily trying to please myself, but still maintaining an idea of who the audience is. It certainly isn't the CG world. It's the director and myself. I know a lot of audiences respond the same way I do to things, which is lucky for me. If they didn't, then I'd be making art films somewhere and nobody would be seeing them. There's nothing wrong with that, but that would be the reality of it. Because I've got some common vision with the public, as do a lot of the directors I work with, I'm able to share it with a greater number of people.

> **I know a lot of audiences respond the same way I do to things, which is lucky for me.**

DAVID: *When we worked together you were always able to provide very clear verbal descriptions of what you were after visually. Do you think that ability to communicate comes from your traditional experience, or is it something you've developed more on the CG side, or is it natural for you?*

DENNIS: It certainly isn't natural. I never used to be able to do that. I directed a film when I was in college, and in talking with the actors I had to learn that. You make a choice at some point on whether you want to work for somebody else or you want to be the boss. If you're going to be a boss, you have to talk to people, and you have to learn how to do that well. Everyone offers guidance differently. I like to try to bring solutions to a dialogue, and I know some people don't. They will say here's what the problem is, you figure it out. That's another way of working, and it may be easier actually on the TDs than the way I do it. I still wish I was directly involved in doing the shots. I feel like I can be making a contribution when I see some of things that sometimes the TDs can't see, and lead them in the right direction. Maybe the problem is that the key light is slightly off to one side, and the fill light needs to be a little more orange. Whatever it is, they just can't quite see it and I try to help them with that. Also, I'm the one at that moment they need to please, so they've got to work to make me happy, so that hopefully I can make the director happy. You've got to be working for somebody, and it's going to go faster if you can talk to them directly. The TDs and everybody else are part of a team. Within the team, the individuals are all trying really, really hard to make things look right. They all want to learn and do a good job, so people are open to suggestions. When things get hard is when they can't quite see it, or the director's changing his mind all the time, or I'm changing my mind because something's not working. That's where it gets difficult. And then everyone has to have patience just to get through it. That goes all through filmmaking. That happens on live-action sets all the time. There are always situations where the director's uncertain and you have to go back and do something again, or the actor didn't like something and you have to do it again. That's just part of working as a team, and that goes on with anything creative.

> **Everyone offers guidance differently. I like to try to bring solutions to a dialogue.**

DAVID: *After all you've done, all of the amazing work and academy awards, is it still fun for you?*

DENNIS: Yes! It is still fun. You know, I do think we need another big shot in the arm. I'm not sure what that's going to be, but I like the idea of 3D Imax films, if they can get those looking really great. That's the thing I've seen that has just really knocked me out. The moments when those 3D Imax films have worked are like you're living the experience. Most of the time they don't work, but there'll be moments in the film where it's like you're there and you're doing it. It's just phenomenal. I'd like to find something else like that, but I haven't seen a big breakthrough coming up in the CG world. We've got the same sort of tools and we're just making them better and faster. We're going to be trying a digital human soon, but it's all still kind of the same thing. I'm still enjoying it, though, and there are still new challenges. I love spectacle. As long as there are spectacle movies where I can see things I can't see in the real world, I'll be doing them. I'll be working on them and enjoying them.

> **I love spectacle. As long as there are spectacle movies, where I can see things I can't see in the real world, I'll be doing them.**

chapter 11
Dead Give-Aways: Real World versus the CG World

Lighting a computer graphics scene is a simple process. Press a button to create a light and then aim the light at the CG elements to bathe the scene in illumination. If it's too dark, increase the brightness or add a couple of extra lights from different directions. Heck, if that still doesn't make it bright enough, the 3D software people have come up with ambient lights, which light the whole scene without the trouble of aiming the light. It's simple, right? The difficulty lies in imparting the real-world subtleties of lighting upon the CG world. Following the steps outlined above produces a bright, shiny, and unrealistic scene. All the work on the models, the shaders, and the textures can quickly be nullified with a poorly conceived lighting approach. Mathematics and physics provide rules for how a light reflects off a surface, but no such rules exist for how to bring life to a computer graphics scene through lighting.

You can approach lighting a shot many ways, and how to begin can seem an overwhelming decision. The basic three-light setup of the key, fill, and rim lights offers a good starting point, but even given that paradigm, the number of options quickly multiplies. Each light has a number of controls affecting the look of the image as well as the time it takes to render. The lighting artist constantly walks the line between efficiency and image quality when adjusting the lighting and rendering options. The computer does a great deal of the work, but the price in terms of time and computer power is sometimes prohibitive. There are many tricks and shortcuts for simulating computationally expensive processes, and this chapter explores various techniques available to the TD.

Choosing a Technique

There are as many different ways to light a computer graphics scene as there are lights on a movie set. I have known TDs who light exclusively with spotlights, those who rarely use more than 5 lights in any scene, some who use 30 lights no matter how simple the background, and others who rely heavily on computationally expensive processes. In a professional production environment, many of these choices are made before the shot is ever scanned. Each studio has specific software solutions, some proprietary and others "off the shelf," and a pipeline in place for lighting a scene. While it is possible to implement new approaches in a studio, it is difficult to change the general approach used for lighting a scene. With personal projects there is more freedom, but the price of software and hardware can be prohibitive. Each situation requires careful evaluation of the requested effects, the research requirements, the software and hardware required, and the necessary talent. As you might expect, the mighty dollar plays a large role, and every stage is evaluated in terms of the overall budget for the project.

Large Studios

The choice of technique for lighting a shot is in large part dependent upon whether the production is handled by a small group or a large studio. Small groups or individuals generally have more freedom to explore creative options, but less money to spend on them. Large studios have more money, but are often restricted by established pipelines and lengthy testing phases for the implementation of new techniques. New techniques for achieving more realistic or stylized images are frequently discussed, but there must be a good reason (along with

sufficient budget) to use them on a production. If the techniques require the purchase of software, that costs money. It also takes time and money for a studio's programmers to write software and to integrate it into the lighting pipeline. If the technique is computationally expensive and requires a large amount of memory, disk space, and/or render time, this can affect every production in the facility. This either calls for the purchase of more machines and disk space or a delay in the output of images. These factors often outweigh the fact that a new technique will produce better imagery. If new techniques are promising, they are often tested on smaller projects, independent of the main pipeline for a studio. If the tests prove successful, the new technique can begin the process of integration with the studio's main production pipeline. The competition is also a consideration, because another studio using a new technique to create higher quality images in less time always gets the attention of those in charge of the budget. At some point, regardless of the difficulties in implementation, most developments in computer graphics become affordable and are added to the studio's arsenal.

Small Studios or Individuals

For an individual or a small group, the options for how to light and render elements must go through a similar process. The initial evaluation investigates whether the technique really provides the desired look for the entire project. Every computer graphics artist wants his work to look as good as possible, but it still comes down to ability, time, and money. The individual must have the knowledge and experience to use the technique properly or write software to create it in the first place. This is where a large studio, with a large talent base, may have an advantage. An individual or a smaller group, because of time and talent constraints, may be relegated to using software written by third-party vendors. Also, the specific needs of a production may require enhancements to existing software for achieving the desired results. If a small group does not have the technical ability to write the computer code for those enhancements, the cost of hiring a skilled and experienced programmer can take funding away from other areas of the project. Money plays a role in the talent as well as the computing power for generating the images. If more money and time are spent on a programmer developing specific techniques, less time remains in which to output the images. This requires more money still, for computers with sufficient memory, disk space, and processor speed to allow the production to keep on schedule. Each decision affects the other, and a small group on a tight budget must evaluate a number of techniques and the effect they will have on the production schedule.

Efficiency

The lighting workflow can be optimized within any system, regardless of the techniques chosen. Prioritization is the first step because every shot tends to have more tasks and details than accounted for in the production schedule. Each shot is a set of visual layers and each layer needs to be prioritized. In terms of lighting, this means breaking down the contributions and deciding how much time can be spent on each. One possibility is to render each light separately, and control their relative levels in the compositing stage. Another approach is to separate the computer graphics elements into components, such as fill, bounce, and specular, which can also be combined in the composite stage. The choice is up to the artists' personal preferences, but each requires starting simple and building on a base.

Simple Tests

In the early lighting stages, many simple tests are more valuable than a single complex test. With the minimum number of lights to provide a general idea of the lighting scheme, many tests can be done on variations of the light positions, intensities, and colors. If the subject of the scene is an extremely complex CG model, the initial testing phase should be done on a simplified version (a proxy model) or stand-in object such as a deformed sphere. The size of these renders also plays a large role in the speed, because a render of one-half the resolution in pixels takes about one-quarter the time to render (not including render overhead such as file access times). Other factors in the speed are the render quality and optimization controls such as the number of samples or the shading rate. Samples refer to the number of samples used in anti-aliasing. More samples usually produce better quality, but other factors can affect this. The shading rate defines how fine an area is sampled to select the color for a pixel; a smaller sampling area produces better quality and a longer render time (see the "Rendering" section in Chapter 9, "Computer Representations of Lights and Surfaces").

Shifting to High Resolution

After the basics are established, it is time to move on to the high-resolution model and incorporate the lighting details. To judge the CG elements properly, the shading quality options need to be set close to their final values. The resolution also needs to be set to a reasonable size, because many of the details to be fine-tuned are not evident at lower resolutions. Once all the settings are established for a high-resolution image, the render time per frame of the tests is much longer. As stated earlier, doubling the pixel resolution quadruples the render time, and increasing any quality option parameters lengthens the render further. This makes it difficult and impractical to render an entire image each time a light is tweaked.

A good practice is to render the entire image as a base starting point, and save a copy of that image to disk. Then focus on a particular, representative area of the CG element and do test renders of only a very small portion of the entire image. Different software packages have different names for this render option—and in Maya it is called a render region. An area can be selected simply by dragging a rectangle with the mouse, and then only the area defined by that rectangle is rendered. This saves a tremendous amount of time, but be wary of spending too much time making changes with a small area of the image as your visual feedback. Lighting adjustments can cause unforeseen or unwanted results in other areas of the frame, so be sure to occasionally test the entire frame to ensure the desired look for the image.

Shadow Time-Savers

Shadows are discussed in more detail later in this chapter, but it is necessary to introduce a time-saving device with regards to shadow maps. The creation of depth map shadows can take a tremendous amount of rendering time. For each frame of a shot, the scene must be rendered once from the view of each light utilizing depth map shadows. Larger depth maps yield sharper resolution in the shadow but take more time to render. Start off with small maps, probably 512 pixels square, and see how the image looks. Most likely the shadow buffer (another term for shadow depth map) size will need to be increased, but the goal is to use the smallest size you can get away with. Depending on the renderer, low-resolution shadow maps may produce a desirable, soft shadow, or an undesirable, jagged shadow. Experimentation is important to understanding and optimizing this process.

Another time-saving method for use with depth map shadows is rendering the shadow buffers once, and then reusing them over and over again. Most software packages offer the option to save the shadow buffers and use them over again the next time the image is rendered. With the shadow buffers created ahead of time, the render process is sped up considerably. Only use this technique if the lights are in their final position, because moving the lights means new shadow maps must be rendered. Also, if the shadow buffers are rendered and saved to disk before the final render is completed, image manipulation can be performed on those frames. An additional shadow can be added, for example. This brings up a good point on efficiency when dealing with rendered sequences of frames. With an adjustment like the one just mentioned, in which a sequence of frames needs to be adjusted and overwritten, it is good practice to make a copy of the original sequence first.

Saving Versions

On the subject of saving frames, it is useful to save as many frames as possible during the progression of lighting a shot. Systems administrators and producers will hate me for saying this, but save as many images online as you can get away with. Images take up a great deal of disk space, but they are both the end result and the only true documentation of the incremental steps along the way. Supervisors and directors frequently ask to see previous versions, and sifting back through videotapes of the shot's history may not provide the necessary information. Images saved online also offer the opportunity to compare earlier and newer images side by side on the monitor. This can offer the lighting artist a great indication of progress, and can frequently help him spot areas that may have gotten worse instead of better. In addition to images, save as many versions of the lighting files as possible, with careful notes identifying the changes to each file. It is important to have a direct reference between images and lighting files, so make sure also that the file names for the images clearly link them with the lighting file which produced them. Any shot shown in dailies or to a supervisor should be kept track of because many times a director or supervisor asks to go back to something from several days or even several weeks ago. With careful notes and versioning, reproducing earlier lighting takes is a simple task.

IBL Basics

Global illumination is a term to describe light originating from every reflective and transmissive surface in a scene as well as light sources. As a technique, its most common implementations are radiosity and a variety of image-based lighting (IBL) techniques. Image-based lighting uses imagery in some way to illuminate the scene. In the past several years, much research has gone into implementing many IBL techniques to produce spectacular images. Many of these also incorporate very complex computer vision or image-based rendering techniques. The term global illumination is thrown around by a number of artists, supervisors, and directors, but it is often actually describing a shortcut or a fake of true global illumination.

Multiple Lights

One basic IBL technique involves creating lights colored and positioned by the scene in the image. Suppose we have an image of a day at the park in which a CG character is to be placed. The background image is sampled and lights of the sampled color and intensity are placed in their apparent position (see Figure 11.1). It could be assumed that the park is similar on the right, left, and behind the character, and the lights can be copied to each side. Additionally, only the brightest lights may be allowed to produce a specular reflection. Higher sampling creates more

Figure 11.1
IBL technique creating, coloring, and positioning lights according to the background image.

Figure 11.2
IBL technique using the background image as an environment map.

lights and more accurate results, but more lights are typically computationally expensive. This technique has been used to create automated lighting for entire sequences of shots. Once set up, a lighting TD need not touch another shot if all goes well. A 360-degree photo of the environment would generate a more accurate set of lights. This could be created from many stills tiled together to capture a panorama (which appears later in this chapter) or just a couple of fisheye lens shots.

Environment Map

Why do we even need lights at all? Another IBL technique simply uses the image like an environment map and multiplies the CG object's diffuse color by the corresponding color in the environment map. This technique uses no lights at all, so it can render very quickly. The shortcomings of this technique are that specular highlights are missing, and the object looks like the environment was shrink-wrapped onto it (see Figure 11.2). The lighting all comes from the same distance away and each piece of the environment map strikes an equal area on the object. To make this technique more useful (or useful at all), lights are added for bright locations of the image, and the image is filtered before it is used as an environment map (see Figure 11.3). Suddenly this technique is more efficient than the first one mentioned, and it can provide almost the same quality and automation capability.

Figure 11.3
IBL technique using a filtered background image as an environment map.

Of course, there are still many more tricks to getting these techniques to produce beautiful images, but that discussion can and has filled volumes.

If you do not have the ability to implement an IBL or radiosity technique, there are a few ways to simulate their qualities. Appropriately colored and positioned bounce lights mimic reflective illumination. It is essentially an implementation of the above technique, by hand with only a select set of samples and lights. Using a texture map that already has the environment's lighting built in is also a very common way to simulate global illumination. Unless camera and character motion is limited, however, this "cheat" is easily noticed.

Shadows in Lights

In the real world, there is no such animal as a light that does not cast a shadow. In the CG world, however, shadows are optional. This level of control is beneficial for optimization and saving render time, but it is horrible for creating believable imagery. Computer graphics lights also enable the lighter to choose from a variety of shadow methods, including ray-traced shadows, depth map shadows, and shadows rendered as separate passes. Chapter 6 illustrates some of the problems with using non-shadowed lights (shown specifically in Figures 6.6 and 6.7), one being that light passes through objects if shadows are turned off. In many cases this is not an issue, but it can often cause problems by lighting up interior surfaces of a model that would otherwise be dark. The inside of a creature or character's mouth is a good example (see Figure 11.4).

Some supervisors insist that every light in a computer graphics scene use shadows, but practicality usually calls for some lights without shadows. The render time savings is one reason, but the affects of a shadowless light can be to the advantage of the final image. Because it is unobstructed, it produces a fairly even level of illumination across a broader area than the same light with shadows. This can be useful for fill lights and bounce lights, or any light in a scene set to a fairly low intensity level. These shadowless lights become evident when they are bright or produce bright specular highlights, because the lack of a shadow opposite intense illumination is a glaring problem. A good way to test the effects of such a light is to isolate it, increase its intensity value to a high level, and render the scene. This points out areas to watch when the light is returned to its normal lighting values.

Types of Shadows

The difference between cast shadows and self shadows is important to emphasize. Cast shadows are created when one object blocks the light from another object. A simple example is a character standing on the ground, blocking the light from

Figure 11.4
No shadows in lights, causing a brightly lit mouth interior.

hitting certain areas. The shadow on the ground appears as a cut-out of the shape of the object occluding the light, and appears as if the object is casting its shape onto the ground. Cast shadows are only created in computer graphics scenes if the objects the shadows are to be cast upon are built in the scene. In the case of adding a character to a live-action background plate, the other objects are in the film but not necessarily in the CG scene, so creating cast shadows becomes a bit of a trick. Surfaces to receive shadows need to be created in the computer to mimic those in the image. The shadow pass can then be applied to the images in the composite. Purely digital scenes, in which every element exists in the computer graphics scene, offer an easier solution to cast shadows, because they are produced automatically if shadows are turned on.

Self shadows are created when a part of a CG element occludes the light from another part of that same CG object. A good example is a character's arm moving between his body and the light source (see Figure 11.5). This shadow is the same in principle as a cast shadow, because one object (the arm) is occluding the light from another object (the body). The difference in computer graphics is that the renderer needs to include each object in its own list of objects to consider when being shadowed. For ray-traced shadows, this means that rays bouncing between

Figure 11.5
A self shadow from the arm onto the body.

Figure 11.6
Sharp self shadows from many directions.

surfaces of the same object must be considered. A complex object shape may cause the ray tracer to hit its ray bounce limit sooner. If the level of illumination is to be maintained, more bounces must be allowed, which means more render time. This is why self-shadowing is often an option in a ray tracer. Self shadows and cast shadows are both vital for making a computer graphics scene convincing. If a character is being placed into a live-action scene, and the shaders offer control over the softness of the shadow's edges, it is beneficial to turn shadows on in all or most of the lights in a scene. The control over the shadow's edges is important, because an element can begin to look a little crazy with sharp self shadows from a variety of directions (see Figure 11.6).

A scene typically has a single, dominant light source, called the key light. This light usually produces the most clearly defined shadow in a scene, while other less intense lights cast softer, fuzzier shadows. This is especially true for a light used to simulate ambient lighting in a scene, such as a bounce light (remember, ambient lighting is not the same as a CG ambient light). Every light source casts shadows, but the more diffused the source, the less perceptible the shadow becomes. With ambient lighting in a scene that has bounced off several surfaces before reaching the subject, the shadow can be faint and almost imperceptible. This makes it possible to place a great amount of blur on shadows from bounce lights, or even turn them off completely (see Figure 11.7).

Figure 11.7
Sharp self shadow from the key light and soft self shadowing from additional lights.

While fully digital scenes offer all the geometry necessary for cast shadows, they also present a problem in terms of using shadows in all lights. Due to the diffusion of many light sources in a scene, it is likely not desirable to have harsh shadows from every light criss-crossing through the image. This can completely change the composition of an image, not to mention confusing the original point of interest. For this reason, I find it more appropriate to use most lights without shadows in purely digital scenes as compared with fitting a CG element into a live-action background. The fully digital scene has no point of reference within the image to point out the inconsistencies of non-shadowed lights with reality. It is not advisable to turn off shadows in every light in a digital scene, or even in every light other than the key. Having several shadowless bounce and fill lights, however, can work as long as the possible pitfalls are taken into account.

Cookies

Cookies offer a nice break from the technical discussions of shading rates and anti-aliasing. Although they're not as tasty as their name might indicate, cookies are a valuable tool in both live-action film lighting and computer graphics lighting. A cookie (also called gobo, cukaloris, cuke, or slide map) is something placed in front of a light, usually with irregular openings, to occlude certain areas of light from the subject. The resulting patterns simulate something between the light source and the subject, such as tree leaves, clouds, and so on. In computer graphics, a painted texture is often used as the cookie. The texture can be purely black and white, with black completely occluding light and white being completely transparent. Gray values can also be used with a 50 percent gray area filtering out one-half of the light's intensity. Colors used in the cookie texture simulate effects such as light shining through a stained glass window. These colors affect not only the intensity of the light (colors represent a value which decreases the amount of illumination, just as with the grayscale image), but also contribute to the color of the illumination reaching the subject.

A common usage for a cookie, seen in many films, is a dappled sunlight effect. A cookie is created in the form of a gray-scale image to produce a pattern of tree leaves in the key light for a scene (see Figure 11.8). This pattern is large in scale and simulates a high canopy of trees with larger clumps as opposed to individual leaf shapes. The gray areas in the transition between black and white will only partially occlude the light, and they help make the transition from light to shadow less harsh. The cookie shown here is sharp and high in contrast, but it can be

Figure 11.8
Texture used as a cookie for creating a dappled sunlight effect.

processed, prior to its use in a light, to add blur or distortion. It can provide the subtle effect of a character or creature walking in and out of sunlight and tree shadows without producing harsh shapes and distracting the viewer from the intended point of emphasis in the scene. The cookie used in front of the light for a scene from *Star Wars: Episode I—The Phantom Menace* is blurred considerably, because hard-edged shadows on Jar Jar would distract from the intent of the scene (see Figure 11.9). Each of Jar Jar's forefingers receives a bright hit of light in which the key light makes its way cleanly through the cookie. The forest behind the three foreground characters offers additional reference for the type of lighting a cookie is often used to simulate. The effect is downplayed slightly in this close-up scene, but in studying previous scenes, the effect is more pronounced as Jar Jar walks through the forest. In those scenes, the primary goal of the shots is to emphasize the motion of traveling through the forest. Well-defined shadows from the trees offer a clear indication of the distance over which the character travels. To that end, less blur on the cookie textures serves to enhance rather than distract from the shot's intent.

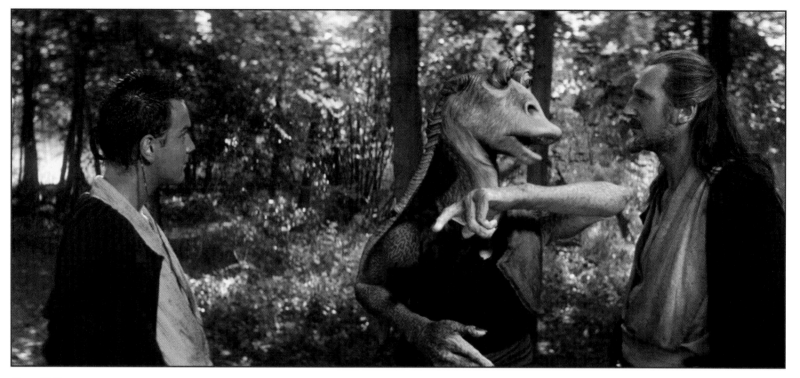

Figure 11.9
Dappled light effect from the film *Star Wars: Episode I—The Phantom Menace*. COURTESY OF LUCASFILM LTD. Star Wars: Episode I—The Phantom Menace © Lucasfilm Ltd. & ™. All rights reserved. Used under authorization. Unauthorized duplication is a violation of applicable law.

Instead of a single texture used as a cookie, a sequence of frames can be used to simulate motion of the occluding object. Using the leaves from the previous example, a simulation could produce the effect of rustling leaves. The textures are simulated, either with a particle system or a procedural texture map that changes over time, and are rendered out as a sequence of frames. Footage of the sky viewed through leaves blowing in the wind could also be used. The total number of textures is usually at least the length of the shot for which they are to be used. Many times, the textures are used on multiple shots, and the sequence may need to be looped (looping is continuously repeating a sequence of frames) to cover the entire sequence. As long as there are no distinctive movements and the shapes produced by the cookie textures are not too well defined, looping the sequence is usually not noticeable.

Motion Blur

Among the many computationally expensive computer graphics techniques, motion blur is one of the most important in creating believable scenes. Even with fairly limited knowledge of computer graphics elements, viewers will quickly spot that something is wrong if CG elements are rendered without motion blur. Motion blur is a result of motion relative to the camera, such as a camera moving across a still scene, subjects moving across the camera plane, or a combination of the two. Film and still cameras alike produce motion blur and although it can be minimized with an increase in shutter speed, it is an expected phenomenon for any movement recorded on film.

Motion blur is broken down into two basic categories: transformation and deformation. Transformation motion blur happens when something is moved (or transformed) through space. An example would be a ball passing in front of a camera

or a camera panning across a scene. With deformation motion blur, the movement is the result of something changing shape. An example of this type of blur would be the swinging of a tail that is part of a sitting dog. The dog is not being translated through space; the points defining the tail are being deformed to create a new tail shape. Deformation motion blur actually involves copying two sets of geometry into the renderer, whereas transformation blur only requires one set of geometry (for each item moving through the scene) and its transformation information. Each motion blur type is captured automatically by the film camera but takes quite a bit of computation to create in computer graphics.

Shutter Speed

Motion blur is a result of motion during the exposure time of a frame of film. With a computer graphics camera, however, the shutter exposes the image plane instantaneously, thereby eliminating motion blur. In order to create motion blur for a CG camera, a camera shutter is simulated. Most film cameras use a 180-degree shutter (although other shutter angles can be used) with a film speed of 24 frames per second. In this setup, the shutter is open for 1/48 of a second recording the image, and closed for 1/48 of a second while the film is advanced. The 1/48 of a second represents one-half of the time a single frame of film occupies the screen. For that reason, many 3D computer graphics rendering software packages use a 0.5 (half frame) shutter speed to evaluate motion blur. What this means for the computer camera is the creation of an extra rendered frame to simulate the motion blur.

With two frames, the renderer can compare the difference between the two, evaluate which pieces of geometry have changed location, and blur them according to how far they have moved. With a motion blur shutter speed setting of 0.5, the CG camera will render two images, each one a half frame (1/48 of a second) apart. You can accomplish this several different, but a common method is to render the actual frame and also an additional frame one-half frame later. For instance, if frame 22 is being rendered, then with a 0.5 shutter setting, frame 22 and frame 22.5 could be rendered for comparison. The software automatically does the comparison, applies a blur according to the amount of movement, and outputs a single render for frame 22. It becomes clear why this process is so computationally expensive, because it means rendering two frames for every one that is output and applying some sort of 3D filter to create the blur. Depending on the software package, a shutter speed of 0.5 may also evaluate a frame using frames 21.75 and 22.25 or frames 21.5 and 22 in order to output a motion blurred frame 22. Each method produces slightly different results, but for the purposes of this text, it is sufficient to understand the concept of two frames being calculated for the output of one.

3D CG Motion Blur Comparisons

The amount of motion blur depends on the speed of the motion, and this factor can have a large impact on how computer graphics elements are viewed. With the simple composite shown in Figure 11.10, the block is rendered with no motion blur. The block is actually moving from the top right to the bottom left of the picture plane, but this image gives no indication of that animation. The clarity of the render, along with its size in the frame, gives away the lack of detail in the block's textures. The sharp edges of the block are a dead giveaway that it has not been thrown across the view of the camera, even though the 3D computer graphics scene indicates that it has.

The image in Figure 11.11 shows the block with the same animation as in Figure 11.10, but this time motion blur has been turned on in the renderer with a shutter speed setting of 0.1. The block, when in motion, now appears as if it was tossed gently in front of the camera. The shutter speed is set lower than a normal film camera would record. Because the normal setting would be 0.5, this image produces 1/5 the amount of blur one would expect to see with a block moving this speed and recorded with a 180-degree shutter. Although the motion blur is slight, it still makes quite a difference in the look of the image. The interior of the block

Figure 11.10
Block with no motion blur composited over a background plate.

Figure 11.11
Block with motion blur and a shutter speed setting of 0.1.

Figure 11.12
Block with motion blur and a shutter speed setting of 0.25.

is blurred, but note the edges. A small range of pixels around the outside of the image is now semi-transparent, allowing portions of the background scene to be viewed through the block's edges. 3D motion blur calculates the opacity of the object by making it proportional to the amount of time the object resides in that pixel. With the shutter setting at 0.1, the moving block is exposed to the "film" for only 1/240 of a second, so the amount of motion blur and transparency are small.

Increasing the shutter speed to 0.25 yields the result shown in Figure 11.12. This amount of blur creates the perception that the block is moving much faster. The transparent area around the edges is much larger, as the two frames combined to create this image are now farther apart. The blurring has also reduced the contrast and saturation of the block, because the values are mixed together.

If the block is moving very fast across the picture frame (which it is in this particular animation), an image like that in Figure 11.13 is appropriate. The shutter speed setting for this frame is 0.5, which matches a typical film camera with a 180-degree shutter. At this setting, the block has moved a great distance between frames 22 and 22.5, creating large areas of transparency. The blur is so great that the object is now barely recognizable as a block. If this block only appears in shots with a great deal of motion blur, making its color and texture almost indiscernible, the texture painting and shader departments should be alerted ahead of

Figure 11.13
Block with motion blur and a shutter speed setting of 0.5.

time. It does not makes sense to spend time painting detailed textures and developing complex shaders for a computer graphics object only viewed as a blur. If the object is to be used in other scenes in which it is moving less or not at all, attention to detail in the textures and shaders is appropriate. If the block is viewed only as in Figure 11.13, the time is better spent elsewhere.

2D Motion Blur Techniques

Motion blur can also be accomplished using 2D techniques, which are computationally simpler than but not as accurate as the 3D method. 2D motion blur evaluates the change in position of pixels on the picture plane, and it does not take into account the actual 3D distance covered by objects. This method works fairly well for motion across the picture plane, but is less successful when objects rotate, deform, or fly directly toward or away from the camera. 2D blur evaluates the difference between two images and blurs differing pixels by an amount proportionate to the distance (in 2D screen space) they have changed. Some 3D software packages incorporate the 2D motion blur technique, with the shutter setting defining times for two renders, much the same as with the 3D method. If 2D motion blur is added, the difference between the two renders required for the blur can only be measured in the x and y directions. No movement in the z direction is taken into account. As with 3D motion blur, though, the edges will still be semi-transparent. This is a result of combining images in which the block exists in different positions. If the two renders (one at frame 22 for instance, and one at frame 22.1) are overlaid, the transparency is defined by the areas where one image extends beyond the other (see Figure 11.14). In this figure, one block is semi-transparent and the other darkened to clearly illustrate the areas in which one extends beyond the other. In the interior areas of the block, in which each render has red, green, blue, and alpha values, the two images are blurred together. In the areas in which one block extends beyond the other, one block is blurred to fill the space of the second block's alpha or each block is blurred into the other block's alpha and then those images are averaged. The blurring of color and alpha channels creates semi-transparency. There are several variations in 2D motion blur methods implemented by different software packages or used for different situations. They all come down mixing, blurring, and repositioning a combination of images.

Reflections

Reflections help clearly integrate computer graphics objects into scenes. They are most noticeable in very reflective objects but are also helpful in providing subtle details to many elements in a scene. A reflection is, in essence, the same phenomenon that provides a specular highlight on any surface. It is the light reflecting

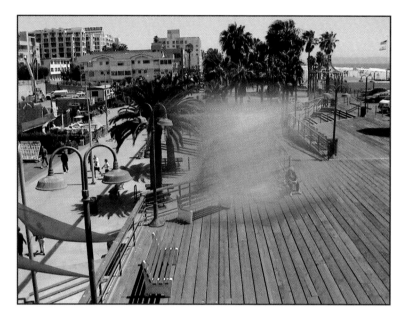

Figure 11.14
Illustration of two block renders to be combined for motion blur.

directly from a surface into the camera lens. If the surface is very smooth, as with a perfect mirror, then the reflected light provides a clear reproduction of the elements in the scene. As the roughness of the surface increases, the clarity of the reflection is reduced due to scattering of light. The brightest light sources and objects reflect off almost any surface causing specular highlights.

Collecting Textures

A surface reflects the world around it, but unfortunately the camera only records a very narrow view of this world. To create an accurate reflection in computer graphics, additional footage is required of the surrounding scene. One way to collect this information is to take several shots of the surrounding area using a wide-angle lens. With the camera placed in the position of the subject, shots are taken of the surrounding area to the left and right, as well as above and below. The sky and the ground in most scenes are the simplest part of this process, because they can be generic textures. The viewer expects to see a blue sky reflected in the top of a shiny element, and grass, concrete, or any generic ground texture as the bottom portion of the reflection (see Figures 11.15 and 11.16).

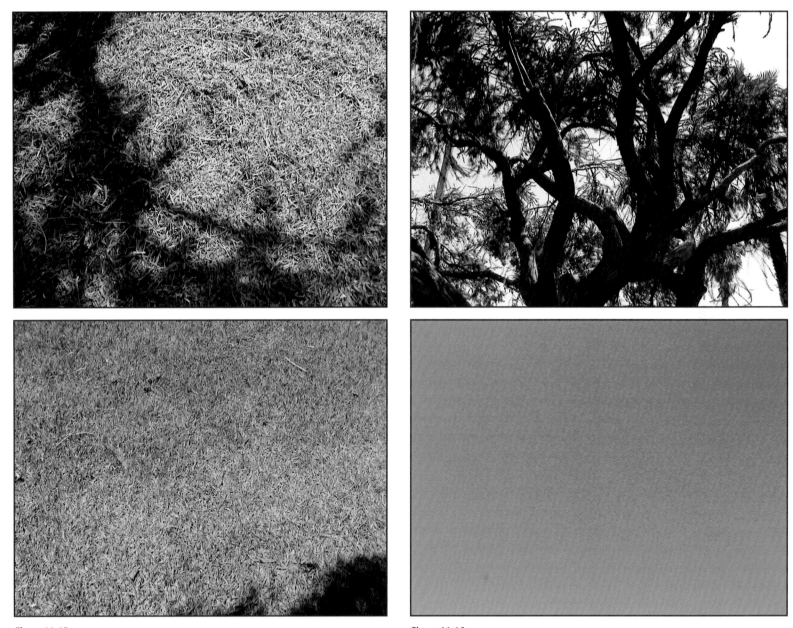

Figure 11.15
Possible ground textures.

Figure 11.16
Possible sky textures.

The other elements in the scene may require more attention, because they are typically at eye level and more clearly in the camera's view (depending on the angle of the camera), but still do not require extremely detailed texture maps. Because reflections are distorted by both the shape of the object they reflect off, as well as the roughness of that surface, complete precision when creating reflection texture maps is not necessary. A 360-degree panorama, created by piecing together many shots from the position of the subject in a scene can be used without the necessity of exactly matching and blending every seam between images (see Figure 11.17). The images used for the environment map in Figure 11.17 have been reduced in scale in the x direction to make a more manageable image file (at actual size, the image is more than 10,000 pixels wide) and to display more easily on the page. If the portions of the reflection map showing up on the subject appear incorrect, the environment texture can be scaled during the texture mapping phase in the shader. Unless viewed in a perfect, flat mirror, the reflections are distorted and faint on most surfaces and any inaccuracy is not noticeable.

CG Environment Types

To project the environment texture onto a subject, a choice is made in the shader for the shape defining the environment. This shape is most commonly a sphere, a cube, or a cylinder. Each type creates a slightly different reflection and has advantages and disadvantages. The spherical projection method most closely re-creates the real-world environment, but warps standard rectilinear images to fit to its shape. To provide an accurate map, this method requires a texture recorded with a fisheye lens. These lenses are expensive and not always readily available. A cube environment shape lends itself for use as the walls, ceiling, and floor of a room containing reflective objects. In the example presented here, a beach ball is placed into the scene in Figure 11.17. The reflection map in this case uses cylindrical mapping and is shown at full intensity in the image on the left of Figure 11.18. The reflection is completely independent of lights in the scene, so even with no lights or each light's intensity set to zero, the reflection is still evident. The amount of reflection is controlled in the surface shader, and is typically a percentage or a normalized value between zero and one. When the amount of reflection is reduced to an appropriate level for the surface material, the effect offers another touch of realism for blending the computer graphics element into the shot (see Figure 11.18, right).

Figure 11.17
A 360-degree view pieced together from multiple photographs.

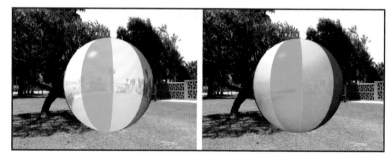

Figure 11.18
A beach ball with full reflection on the left, and a beach ball with reflection dialed in to match the background on the right.

Specific Reflections

In some cases, the reflection is vital to the scene, and the director asks for a specific image to be clearly defined. In *Terminator 2: Judgment Day*, the liquid metal Terminator taking control of a helicopter looks at the pilot and tells him to get out. For this scene, it is important to the story that the pilot's frightened face be clearly shown in the reflections on the Terminator's head. In such a case, the most reliable way to attain the desired result is recording a clear shot of the image required for the reflections. This image can then be manipulated or placed over an appropriate background to fit with the scene, and then be used as the reflection texture. The image can simply be another texture added to the appropriate area of the object. The other reflections are non-descript, simply matching the color and value of the surrounding scene. When using reflections, identify the important element, and make the remaining areas of the reflection map unobtrusive, even if not entirely accurate.

Additional data for creating environment maps is found in the reference shots of a chrome sphere. The chrome sphere offers precise data for creating reflections in a scene from the camera's point of view. If the camera is zoomed in on the chrome sphere to capture enough detail, this image can be used as an environment texture. This method creates accurate and believable reflections, and it is a valuable tool in a digital production pipeline.

Eyes

Eyes represent the life force behind believable computer graphics creatures and characters. Every director and supervisor on the projects I have worked on has concentrated a great deal of energy and attention on the eyes of CG characters. There are several methods for ensuring that the audience notices the eyes and believes there is life and energy behind them. We look people in the eye every day during conversations and interactions, so we have a great deal of experience with how eyes should look. You may not be able to explain that a glisten is missing from the caruncula lacrymalis (the fleshy area on the inner angle of the eye), but the lifeless eye is noticed.

Textures

A believable eye begins with a high-quality texture (see Figure 11.19). The texture shown here has a reasonable amount of detail in the cornea (the orange section), as well as some vein detail in the whites of the eyes. The distortion of this texture (the black at the top represents the pupil) is the result of a square image for the spherical map corresponding to the shape of an eyeball. A great deal of reference study is invested in the construction of eyes and in the painting of their textures. Depending on how close the character or creature comes to the camera, details such as individual red blood vessels in the whites of the eyes are added or ignored.

The lighting and reflections also play an important role in the look of the eyes on a CG character or creature. Reflections in eyes, because they are a smooth, wet, shiny surface, are sometimes quite distinctive. If the eyes come close to the camera, an identifiable shape, such as a window, light fixture, or cloud can add a great deal of realism to the character (see Figure 11.20). A particular reflection can be added to the eye with a special environment texture map. The sky and clouds here were specifically chosen and oriented to be distinctive on the character's eyes.

Figure 11.19
Eye texture map.

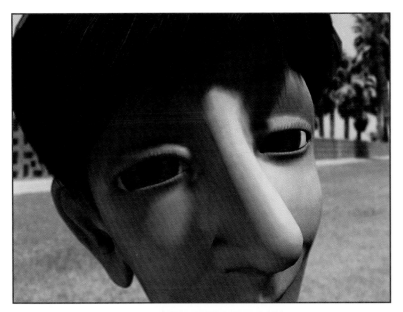

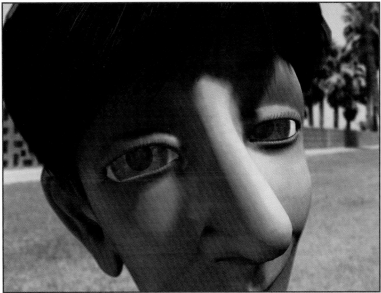

Figure 11.20
A sky with clouds reflected in the character's eyes.

Specular Highlights

Although reflections are important, every special effects supervisor I have ever worked with has asked specifically to see specular highlights on the eyes of characters and creatures. It has long been standard procedure to use special eye lights on close-ups of live actors to accentuate their performance. To blend CG characters into the film requires the same treatment. These lights can be placed fairly close to the eyes, and often a separate one is created for each eye. The light should be a specular-only light, and can be roughly located with the specular information offered in the hardware render window, before fine-tuning the location in the rendered image (see Figure 11.21). The specular highlights on the eyes are usually small and tight, once again because of the wet, shiny, and smooth surface of the eyeball. Parameters for the size of the specular highlight can be adjusted in the light.

Animated characters are likely to move out of the lights providing the specular highlights with the setup just described. It is sometimes beneficial to parent (attach to maintain a fixed relative position and orientation) the eye lights to the character so that they move wherever he does. For this to appear believable, it is important to have the lights inherit the translations but not the rotations of the character. If they follow both the translations and rotations, the specular highlights will appear on the exact same spot in each eye, no matter how much the character moves and rotates, in every frame of the shot.

The best reference for creating believable CG eyes is found in studying the eyes of everyone around you. Look closely and see what gives a person's eyes depth and life. Also, look at the films with CG characters you think are particularly lifelike, and study their eyes. Chances are the lighting artists who created them paid a great deal of attention to the eyes.

The Dangers of Accuracy

Several of the headings in this chapter point out ways to add detail and realism to CG renders and make them more believable. Before attempting to include all these techniques in creating the perfect computer graphics scene, step back and evaluate the visuals created by all these techniques. Numbers can be perfect but still look wrong. As with a lighting diagram, the reference and data is collected and interpreted but not blindly entered into the computer as the final lighting data of a scene. The end result is the key, and the eyes are the only true judges. If the numbers all say it is a perfect match, but everyone you show it to says it looks out of

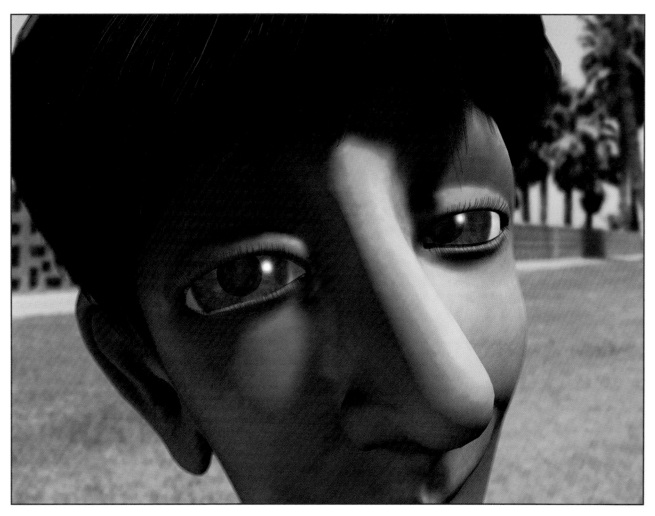

Figure 11.21
Specular highlights in the character's eyes.

place, then the numbers are wrong. Do not fall in love with numbers, symmetry, and the enticement of an image in which every pixel fits neatly into a predetermined equation. The way light sculpts the forms of a scene is an organic process. The difference between a natural lighting setup and a crystal-clear, shiny computer graphics scene is obvious to the most casual observer.

With that said, attention to detail is still extremely important. The details in the eyes help the viewer identify with a character and add life to CG creatures. Reflections tie elements in directly with the elements surrounding them, and motion blur helps to mimic the recording process of a film camera. Cookies and shadows offer methods for occluding light to add both realism and compositional interest to a scene. Each of these techniques can be explored to give the lighting artist indispensible tools for creating quality computer graphics imagery.

chapter 12
Compositing Techniques and Methods

The previous chapters concentrate on creating quality layers, but deal little with combining those layers into a successful composition. This chapter outlines the basic processes involved in manipulating those layers. As with 3D lighting techniques, 2D image creation and editing starts with observation. The challenges of compositing include creating depth and realism, as well as interaction between computer graphics elements and live-action elements within a 2D presentation. Compositing covers a wide range of topics including bluescreen matte extraction, color correction, and the process of layering one image on top of another. As the number of elements and processes increases, organizing the composite in a clear and logical manner becomes vital. The sequence of operations the compositor links together to create the final composite is called the compositing script. It gets this name because the compositing software generates a script of operations for the computer to process and generate the final images. If a comp (short for composite) script is a jumbled mess that can only be understood by its creator, it becomes not only difficult for others to work with, but makes it difficult for peers or supervisors to offer helpful suggestions. If someone looking at a script does not understand it, he will be unable to help when problems arise. As with every aspect of computer graphics, the end goal is to communicate ideas and story points visually. This concept extends through the entire digital production process and is important to keep in mind when creating comp scripts. If a comp script clearly outlines its steps and procedures, it is much more likely to be visually successful.

Compositing is an expansive topic and, as with lighting and rendering, can occupy an entire book on its own. (*The Art and Science of Digital Compositing* by Ron Brinkmann is an excellent example.) The purpose of this chapter is to describe the concepts behind creating believable imagery, while outlining the basic compositing functions found in most software packages. The concepts are not software specific and are useful for enhancing a scene with numerous live-action and computer graphics elements, as well as a fully-digital computer graphics scene.

How Many Layers?

Many of the factors that affect a shot in the compositing stage are determined long before elements are brought into a 2D software package. Where the backgrounds are shot, how the scene is lit, which bluescreen elements are needed, and so on is decided ahead of time. Of course, the plan usually changes as scripts and stories are updated, budgets change, and unforeseen challenges arise in shooting particular scenes. Problems faced in shooting live-action footage are often expected to be fixed in the compositing stage of the production pipeline. These problems can create challenges for the compositor, but solid planning up front, with a seasoned computer graphics professional (on-set supervisor) on hand to offer suggestions during the live-action shoot, often makes the process easier. The on-set supervisor advises the crew on how to best film a shot for visual effects.

The more layers the compositor has, the more individual control he has over elements in the scene. A drawback to separating a scene into many layers is a composite script that is complex and difficult to manage. Interaction between elements is a primary concern, and applying multiple processes in the compositing software can create a great deal of additional work. It is necessary to evaluate the benefit of precise control over separate elements versus the interaction among elements that are rendered as a part of the same scene. One such example would be a character added to a scene along with a particle pass of dust he is kicking up from the ground. The dust must interact with the shoes and legs of the character, and will most likely appear both in front and behind the character from the camera's point

of view. If the character and dust are rendered separately, the compositor must then combine the layers in such a way to make the interaction between the two appear believable (see Figures 12.1 and 12.2). If both the dust and the character are rendered within the same pass, the interaction will happen automatically (see Figure 12.3). One negative with this technique is a slight change to the motion of the dust means a complete re-render of both the dust and the character. Another problem in rendering both together is the added difficulty in making color adjustments to the dust or character individually. The dust can be rendered as a separate pass, using the character as a hold-out matte (a matte used to obscure parts of one element so that another element can appear in front of it) for certain portions of the dust (see Figure 12.2). This still involves rendering the character along with the dust element, but with a simple shader calculating only the alpha channel of the character with no color values. When the two passes are combined, the hold-out matte helps give the appearance that the dust is both in front of and behind the character (see Figure 12.4).

The number of layers required is analyzed at many points during the production of a shot. If the shot is completely digital, then the entire scene may be rendered as a single layer, thereby greatly simplifying the compositing stage of the production. A shot for a feature film may have only a single creature to composite over the top of a background plate. Another shot of that same creature may require rotoscoped mattes to place him behind certain elements in the live-action plate, water he's splashing, fog he is walking through, and a glow around his eyes. The complexity can increase rapidly, particularly if multiple characters, creatures, or elements are added within a single scene. An example from *Jurassic Park: The Lost World* (see Figure 12.5) shows how complex a scene with only a single creature can become. The explosion creates layers of smoke and sparks that make the compositing much more complex. The T-Rex is blended not only with the live-action explosion, but also with additional layers of CG smoke, sparks, and atmosphere. Notice also the difference between the head and tail of the T-Rex, with multiple layers causing blurring and fading as the creature extends farther back into the scene. On the other hand, in the video game industry, compositing plays a relatively minor role. Cinematics appearing within a game require compositing, but the programmers who write the game's engine handle the majority of the layering in the game. As a shot progresses to its final state, additional layers are often added to the comp. Perhaps a separate specular pass is rendered for a character to give him a shiny arm in one particular part of the scene, or maybe additional dust is needed to blend an element more subtly into the background plate. Whatever the scenario, a compositor is constantly trying to improve the layers that are provided and

Figure 12.1
Rendered character pass.

Figure 12.2
Rendered dust pass.

Figure 12.3
Character and dust rendered in the same pass.

Figure 12.4
Separate character and dust pass composited together.

seamlessly blend them into a shot. The compositor may add layers created in a 2D software package to assist the blending and layering process. Possible 2D layers include rotoscoped mattes, color cards, film grain, and edges for blending elements into the background. In the end, it doesn't really matter how many layers there are, as long as the final image gets the point across.

To get the point across clearly, the compositor must consider the obvious ways a viewer might be distracted from the story. This brings up a key consideration during the compositing stage, which is the need for continuity between shots. Along with referencing real world examples for specific shots, the compositor also makes sure shots match with the surrounding scenes. A shot approved as a final serves as a crucial reference for the shots that cut directly next to it. Whereas it is important for shots to maintain consistency within any scene, the greatest need for matching the overall look and feel comes when two shots from the same scene are cut directly together. This scenario offers no room for error, because the viewer's eyes will spot even slight inconsistencies when the shots appear in rapid succession. If a shot from a different scene is in between two similar shots, the compositor has more leeway. The in-between shot can provide a distraction for the viewers, covering up minor inconsistencies between shots. Whether the shots are cut directly together or not, another shot in the sequence is always a valuable and necessary reference. If two shots are in production simultaneously, they need to be compared as often as possible. Two compositing artists working for a single day on shots within the same scene can create a drastically different look and feel for their shots. Communication and visual comparisons will help solve this problem before it arises. Checking in with another compositing artist also provides an opportunity to learn new techniques.

Basic Processes

The techniques used in compositing are similar whether working on a multi-million dollar software/hardware editing system or using the most basic compositing software. One might provide faster interaction or a few more tricky gadgets, but the basic concepts and functions for compositing layers together are fairl y universal. As with lighting, the basics of transforming the 3D world into a 2D composition are essential to making the most out of the tools. The most expensive compositing system in the world will not create a pleasing or realistic composition without a skilled operator. With a strong understanding of the processes and functions described in this chapter, you will become more effective with any compositing software package.

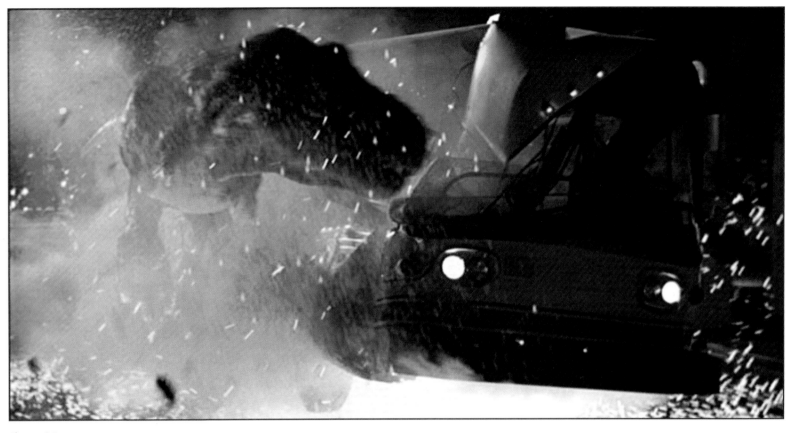

Figure 12.5
A shot with one creature and many additional layers from the 1997 film *Jurassic Park: The Lost World*. Copyright © 2002 by Universal Studios. Courtesy of Universal Studios Publishing Rights, a Division of Universal Studios Licensing, Inc. All rights reserved.

The functions performed by most compositing software packages can be broken down into six basic categories.

- ◆ Source imagery
- ◆ Compositing operations
- ◆ Color management
- ◆ Matte-extraction operations
- ◆ Image processing
- ◆ Transformations

The names of operations may vary from package to package and may be categorized in many ways, but these provide a solid starting point. I'll start with a brief explanation of each category and then provide visual examples of specific functions in each area.

Source Imagery

The *source imagery* category is comprised of operators to produce the images that serve as the building blocks from which the entire compositing script is based. File operators load rendered images, film or video backgrounds, bluescreen or greenscreen elements, particle passes, and anything saved in an image format supported by the compositing software. (See Figure 12.6 and see the Appendix for a list and descriptions of the various image formats.) Image generation operators create additional layers for the composite script, such as mattes, noise fields, color cards, and gradients (see Figure 12.7). Source imagery is the basis of every comp script and provides the pieces that serve as layers for the compositing operations.

Figure 12.7
Source imagery in the form of a matte, noise field, color card, and gray-scale gradient.

Figure 12.6
Source imagery in the form of live-action and computer graphics elements.

Compositing Operations

Compositing operations are the methods for combining images. Layers can be placed one over another, one inside of another, one mixed with another, or combined in any number of other ways. The basis for most compositing operations deals with fairly simple mathematical equations. For instance, if two images are combined using an add function, the pixel values are simply added together to achieve the resulting image (see Figure 12.8). Because every image can be described with numbers identifying red, green, and blue contributions, each color channel in two different images can simply be added together to produce a new image. Most compositing packages will cut off, or clamp, the color values once they reach the maximum. For instance, a solid-white area of an image cannot get any whiter (pure white being the maximum contribution of red, green, and blue), so anything added to pure white will remain pure white. In some software packages, the raw number values in an add function may be maintained internally (as with two white images being added together and equaling twice the maximum value of pure white) for additional calculations and only be clamped in order to display the image.

The alpha channel is a fourth channel created with many images in addition to the red, green, and blue color channels. Many compositing functions use the alpha, or matte, channel to identify levels of transparency used in layering images. When the alpha is white, the image is opaque and where the alpha is black, the image is completely transparent. The alpha channel typically looks like a white cut-out of the color image it accompanies. When dealing with processes involving an alpha channel, a major area of difficulty lies in understanding what occurs at the edges between the black and white. A gray value halfway between black and white produces a 50 percent opacity level for the image. As the alpha channel's value transitions between black and white, there is typically an area that gradates through gray values. This can be minimal(when there is a very distinct and quick dropoff between the black and white) or broader (when there is a larger transition). A larger transition area between the black and white values fades the image off gradually to the edge. There are image formats and operations that support a different alpha channel for each color channel, but that discussion is left for another book. The concept of edge control, as it relates to the alpha channel, is explored further later in this chapter.

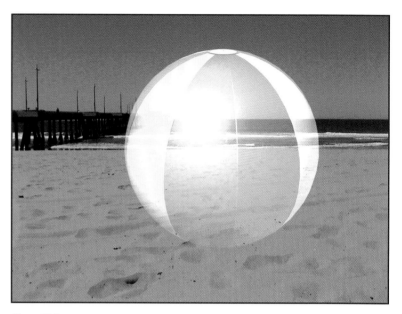

Figure 12.8
Two elements combined with an add function.

Color Management

Whereas the compositing operations layer images together, *color management* functions affect the color and alpha channel values of the layers. If a layer or an overall image needs to be redder, a color function can be used to increase the amount of red (see Figures 12.9 and 12.10). These functions include adjusting RGB values, HSV values, brightness, and any other process involving the application of mathematical operations to the color or alpha channels. Brightness and contrast are two other commonly used color management functions that adjust images. A brightness function increases the values of all channels in an image by a given percentage. A contrast function increases the difference between the dark and light values in an image. With any color management tool, it is important to carefully study the resulting image, because unwanted artifacts may occur. If an image is pushed too far from its original color, brightness, or contrast levels, degradation of the image can occur, causing an image that appears processed or unrealistic (see Figure 12.11). Color management tools are vital for making subtle or more drastic changes to the look of elements. In the hands of a compositor with strong color theory skills and a solid understanding of the mathematics involved in each operation, these tools can help make an average image look stunning.

Figure 12.9
A basic background element.

Figure 12.11
An image that has been over-processed with a contrast function.

Figure 12.10
A basic background element with an RGB adjustment to increase the red values.

Matte Extraction

Matte extraction operators, such as `chromakey` or `lumakey`, are another set of compositing tools, which create an alpha channel from color or luminance information in an image. Creating the alpha channel involves isolating a particular range of color or luminance in an image and generating a channel in which everything in that range forms the transparent portion of the alpha channel. One common type of extraction is known as a bluescreen extraction (or pull). With a bluescreen element, a subject is shot in front of a uniformly colored and lit bluescreen surface (see Figure 12.12). The compositing software is then able to isolate the blue values, based on a range of RGB values input by the user, and create an alpha channel (see Figure 12.13). By giving the blue areas an alpha value of zero, making them transparent in the compositing operation (as long as the image is pre-multiplied, which is discussed later in this chapter), the blue areas are removed, leaving only the intended subject. This process works well unless the subject happens to have a color within it matching the blue of the background. This is why it may not be a good idea to wear blue jeans to a bluescreen shoot. The pants may become transparent, producing a subject with no legs when the shot is composited. To help alleviate this problem, the backgrounds are usually a

Figure 12.12
An element shot in front of a bluescreen.

Figure 12.13
The alpha channel created by extracting the blue colors from the backdrop.

very saturated blue or green color that is very distinguishable from clothing. An alternative to using a color to create the alpha channel is using the luminance values from an image. Just as chromakey uses a color, a luminance key takes a brightness value or range to select a portion of the image. This creates a matte using everything in the image within that luminance range. This type of matte can be useful in an image with very bright highlights that need to be attenuated. A luminance matte can be used to create an alpha channel around only the brightest highlights, and then those highlights can be darkened without affecting the rest of the image. Extractions are not restricted to blue or green colors and can be powerful tools for creating specialized mattes for specific control of areas with an image.

Image Processing

To this point, the compositing functions described have involved fairly simple mathematical functions. Values have been added together, multipliers have changed the brightness, and specific color values have been removed to create alpha channels. The next set of functions involves more complex mathematical computations. These functions are in the *image processing* category and include blurring, dilating, eroding, edge detecting, swirling, and displacing. Image processing requires more than the individual pixel location required by a compositing function. The add compositing function mentioned earlier takes each individual pixel in an image, and adds a value to that pixel taken from the exact same pixel location in another image. With image processing functions, however, a function uses surrounding pixels to evaluate a pixel's new value. A blur function will average each pixel with surrounding pixels (the number of surrounding pixels it uses depends on a blur size parameter) to establish a new value for each pixel. The result is an image with the pixels across the entire image mixed together, or blurred (see Figure 12.14). Because image processing operators must evaluate additional pixels for every pixel value output, they are more memory-intensive and time-consuming than other types of compositing functions. These operations are the muscle power of a compositing software package. The variety and efficiency of these processes play a large role in differentiating between average compositing software packages and more sophisticated ones.

Transformations

The final category to be introduced here is *transformations*. Transformations take an existing image and adjust it by moving or scaling it.. Pixels maintain their relationships with surrounding pixels, so no complex mathematical operations are being performed on the image. Transformations include translating, scaling, cropping, and rotating. A good way to understand transformations is to refer back to the concept of a picture plane introduced in Chapter 5, "Tools of the Trade." A 2D

Figure 12.14
An image with a blur image processing function applied.

Figure 12.15
A full-screen background image with no transformations applied.

image exists within a defined boundary called a picture plane. It not only serves as a plane for flattening out the 3D world, but also provides boundaries at the top and bottom, left and right. Anything extending beyond those boundaries is outside of the picture plane and, therefore, cannot be seen by the viewer. Performing a basic `translate` function (also called a 2D transform or a move 2D) on an image beyond the borders of the picture plane (see Figure 12.15) crops the original image (see Figure 12.16). The amount cropped depends upon the distance the image is translated. The image in Figure 12.16 has been translated approximately 400 pixels in the x direction and 200 pixels in the y direction. As you can see, the right side and the bottom of the original image have now been cropped off as a result of this translation. Those portions are now outside of the picture plane and are, therefore, no longer a part of the image. The translation has also created a black area at the top and left of the image. Because there was nothing underneath the original image, the space left behind has no pixel values.

The image in Figure 12.15 may have been created as a new background image, which cuts out the tall white building visible in the original. There are many instances in which a background must be adjusted to fit with the artistic vision of a particular shot, and transformation operations, such as a translate or a scale, are often used to accomplish this task. Transformations are frequently used in conjunction with one another, and the order in which operations are performed

Figure 12.16
A background image with a 400 pixel x and 200 pixel y translation applied.

affects the final result. To make use of the translated image from Figure 12.15 as a background, it is necessary to scale it back to encompass the full frame. By placing the *scale* center (or pivot) at the bottom right corner of the frame, the image can be scaled (in this case 1.425 in the x direction and 1.25 in the y direction) to fill the frame (see Figure 12.17). Because the x and y scales differ, the image has been stretched more in x than in y, and, therefore, no longer has the same proportions as the original image. Human figures are now wider in relation to their height than in the original image, as are all of the other parts of the scene. In this case, however, because the image serves as a distant background, it is a cheat that is barely noticeable. What would happen if you input the exact same numerical values for the `translate` and `scale` functions but performed them in the reverse order? If the `scale` is applied first and then the `translate` is applied, the resulting image no longer cuts out the tall white building at the left of the frame (see Figure 12.18). As with many transformations in the graphics world, the order of application can dramatically affect the result. For this reason, it is always necessary to have a clear understanding of not only which layers are necessary to create an image, but also in what order they will need to come together.

Basic Compositing Operations

Compositing at its most basic level is the combination of images. In this book, those images are referred to as layers. The way those layers are combined is important in creating the final look of the image. Compositing software packages have many functions for combining layers, but a solid understanding of the basic ones goes a long way in helping the compositor make the most of the input images. The following examples provide a brief explanation along with a visual representation of the most common layering processes found in compositing software packages. (The mathematics behind each function are described in the Appendix.) For the purposes of consistency, each example in this section utilizes the same simple, computer graphics elements. The elements are a building block, which will be the A input for each example (see Figure 12.19), and a beach ball, which will be the B input (see Figure 12.20).

Over and Under

To begin with, examine one of the most commonly used functions in any compositor's toolbox: the `over` function. The most basic compositing script can be described as A `over` B. In the simplest terms, this means putting one element (called A) `over` another element (called B). The key to understanding how the `over` function works lies in the alpha channel and the concept of premultiplied images. The alpha channel defines the portion of the image that is maintained during the over-processing. The black portion of the alpha is what gets thrown away,

Figure 12.17
A background image with a 400 pixel x and 200 pixel y translation applied, followed by a 1.425 scaling in x and a 1.25 scaling in y.

Figure 12.18
A background image with a 1.425 scaling in x and a 1.25 scaling in y applied, followed by a 400 pixel x and 200 pixel y translation.

Figure 12.19
A building block element.

whereas the white portion is what gets composited. This is true, however, only if the image is premultiplied, which means multiplying the alpha channel values times the color channel values. Where the alpha is black (a value of zero), this multiplication yields a result of zero. Where the alpha is white (a value of one), this multiplication yields the exact same color value seen in the red, green, and blue channels. Some software packages automatically premultiply an image when the over function is applied, and others do not. Without premultiplied images, the over function will not work as expected, so it is vital to determine whether the software performs this function automatically.

The next step in the over process is taking the alpha channel of the A element, inverting it, and multiplying it with the B element, or the lower layer of this composite. This multiplication creates a hole in the B element, in which the A element will fit perfectly. With the hole cut out of the B side of the composite, the A and B image can now be added together. The resulting image is the A element over the B element (see Figure 12.21). Fortunately, the software does most of the work, and the compositor simply specifies the A and B sides for the over function. The primary task for a compositor when utilizing the over function is dealing with the

Figure 12.20
A beach ball element.

Figure 12.21
An over function, with the block as the A side and the beach ball as the B side.

edges of the objects being composited. Where the alpha channel is pure white or pure black, the result is cut and dry. At the edges, where the alpha transitions between black and white, the compositor's job becomes more complex. As the alpha values transition, the premultiplication process modifies the values in the red, green, and blue channels, adding a fraction of the foreground color to the inverse fraction of the background color. If the alpha's edge transition is not correctly positioned or valued, the effect is a noticeable brightening or darkening of the color values at the edge of an object. Attention to edges is critical to creating good composites.

The sister function to the over function is the under function. It is, in essence, the same function performed in reverse. Instead of placing the A side over the B side, this function does just the opposite, placing the A side under the B side (see Figure 12.22). To achieve the same result, the inputs to the over command can be switched, making it a B over A comp (yielding the exact same results as an A under B comp). Many compositing functions have a counterpart to perform the complementary mathematical calculations. For each operation listed here, the most commonly used and referred to operation is explained first, and the less common operation is described afterward.

Figure 12.22
An under function, with the block as the A side and the beach ball as the B side.

Add and Subtract

The add function is a bit simpler than the over function. With the add function, each channel value from the A side is simply added to the B side (see Figure 12.23). For areas in which the values added together exceed the maximum allowable value (pure white), the value is clamped to the highest value. For this reason, bright images that are added together often yield the result of a predominately white image. All of the color channels (red, green, and blue), as well as the alpha channel from the A side are added to the corresponding channel of the B side. Referring to the example shown in Figure 12.23, because the alpha is either black or white for each of the two images, the addition of the alpha channels produces a simple result. Black, or zero, added to black is black, and because the values are clamped at the maximum, white added to white yields white. As with the over function, there can be problems at the edges where alpha values transition from black to white. Adding two images where the alpha channels are each at 50 percent will produce a completely white alpha. A 50 percent alpha basically only allows 50 percent of the color values to come through in compositing functions. When two 50 percent alpha channels are added together, 100 percent of the color channels come through and can create unwanted bright edges around elements added together. When using an add function, it is often necessary to replace the alpha channel of the resulting image, such as with one from the original input images.

Figure 12.23
An add function with the block being added to the beach ball.

The add function is useful for adding extra lighting effects to CG characters. Rendering a separate specular pass for a particular light provides an element that can be added into the original character. Because the alpha channels between the fully rendered character and the specular-only pass should match, the alpha can simply be replaced with the alpha from the original input image after the add function is performed. This is a powerful tool for adding detail elements and maintaining separate control of those elements within a comp script.

The opposite of an add function is a subtract function. This function takes each value from the A input side and subtracts the same channel's information from the B side. This function can create visually unusual results (see Figure 12.24), and I have rarely found a use for it in a production environment. Notice the areas in which the B image extends beyond the boundaries of the A image; the subtract function completely eliminates the values of the B side (because the values outside of the cube are zero, and subtracting from them gets clamped to zero). It is also interesting to note that the brightest areas of the ball, where it was white, now become the darkest areas of the resulting image. If the A and B inputs are reversed and the beach ball becomes the A side with the cube becoming the B side, the result is quite different (see Figure 12.25). The beach ball now forms the boundaries of the resulting image with a portion of the block appearing within it. If you

Figure 12.25
A subtract function with the block being subtracted from the beach ball.

thought the add function created unusual alpha channels, wait until you see what the subtract function does. Because the alpha values are subtracted, the resulting alpha is rarely useful for compositing the resulting image later in the comp script (see Figure 12.26). The confusing part is that the alpha channel resulting from a subtract operation does not match up with the color channels. In most compositing operations, the alpha channel mimics the outline of the color channels. Because the subtract function negates that correlation, utilizing an alpha channel resulting from the subtract function can be confusing.

Figure 12.26
Alpha channels from Figure 12.23 on the left and Figure 12.24 on the right.

Figure 12.24
A subtract function with the beach ball being subtracted from the block.

Inside and Outside

The inside function takes the input from the A side and places it inside of the B side's alpha channel. The color channels from the B side of the function are not used at all and have absolutely no effect on the resulting image (see Figure 12.27). Assuming that each shape has a solid alpha with the same shape as its color channels, the resulting image will have an alpha channel matching the resulting shape of the building block's color channels. If the A input to the inside function has no alpha, the inside function will still produce the same results in the color channels but will have a blank alpha channel. This is because the actual operation is a multiplication of all the A-side channels by the B-side alpha. The inside function is often shortened and referred to as an in function.

The reverse of an inside function is an outside function. The outside function takes the inverse of the alpha channel from the B side of the function to multiply with the A side (see Figure 12.28). As with the inside function, the outside function does not use the color channels from the B input at all. Only the alpha channel from the B input is utilized. The outside function is also commonly shortened, and referred to simply as an *out*.

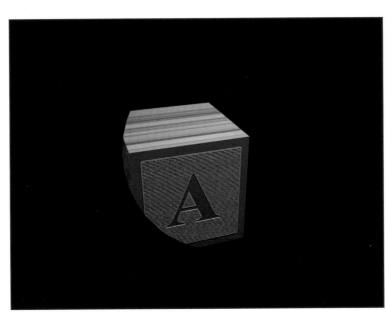

Figure 12.27
An inside function with the block being placed inside the beach ball.

Figure 12.28
An outside function with the block being placed outside the beach ball.

Mix

The mix function combines two images together based on a percentage input by the compositor. The percentage represents the amount of the A input that will be included in the resulting image. The percentage remaining to reach 100 percent is the amount of the B input that will be mixed into the output image. For example, if the input number for the mix function is 75 percent, then the resulting image will include 75 percent of the A image and 25 percent of the B image (see Figure 12.29). This function applies the percentage to the color channels as well as the alpha.

Multiply and Divide

The multiply function multiplies all of the channels in the A input image by their respective channels in the B input image. Because values are multiplied together, any pixel location with a zero value in either image results in a zero pixel value in the output image. This means that the resulting image can only have values where the two input images overlap (see Figure 12.30). Any area in the A image multiplied with almost any corresponding area in the B image will be darkened by the multiplication. This is true because the values in each channel are normalized (placed in a range from 0 to 1), meaning two decimals are usually being

Figure 12.29
A mix function with 75 percent of the cube and 25 percent of the beach ball.

Figure 12.30
A multiply function with the block being multiplied by the beach ball.

multiplied together. The only instance in which darkening does not occur is when corresponding areas in both images are pure white, giving them each values of 1, and producing and output value which is also 1. Multiplication of color channels produces results that are not intuitive to how the eyes interpret color. For this reason, I rarely use the multiply function in normal compositing tasks.

The opposite of the multiply function is the divide function. The divide function produces an image with value only where the A input image has values. The B input will appear only in the areas in which it overlaps the A input (see Figure 12.31). The areas in which the A image exists outside of the B image (the bottom-right corner of the block in Figure 12.31) appear as an unchanged version of the A input image. This area has values in the channel for the A input but no values for the B input. This produces the illegal operation of division by zero, so the compositing software simply makes the choice of preserving the existing value for the output image.

Figure 12.31
A divide function with the block being divided by the beach ball.

Max and Min

The max function takes the maximum value from the two inputs and assigns that value to the output image. The brightest portion of each image is used in the resulting image (see Figure 12.32). Unlike many of the previous examples, the order of application does not matter with this function. Switching the A and B inputs will yield the exact same result. Given two images with solid alpha channels defining their shapes, the resulting alpha channel of a max function will be the combination of the two input image shapes.

The inverse of the max function is the min function. Because this takes the minimum values of each input, the resulting image will only have values where the two input images overlap. In those areas, each pixel will be the lowest between the two inputs (see Figure 12.33). The alpha channel will only exist in the overlap as well, because in all other areas, one of the alpha channels is 0.

These are the more common compositing operators found in software packages. During everyday compositing, the over function will likely be used more than all of the other operators combined. The over function is a powerful tool and is definitely worth studying in depth. Understanding the mathematics behind the

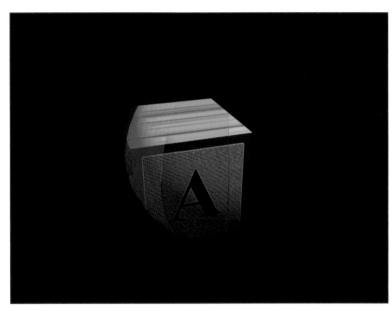

Figure 12.33
A min function, with the block and the beach ball as the inputs.

operation, as described in the Appendix provides the compositor with an excellent point of reference for gaining control over the process of layering images.

Depth Cues and Contrast

As mentioned in Chapter 5, "Tools of the Trade," depth cues are a primary method for clarifying the three-dimensionality of a scene within a two-dimensional image. Depth cues provide the viewer with information to indicate which elements in the scene are closer and which are farther from the camera. These cues can be occlusions of objects by another, relative sizes of objects, reduced clarity, blurring, haze, and atmosphere, to name a few. All of these cues can be introduced or enhanced during the compositing stage of a shot. The compositional basics presented in Chapter 5, "Tools of the Trade," also play an important role in implementing these depth cues. The first step (you'll start to see a pattern here) is observation. As lighting requires the study and observation of how the human eye perceives illumination, compositing requires those same steps to understand how to combine layers in a realistic manner. Once the rules are learned, they can be stretched or broken to serve the intent of the artist. A strong understanding of how camera lenses and the human eye interpret the world and its three-dimensionality will give the compositing artist a visual vocabulary with which to build images. Compositing is a construction process with images, elements, and compositing operations being the layers with which you build.

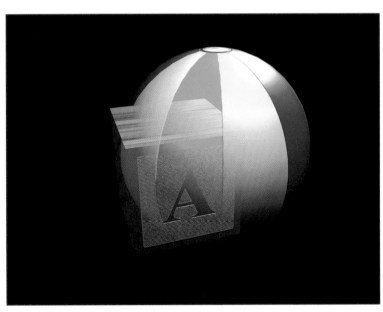

Figure 12.32
A max function with the block and the beach ball as the inputs.

Observing the world around you is the first step, so studying and breaking down the depth cues in a traditional photograph is a good starting point. The photo in Figure 12.33 shows many of the depth cues seen every day but, in many instances, taken for granted. The specific depth cues examined here are the following:

◆ Overlap

◆ Scale

◆ Level of detail

◆ Depth of field

◆ Contrast

◆ Atmosphere

Overlap

There are several distinct layers represented in this photograph (Figure 12.34), with multiple foreground elements, a distinct midground, a background, and a distant background. Starting with the foreground and working backward into the image, look at the oblong light mounted on the wooden post. The most basic indication that this object is in the foreground is the fact that it is obscuring other parts of the scene. The light fixture *overlaps* the shrubbery, water, and dock retaining wall. Based on experience viewing the world, our eyes interpret this overlap as

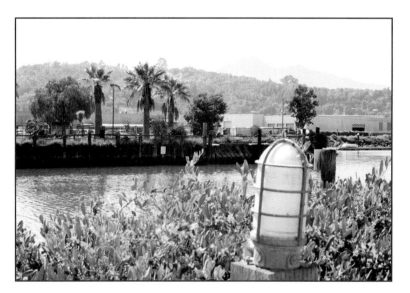

Figure 12.34
A photograph displaying various depth cues.

a clear indicator that the light fixture is closer to the camera than the other objects. With a photograph, the elements automatically overlap each other correctly according to their placement in the scene. In a composited image, however, the compositor chooses the layering order of elements. If the light fixture is element A and the shrubbery is element B in a composite script, placing A *over* B is just as easy as placing B *over* A. Layering the shrubbery over the light fixture would be possible, and due to the close proximity of the two layers in the scene, it might even look correct. It would, however, drastically change the composition and emphasis of the shot, with just a small portion of the light fixture peeking over the shrubs. A compositor must always maintain a clear understanding of the relationships between objects in three-dimensional space and attempt to layer the elements accordingly.

Scale

Another depth cue for this foreground element is its *scale*. The size of the light fixture, relative to the other objects in the scene, gives the viewer a clue to its proximity to the camera. If an element is larger in frame relative to another assumed comparably sized object in the scene, then it appears to be closer to the camera. This effect takes into account a viewer's background knowledge and sense of scale with known objects. For instance, even though it may not be of a type specifically seen before, a light fixture has a certain size in most people's minds. Scale has a great deal to do with human perception and experience, and the way we are accustomed to seeing things. Because the world is taken in through the eyes and processed with the brain each day, familiar items are categorized in terms of their scale. The trees in the midground of the photo are a good example. The trees relative to the scale of the light fixture are actually smaller in this photograph. The mind interprets the scale of the trees to mean they are much farther away from the camera than the light fixture.

Level of Detail

Along with scale, it is important to note the *level of detail* of each layer within a scene. Every portion of a scene displays details to help the viewer understand how far it is from camera. Certain objects display a greater level of detail, giving a clue as to their distance from the viewer. In Figure 12.33, the plant life along each bank of the waterway provides a good comparison of level of detail. The plants on the bank nearest to the camera can be clearly resolved into leaves, flowers, and branches. The plants on the opposite bank, however, can only be seen as a green color and a basic outline. When rendering elements for a computer graphics scene, this type of depth cue not only helps a composition come together more realistically, but also presents an opportunity to save rendering time. The objects

nearest camera need attention to detail in their textures, lighting, and resolution. The same object placed farther away in the scene requires less attention in each of those areas. Whereas a foreground object may require rendering at a resolution of 2k, with high-resolution textures and large shadow maps in the lights, a midground object may only require a 1k render, with medium resolution textures and much smaller shadow maps. Each of those optimizations can save a tremendous amount of render time. Attention to detail in composition is important but not in areas in which it goes unnoticed. Spending time on the texture and lighting quality of foreground objects will usually be more important to establishing the quality level of a shot than using the same attention to detail in midground and background elements. There are a couple of exceptions to this: when a foreground element moves quickly through the scene and is highly motion-blurred, or when a midground or background element will be used in another shot in which it appears closer to camera.

Depth of Field

Another depth cue, which often dictates whether the level of detail is discernable, is *depth of field*. A camera lens, along with the human eye, can only focus on a specific distance from the lens, and anything in front of or behind that point is not in precise focus. The range that appears in focus is dependent on the aperture and focal length of the camera recording the image. A shot taken from exactly the same point as in Figure 12.34 can yield a very different result with a much lower aperture setting, which results in a narrow depth of field (see Figure 12.35). This new image has a narrow depth of field with focus centered on the light fixture in the foreground. Notice that the range of focus is so narrow that even the foreground shrubs are now becoming blurred. This narrow range of focus can also serve to trick the viewer into thinking the midground trees on the opposite side of the waterway are farther away than they really are. Because the human eye often maintains a broad depth of field, the interpretation when viewing an image with a narrow depth of field can be that of a drastically increased distance between layers in the scene. Another difference between Figures 12.34 and 12.35 is in the level of detail on the foreground light fixture. At first glance, Figure 12.34 appears to represent the majority of the scene in focus, including the light fixture. When comparing it with Figure 12.35, however, it is clear that the level of detail in the foreground object is now much higher. The corrugation on the interior portion of the light is now evident, as are the screws at the base and the grain on the wooden support post. If the light fixture is the point of interest for this shot, then Figure 12.34 has failed to fully display its level of detail, despite the greater overall depth of field. The compositor must always keep in mind the intended emphasis of a shot and avoid operations that will diminish or obscure important elements in a scene.

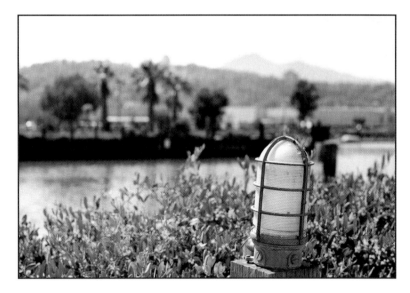

Figure 12.35
A photograph with a narrow depth of field.

Contrast

Contrast is an often overlooked depth cue. The level of contrast in an element and between elements in a scene helps the viewer place the objects in 3D space. Contrast is closely related to each of the previous categories, in that each can increase or decrease the perceived level of contrast within an element or between elements. Contrast is the amount of difference between the brightness of different elements. The greater the difference is between elements, the higher the level of contrast. Unfortunately, the human perception of contrast is affected by many variables which makes contrast a much more complicated topic. Outside factors, such as color, saturation, and illumination can change the perception of contrast within a scene. As a general rule, elements closer to the camera appear higher in contrast than those farther away. This is tied closely with level of detail, which allows the viewer to resolve an element in clearer focus and thereby perceive it as having crisper edges and higher contrast and color saturation values. Objects closer to the camera do not necessarily have higher contrast or saturation values, but the camera lens, as well as the human eye, is able to resolve closer objects with more detail than those farther away. Be aware that juxtaposition can also affect the perception of color and brightness. A solid white object appears brighter when placed on a solid black background, as opposed to a light gray background. Likewise, a blue element appears more saturated and vibrant when surrounded by

its complementary color of orange, as opposed to a color such as purple or green. *The Art of Color*, by Johannes Itten provides an excellent reference for studying the principles and perception of color.

Atmosphere

The last depth cue in this discussion is *atmosphere*. Looking back at Figure 12.33, notice the two most distant layers in the background, the tree-covered hill and the peak in the distance. Each of these layers displays the effects of atmosphere on elements far from the camera. Depending on the amount of moisture in the air, the atmosphere will reduce the contrast and clarity with which distant elements are perceived. The layer of background trees on the hills appears to have much less contrast than the trees in the foreground, due to the effects of the atmosphere on the resolution. The most distant peak in the photo shows even greater atmospheric effects, with almost no detail or contrast visible. Each of these elements also begins to take on the value of the area surrounding them—in this case the sky. The water and particles in the atmosphere reflect the color of the sky, and as the distance from the camera increases, this effect becomes more pronounced. With elements in this scene extending farther back in the distance, dark areas become bright or washed out and brighter areas become duller. Comparing the distant trees with the palm trees in front of them, the difference in perceived contrast is clear. The palm trees can be more clearly delineated, and the atmospheric hazing effect is less because they are much closer to the camera. In a comp script, the effects of the atmosphere on distant elements can be simulated by blurring the elements, decreasing their contrast levels, and adding a sky-colored haze. Atmosphere, along with each of the other depth cues, can help in adding a great deal of realism to computer graphics elements and composites.

Edges and Blending

One of the primary concerns when layering images together is the edge quality of the elements. When placing an element over a background, the place for problems to be introduced and noticed is most likely the outer edge of the element being composited. As stated in the section describing the over function, a premultiplied image is necessary for many basic compositing functions. The process of multiplying the color channels by the alpha channel is necessary for an operation such as the over, but is not desirable for operations such as color corrections. Premultiplication changes the color channels in order to provide the proper blending levels for compositing functions. By changing those values, however, a different set of color channels is produced, affecting any future adjustments to color. If the over operator is the final step in the composite, the premultiplied image is what is needed. If color corrections are required on the original element, though, they should be performed before the premultiplication. If performed afterward, the edges of the image will be adjusted incorrectly. For instance, if an image has a portion of its matte edge with an alpha value of 0.5, during the premultiply process each color channel will be multiplied by 0.5. Each red, green, and blue value will become one-half of its original value in those edge areas in which the alpha value is 0.5. A color operation, such as a *brightness* call, performed after that premultiplication adjusts a darker value of each color channel than in the original image. A *brightness* value of two will double the red, green, and blue values for the majority of the image. In those edge areas in which the premultiplication has reduced the values of the color channels, however, the resulting colors will be darker than if the original color values had been brightened. If that image is then used in an over function, a dark edge will appear around the element. If the alpha edge is fairly abrupt, meaning the transition from values of zero to one happens in a very small amount of space, the artifacts introduced by premultiplying before a color correction may very well be imperceptible. The problem is most pronounced with soft-edged matte channels, in which the transition from values of zero to one happens over a larger distance. In any case, it is good practice to consistently make color corrections on unpremultiplied images. Even the smallest of lines around the edge of an element can balloon into larger problems by the end of a complex comp script.

The Earth mentioned in Chapter 6, "If You Can See It, You Can Light It," presents a good example of layering several elements together. The elements combined in creating the Earth are the planet itself, the clouds, and a smoke layer to be used on the outer edge. It is important to note with any composite script and any element, the image is not confined to only the images provided. A composite script may start with only three layers, but each of those three layers may be manipulated to create several additional layers. Each layer presents an opportunity to add realism to a scene. With a strong understanding of the desired look gained from studying reference images and footage, additional layers can be created and introduced into the comp script in ways to enhance the final output.

Base Layers

The first layer to be utilized for compositing the Earth is a render of a sphere with the continents and ocean textures applied (see Figure 12.36). The two texture layers of land and water are combined in the rendering stage. The clouds are rendered separately as their own layer, and are simply a texture map applied to the same sphere as the Earth element (see Figure 12.37). Step number one is placing a shadow of the soon-to-be added cloud layer on the earth. This is accomplished by taking the cloud layer and using it as a matte for the Earth. To do this, an alpha channel must be created which will outline the shapes of the clouds and provide transparency values for the clouds that are less dense. The alpha channel resulting from the render of the cloud layer is a solid outline of the entire Earth sphere.

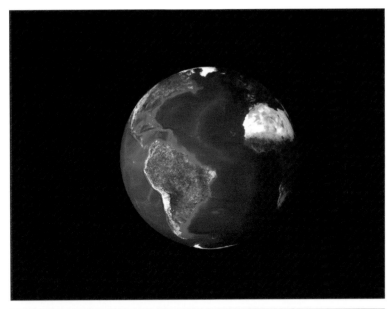

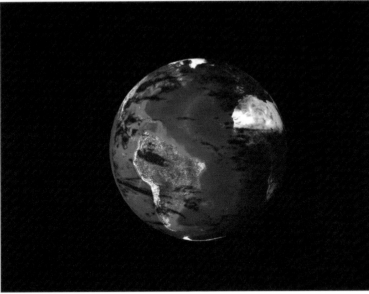

Figure 12.36
Earth render on the top, and cloud shadow element added on the bottom.

Because this is not what is needed in this situation, another alpha channel must be created. One way to do this is with a luminance key operator, called a luma key for short. The *luma key* creates an alpha channel for an element based on the luminance value calculated from the combined color channels. The luma key creates more opaque alpha values for brighter portions of the image, with pure white areas being completely opaque, whereas pure black areas are completely transparent.

Cloud Layers

The alpha channel from the luma key operation on the clouds is then translated slightly down and to the right (because the sun is above and to the left). A new element is created by placing the Earth inside the translated cloud alpha and darkened with a brightness function. This layer is now clouds of darkened Earth. By placing this cloud shadow layer back over the original earth, cloud shadows are simulated (see Figure 12.36). Before placing the cloud shadow layer back over the Earth, it is necessary to perform an `inside` operation, to limit the cloud shadows to the Earth. Otherwise, because the clouds shadow layer is translated down and to the right, the shadows would extend past the Earth's edge. This method of creating shadows is not technically accurate (the fact that the offset shadow would extend beyond the Earth's edge instead of wrapping around is a clear sign of this), but at this distance it is a very good trick. It is much faster and easier than rendering an actual shadow pass of clouds onto the Earth (and it also saves disk space). Because the most inaccurate portion of the shadows is to the lower right of the Earth, which is the darker side opposite the sun, it works well.

The next step is to add the clouds that are casting the shadows. The clouds are rendered separately as their own layer, and are simply a texture map applied to the same sphere as the Earth element (see Figure 12.37). The cloud render is fairly hard edged, so a slight blur is performed on the element (see Figure 12.37). Notice that the blur not only softens the edges, but also reduces the contrast. The amount of blur is slight to maintain the distinctive shape of the clouds, yet slightly reduce their harshness and contrast.

Haze Layer

In addition to the clouds, another pass of the Earth is rendered to help with the edges. To simulate the light refracting through the Earth's atmosphere at the edges, a separate haze pass is rendered (see Figure 12.38). Because this pass is intended to extend beyond the edges of the original Earth element, it is rendered on a sphere scaled up five percent larger than the original Earth sphere. The smoke texture used for this render is a generic smoke texture and is simply used to break up this particular element.

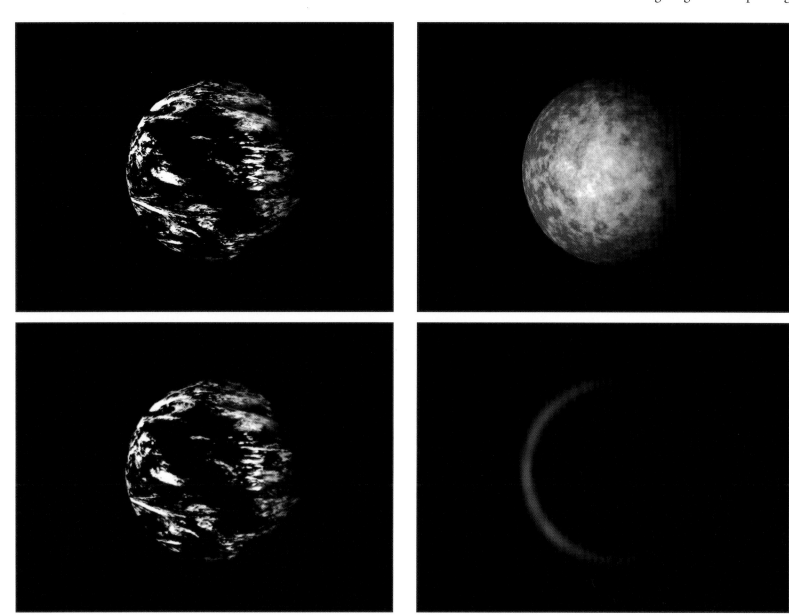

Figure 12.37
Cloud render on the top, and slightly blurred cloud render on the bottom.

Figure 12.38
Haze render on the top, and blurred haze render outside Earth alpha on the bottom.

12. Compositing Techniques and Methods

179

Combining the Earth Layers

Once the elements have been created, the fun of layering them together into a final image begins. The base layer for this composite is the Earth render with the darkened clouds on top of it (see Figure 12.36). An add operation is used to place the next layer, the clouds (see Figure 12.37), onto the Earth. This step can be accomplished with either an add operation or an over operation (utilizing the alpha channel created with the luma key). A benefit of the add operation is the control over the precise amount of clouds added to the Earth. For this comp, the clouds were added in at a value of 75 percent. Another benefit to using the add operation is the mixture of cloud color with the existing color channels of the Earth. Adding a gray cloud RGB value to the green continent backdrop of the Earth results in a cloud with a green tint, as if the cloud were partially transparent. This can also be accomplished with the over function, but an extra step is involved to provide the cloud's alpha channel for controlling the transparency. After the clouds are added, the final layer in the composite is the haze for the outer edge. This layer offers the same options for layering as the cloud layer, and it too is composited into the image with an add operator. The outer edge is added in at 90 percent to strongly differentiate it from the background. Once all of the Earth's layers are combined, they can be placed over a star field to see how it melds with the background (see Figure 12.39). Notice how the transparency of the outer edge layer affects the stars behind it providing interaction between the Earth element and its surroundings. For the purposes of this book, each layer is a little brighter or saturated to clearly illustrate the points. In the production environment, the art direction might call for such chromatic strength or something more subtle. If the spacecraft is headed for the Earth, and the director wishes the emphasis to be on the destination, then it may well show up in a scene, as depicted here.

Although each of the layers in the Earth composite might seem like elements created independently from each other, it is important to realize the interconnectedness of these pieces. The first step of most composites is to place the basic foreground over the basic background. In this case, the base Earth render would be placed over a simple star field, or possibly even a crude, low resolution image of stars. This first, quick or rough comp (sometimes referred to as a slap comp) is a vital first step in the compositing process. The broad strokes are put down first, and the details can then be added as the shot progresses. In compositing, the first 80 to 90 percent of the process is usually straightforward. The last 10 to 20 percent is where the serious amounts of time and energy are necessary for adding the details and fine tuning. Because the first part of the job is easier, it makes sense to look at several rough comps in a sequence before putting the time and energy into the details. The rough edit of these simple comps is valuable in determining whether a shot will work as intended. It's a much more efficient process if those

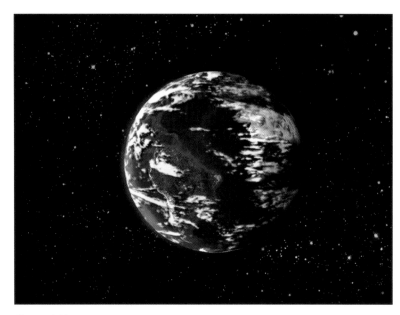

Figure 12.39
All Earth layers composited together and placed over a star field.

decisions are made before the painstaking detail work is done. This is true for large film productions as well as small personal productions. The sooner the shots can be cut together, even in the simplest form, the easier it is to get a handle on the need for details, and where time can be saved on things that are unnecessary or will never be seen.

Edges

Edges in compositing go unnoticed if they're done well, but can destroy a shot if not handled properly. The two most glaring problems a viewer normally spots in a poorly composited shot are lighting and edge problems. When an element's lighting does not match the rest of the scene, the viewer's eye is drawn to it as odd rather than as a visual point of interest. Poor lighting can also accentuate problems with the edge of an element, making a tough problem even worse. If elements are created on the computer graphics side of things, there is no excuse for mismatched lighting. The CG lights can be set up to match any environment and made consistent from element to rendered element. The problem becomes more difficult when bluescreen or greenscreen elements do not match the lighting of the scenes with which they are to be combined. A bluescreen character with high fill levels and a key to the left can be extremely difficult to integrate into a live-action scene with the key on the right and low fill levels. For this reason, it is important in the

planning stages of shots, particularly for bluescreen or greenscreen elements, to create a solid lighting plan and stick with it. Changes can and will be made down the line, but major shifts in lighting emphasis, such as switching the key light to the opposite side, can make for many long days in the compositor's world.

The edges in bluescreen and greenscreen extractions can take a considerable amount of work. Element edges in compositing definitely fall into the final 10 to 20 percent category that can be the most challenging part of a shot. Fortunately, there are several powerful software options that provide excellent tools for simplifying this task (Ultimatte from the Ultimatte Corporation and Primatte from Photron, Inc. are two examples). The ins and outs of extractions can be learned from the software manuals, from a mentor, or from trial and error. There's no substitute for experience in this area, so practicing with bluescreen and greenscreen extractions is important. One good type of practice subject is a bluescreen or greenscreen element of a person with long hair, which can be extremely challenging due to the fine detail and transparency of the hair. Another practice scenario involves a bluescreen element shot with excessive blue light spilling across the subject. This blue spill needs to be removed or suppressed and replaced with colors matching both the subject and the scene. Before, during, and after each operation in the extraction process, it is necessary to pay careful attention to the edges of the element. Check for deterioration, discontinuities, loss of edge detail, excessive fuzziness or crispness, and ensure that the matte resulting from the extraction, accurately represents the shape of the object being composited.

Grain and Finishing Touches

After combining the elements and sorting out the layering processes, the final touches can be applied to the composite. These final touches vary depending upon the types of input and output the shot requires. They include adding grain to match film footage, carefully checking each color channel for details and inconsistencies, evaluating the black levels to ensure consistency between CG elements and film or video elements, and adding in additional renders or elements for small details.

For film work, in which computer graphics elements are added to film footage, it is necessary to match the grain of the film. Grain is the noise variation due to the uneven distribution of the light-sensitive crystals which capture the image. Each color has its own layer of crystals on the film, so each color has different grain properties. Additionally, each film type has its own distinctive type of grain due to its chemical composition, and the grain amounts can vary greatly from one roll of film to the next, based on the manufacturing run. The best way to view the grain is by zooming very close on the image and checking each individual color channel. In most cases, the blue channel has the densest grain, followed by green, with the

least amount usually in the red channel. The grain appears as a subtle change to the image, but is more noticeable in moving footage. Grain is simulated in the compositing stage with a noise function. This noise function can be adjusted in terms of scale and intensity in each color channel to closely resemble the look of the background film image (see Figure 12.40). The scale and intensity of the grain in the example shown here are magnified to show the element more clearly. There is also grain in digital video footage that sometimes goes unnoticed. The light-sensitive chip in a video camera is also susceptible to manufacturing imperfections and electromagnetic interference, which can add noise to the image recorded digitally (see Figure 12.41). The digital footage of the beach and pier clearly show the grain effect in the sky of the blue channel. If grain is not added, computer graphics elements will stand out as too crisp and clean. Grain is one of the many elements utilized by the compositor to combat the perfect CG look.

The following steps demonstrate techniques used in placing a simple computer graphics beach ball into the scene of Figure 12.41. The beach ball is rendered in two separate passes, one for the diffuse light contributions and a second for the specular (see Figure 12.42). By rendering these elements separately and then compositing them with the add operator, the specular highlight can be quickly and easily increased or decreased.

Figure 12.40
Noise field to simulate film grain, shown in red, green, blue, and all color channels.

Figure 12.41
Digital video frame on the top and the blue channel isolated on the bottom to show the grain.

Figure 12.42
Separate diffuse and specular renders of a beach ball element.

Shadows

Two additional elements for this scene are shadows. When combining computer graphics elements with live-action footage, it is often necessary to render separate shadow passes. The shadows to be rendered must be cast upon a surface in the CG scene. This surface is a ground plane placed to match the ground plane of the live-action scene. With rudimentary pushing and pulling of points on the ground plane model, a rough or undulating surface can be simulated. The background image can be used as a guide in the 3D software package. Keep in mind that the ground surface need not match precisely, because the shadows are not the focus of most shots. Providing enough variation in the ground surface to break up the general shape of the shadow will suffice. The rendered shadow pass can then be used as a mask channel for darkening the background image (see Figure 12.43). Notice also the darker area on the inside left of the shadow. This is the second shadow render pass, referred to as the contact shadow. This pass represents the darker area closest to where the element comes into contact with the ground. In most scenarios, the ambient light in the scene lightens the shadow as it gets farther from the object casting it. This depends on a variety of external conditions, such as the amount of bounce light, additional light sources, and the intensity of the key light, but as a general rule, the contact shadow will help integrate a CG element more cleanly.

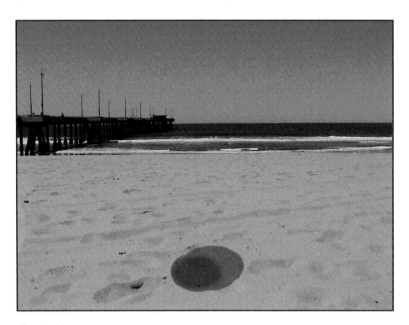

Figure 12.43
Background darkened through mattes created with the shadow and drop shadow render passes.

The contact shadow pass is often blurred more than the full shadow pass, and is used to make that area slightly darker than the original shadow.

Grain and Edge Blending

By using the beach ball element, two more useful elements are created for integrating the ball into the background scene: a grain element and an edge-blending element. The grain element is created with a noise field matching the noise existing in the background element. In this instance, a small bit of the background sand is added in with the grain to provide additional break up (see Figure 12.44). The elements in Figure 12.44 are enlarged to better show the detail. The new grain element is then placed inside the alpha of the beach ball and combined with an add function to the beach ball element. The second element, shown on the bottom of Figure 12.44, is an edge element. This element is created by applying an *edge detection* filter on the beach ball element. Most compositing software packages provide an edge detection filter. It is important to note that the edge filter's utility depends heavily upon the contrast level of the element involved. Edge detection algorithms are based on contrast, so it is frequently necessary to boost the contrast on an element before using such a filter. Once the edge matte is created, it can be used for a number of final compositing tweaks. In this case, it will be used for a slight edge blur on the final composite.

Color Adjustments

These elements can now all be layered together to help place the beach ball on the beach. The first step in the process is placing the beach ball over the background plate and making a simple A over B composite (see Figure 12.45). The beach ball does not exactly blend in seamlessly with the background. The render itself is extremely bright and high in contrast with anti-aliasing problems around the edges, and no shadow to tie it to the ground. It needs help, and that's exactly what the shadow, grain, and edge elements will do. Adding those elements, along with color corrections to the beach ball, makes this scene much less offensive to the eye. This rough comp provides direction and clearly illustrates the problems with the element. Before the additional layers are added, the beach ball *saturation* is reduced, and the specular highlight is attenuated to 60 percent of its original value. These values are adjusted using trial and error to select values for each operator until the ball blends more closely with the background. This can be evaluated by taking pixel readings from the background to determine saturation and brightness values. The beach ball values can be adjusted to put them in the same range as the background. Once the numbers are fairly close, look at the ball and see if it looks right. This is one point where it benefits the compositor to take a step back, and look outside the numbers. If it still looks too saturated, even if the

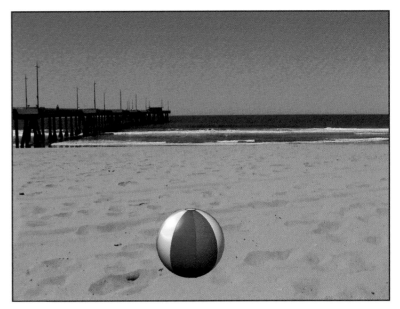

Figure 12.45
Rough comp of beach ball over beach background.

Figure 12.44
Beach ball grain element and edge element.

numbers match with the background, reduce the saturation. The eye of the viewer is the final judge, and even with precise value matching, a shot can still look wrong.

Combining the Beach Ball Layers

The grain can now be added to the beach ball element. If the grain is adjusted to match the background element closely, this should be a straightforward add process. Once again, if the grain looks incorrect, adjust the values to help the ball blend in with the background. With the grain applied to the beach ball, the result can be placed over the background. Because the background has already been darkened using the shadow mattes, the beach ball should fit nicely over its shadow. The last step in this example is the application of the edge blending. In the photographic reproduction of most scenes, there is a certain amount of interaction between the elements. It is noticeable particularly at the edges of objects, in which a small amount of the background appears to bleed into the edge of the foreground element. This can be simulated with the edge matte created earlier. In this example, the beach ball element is blurred through the edge matte. This creates a semi-transparent thin edge to the ball, allowing pixels from the background to bleed through slightly. This is a delicate operation, and keeping the edge matte

thin, as well as using a reasonable blur amount, will prevent the edge of the ball from appearing transparent (see Figure 12.46). An alternate method for blending the edge with the background begins with putting the background inside the edge matte after the beach ball shadow has been applied to the background. This provides the beach ball's edge, but with the background inside of it. This new element can then be blurred and carefully added to the beach ball after it has been placed over the background. This essentially accomplishes the same thing as blurring through the matte but with different operators. There is rarely a single solution to a compositing challenge, and experimenting with different approaches often helps the compositor develop new tricks and a stronger understanding of the discipline.

Each of these finishing touches can add a great deal to a shot, but many may also go unnoticed. When adding these touches to a shot, carefully evaluate the time involved in their creation versus the ultimate visual payoff. For instance, you might spend an entire day adding just the right specular glint to a character's fingernail for two frames of a shot. If no one notices it, then it hasn't really improved the shot, and the time could have been better spent making progress on other shots. There is a fine line between appropriate attention to detail and excessive tweaking. Until you've gained the experience to confidently make this call on your own, it is vital to solicit the opinions of peers and supervisors to help develop this sensibility. There are many valuable concepts presented in this chapter, but it only begins to scratch the surface of compositing as an art and a profession. With the ease of shooting digital video and capturing it on a computer, opportunities to practice are readily available. Observation and reference remain the most valuable tools, because compositing is ultimately understanding how 2D layers come together to simulate a 3D world.

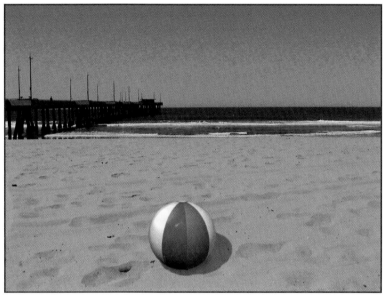

Figure 12.46
Final comp of beach ball over beach background.

chapter 13
An Interview with Mark Forker

A Brief Introduction

Mark Forker is a Visual Effects Supervisor at Digital Domain in Venice, California. Mark holds a double degree in Fine Art Photography and Film/Television from Pennsylvania State University. After several years of working in Philadelphia and New York City as a television commercial effects compositor, editor, and teacher, Mark made the move to California. Once in Los Angeles, Mark was hired by a fledgling visual effects company, Digital Domain. Mark utilized his previous experience in effects production, as well as his photographic background, to quickly rise through the ranks at Digital Domain.

As a compositor, Mark began his career in feature-film visual effects with work on *Chain Reaction*, *Dante's Peak*, and *Apollo 13*. He then served as compositing supervisor for *Waterworld*, *T2-3D*, *Titanic*, *Armageddon*, *EdTV*, and *Kundun*. In his current role as visual effects supervisor, Mark has worked on television commercials for Capri Sun and Dodge Trucks as well as on a theme park ride film for Disney Imagineering. His most recent visual effects supervisor credit is for *The Lord of the Rings*, and he is currently working on *Star Trek 10*.

Note: This interview was conducted by David Santiago (Technical Advisor to this book) outside the stage where Mr. Forker was supervising the shooting of practical effects for *Star Trek 10*.

Interview

DAVID: *Tell me a little about your background.*

MARK: I come from a still photography background. When I was a kid I got very interested in photography. I carried that on into college pursuing a fine arts degree with photography as the focus. Then in my junior year I took a film course and I thought it was a blast. I focused on the editorial part of filmmaking, like directing and editing—not so much writing or even shooting or anything, which would have been more natural since I had the photography background. I came out of school with a film degree and a photography degree. When I got out of school, the first thing I did was still photography. I liked photography so much that I didn't want to make money at it. It became a lot less interesting when I had to make my career at it. So I switched back over to film thinking, "That's a collaborative thing." I did TV and editing in television and then I started editing for post-production houses. That was somewhere around the early '80s.

> I liked photography so much that I didn't want to make money at it.

DAVID: *Let's take a step back. Where are you from and where did all this happen?*

MARK: I'm from New York, but my family moved to Pennsylvania, in the Philadelphia area and I went to Penn State.

DAVID: *And where did you start the photography business?*

MARK: I started in the Philadelphia area. I did everything from newspaper work to wedding photography to portraiture. I worked for a personnel directory company where I traveled around the U.S. and photographed church congregations, and military bases, and bank personnel [laughs]. That was a blast traveling around the U.S. When I was [in school] I was in the art photography program, not a technical program like RIT [Rochester Institute of Technology]. All this commercial photography

was awful to me. I wanted to just go out on weekends and shoot, and then make my living doing something else. To this day I still do that. I still go out with my camera on Sunday. Nobody else. No producers. Nobody else has any choice in the matter. I shoot what I want, where I want, when I want. I print what I want, when I want (see Figures 13.1, 13.2, 13.3, and 13.4). You know it's totally an individual "sport". Film [work] is completely the opposite for me. It's this thing where you have hundreds of people with ideas about how to do the same thing, and you have to come to this conclusion of how to end up with a single product. As a visual effects supervisor now, I'm trying to bring the director's vision to where he wants it to be, but everybody has to collaborate to get there. So, it's so much the opposite for me than photography. But it's all based on visuals; looking at something and trying to make something interesting out of something that isn't or something realistic, something photo-real. That's the thing that I really like most. People can be in visual effects or compositing, and might be really interested in trying to make things look sci-fi or surreal, like something from the imagination. My favorite aspect of it is trying to make it look exactly like it should look if you photographed a single frame. I enjoy making the imagery, whether it's *Star Trek* or *Titanic*, look like a photographer was there.

> **I enjoy making the imagery, whether it's *Star Trek* or *Titanic*, look like a photographer was there.**

Figure 13.1
A photograph by Mark Forker entitled *Low Flying Plane, 1999*.

Figure 13.2
A photograph by Mark Forker entitled *Doctors Office, 1997*.

DAVID: *How did you jump from photography to editing and moving pictures as a career?*

MARK: I actually got my first [non-photography] job up in Syracuse, New York, at a TV station. I was doing everything from on-air directing to editing news and local TV. But the stuff I really liked was when they had specials. I would edit the specials. This was back using two-inch videotape. It was pretty ancient, but I don't want to sound that ancient. I came in during the last year or two of two-inch tape ever being used and then they switched to one-inch tape for video post production. Now you can't even find one inch. Anyway, I only did that for a year, though, and then I got a job working for the New York State Council for the Arts, where, by the way, they were still using open-reel half-inch as well as three-quarter and other videotape equipment. It was partially funded by the National Endowment for the Arts, before Reagan came in and it still existed. This was the best job I ever had. Any video artists that were getting funding would have to come to this place in Syracuse, called Synapse, and they could edit there. They didn't have to edit there, but as opposed to going to a facility in New York City, which is where most of them lived, and paying 200 bucks an hour or something, they could come there and through their grant money or whatever, pay 25 bucks an hour in this facility, and they're bringing their video art to life. So this was finally pretty cool. I was doing what I went to school for: wanting to do art, but now making a living at it. I could be involved with art and make a living at it. That got me started in a different direction, as opposed to maybe working in a TV station or an editorial company or something like that. I still had it in the back of my mind that with my photography background, I should be a DP or news cameraman. But having worked with this National Endowment for the Arts place showed you could do art and make money at the same time.

Then the funding went away for stuff like that with the Reagan era and I went back to Philadelphia and worked at a post-production facility doing mostly commercial work. In town I quickly became known as the guy to go do effects work with. You know, all the other guys were maybe just straight-cutting guys, but if you wanted to spin somebody's head off or do something really crazy [they came to me]. It was because I had had that other job [at Synapse] where we took every machine to its limit and turned everything upside down and just made things work in all different ways. Right around that time I was

> **...all the other guys were maybe just straight-cutting guys, but if you wanted to spin somebody's head off or do something really crazy [they came to me].**

really lucky (it's early '80s we're talking about), because now digital tools are coming out for manipulating images. You have these simple DVEs [digital video effects devices]. DVEs were anything that could shrink down video in real time or flip it. People were making these cubes [with graphics on the six faces]. You saw it all over the TV in the early and mid-'80s and I was the guy you came to to do that kind of crap. Although instead of making cubes, I would make pyramids and other kinds of things; I'd light them, and everybody else was just doing the straight stuff. Among all the big facilities in New York (which isn't that far from Philly; Philly is like a bedroom community to New York) there were some just set up to do effects for commercials. So I went to one of those, a place called Charlex that won all the awards in the mid-'80s for editing commercials and stuff, because they did all the effects work, all the craziest. They did the Cars' music video *You Might Think*, which was revolutionary at the time, and all these Cherry Coke commercials with a 'million' elements. It was compositing work people had never seen before. I came to them and they were already doing it. I just fit into the thing because I was doing a minor version of it. Then the tools really started to pour on—the digital effects tools. It was a horrible time. The marriage between the old video world and computerized digital tools was such that nobody knew how to build any ways to synchronize them. I mean it was an awful, awful time, actually making the stuff work together or trying to combine elements. There were no real systems or pipelines or anything. I worked at the New York facility for about five years. In the commercial world, I got tired of the crazy assistant art directors, you know, coming in there and screwing things up and everything.

I had enough of it, so in order to make some grandiose change, I found a company in 1989 in New York that thought that HD [High Definition Television] was right around the corner. While only the Japanese were starting to use it in the smallest way, this guy, Barry Rebo, said, "HD can't be any more than five years

> **...in order to make some grandiose change, I found a company in 1989 in New York that thought that HD [High Definition Television] was right around the corner.**

away. This is the future." That was in '88 or '89, and here it is 2002 and I still don't say, "It's here." It's just still out there floating around, and in many ways it's just starting to infiltrate. We thought it was going to be on the air with everything broadcast and everybody with a new TV by 1995. We were convinced of it. So it was interesting work, in that I went from working on the most sophisticated tools for 1988 (we bought the

hottest, coolest stuff [at Charlex]) to a technology that could make beautiful images, but that's all it could do. It had a great monitor and a great camera, but there was nothing in between. There were no tools in order to do video effects. It was like going back to Synapse where we didn't have any sophistication. You just had to go back to old effects methodologies. I went back to old film books and animation to try to figure out how they did things. I tried to apply all the things I had done in the commercial world, because there were no tools. It was interesting and we struggled with it for a while. Again I worked for them [Rebo High Definition Studios] for five years and every year we were doing something new. I was back directing live shows and directing Japanese videos for Japanese TV. We worked on commercials, for whatever reason I don't know since they'd all have to be transferred to normal def anyway, standard def as they call it now. We also did documentaries. Every year they thought they had a new niche into something. I'd come back and do the effects and do the editing for all those things. It was a company with anywhere from 15 to 50 people, but you sort of do whatever needs to be done. So I worked with HD in New York City for about five years.

What got me from New York to out here [Los Angeles] is that he [Barry Rebo] had a moderate amount of success, but he really thought HD would catch on faster out here, so he opened up a facility in Burbank. I said, "I'll open up the place for you, maybe work up to a year or something and then I'm out of there." That's what I did. I came out here and wasn't here for a month when Digital Domain opened up. I moved out here in '93 and soon after that Digital Domain opened up. I talked to them right away, but I had the commitment to the high def folks, so I did high def out here for nine or ten months and got them going. Price [Pethel] and Scott [Ross], who I had actually known from the video world prior to DD, said "We'll wait for you. When you're ready to come over, come over." So I came over here [to Digital Domain]. Between the editing I had done and the effects directing work, I had a combination of skills. At that time DD was beginning to hire everybody from all different backgrounds, math, etc. You (David Santiago) got hired around that time. [Note: David Santiago was hired at DD in 1996 at the tail end of that hiring period.] "You're really good at math, you can probably work here. You've done film, you should come over here. You've done high-end effects in the commercial work, we can use you." Nobody had real experience. Everybody

> **I came out here and wasn't here for a month when Digital Domain opened up.**

was just bringing people over who sounded like they'd be good at it or interested. The work I had done was most like compositing. Although, I had already been supervising everything in those other places, it was an opportunity to learn the box [computer system and software] I might end up supervising. I started doing Flame, and *Apollo [13]* was my first job on the Flame. That brings me up to DD. Should we switch questions?

DAVID: *What about the tools? Did you learn all the film compositing tools when you arrived at Digital Domain?*

MARK: Yeah. I didn't know the box and I didn't know the film business. I was sitting down at the box learning the Flame, and Digital Domain was just learning how to do everything themselves, too. The first year or two was just the learning process of this business in its infancy. I seemed to have hooked into a lot of things early. I feel like I've been riding a wave, in a way. The commercial world started to intermix with the digital video and I took to that. With HD, I might have jumped in a little too soon, trying to stay up with the latest tools. I'm not as technical as a lot of other people, so although I seem to be floating around these technically oriented disciplines, that's not really my approach to it. But I'm savvy enough to apply the technology to my creative approach.

> **I seemed to have hooked into a lot of things early. I feel like I've been riding a wave, in a way.**

DAVID: *So you started with Flame on all the shows. When did Nuke [Digital Domain's proprietary compositing software] start getting used?*

MARK: It wasn't until *Terminator 2: 3D* that it was really used. It had been used in shell-based mode before [command line], but not that much. There were a lot of other packages floating around. We had Ice and Wavefront's compositor and several others for people to play with. I was pretty intrigued with Nuke right away. I haven't played much with anything else.

DAVID: *Did the compositing then come naturally from your background, other than learning the tools?*

MARK: Yeah, it was just putting things together to make them look photo-real.

DAVID: *When did you become a compositing supervisor at DD?*

MARK: Right after *Apollo 13*, I supervised 12 to 18 shots on *Waterworld*. Because I'd done all that work supervising in New York and a lot of the people coming here didn't have the skills to deal with the clients, it just became a natural thing. I didn't really want to get off the box and stop doing the art. I like doing the work and like saying, "that's my shot." Because of the background I had, Digital Domain moved me into the position. I hadn't been here a year, and I guess that was a test bed they had for me. Then I [compositing] supervised a couple of commercials, because back then they used to sling people back and forth between the film and commercial departments. Then the next stage happened when a commercial job came up and there was no one to supervise it. It was a week or so project that was my test bed for visual effects supervising. I wasn't necessarily the hottest Flame artist or anything like that. I could give people what they wanted and I could deal with the people and do the people part of it. I think I was interested in bringing other people's visions to life. "He brings vision to life"; I sound like Kodak or something [laughs].

DAVID: *What was that first commercial you first visual effects supervised?*

MARK: That was Capri Sun "Silver Surfer." Did you work on that?

DAVID: *I think I was on* Armageddon *previs [shot pre-visualization].*

MARK: Oh yeah, I worked on that too. It was all around the same time.

DAVID: *What do you think is the most important thing a compositor should know or understand?*

MARK: I would say lighting. That jumps to mind fairly quickly. When I used to work in post-production, in video, they had switchers, which are really ways of routing signals around so you can combine them. Basically, it's this big board that all the signals are routed into where you can dissolve between things or transition between things. I used to see it as a lighting grid. On one bank, I'd have the shot and in the second bank, I'd have the shot with a big black square over it. Then on the third bank, I would dissolve between the first two and actually be changing the lighting levels of the shot. I saw everything as lighting tricks and lighting adjustments. From photography I learned what light does when it falls on something at the middle of the day or the end of the day and what the reflections and shadows do. That sort of thing is all about lighting. So I'd say that was the most important thing. Then of course there's color, which is completely integrated with lighting, but broken down. Color changes your view of an image, its three-dimensionality or

whatever. Color and lighting are the things. Of course, you're going to have to learn greenscreen mattes and the tools, but I think to be a good compositor, you've got to have a sense of lighting.

DAVID: *Having been provided with the elements for a composite, how do you proceed?*

MARK: Well, given any number of elements for any specific shot, as an artist and as a supervisor, I need to very quickly and very roughly get it into a form I can iterate over the quickest. So when I first put something together, it's like a rough stone, and each iteration is polishing the stone. The first step is to take the big chunks out of it. For example, even when we are rushing, like on *Titanic* we used to talk about slap comps. Slap comps were just a quick way to get the elements together, with no concern over the edge, how it looked or lighting or anything, and then one by one, start eliminating the most incorrect things. Like one element is lit completely wrong or maybe there are more three-dimensional issues, like one element is rendered with the wrong aspect or the tracking is off. When you get the rough stone together, one by one you are now attacking to eliminate things from the grossest to the finest. So that's my initial approach. Put it together roughly. Then I'm very concerned about how to iterate the fastest. It's like back in the art department of my college. If you take three to four days to do something, you're not learning as quickly as if you're doing it faster. Of course, like in the early days of Nuke when things weren't fast, or *Titanic* and two other jobs are working at the same time and renders take 12 hours instead of 4, that just kills the creative process. The big concerns are being able to put it together quickly and being able to iterate quickly. You say, "Now that I've got this, I can add a little bit of edge light. If the shot had to go out now it'd be okay, but it'd be better if I could add a little bit of rim light." It's coming down to the details. The longer I have to work on something, the more I can work on the details.

> Of course, you're going to have to learn greenscreen mattes and the tools, but I think to be a good compositor, you've got to have a sense of lighting.

> So that's my initial approach. Put it together roughly. Then I'm very concerned about how to iterate the fastest.

DAVID: *How heavily do you rely on compositing to create the finished image?*

MARK: My biggest concern, ultimately, is that the shot doesn't stand out. There can be issues with the 3D elements, or the animation, or a story point, or the way it was shot, or the lighting. There can be issues with all of those things, and there often are. Not every movie is great and not every chapter in a book is good. But if a shot is noticed as an effects shot, it's for compositing issues. If my mom can tell me that it's an effects shot, that's a big problem to me. I think that it's less due to 3D issues. Sure, usually the 3D elements don't always get to you [the compositor] in such a way that they're ready to put in the shot, but you can almost always massage them in such a way that they fit in. Again, my big thing is to make it look like I photographed it, whether it's in outer space, or on the *Titanic*, or some ride film. Compositing gives it away or sells it.

> **If my mom can tell me that it's an effects shot, that's a big problem to me.**

DAVID: *What are you looking for in the 3D elements you receive?*

MARK: The ideal situation, if there is enough time, and ability to render, and disk space, and enough money and everything, is that every element is broken down into the most layers possible. Like for a shot in *Star Trek*, first the ship is delivered ambient lit, then a key-light pass, and then a rim-light pass, and then a reflection pass, a self-shadowing pass, and then the shadow pass. As many elements as you can that separate light. I find it very ideal to have a [compositing] script with all those passes and it's like doing an audio mix that you're doing at the end. That's my preferred situation, when the 3D elements can be broken down into the most passes possible, and I get to put them back together in one piece again. That's often a situation that's dictated by the production or time. Money or time [laughs].

> **The ideal situation, if there is enough time, and ability to render, and disk space, and enough money and everything, is that every element is broken down into the most layers possible.**

DAVID: *As a compositor and supervisor who works directly with clients, how do you go about developing a new relationship with a client?*

MARK: Well, I would quickly give them the sense that not only do I have a lot of my own ideas to contribute, but I am also willing to be part of the collaboration. Not just that I have a lot of ideas and I'm headstrong, but "I have a lot of ideas, but I'll do it your way too" kind of a thing. If you don't have any ideas, you'll find me filling in. When they have a blank page, I can fill it up, and when their page is full, I'll stay out of the way. The way the relationship develops changes with every person. Sometimes you talk about other jobs you've been on, or show them other work you've done, or you talk about movies you just saw last weekend. There are a few ways to establish rapport with someone.

DAVID: *How much of the collaboration happens in pre-production and how much happens during production?*

MARK: As much as possible should happen in pre-production. That's a luxury again that has to do with the time and money thing. There's a lot of belt tightening going on. The first places they always try to save money are pre-production and post-production. It always stays in production, I find. So, usually pre-production is not long enough and quite frankly, personally, I probably take longer on that than I should. I always wish there was more pre-production and planning—more time to wrap your head around it. I'll admit whole-heartedly, even before I started doing this, I was an Alfred Hitchcock freak. Alfred Hitchcock always said that he hated actually making moves, but he loved planning to do them. It was all planning to do that shot, and the costumes, and the designs, and the story, but once the first day, the first unit started rolling, he hated the job right until the end. I always thought that was interesting, and now I find myself seeing exactly what he meant. I do like the post-production part of the job, but I wish that more time was spent in pre-production. I feel pretty good and confident of my abilities during first unit production, because that's all about making decisions on the fly. You can have as many plans as you want, but when you are shooting in the most expensive part per hour of the job, you have to make decisions quickly. I like doing that.

> **You can have as many plans as you want, but when you are shooting in the most expensive part per hour of the job, you have to make decisions quickly.**

That's like sports or something. You have to make quick decisions and then you have to live by them all of a sudden. I love doing that; it's adrenaline inducing. Actually, when I worked for the television station it was that whole *Broadcast News* syndrome; I loved that stuff. 'Gotta be out in an hour.' You can't not make the evening news. That kind of experience makes me like production, but a lot of the time it's the worst place in the world to be, sitting around on first unit. Anyway, I think being able to respond on your feet is an important part of the job during production.

Also, during production and post-production there are procedures as you work. You have to know when to turn around and re-address things another way. Sometimes people get stuck because they feel they're 85 percent of the way done and think they must finish that way because there's only 15 percent of the work left to do. But I have a very specific theory about this. I once wrote it down, but I don't have it around here anywhere. In doing any job, in making any composite look good or creating any piece of art, whether it's a sequence or shot or movie, you can do 80 percent of the work in 20 percent of the time. The next five percent may take another five percent of the time. So you can get very close, 85 percent of the way to something looking good, to something completed in a fraction of the overall time it takes to do all the work. The difference, and the really hard work, which makes the art or the shot or the

> **The difference, and the really hard work, which makes the art or the shot or the sequence or the movie, comes in the last 10 to 15 percent of the work.**

sequence or the movie, comes in the last 10 to 15 percent of the work. You'll spend 75 percent of the time on the last 10 percent of the work. You could do a slap comp in a few hours, but you might end up working three months on the shot for the details. So you have to think, "I might be 85 percent down the path on this, but it doesn't mean I can't back up and approach it really differently. I can get 85 percent down on the path in a couple of days, and I know I'm going to work on this shot or sequence for weeks." I think that is something that I always try to keep in mind.

DAVID: *What part of the work is the most fun for you now? Is it supervising the artists, collaborating with the clients, or something else?*

MARK: I would say the most fun is whatever presents the most challenge. Right now, what I am focusing on is trying to understand each director more fully, getting inside of what he wants and knowing his work methodology. I guess it has a lot to do with the pre-production part of it. Being able to approach and attack a job based on that person. And then, I always like the finishing part of the job [laughs]. You know, seeing it realized, knowing that hundreds of decisions were made to take this path and that path. Feeling that more

> **I would say the most fun is whatever presents the most challenge.**

of the decisions were the right ones than less, and so on and so forth is nice. I also like teaching what I do. I think actually as a compositing supervisor, I had more of an opportunity to do that, because I had people new to the software and to the field and you could bring that to them. As a visual effects supervisor, I don't feel I am as much of a teacher, in that I don't get to help people benefit from my previous knowledge since I spend more of my time trying to interpret the director's purpose and trying to have it realized.

DAVID: *What kind of tips or tricks do you have for getting that last five percent done on a composite?*

MARK: Ten years ago, 80 percent of the elements you put together came from photographic elements and 20 percent came from CG elements. Now it's the opposite of that. On *Star Trek*, I'm dealing with 80 percent CG elements. Well, I shouldn't say that. If I took that show as a whole, it's probably not that way. But I don't even count stars outside of windows; that's just extra stuff. My point is that in more and more of what we work on, more of the frame is 3D and less is photographic elements. So what I was basically leading to is that you could have all your ducks in a row with the lighting and color relationships, but it still doesn't look right. It doesn't look photo-real. The last little touches are what make a photo look like a photo. What is that photographic thing that happens in any kind of photography, whether it is motion picture or still? It usually has to do with lens distortions and anomalies. You've probably composed a scene that looks good, but you haven't put the

"camera" in front of it. It's basically naked out there, and now you have to put a camera out there so it looks like it was photographed. So it looks like it exists with the rest of the film. So how do you do that? You screw up the image; you distort it; you add grain; you add lens distortion and lens flare. You take away from that image that you made so beautiful and so tight. Everything looked perfect. You soften edges, zoom in on a photograph, and get closer and closer and hardly any edges are really sharp. Look at the edge of the frame. Almost all frames are vignetted in some way. Look at the way light falls off as a whole on that square, not the way light is hitting one particular element within the frame. Look edge to edge on the whole square and see what it is you can do to put a camera in front of it.

> **It's basically naked out there, and now you have to put a camera out there so it looks like it was photographed. So it looks like it exists with the rest of the film.**

DAVID: *Is there a difference in the way you go about compositing a commercial or a feature film or a video?*

MARK: Again there's kind of a mix between how much money you have, which translates to how much time. Or how much time are you willing to spend. Are you making art? Are you selling something here? Commercials are ultimately disposable, because they have a known lifetime. You don't usually see a commercial for more than a couple of months. Yes, a lot of money is spent on a commercial, but you don't spend the time on a commercial that you do on a film because the film has a longer shelf life. So everyone buys into the high ideal that it's more important. From the script to the screen, to sound kind of corny, if the photography is good, and the story is good, and written well, and acted well, and the effects are good…if everything is well done, this might be something that outlives us 10 times. It's fun to work on the other media, though. Like I said, I am actually one of the few people who enjoyed working broadcast television. Every day was completely different, although in retrospect every day was awfully the same. I don't mind that kind of stuff. It turns on a different switch inside of you. Music videos—there's never enough money to do those things right. They're not really supported that way. But yet, you can turn on the TV and see a video from the '80s or something. So it certainly has a much longer life than commercials, but not half as well done as most commercials. Commercials, TV broadcast, music videos, and films all have their own interesting goals as part of what they do. Even commercials can be a lot of fun. They're like

> **So maybe in an ideal world, you could arbitrarily switch between the media. I think it would be very helpful.**

with details so I'd like to work on a film now." So maybe in an ideal world, you could arbitrarily switch between the media. I think it would be very helpful. A lot of times, new compositors and artists come into this and I feel bad that they've never worked in some of these other disciplines. I think it would be excellent for everyone to work in television at some point in time. I think compositors should know how to edit and they should know about music. The same way I make analogies to lighting grids, I can make analogies of an audio mix-down to compositing. I find the editing, compositing, and music mixing disciplines very similar in the way I approach them.

DAVID: *Maybe compositors should be required to edit a project together with video and audio.*

MARK: I absolutely, definitely believe that. I think every person in this facility here should shoot and edit something on his own—to be in charge, and really sit down and work through all those disciplines.

DAVID: *What do you think is one of your most notable technical challenges or accomplishments?*

MARK: *Stormrider* [a 2001 Disney ride film] was the first job that really swapped that priority between photographic and CG elements. Now it was whole minutes of CG that had to last on its own. It was on the big screen, 65mm finish for a ride film, so you are immersed in it and very close to the image. That project had a lot of technical achievements. Integrating it with the ride and with Disney's tradition was a challenge. They had a whole system for doing that sort of thing [ride film motion interactivity]. I researched many ride films. The worst thing about them to

short films. They often have a lot of production value, but you have to work faster on it so you don't have to spend a year on it. Every single medium has something fun. Maybe in an ideal situation you can float between those disciplines. "I can pick up my speed chops, or work on my quick thinking, or learn to deal

> **That project had a lot of technical achievements. Integrating it with the ride and with Disney's tradition was a challenge.**

me was that the picture was not well-integrated with the ride experience. My idea was that we should have a version of the ride simulator here, at Digital Domain. When we'd finish a sequence we could pop it on the simulator and view it. Not only viewing it with the ride, but actually program the ride to have a cool move in it and have that fold back into the film. Houdini [a graphics package from Side Effects Software] was talking back and forth to the simulator. We kind of got it working, but at the end of the day, the Disney people didn't take as much advantage of it as they could have. Maybe it was a bit of a failure on my part [in my attempt] to bring some new technology to them. They were comfortable with the old system of some guy sitting there with the joystick making the ride exactly how they wanted it to be. Because I couldn't get them to latch on, we didn't use it [DD's in-house motion simulator] as much as we could have. I think it was a great technical achievement. It didn't come to fruition on the screen, but I spearheaded that and people like Mike [O'Neal, the CG Supervisor] and a bunch of others who worked on that job, did a great job. So, *Stormrider* had a lot of achievements: Producing an image that was not shot on 65mm, so we had to blow up the image; distorting the image since it was on this huge domed screen and had to end up looking flat; integrating the film with the ride program. *Stormrider* had more technical challenges than creative challenges, but the creative challenges were vast too. When it came down to it, it was one five-minute shot. I could just go off with the complications of *Stormrider* being one shot and dividing it up so we could work on it. There were aspects of the ride film that weren't well-evolved before we started. For example, we are supposed to be in a plane with 10 windows on the sides of the cabin. So these portholes were looking out to the scene out there. Not only do we have the five minutes full screen in front of us, but 10 more screens we need to fill. What exactly should those look like? How sharp are they? How clear are they? How perfectly rendered are the images on the side screens? Wouldn't that distract from the movie on the front screen? How do you get around that? I really had to spend a lot of time thinking through that. Sometimes bringing more priority to something like that is part of my job. Those 122 viewers in this room bouncing around are going to be rushing by 10 screens. How do you guarantee those screens are color corrected? If they're TV monitors, what if one's green and one's red one day? You're not going to feel like you're in a plane anymore. It's going to be obvious. Usually you have a single image to look at, and now you've got 11 and they've got to match. Part of making them integrate better was actually making suggestions of how to make them a much

> **I do every possible thing I can to not think about the technical aspects of it. I want that to be transparent.**

smaller deal. Suggesting there is an iris on the window that opens and closes at certain parts of the film, or that the windows are frosted. I always wanted to enhance the experience. I do everything I can in my job to make it a non-technical job. It's not the way other people approach it. I do every possible thing I can to not think about the technical aspects of it. I want that to be transparent. I want it to be a creative position where I am visualizing, helping someone interpret their vision, and keeping the technical aspects transparent. Maybe this is from my commercial background and working in post-production. They have these fancy suites and leather couches for the clients that come in, and they serve them nice food and drinks. Everything is to soften the fact that this is an awfully tedious process that they are experiencing. If you had a cold room with hard furniture and no phones or food or anything, then it would be unbearable for them to sit in there. Actually I think some places do that so they [clients] don't sit in there. The point is that those machines are connected to machine rooms in the back somewhere, so the whole engineering and technical processes are transparent. You should feel like you are in a creative environment. From my post-production days, the idea was that there were hundreds of engineers in the background turning the cranks and making things work, but not in the room. The minute engineering or software or systems shows up, something is technically going wrong with the job and the client gets all upset. Why is he in there? I try to focus on the creative and make the technology adapt to the creative process. Don't make a technological challenge out of it. And when you have a technological challenge, what's the creative approach to diminishing the technology to get you there? I won't always use the latest and greatest to do something. On *Stormrider*, we used splashes that I shot with a video camera in somebody's backyard pool. People would say, "This is going to be on a 65mm screen, so let's go shoot those on film or high def." I shot some stuff in a pool with a video camera and we used it. It's in the final image and nobody would know. Whatever it takes to get there.

DAVID: *Does Disney know that?*

MARK: Ultimately we told them [laughs]. They saw it worked well.

13. An Interview with Mark Forker

DAVID: *What is a past creative challenge or accomplishment that comes to mind?*

MARK: Let me think of one. On *Apollo*, although I had a certain amount of background in effects, I was using a new tool, the Flame. It was more about there being good compositors and competent compositors and bad compositors and everything in between. I'm assuming that all three of those categories understand the color and lighting issues I talked about. But a really good compositor can make something out of nothing. Say you're delivering 10 elements to put this shot together: the background, a couple of foreground greenscreens, a couple of 3D elements, some lighting effects, and a spark. You're given these elements to put the shot together. You can understand color and lighting, the technical issues of putting the comp together, and put the final touches on with the photographic or lens distortion effects or whatever, and it can be just a fine composite. But a person who takes those elements and ends up having a 20-element comp because he's created 10 of his own elements out of bits of dust, flame, or sparks from somewhere else is a good compositor. A lot of compositors (actually I've got this myself from when I was a tape editor in the video world) collect little reels of effects. When you need water, you use it. You have a piece of water you know you can use in a hundred different ways. As a video editor, I had elements like that I could always count on, that I could make something else out of. I think likewise, for a compositor it's an enormous trait to be able to say, "He asked for a certain kind of atmosphere and sure enough he delivered me a smoke element, but what he really needs to do is multiply the smoke by this fire element I have to help add some animation to it. I'll print it in really light and I'm only multiplying by a little so you won't really see it." On *Apollo*, I felt I had really learned how to do that in this field. I'd been doing that stuff, as I mentioned, prior to that in the video world. But on *Apollo*, I

> **...a person who takes those elements and ends up having a 20-element comp because he's created 10 of his own elements out of bits of dust, flame, or sparks from somewhere else is a good compositor.**

> **Creating something from nothing, to me, is a characteristic of a compositor that's above the rest.**

was surprised I was able to do that, since I was so new to the tools and the package and format. Personally, I ended up getting a lot of the launch sequence. So I was making all the smoke and fire elements that came out of the bottom of the ship completely from scratch or from found elements or reutilizing elements from other shots. Creating something from nothing, to me, is a characteristic of a compositor that's above the rest.

DAVID: *Are there any other creative accomplishments you would like to talk about?*

MARK: Well, when you first asked the question, I was going to mention something about *Titanic*. That job for me was the first use of mocap [motion capture] and trying to use digital characters. There were always digital elements, but never digital people—people with skin and clothes and so on and so forth. For us, it was a whole new thing, for everybody here using mocap and how to make that actually work. So when you asked the question originally, I thought about the very first way we proved that to ourselves. We took a shot that I don't even know where it came from. It feels like a shot that was on the end of a film reel or something. I don't think we shot it for this test that I must have worked on for three or four months. It was a guy sitting on a bench out in the parking lot or somewhere. We said, "Let's take that shot and have a guy that looks just like him come in and sit down next to him. He'll be dressed the same way—a twin. Let's make his twin completely from 3D." Again, for some reason now in the blur that *Titanic* is, I don't remember how planned that plate was. But we spent months working on every aspect of skin, lighting, clothes, and textures. In the background, all the animators, character guys, modelers, and everyone worked on all the issues of using mocap and smoothing out animation. It was all happening at the same time, but in my little world, I was just making A match B, and making him look like his twin. That was the setup, and created the paradigm for the rest of the show. We came up with these multiple mattes, reflections, lighting passes, rgb passes, and so on. You were on *Titanic*, you must have used or made some of those?

DAVID: *I mostly made it possible to use those, but I guess I used some for tests.*

MARK: Yeah, I forget what you do. You've done it all. So anyway, the first time I had to twin somebody was a huge creative challenge. I spent a long time on it and I feel really good about it. I wish that little shot of the guy walking in the parking lot was in the movie.

DAVID: *It's got to be on film somewhere. I've seen it 'millions' of times.*

MARK: Do you remember that shot? Did we really shoot that plate for that?

DAVID: *I think we shot it. I think along with the test of the guy whose hat blows away from him. Maybe not, but it was on film.*

MARK: Well anyway, that was the shot.

DAVID: *So, what advice would you give someone interested in becoming a compositor and entering that career path?*

MARK: Quite honestly, in little bits and pieces I've kind of gone over this. I can only say from my own background, but I've met a lot of people with photography backgrounds in this business. Either they were interested in photography or had to do something with print. When I say print I mean commercial print that uses photography, which is all about lighting to make single images look good. So we've mentioned the photography aspects. Another skill I've found useful is understanding color from a technical point of view, like color space and how color works and mixes. Also, in every free moment you have, you should be looking at that world outside. You see a car coming by and try to see where and what that car is reflecting in the puddle or the signs. It often doesn't really make sense how it shifts and reflects around. Take a close look in your windshield [at the light and reflections]

Figure 13.3
A photograph by Mark Forker entitled *Los Alamos Storage, 1998*.

Figure 13.4
A photograph by Mark Forker entitled *Christmas in Utah, 1997*.

13. An Interview with Mark Forker

when you're driving. Every time you think of it, look at the world around you. For example, in *Titanic*, so much of it was making the water. Making CG water for a show had been done a little bit before us with *Waterworld*, but at Digital Domain it was our first big water job. Since then, we get a lot of jobs, it seems, that have water in them. So during *Titanic*, I happened to live in a place where everyday I drove down PCH [Pacific Coast Highway] to get to work. Every day I looked at the same spot out on the water for five months, and made a point of noticing what that spot looked like. At this point I wished I had stopped and taken a photograph. I would have realized that for as many days, especially here in Southern California, which appear to be exactly the same kind of weather, something different is happening out on the water. It proves a couple of things to me: As much as the weather seems similar day after day, there are a lot of details that go into making that. A lot of times when somebody like a director wants something to look a certain way, you can justify it because the exact same moment in time with similar lighting, situations can have different things going on. I'm never one to think that there

is only one way you can make things look. So, if you are pointing south, and the sun is high in the sky, and it's a clear day, it's got to look like this. I don't buy into that. I passed that spot every day—I said for five months, but I don't know why I said that. I worked on *Titanic* for a year and a quarter. I saw the same exact spot and I wish I'd photographed it. Actually there is a book that just came out of this guy who stuck his camera in the exact same spot and took hundreds and hundreds of photos over many years. [*Golden Gate* by Richard Misrach, Publisher: Arena Editions] He was trying to show how different every one of those photographs was. But what's more interesting to me is how I can show you 50 photographs that look broadly similar to each other, but really have a lot of nuances and details that make them different. I think I started saying this, but be very overly aware of how light and color and the things in the world around you work. I think the question started out [laughing] as "What would you recommend to a young compositor?" Did I answer that?

But what's more interesting to me is how I can show you 50 photographs that look broadly similar to each other, but really have a lot of nuances and details that make them different.

inspired
3D LIGHTING AND COMPOSITING

PART III

Practical
Application

chapter 14
Lighting a Production Shot

The previous chapters described techniques and shared the knowledge and experience of established industry professionals. This chapter begins the practical application section, in which some of those tips and concepts are applied to a real-world example. The next two chapters step through the process of lighting and compositing a shot, from the time the scene data is collected to the point when the shots are complete and labeled as "final." This description is a continuation of the processes shared in each of the four books in the Premier Press *Inspired* series. The models for this scene are provided by Tom Capizzi, and the steps involved in creating and texturing the models used here are covered in his book, *Inspired 3D Modeling and Texture Mapping*. The process of creating the character rig used in the scenes, which includes the joints, facial controls, and anything enabling the character's movements, is covered in the book by Michael Ford and Alan Lehman titled *Inspired 3D Character Setup*. Kyle Clark gives life to the character, and in his book, *Inspired 3D Character Animation*, covers the process of animating the character in the story. That brings us to the lighting and compositing.

This collaborative effort mimics the production pipelines found in digital production studios. The communication, hardware and software issues, and critiques of the work are all a part of the process. The project revolves around a story created specifically for this book series, with the intent of exploring the process of creating our own pipeline and creative content. Sharing ideas and data with a group of people scattered across the country has proven at times to be difficult, but the overall experience has been both enlightening and successful.

Without a production crew tracking every detail and every element, each author is responsible for his own organization and prioritization. The constraints include hardware considerations, the scope of the project, deadlines, and budget. With four books in production, in addition to the creation of the scenes used for the practical application sections, the process took on a slightly different path than that of a visual effects studio. The machines used for the renders are our own personal computers, not the hundreds of processors in huge render farms available at large studios. Iterations are limited, and planning takes on an even greater role in this scenario. The budget is not that of a summer blockbuster film, so our examples emphasize the process while still creating an interesting character that serves the story. The techniques covered earlier in this book are put to use here, with more emphasis now on the workflow and less on the technical aspects of how it all works. With that in mind, I'll start the process and you'll see what the computer graphics world has in store for the newborn character.

The Goal of the Shot

To begin any shot, the TD first needs a clear understanding of the goal for a shot and how it fits in with the surrounding shots. The storyboards offer a good starting point for obtaining a general idea of the story points and how they cut with each other. With the project for this book, called ISF (Inspired Short Film is the not-so-great working title), discussions were conducted early in the process regarding the story and the creation of the artwork. Once the story was ironed out and the script was created, storyboards were drawn to help with visualization (see Figures 14.1 and 14.2). Artwork used as a reference is usually discussed with the supervisor or the person in charge of the artistic direction during the shot production. The

Figure 14.1
Storyboards for CG animation shots SF-00 and SF-01.

Figure 14.2
Storyboards for CG animation shots SF-02 and SF-03.

supervisor acts as a go-between for the original creators of the artwork and the people working on the shots. Because each of the participants in ISF was actively involved in the storyboarding process, there was no need for such a middleman. Storyboards offer a good starting point, and they are valuable to look back on at times as a reminder of the story's intent. They are simply guides, though, and things can change as the shots develop and detail is added.

In an effects facility, a storyboard for a shot is usually accompanied by a chart providing many other useful bits of information. Because the ISF production was small, each of the participants involved was responsible for recording and maintaining this information during the course of the project. An online database was created, and each of us made updates and changes as the project progressed. Through e-mail, each member of the group was notified of every change, and all messages were stored for future reference if necessary. The pipeline for ISF required the ability to send large images and scene files back and forth among the participants on the project. Using this workflow, the requirements for the lighting and compositing were established.

Shots in Context

The surrounding shots and the story are important aspects to the goal of the shot. Familiarization with the sequence and how the shots cut together is useful both for establishing continuity and for understanding the major points of interest. The scenes depicted in the storyboard drawings of Figure 14.1 cut directly together. On the left is an opening shot establishing the scene in a workplace of cubicles. As the first shot in the sequence (labeled SF-00), it sets up the mood for the shots to follow. Shots in a digital production require names, and a common format is a two-letter abbreviation representing the sequence name (in this case, Short Film), and a two-digit number, representing the shot number in the sequence. Shot SF-01, depicted on the right of Figure 14.1, represents the interior of one of these cubicles and our hero stretching and yawning. Because these two shots cut together, it is necessary to match the general mood and lighting scheme. They are, however, different camera angles showing different areas of the workplace, so there is some artistic leeway with regard to perfect continuity. Cutting to the third shot in the sequence does not offer this luxury (see Figure 14.2, left). Shot SF-02, a close-up of the character yawning, requires accurately matching the previous shot's lighting. The fourth shot in the sequence (see Figure 14.2, right) shows the character heading back to his chair and settling down to work. Once again, shot SF-03 must maintain the lighting and look of the previous shot due to the similar camera angle on the character in the shot.

The story represented by these boards is that of an energetic computer graphics artist dealing with many of the craft's frustrating events. The four shots pictured are the opening shots of the short animated piece. They offer insight into the flow of the story and the goals for making each shot fit with those surrounding it. Each of these goals is related to the ultimate vision for the look and feel of the shot. Many opinions are involved in creating and improving the work, but in the end, it is the director's vision that determines when a shot is ready for a spot in the final product.

The Director's Vision

Maybe it's Spielberg or maybe it's you, but someone has the vision for the shot, and it's up to you to understand it and produce it with computer graphics imagery. This is the goal, and without an understanding of that, the most beautifully lit scene may not achieve the result requested. Developing new techniques and coming up with amazing new looks is great, but creating an image showing off brightly lit, perfect reflection maps, brings few plaudits if the director asks for a dull, unobtrusive CG element.

So how do you know what the director's vision is and how to obtain it? Many of the answers lie in the meetings that take place at the beginning of a project. With a large film project, these meetings occur long before the TD ever sees a shot, as the director, scriptwriters, and studios work to get a project into production. With ISF, however, the process was quite different. Due to the collaborative nature of the project, we each had input at the beginning and all through the production on how the scenes would look and for the ultimate vision for the project. Each of us played, in part, the role of director and shaped the vision for the project. This process offers the opportunity for each person involved in the production pipeline to offer input on not only creative concepts, but also optimization. As the specific portions of the story were discussed, each member of the team was able to offer ideas and suggestions on what was possible, what might help make things move more smoothly, and what would be unlikely given the time and the resources. In terms of lighting and compositing, it was important for me to point out when elements would be required and in what format they would need to be created. Directing by committee takes a tremendous amount of communication and willingness to compromise, but in the end, the result has been a rewarding experience.

Setting Up the Lights

Armed with a clear visual understanding of the shot's intent, it's time to add the lights and make it look beautiful. The shot begins with analysis of both the background plate and the online reference to determine where the initial lights are placed. If the scene is completely digital, as the shots in this chapter are, then all elements necessary to render the scene may be in one 3D scene. Depending on the complexity of the elements, scenes are split up for easier management, and either combined during the rendering process or afterward in the compositing stage.

To understand the scene, it is helpful to view it from several different angles, in addition to the scene's camera. A top view and a side view offer a feel for the scale of the scene, how far away to place the lights, and how the character relates in 3D space to the set (see Figure 14.3). The shot here is SF-02, which is a close-up of the character yawning. The camera for this scene is the highlighted green camera. The other cameras represent views from other scenes. The view from the camera shows exactly how the character fits within the picture plane (see Figure 14.4). At this point, it is helpful to look at several different frames throughout the shot's length. Creating a quick, hardware-rendered flipbook (see Maya's manual entries for *playblast*) provides reference showing the character movement as the shot plays through its frame count. Take note of which character parts stay in frame, which parts may enter or leave frame, and where the eye is drawn by the motion throughout the scene. The character's animation and framing work together with the lighting to create the visual impact agreed upon when establishing the vision for the project.

The Key-Light

Now it's time to create and locate the lights. From the storyboards and the art direction of this shot, it is apparent that the character is the emphasis. The framing leaves little other choice, and the yawn is the obvious story point. With that in mind, start with the basic three-light setup. Although the shot does not at first glance lend itself to the strong key setup that exists in a scene with direct sunlight, it is still a good starting point. To identify the direction of the key, the scene is analyzed in terms of possible lighting contributions. The desk lamp in the corner has been chosen as the key-light for this scene, because it has an obvious presence in the environment. With a live-action background plate, the set lighting dictates the starting point for the CG lighting. Before adding the fill and rim, the key can be tested by itself and adjusted to create the most pleasing composition for the scene. Using only the key creates a high contrast scene and provides a base to build from with the other lights. Once the key-light looks good, the others are integrated

Figure 14.3
Top view (top) and side view (bottom) of the scene for shot SF-02.

Figure 14.4
Default lighting, shaded view from the camera for shot SF-02.

much more easily. Do not underestimate the power of a single light source. For an excellent example of dramatic but minimal lighting, watch the classic film *Citizen Kane*. By using harsh lighting techniques, Orson Welles creates a world of striking contrast and visual intrigue. The character in shot SF-02, rendered with only a key-light, might not quite be up to *Citizen Kane* standards, but it's a start (see Figure 14.5).

It is common for a TD to work on multiple shots simultaneously, and many times similar shots are handled by the same TD to help maintain continuity. Shots SF-01, SF-02, and SF-03 are all similar shots and can likely utilize many of the same lights. A lighting rig, comprised of lights the scenes have in common, helps to maintain consistency. There are a number of ways to create the rig, the simplest being to create the lights, export them into a separate file, and copy that file into each scene. If the setup is more complicated, involving constraints to geometry the scenes share for instance, a simple scripted set of commands can automate import of the lighting rig. Lighting rigs are particularly useful on large productions with many shots of the same creature or character in similar lighting conditions.

Figure 14.5
Shot SF-02 rendered with the key-light only, from two different light positions.

Testing Key-Light Positions

Because the lighting for shot SF-02 needs to work well with shots SF-01 and SF-03, key-light tests on frames from those shots are helpful as well (see Figures 14.6 and 14.7). In Figure 14.6, the key-light is fairly low and in front of the character. This position most closely simulates the desk lamp, but using the key-light from a low angle such as this results in a frightening looking character. Lighting from low angles is commonly used in horror films, but the goal is not to create a demonically possessed CG artist. Because most people are seen with lighting from above, whether it is from the sun or a light fixture, the unusual shadows cast by lighting from below cause the character to look otherworldly. The key-light positioning in Figure 14.7 offers a more flattering look for the character.

CG Light Choice

The key-light is a spotlight with no color adjustments at this point. The cone angle is wide enough to extend beyond the view of the camera, and the edges are softened using a value of 20 in the penumbra field. Each person develops his own techniques and preferences for choosing lights and placing them in a scene. There are no hard fast rules in this process, because the final image is judged and not the CG lighting setup. The examples shown here use only spotlights because of their versatility and the level of control they offer. The key-light in each of these scenes uses depth-map shadows with a 2k resolution. This is a fairly high-resolution size for shadow maps, which helps reduce artifacts apparent in self-shadowing situations. Figure 14.8 is a detail view from a frame of shot SF-01

Figure 14.6
Shot SF-01 (left), SF-02 (middle), and SF-03 (right) rendered with the key-light at a low angle.

Figure 14.7
Shot SF-01 (left), SF-02 (middle), and SF-03 (right) rendered with the key-light at a high angle.

showing the key-light shadow from the character's left arm casting onto his body. In the top image, the depth map shadows are rendered at a resolution of 512 pixels square, and in the bottom image they are increased to 2,048 pixels square. The top image shows artifacting in the shadow's edges, while the increased shadow map resolution in the image on the bottom has smoothed the shadow's edges considerably.

Of note, relating to the key-light, is a special light added for shots SF-01 and SF-03. The desk lamp providing the primary source of illumination for the scene is just behind the computer, in the screen-right corner of the cubicle. The light itself is not visible from the camera, but its affect on the wall is. The desk lamp is aimed at the wall and the resulting light bounces to illuminate the cubicle. Because the renderer is scan line and not ray traced, this effect is simulated with two lights. The key-light shines out onto the scene as the light bounces from the wall. A special light for the desk lamp shines from the desk up onto the cubicle wall (see Figure 14.9). The only illumination provided by the desk lamp visible from the camera is on the far wall of the cubicle.

Figure 14.8
Shot SF-01 shadow detail with 512 pixels square shadow-map resolution (top), and with 2,048 pixels square shadow-map resolution (bottom).

Figure 14.9
Shot SF-03 showing the special desk lamp light.

207

Figure 14.10
Fill light placement in plan (top) and elevation views (bottom).

Fill Light

Now it's time to add the fill and rim lights to the lighting rig. Because the rig should be as generic as possible, SF-01 is a prime candidate for a template lighting shot. The camera for this shot provides the widest view of the scene, so if the lights illuminate the proper elements here, they also cover everything in the tighter shots. The close-up shots may require additional lights for details, but that comes later in the process. The first fill light typically illuminates the side of the character opposite the key-light. Here, the fill is placed off to the screen-left side and lower in elevation than the key to more evenly fill in the left side of the character (see Figure 14.10). Figure 14.10 shows the key-light as well as the camera. Note the lines extending from the camera, indicating its field of view. This is helpful in determining the placement of certain lights to cover the camera's entire viewing area. Figure 14.11 shows the rendered result of the fill light's contribution.

Figure 14.11
Shot SF-01 rendered with the fill light only.

Rim Light

The rim light can be tricky and often requires a good deal of experimentation. To match the typical film lighting techniques, it is usually placed above and behind the character to be emphasized. In this scene, as with many movie scenes, there is no motivation for this light. There is not an actual light in the scene that would produce the rim lighting, but its purpose is to outline and accentuate the character. In my experience, the placement of CG rim lights tends to be higher and more toward camera than their real-world counterparts. Figure 14.12 shows the plan and side views of a rim light's placement, and Figure 14.13 shows two rendered variations of the rim light. Notice in the left image of Figure 14.13 that the character's screen-left arm has an intensely bright highlight as a result of the rim light's location almost directly above. The rim effect is usually a fairly narrow, bright edge, just big enough to define the character's outline. The image on the right of Figure 14.13 (which matches the light position shown in Figure 14.12) shows a narrower rim effect, although because of the character's position, the amount of rim varies greatly between the hair and arms. If a rim with consistent width is requested, it is sometimes necessary to add multiple rim lights that illuminate only certain portions of the character. These additional lights can either be created to shine only on specific geometry (called "object-centric" lighting in Maya) or can be zoomed in close with large penumbra settings so their edges are not noticeable.

Key, Fill, and Rim Combined

With the key, fill, and rim lights placed, the scene can now be rendered and evaluated with the contribution of all three lights (see Figure 14.14). This is the beginning of the lighting for the scene and establishes a basic key-to-fill ratio along with a rim location. The task now is in evaluating where the lighting looks good and where it needs help. Certain areas need help, such as the face, specifically the eyes. More general areas of concern are the ambient contributions from the scene and the many surfaces in this space from which to bounce light. Because one shot is a close-up, however, and likely requires different bounce lighting than the other two shots, the bounce lights are left out of the generic rig. For the purposes of this discussion, the three spotlights (key, fill, and rim) are considered the lighting rig to be shared among shots SF-01, SF-02, and SF-03.

Figure 14.12
Rim light placement in plan (top) and elevation views (bottom).

Figure 14.13
Two positions for the rim light in shot SF-01.

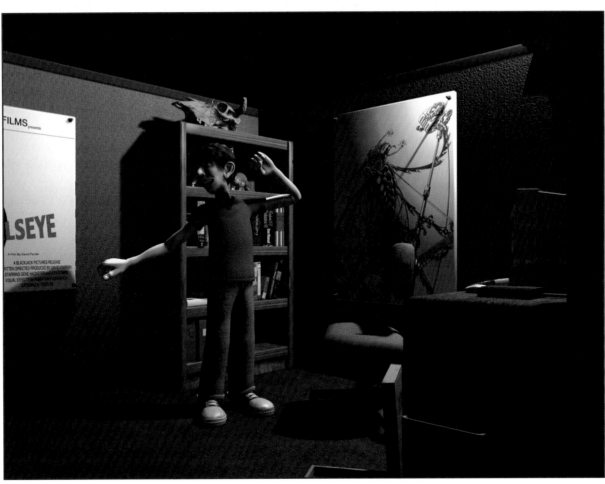

Figure 14.14
Key, fill, and rim lights illuminating shot SF-01.

14. Lighting a Production Shot

The lighting rig location is not locked. The rig may need to be moved based on the location of the character. If the entire rig is grouped under a single node (a parent node), it can be moved to other parts of the scene as one piece. Because the character is the center point of the shots, the lights need to follow him. Translation of the lights maintains the basic look established in the template shot, but any rotation changes the look and feel of the scene and hinders the continuity between shots. In shot SF-03, the character is closer to the monitor, so the entire rig may need to be moved in that direction. If the lights are far enough away, the character remains in the beams of the lights. You might ask, why not just move every light a great distance from the models to maintain the light contributions? There are two reasons why this is not a good idea: One is that the farther a light is from the objects in the scene, the less detail and resolution there is in the shadow maps. The shadow maps are rendered from the point of view of the light, so if the light is far away and the character is a speck in the middle of the shadow buffer, then no detail appears in the shadow maps. This limited information in the shadow maps causes artifacting in the render (worse than that depicted in Figure 14.8, top). The other reason to keep lights closer to the scene's subjects is attenuation. If the lights have falloff, as real-world lights do, their proximity to the models affects the illumination. If the lights are farther away, the intensity of the light can be increased until the light reaches the subjects. This solution has a major drawback, however, because a distant light offers a much shallower falloff gradient. The light decreases in intensity from its point of origin until it fades off to zero. Over a longer distance, this attenuation is gradual. Unless the light being simulated is sunlight, attenuation is more accurate and more noticeable if the lights are placed close to the subjects.

Reference and Observation

During the process of lighting a shot, observation and reference remain worthy of consideration. For the shots in this sequence, a general look for the lighting and color scheme is chosen by the team involved in the production. A color palette is produced to gain a better understanding of the range of colors that are expected once the scene is lit and rendered (see Figure 14.15). These color palettes are common in fully digital features, because the entire film is often mapped out in terms of colors and the moods they create. The overriding color scheme has a tremendous effect on the scene's impact on the audience. Color establishes the mood, and this scene is dominated by the blue portion of the spectrum. This tranquil coloring helps with the sleepy, late-night time frame that the shots span. By adding small amounts of the colors found in the palette to the lights, the scene takes a step toward fitting more closely with the intended vision.

The shots in this sequence received general lighting direction from the team of artists participating in the production. This direction calls for the scene to be lit

Figure 14.15
Scene color palette.

from the corner by a desk lamp. The glow of the computer screen is also described, but no additional specifics are mentioned. The character is obviously the focus, so the task is to create a lighting scenario within the basic range provided by the color palette and maintain emphasis on the character. A test scenario is created to investigate the type of illumination a desk lamp creates and how the glow of the computer monitor adds to the lighting of a fairly dark scene. By taking photographs of a scene with a desk lamp and a computer, additional reference is provided (see Figure 14.16). These photographs offer valuable footage, describing how a desk lamp can provide bounced illumination for the scene, as well as the effect a glowing computer screen can have on a character's face. This type of reference can be collected during the entire life of a shot and usually

Figure 14.16
Test reference scene with desk lamp and computer.

provides suggestions for improving the lighting. Each time a difference is noticed between a reference photograph and the computer graphics scene, ask the question, "What's missing?" By identifying the specific differences between the goal and the CG scene, creating the effect becomes a much simpler task.

Tests and Isolation

Once the initial lighting rig is created, additional lights are added as the shot enters the fine-tuning stage. Once the lights are in place, the render times increase and efficient testing of the entire frame becomes impractical. Test renders at this stage need to be done on smaller portions of the frame. Detail items such as the eyes, skin, cloth, and hair can be evaluated with very small renders showing only a portion of the scene. A typical method involves rendering the entire scene at its final output resolution for a single representative frame. That frame is saved and multiple tests are then created of small sections within the frame. These tests are then compared with the original render, as well as other tests, to judge whether the adjustments are successful.

The eyes offer a good example of this technique. Because shot SF-02 is so close on the character's face, the eyes take on more importance. With a render of the entire scene completed, smaller renders of only the eyes can then be completed very quickly (see Figure 14.17). This allows many more iterations for adding things such as specular highlights to the eyes.

Another technique involves isolating a particular piece of geometry and rendering it alone. The eyes can be handled in this way as well by selecting only the eyeballs, hiding everything else in the scene, and rendering. If the shadow maps are already rendered and saved to disk, this isolation of the eyes shows the proper effects of shadow from the eyelids or other hidden elements in the scene. Placing specular highlights in the eyes can be a difficult process, but this technique makes it much easier to run a great number of tests in a small amount of time. The special eye-highlight lights are added, tested until the specular hits are in the exact location desired, and then the rest of the geometry is turned back on to test the frame once again. The eye lights are typically specular-only lights with no diffuse contributions. They can also be set up as object-centric lights and only illuminate the eye geometry.

Isolating elements for testing is a valuable way to save time, but it can also cause problems when all the geometry in the scene is rendered. Be cautious of testing lights that affect an entire scene on just a small portion of the character. Unexpected or undesired results may occur in the areas not represented in the

Figure 14.17
Shot SF-02 with a partial render around the eyes created for testing.

small test areas. After all the adjustments are made in the small testing area, it is worthwhile to render the entire frame again to eliminate surprises. This is true on a single frame and also for other frames in the shot. A light producing the perfect specular highlight in one frame may produce entirely different (and unwanted) results at a different frame. It may not be possible to test every frame, but representative frames on the character's extreme positions and boundaries of the camera move are often worth a test render.

Critique and Prioritization

When the work is ready to be reviewed, the shot is rendered for the entire frame range in preparation for a critique. Each studio has its own way of handling critiques, but most are conducted in a forum known as dailies. As the name implies, these occur each day, usually at the same time at the beginning of the workday. The work is presented to the supervisors and other crew members, suggestions and criticisms are made, and the rest of the day is spent incorporating as many improvements as possible. Dailies present a great deal of valuable information, and taking notes is helpful for remembering each point.

Start Simple

The first time a shot is sent to dailies, it is in a rough format with basic elements and rough lighting. The first takes start the progression involved in critique and improvement. It is the time to get as many elements as possible into the shot rendered at full length. This involves render time, which takes place on the render farm of a studio. Depending on the size of the studio and the budget of the production, a certain number of processors are available for rendering the shots each night. Priorities are set based on how processor-intensive a shot is, as well as on how close the shot is to being completed. As a shot becomes more refined, it gains priority in the hierarchy in an attempt to complete the shots and achieve the quotas set by the production schedule.

Because the early stages of a shot receive lower priority in terms of processor time, it is necessary to keep things simple. The key, fill, and rim lights are enough for this take, particularly if one TD is running two or three shots at a time. The goal of this take is to show the entire shot with a basic lighting scheme and evaluate how the scene looks with the animation, camera move, and textures. The process for the shots represented in this book is similar, and each shot is run from start to finish with a basic lighting setup. This allows the modeler to evaluate the geometry, the character setup team to evaluate the character's skin and movement, the animator to evaluate the actions, the lighter to evaluate the lighting, and the entire team to evaluate the overall look and feel of the shots. The render resources for this small project are minimal, because we do not have access to a farm of processors, but the concept is the same: Get the entire length of the shot out in some form as soon as possible and begin the critical analysis.

Shot-Specific Details

Shots SF-01, SF-02, and SF03 start with the lighting rig and are developed on a shot-by-shot basis from that point. After each is shown in rendered format, decisions are made on what needs to be added, and priorities are assigned. Each shot requires the addition of bounce lights to fill in the darker areas underneath the chin of the character. The suggestion is also made to change the key-light to a warmer color and see how that affects the character's appearance in the primarily blue environment. This suggestion definitely yields a result giving the character a less pasty feel, while still maintaining the overall color scheme of the shot (see Figure 14.18). Shot SF-02 also requires additional work on the eyes.

Figure 14.18
Shot SF-02 with a warmer color added to the key-light.

The computer monitor produces a glow most prominent in shot SF-03, in which the character is closest to the screen (see Figure 14.19). This light offers a great deal of flexibility, because it can be any color. Changing its color from blue to red through the course of the sequence can be useful for changing the mood as the story progresses.

As these additional lighting suggestions are added to the shots, the refinement process continues. Each suggestion must be prioritized in order of importance to the shot and the time it takes to accomplish. More difficult additions should be started early, in case additional support is needed or an alternate method must be devised. The additions for shots SF-01, SF-02, and SF-03 are all fairly simple to execute, but each requires many test renders for fine-tuning. The critiques continue even when a shot is labeled as complete, but the renders at this point are labeled as final (see Figures 14.20, 14.21, and 14.22).

The process followed to create the images in this chapter is one of many possible approaches to producing a computer graphics shot. Because a great number of the technical aspects are covered in other chapters, this chapter simplifies the steps. With the basic computer graphics knowledge from those chapters, along with a solid understanding of a 3D software package, a computer graphics scene can be produced. The quality of that result depends on the time spent, the hardware and software resources, and the talent involved. The elements created in this chapter are broken down and reassembled in the following chapter on compositing.

Figure 14.19
Shot SF-03 with a light to simulate a glow from the computer monitor.

Figure 14.20
Shot SF-01 final render.

Figure 14.21
Shot SF-02 final render.

Figure 14.22
Shot SF-03 final render.

chapter 15
Compositing a Production Shot

N ow it is time to take the pieces and put them together in their final presentation format. The techniques presented in Chapter 12 are applied in this chapter to combine the layers created in Chapter 14. The layers in this case are created by a single person, yours truly, but the data used to create them is a collaborative effort among all authors of the *Inspired* book series. A small studio environment typically involves the same type of workflow, but a large studio utilizes more resources in terms of both computer processing power and man-hours. Multiple TDs often work on shots, layers are divided among those with different specialized skills, and the compositing is done by another TD. As deadlines near, the work is often divided among not only different shot TDs but also among different studios, as producers scramble to meet deadlines and make up for earlier production delays. Just as a single person working on a project needs to enlist the help of his peers to complete a project, effects houses often need the help of other facilities to finish their work for final delivery to the distributing studio.

The compositing stage can be a hectic time in the production process. Whether it's a huge film studio or a small group of friends, everyone wants to see the final product as quickly as possible. During the compositing stage, the expectations for quality and efficiency are high, and the time constraints are tight. This stage can make or break the hard work and input provided by every other artist involved in the project, so the pressure is great. The reward is definitely worth it, though, as the result of all the hard work is finally output as moving images.

The elements created for shots SF-01, SF-02, and SF-03 are completely digital, so some of the techniques mentioned in Chapter 12 are not applicable here. There are no live-action background plates used in this composite, but the same layering concepts remain the basis for creating a pleasing scene.

Evaluating the Renders

Many of the decisions concerning the different layers in the compositing stage are made at the beginning of a project when the shots are broken down into distinct elements. Whether the production decides or the shot TD, the compositor receives a scene in layers established by a master plan. The plan for breaking down the elements of ISF (the Inspired Short Film) was a joint effort from the project's team. Our concerns were based on how to optimize the limited resources at our disposal and gain the most control over necessary adjustments to the renders. Because the character is the focus, and would most likely require the greatest number of tweaks, he is rendered as a separate element. The environment is rendered as its own layer, and any additional decisions regarding layers are made after the shot reaches the lighting and compositing stages.

After rendering the first lighting passes, the layers are combined in a simple A *over* B composite script, placing the character over the environment (see Figure 15.1). At this point, it is apparent that certain additional elements in the scene need to be separated into their own layers. The rim light for the character is one example. A single rim light makes one arm bright without providing appreciable results on the other arm. Separating the rim into two passes, with a different light for each, offers

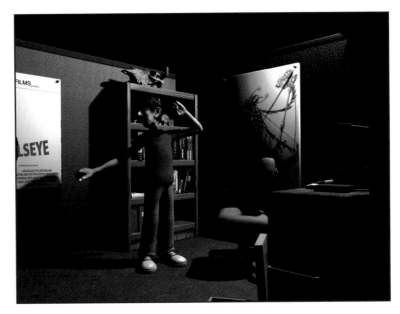

Figure 15.1
SF-01 early comp with the character over the background.

individual control over the width as well as the intensity on both sides of the character (see Figure 15.2). We also decided to render the glow from the computer screen as a separate pass (see Figure 15.3). This allows separate control over the glow, as well as more flexibility in experimenting with different methods for creating it.

During the compositing stage, it is necessary to not only combine the layers, but also do a quality control check for each layer. Checking each layer's entire sequence of frames pinpoints missing frames and frames with errors. It is also important that each render displays the intended elements. Renders are examined closely to ensure necessary geometry is not hidden, the proper lights are included, the correct camera is used, the shadows are correct, and so on. Separate channels are checked as well, because a problem occurring in the alpha channel is not evident when viewing only the color channels. Any number of glitches with the software or hardware can also cause problems, so careful examination of the entire sequence is necessary.

Figure 15.2
SF-01 separate renders for the character's left and right side rim lights.

Figure 15.3
SF-01 separate render for the computer screen glow.

In addition to separating the layers, identifying the layering order is also important. Placing one element *over* another is a simple process and works fine for shots SF-01 and SF-02. The character in these shots is clearly between the camera and the background elements for the entire frame range of each shot. Shot SF-03, however, is more challenging. In this shot, the character hops into his chair, rotates toward the desk, and slides up to the computer. During the process, his legs travel beneath the desk and his hands come down to rest on the keyboard. In compositing terms, this places part of the character *over* the desk (his hands) and part of him *under* the desk (his legs). Without some help, neither of these simple compositing steps correctly places the character into the scene (see Figure 15.4).

One solution to this problem is rendering the character and the scene all in the same render pass. This way, the renderer determines which elements occlude others, and the result is a properly layered scene with no compositing necessary. Since the decision to render the character separately has already been made, another option is needed. The solution is to assign a holdout material to the desk and include that geometry in the render of the character (see Figure 15.5). The

Figure 15.4
Shot SF-03 with the character placed *over* the desk (top) and the character placed *under* the desk (bottom).

Figure 15.5
Shot SF-01 character render with the desk as a holdout (top) and the character placed over the background (bottom).

holdout material causes the desk to render with an alpha value of zero, without being transparent. This means the desk cuts out any area of the character going behind or under it (since it is not transparent), but does not affect any elements behind it when composited. The character is now placed *over* the background render, and the proper layering is achieved.

Simple Test Comps

After the simple renders are begun with the basic lighting rig, the composites begin, as well. In the case of adding CG elements to film footage, this is simply placing A *over* B, where A represents the computer graphics and B is the film background. The same process is used in the images appearing at the end of Chapter 14. Figures 14.20, 14.21, and 14.22 represent final renders of the background and the character, but they do not include the fine-tuning of the separate elements created for the rim light and the glow from the computer screen. A light is added to the character's face to represent the result of this glow, but the glow itself still needs to be composited into the shot.

Each figure in Chapter 14 represents a quick test composite created to show how the elements work together in the scene. During the early stages of rendering the shot, simple test comps offer an avenue for evaluating and sharing the progress with other team members. For ISF, the images were shared from the earliest stages, even before the geometry and animation were completed (see Figure 15.6). Such images are funny at first glance, and they often find their way onto a joke reel at major studios, but a great deal of valuable information remains in the early tests. In the top image of Figure 15.6, the eyes are not yet animated but the renders still provide information on face lighting levels, the rim effect, and how the character fits within the environment. The image on the bottom of Figure 15.6 has some problems with the character's left arm, but the lighting can still be judged on the other parts of the character and the environment.

I prefer doing as many test composites as possible during the entire life of a shot. This includes simple comps in the beginning, as well as small test portions of more complex comps near the completion of a shot. In the beginning phases, this opens the door to constructive criticism from peers and supervisors. It is sometimes difficult to show work-in-progress to others, but the nature of computer graphics requires critical assessment during the entire process. If a TD waits until every element is just right (in his mind), then the final product may be something very different from what the team expects. A lack of input along the way also prevents the suggestions and improvements a shot gains through consistent evaluation and critiquing.

Figure 15.6
Shot SF-02 render with eye problems (top), and SF-03 render with a broken arm (bottom).

Special Passes

The separate render passes yet to be included in ISF shots are the two rim lights and the computer glow. The two elements for the character's rim light are simply *added* to the character render (see Figure 15.7). The rim passes are *added* in at any percentage of their full value, and they can also be increased beyond the levels of the render with a *brightness* operator (see Figure 15.8). The image on the top of Figure 15.8 shows a small amount of *brightness* increase for each of the rim passes. On the bottom of Figure 15.9 is an example of what happens when the color channels of a layer are pushed too far with a color operator. Notice the areas of solid white, where values reach their maximum in large areas of the render pass. When all three color channels are clipped to their maximum value, white is the result. If the rendered element cannot be sufficiently brightened in the comp without clipping, it is necessary to render the pass again with brighter lights.

The rim light serves an important role in a scene, since it provides the outline of the center of interest. This means many iterations need to be created to pinpoint the correct level for this important light source. With the ISF project, many responses to test images asked for a more prominent rim light. As with such a request for "more" at an effects studio, push it too far and then pull in the reigns. Four different test values for the rim brightness are created: one at the extreme end, one at the initial level, and two more evenly spaced in between (see Figures 15.9 and 15.10). In locating the most desirable value for the rim light, it is usually necessary to identify the boundaries of too little and too much. It is common for TDs to be timid in this scenario and make only slight changes to the values in the comp script. This can cost extra iterations, as the range of possible values is not determined and the small increments may slowly reach the goal. The image on the bottom of Figure 15.10 has a very bright rim, which is obviously too bright for this scene. The other members of the team identified a range between the top image of Figure 15.9 and the top image of Figure 15.10, with the bottom image of Figure 15.9 being the value of choice.

Figure 15.7
Shot SF-01 render with only the screen left rim added (top) and with only the screen right rim added (bottom).

Figure 15.8
Shot SF-01 render with both rims slightly brightened and added to the character (top) and with both rims brightened beyond an acceptable range (bottom).

Figure 15.9
Shot SF-01 render with not enough rim (top) and with an increase in rim value (bottom).

Figure 15.10
Shot SF-01 render with still more rim (top) and with a rim value that is too high (bottom).

15. Compositing a Production Shot

225

The other special pass for this shot is the computer screen's glow (refer to Figure 15.3). This pass is rendered as a light layer with a volumetric fog texture included in the shader. The computer, monitor, keyboard, and desk are included in this pass as holdouts. For shot SF-03, where our hero sits in the chair close to the monitor, the character is also included as a holdout. The glow layer is *added* to the scene or placed with an *over* operator. A brightness operator is also used to adjust the glow pass to 50 percent in the image on the top of Figure 15.11 and 85 percent in the image on the bottom. The 85 percent intensity is the one chosen by the team for the final composites.

Blending It Together

Blending layers into a cohesive product is the primary goal of compositing. When adding computer graphics effects to a film background plate, this task is a complex process of combining different media types. The difference in the nature of images captured on film versus computer-generated elements creates challenges in every pixel where the two meet. With an entirely digital scene, like the one created for the ISF project, this challenge is less daunting. Every element originates in the same world. If each element is rendered with the same renderer, a certain level of cohesiveness is built in. The opportunity to light the background, foreground, and every other element with exactly the same lights is a benefit of fully digital scenes.

A disadvantage of not having live-action footage is the lack of immediate reference material for the CG work. Of course, there's no reason a digital scene needs to look photo-real, and ISF is an example of a stylized look, creating an abstraction to tell a story. Blending issues such as edge blur and film grain still require attention in a fully digital shot. Separate renders can cause problems around element edges, and these should always be examined closely when compositing, regardless of the source. Film grain is not part of the digital rendering process, but it can provide a subtle reduction in the crisp, CG feel of a digital scene. Since film grain is difficult to spot unless viewed in moving footage, an exaggerated example is shown on a frame of shot SF-03 in Figure 15.12.

Along with scrutinizing the edges of composited elements, it is also useful to analyze the individual color channels of an image (see Figure 15.13). By isolating the blue, green, and red channels, new details or problems are sometimes revealed. This is a particularly valuable method for studying how well a computer graphics image blends with a live-action background plate. The overall tone, including the darkest and lightest areas of the image, should match in all channels between the

Figure 15.11
Shot SF-01 computer screen glow render pass.

Figure 15.12
Shot SF-03 composite (top) and with film grain added (bottom).

Figure 15.13
Shot SF-03 red (top), green (middle), and blue channels (bottom).

15. Compositing a Production Shot

CG work and the live-action background. An image can also be pushed to the extreme by applying a temporary gamma operator (nonlinear brightness function), and judging the individual color channels in the adjusted state. If the gamma adjustment causes the CG element to stand out as different from the background, in any one of the color channels, then the difference could become evident when the images are shown in their final format. When elements match the background plate in all channels through extreme color adjustments, they are much more likely to match on film or television.

Organization

The compositing scripts created for the shots in ISF are simple and fairly easy to understand. Because the number of inputs and operators is low, organization does not play a large role. As a compositing script increases in complexity, however, a clear method for organizing the inputs, operators, and outputs becomes necessary. You can organize a comp script many ways, but they all boil down to following a clear path through the operations from input to output. Complex compositing scripts need a logical flow and separation of elements and processes. Different compositing software packages also offer different methods for viewing the steps of the compositing script. The two primary methods are node-based and time-based viewers. A node-based viewer represents every operator and file of the composite script as a node, with lines showing the connections between nodes. A time-based viewer represents each file and operator in a graph type of interface. In this format, a bar in the graph represents each file or element and the length and location of the bar represents when the element occurs during the frame range of the compositing script. The node-based viewer shows the direct connections between nodes, whereas the time-based viewer shows how elements overlap at different times during a shot's frame range.

The technique I use in organizing a composite script in a node-based viewer can be compared to many mountain streams running together to form a network of rivers that run their courses and join before outputting into the ocean. This top to bottom workflow is efficient for me, but any organizational method works as long as it accommodates the necessary operations and is maintained through the life of a shot. Compositing scripts start simple, but they can quickly increase in complexity. Without clear organization, later adjustments to specific operations are time-consuming and frustrating.

Never Finished

For the purposes of this book, shots SF-01, SF-02, and SF-03 are complete (see Figures 15.14, 15.15, and 15.16). They are by no means perfect, and there are many areas for possible improvement. In every shot I have ever worked on, there are things I would like to have fixed. Most shots run short on time and budget before they run out of details to be addressed. This does not mean a shot is unsuccessful. CG artists are often quite critical of their own work, but they need to remember that the details not included in one shot are food for thought on the next. Each shot is a learning process and contributes to the lighting and compositing artist's visual vocabulary.

As with CG shots, this book is also a work in progress. For me, it is both a sharing and a learning experience. I would like to touch on many more topics, and I could share a great deal more detail on the subjects mentioned here, but this book offers a good overview of the digital production process. As long as I have made my point on the importance of observation, I consider the chapters a success. The suggestions here build on the ability to step back, see the pieces that make up an image, and understand how they are assembled. With that knowledge, the creation and combination of high-quality computer graphics layers is possible.

Figure 15.14
Shot SF-01 final composite.

Figure 15.15
Shot SF-02 final composite.

Figure 15.16
Shot SF-03 final composite.

chapter 16
An Interview with Jim Berney

A Brief Introduction

Jim Berney is currently a visual effects supervisor working with Sony Imageworks in Culver City, California. Jim holds two undergraduate degrees in Computer Science and Economics from the University of California, Irvine, focusing on artificial intelligence research funded by NASA. He then completed his master's degree in computer science from California Polytechnic, San Luis Obispo, with studies centering on the research and development of a new global illumination paradigm. Jim also spent one year at the Royal Institute of Technology in Stockholm, Sweden, studying computer architectures. He then spent three years working for DARPA (Defense Advanced Research Projects Agency) as an ADA programmer for a large software engineering consortium.

In making the move to visual effects, Jim worked as a part of the software development team with MetroLight Studios. While at MetroLight, Jim authored flocking software as well as procedural natural phenomenon lighting software. In 1996, Jim joined Imageworks and served an integral role in developing the costuming technology, versioning and publishing, and lighting and rendering tools for the production pipeline. Jim's film credits include *Batman Forever*, *Under Siege 2*, *Mortal Kombat*, *Anaconda*, *Starship Troopers*, *Contact*, *Godzilla*, *Stuart Little*, and *Harry Potter and the Sorcerer's Stone*. When Jim is not creating stunning visual effects or working on a new global illumination paradigm, he enjoys motocross racing.

Interview

DAVID: *Can you tell me a little bit about how you got started in the computer graphics industry?*

JIM: I did my undergraduate studies in computer science, with my emphasis in artificial intelligence. When I graduated, I started doing research with a software engineering consortium called Arcadia that was funded by DARPA. I was basically writing code that would analyze large-scale code, for metric gathering and such, so it was incredibly boring and dry. I did that for a couple of years, and it was nice because I was actually on the UCI (University of California, Irvine) campus. It really wasn't the real world, even though I was getting paid. One day I was at a book fair and I was just walking by a table. There was a book on the table about ray tracing and it was one of the standard references at the time. I bought it. It was a 70 dollar hardback on sale for 20 bucks. I thought, "This stuff's really cool. This looks fun." I started looking at doing my master's and I looked at Cal Poly San Luis Obispo where there was a professor, Chris Buckalew, who was doing really interesting stuff on global illumination paradigms. I ended up going there and getting my master's with an emphasis in computer graphics. My thesis was actually developing a whole new

> **One day I was at a book fair and I was just walking by a table. There was a book on the table about ray tracing.**

paradigm on global illumination. While I was there, I still didn't know what I would do for a living. I didn't know how to make money with this knowledge. At the time, I looked at getting out of computers and being a baker. I actually apprenticed as a baker for a while because I was just so tired of computers. One day I was talking to an undergrad who shared the same advisor as me. He had done an internship at MetroLight, and he was talking about this whole industry that was a complete unknown to me. I understood the underlying theories of animation and computer graphics and rendering, but nothing really about compositing. I remember at the time watching television, seeing a commercial, and still having no idea how that got onto the screen. This kid had already done all the footwork, though. He gave me his list of all the companies and their addresses, so all I had to do was just write a resumé and send it to these people. I did that and of course no one really got back to me. A couple of people asked if I had a demo reel and my response was "What's that?" I had no reel and the only people who really gave me a chance were MetroLight Studios. I was hired there as what they call an RTD. That's a research technical director and the position kind of straddles software and the artist pool. They gave me a shot and my first gig there was writing flocking software for *Batman Forever*. I wrote some really cool flocking software for that movie, and then I actually implemented it within the shots. I remember seeing the film for the first time and finding out then that my shots were cut from the movie and my

> **They gave me a shot and my first gig there was writing flocking software for *Batman Forever*.**

name was cut from the credits. I thought to myself, "Oh this is great." To top it off, my truck got stolen that week as well. So that was my welcome to L.A. MetroLight was a small group, and they only had a couple of people that were really experts at Renderman. One of them left right when we started doing *Under Siege 2*, so I really quickly ramped up on shader writing in Renderman. I started rendering and lighting shots for *Under Siege 2*, and then I did some work for *Mortal Kombat*. We were doing some commercial stuff as well, but those were the two movies. I was there only a year before I moved here to Sony Imageworks.

DAVID: *What were some of the challenges you found in making the transition from your programming background into the world of film effects?*

JIM: Acquiring a good eye for the aesthetics was a challenge. Everything I did before was complete computer coding. It was math. The programming helped,

though, because of the need for efficiency and organization. When I switched over to film effects, my background helped me to take on multiple shots, troubleshoot, and problem-solve.

DAVID: *How did you develop your aesthetic sensibility?*

JIM: It comes with time and the experience of doing all these shots. Since I've been here, I've been able to work with Ken Ralston, John Dykstra, Rob Legato, Jerome Chen, and quite a few others. You start learning from all these guys about what looks good and what doesn't.

> **I've been able to work with Ken Ralston, John Dykstra, Rob Legato, Jerome Chen, and quite a few others. You start learning from all these guys about what looks good and what doesn't.**

DAVID: *What was programming like at an effects company compared to your previous research experience?*

JIM: The projects I was working on before starting in the effects industry were huge in scale, and things had to be more formalized. The reason for the formalization was to allow somebody else to be able to pick it up at any time. The consortium was large and based out of multiple cities, so theoretically somebody from another town might pick up the code and need to easily understand it and use it. Everything had to be very well written, so to speak. Coming into effects, since I wasn't necessarily part of software, it was more like meatball surgery. You came in and you coded some stuff up on the spot. It was in the heat of production and it wasn't like we had six months to write a program and test it out thoroughly before using it. I would just put things together and test them in practice on a shot. If it breaks, you

> **You came in and you coded some stuff up on the spot. It was in the heat of production and it wasn't like we had six months to write a program and test it out thoroughly before using it.**

fix it, and it's a process that constantly repeats as you continue expanding the scope of the program. With really good code, like what we wrote in my engineering days,

there's a huge requirement spec written for a software project. That stage is skipped when a tool needs to be written for a production. If I need something to do a particular task, then I create it. As the needs change, this thing takes a life of its own. It kind of morphs and usually becomes a little less stable.

DAVID: *How does optimization work into the equation in the effects industry?*

JIM: Optimization is tough. Usually it's hard to do in the heat of production. You end up optimizing during down time. A very big case of this is BIRPS, our rendering system. That has slowly been evolving since I've been here. I remember a guy came over just before I did and he started writing the idea of having a sprib, or a single rib, with all of the per-frame information baked out. That was being implemented while I was here and I was actually writing the pipeline around it. We used it on

Anaconda and it worked incredibly well for that. I hacked some stuff together for *Contact* and *Starship Troopers* but then we had some down time and really started to think about the design a little more. We were able to implement those changes for use on *Godzilla*, but again it was kind of rough at first. We were just trying to get it ready for *Godzilla* and didn't really have time to fully develop it. When *Godzilla* ended, the rendering system got bigger and we started thinking about inheritance and multiple material files. We wanted to have the capability of creating standards that people could share. We were starting to implement that at the beginning of *Stuart Little*, and it was necessary because of the scale of that show (see Figure 16.1). Instead of 5 to 10 artists, now you've got almost 50 artists sharing these materials. The addition of material standards made a big impact.

Figure 16.1
A shot showing one of the many costumes worn by Stuart in the 1999 film *Stuart Little*. "STUART LITTLE" © 2002 Columbia Pictures Industries, Inc. All Rights Reserved. Courtesy of Columbia Pictures.

16. An Interview with Jim Berney

DAVID: *What was your progression through the ranks at Sony Imageworks to your current position of visual effects supervisor?*

JIM: I started here as a TD and was hired to work on *Anaconda*, as well as a test for *Dinotopia* with Ken Ralston. I was working with Steve Rosenbaum and I did the *Dinotopia* test as an artist. On *Anaconda*, because I had written the pipeline, I assumed the role of a lighting lead. When I finished those two projects, I ended up splitting time between *Starship Troopers* and *Contact* as an artist. After completing those I'd only been here a year. By then it was time for my review and I was angling towards a senior TD position. I guess Rosenbaum and the others had a different idea, and they were pushing me into a CG supervisor role. When the people I had worked with gave their reviews of me to the department head, they said CG supervisor was the position for me. I had no idea. Basically, I remember having a conversation with Stan (Szymanski, head of Sony's digital department), and I said that if right now you threw me on a project as a CG supe I'd say you're crazy. He said, "Oh really? Because that's the plan." I want to be confident as well as competent and know how to do it before I jump into it. So I said I could see being a CG supe on a smaller project if I have a good mentor, so I'm not without a net. Jerome Chen and I ended up doing a couple of little tests for *Dr. Dolittle* and something for *Paulie*, a talking bird, and one day he came in and said put all that down, we're going to do *Godzilla*. I thought, great, now it's a big project without a net. At that point I became a CG supe within my first year of being with Imageworks. I CG-suped *Godzilla*, and when that wrapped, the same group went on to *Stuart Little*. Our titles didn't change, but what we needed to do got upped a little bit. We were CG supes, but we also did a little bit of the work of a digital effects supe. We were on the live-action set and making a lot of creative calls. There was a lot to do on that side of things, and we were also writing code and building the pipeline. When *Stuart* ended I went on to *Harry Potter*, and there they upped me to digital effects supervisor. The idea was that Jerome was going to be the visual effects supervisor for Imageworks, even though Rob Legato was the production's visual effects supe (Rob Legato was employed by the studio, Warner Brothers). Then Jerome went on to *Stuart Little 2*, so that left me at the top for Imageworks. Since there was now no visual effects supe, then how could you have a digital effects supe? So kind of by default I was moved up to visual

> **I said that if right now you threw me on a project as a CG supe I'd say you're crazy. He said, "Oh really? Because that's the plan."**

effects supervisor. I moved up pretty fast. I was only here a year and they already had me in as a CG supe. I did that for about a year and then I jumped to visual effects supe quickly.

DAVID: *What does it take to successfully integrate a CG character into a live-action scene?*

JIM: If you can do more and more iterations quicker, that's obviously easier. The counterpart, which is kind of where we are if you have a full-furred creature, is a first pass with one light taking 20 minutes just to process before you actually see anything. That's really cumbersome. It's weird because right now it seems like 90 percent of it is technical hurdles and 10 percent is the aesthetics for the artists. If lighting was infinitely fast, you could move lights around in real time, and if it was completely seamless and easy to use, then you could almost take the same paradigm they have on set. There you have a DP (director of photography), a lighting director, and grips moving the stuff around. If the CG were that efficient, the TDs would be scaled down to a role similar to a grip. You'd have lighting directors coming through with multiple TDs who could just sit there in real time and move stuff around. As things get easier, it will go that way. When I first came in, you had to be highly technical because lighting was just script hacking. You had to be a programmer to do photo-real stuff. We didn't have specific shader writers, because the people who wrote the shaders were the only ones who could do the lighting. It was heavily code based, so you had to be a programmer to do the shader writing and the lighting. As tools get easier, it's literally just like moving a physical light around. Then it all becomes aesthetics. We're getting there as the computers and RAM are getting cheaper and faster. The code now could probably be much faster because we're really not completely utilizing concurrent programming. We're not really parallel computing massive arrays of matrices and what not. If we can get into

> **As tools get easier, it's literally just like moving a physical light around. Then it all becomes aesthetics.**

that, we can actually get faster and faster and faster. As things become increasingly faster, then it's just like the real world. You don't need a highly experienced, educated, highly paid person to move the light from A to B. You just need somebody with an eye to tell 100 people to move the lights. If you have one experienced person giving instructions, you could be lighting a lot of shots quickly. It'll be like on the set where you have a director and a DP. It's their vision. It's not the actor's and

it's not the grip's. It's not anybody's vision except the director, the DP, and the people who are paying for it. That's just how it is. It works great now because of the way it's structured. I like people like yourself who are creative and have a good eye and can do that, because it's so cumbersome right now and I can't sit there and hand-hold them. If I say, no the rim is hitting him right in the face, then you go through and make the technical and aesthetic calls to correct it. If it was incredibly fast, though, you could have another type of person that sits there and directs people in real time. Then you render it out and walk away and we'd see it on film.

DAVID: *Does your eye for detail come naturally or is it something that has developed over your time as a supervisor?*

JIM: It's both. It's not natural to the point where it's unconscious. It's actually an effort and it comes from experience. In an extreme case, I had a project where there were two visual effects supes and one of them would come by and say one thing and the other would say another. Sometimes you work with supes that don't necessarily know what they want. One day they want it red, and you make it red, and then they want it blue. Then you make it blue and they want it green, and then all of the sudden you're back at red and you're going in circles. On the other hand, I've noticed working with Jerome on *Godzilla* that he has a target. He says this is what I want. As long as you hit that target, you are done. I just knew that's how you get things done. I never wanted to jack people around. I never wanted to sit there and go one direction and then come back in a circle. That is a conscious effort every time I talk to an artist.

> **He says this is what I want. As long as you hit that target, you are done. I just knew that's how you get things done.**

Whenever we start a shot, I try to figure out what I want and how to attain it, and then feed the artist the information at the time he needs it. I never completely flood them with every little detail. I start in broad strokes with what we want and that's enough information for the beginning. As we progress, then I slowly get to more fine-grain specifics of what should be done.

DAVID: *So when you look at a show, do you evaluate every shot and develop a vision for what each shot will be and how it will get there?*

JIM: Yes, to an extent, and you should. It's a lot of work, but not relative to 100 artists spinning in circles for three weeks per shot instead of the one-week target. Then you're talking about thousands of man-hours instead of me just taking maybe 10 and thinking it out. It's just stopping, thinking, and planning. You've gotta have a plan.

DAVID: *I know from our work together on* Harry Potter *that in addition to having a plan, you always have a positive and encouraging attitude. How do you maintain a positive attitude for yourself and your crew?*

JIM: It never helps to have people who are completely stressed, negative, freaking out, and causing more pressure than there needs to be. It's just putting it in perspective. This is a job. It's a lot work and we should take pride in it, but all in all it is a job. We're making donuts, so to speak. When I first started, it seemed like it was the pressure of a brain surgeon. It's like someone's life is depending on this filmout. It's not. We'll do it again tomorrow. We'll get it done, and it always does get done. Work is not my whole world and it shouldn't be everybody else's whole world. There needs to be things outside of work that you're interested in, having a good time with, and you can spend energy on. That way you don't just get bogged down with work 100 percent of your time. Personally, I've got to get out of the city. I like the mountains and the desert. That's why I like riding motorcycles. I get out.

> **When I first started, it seemed like it was the pressure of a brain surgeon. It's like someone's life is depending on this filmout. It's not.**

> **Personally, I've got to get out of the city. I like the mountains and the desert. That's why I like riding motorcycles.**

On Saturdays when I ride at the track, it's out in these crappy areas and it's hot as hell, but it just feels good. It feels good just to be out in the baking sun.

16. An Interview with Jim Berney

DAVID: *Do you have any methods, tips, or tricks you could share for lighting and compositing a scene and creating believable computer graphics elements?*

JIM: There are a million tricks. One is that you just need to stop. Stop and smartly set things up. People want instant results so they won't spend a day correctly setting something up with no image to show for it. They'll go straight for an image without setting things up properly. Then they'll bang their head for the next two weeks trying to make it look right, but the lights just aren't correctly set up. They'll try to massage the paradigm they've got together, whatever the rig is, for two weeks. You just need to stop, move that light, create another light, and set it up properly from the beginning. A lot of it has to do with the difficulty in the tools. It takes time to create another light with another shadow. That's why we're trying to make shadows much easier. I noticed a long time ago that some people didn't want to put shadows in their lights, or even create another light, because it was a pain in the butt. It used to be even harder. The idea is, and eventually it will be, that lights will be shadowing. That should be a given. All lights should shadow. You shouldn't sit there and have to worry about where shadow map files are going to go and the names, and so on. That's actually why we set the pipeline up the way it is with all the naming conventions and standards. You don't have to worry about where things are and how they're named.

I was on a show recently and we were trying to do a particular type of animation. It wasn't character animation, but rather long, animated camera moves. We were struggling with it, and we'd ask for these very small changes that wouldn't come. We fought it for weeks, and it turned out to be a result of the camera and parenting system being set up incorrectly. In the beginning, I said I don't care if I don't see anything for three days. Just set it up correctly. You know, they went straight to the image to quickly produce stuff. Instead of stopping and setting it up correctly for a day, we fought it for two weeks.

> **People want instant results so they won't spend a day correctly setting something up with no image to show for it.**

As for specific tricks, there are hundreds of them. If you're trying to sit there and see how a new light works, don't render a fully furred creature at 2k with motion blur (see Figure 16.2). You have to optimize for testing. It's a good idea to start with quick renders that are cropped, fast, and low quality just so you can see where the lights are. Start with a sphere. I've asked that from people for a while. I don't want to see the troll. I don't want to see a furred dog. I don't want to see anything but a ball. Just give me a sphere that looks integrated, and then put the dog in. Of course the dog won't look right, but it's a quick way of initially setting up lights. I've noticed when people resist doing things, it's because they're difficult, so you just need to make it easier, or even automatic. I'll sit there and say it needs a little something, like bringing the rim a bit this way. I come back the next day and the rim light's still not moved. I'll ask every day just to bring the rim light around. It turns out all they were doing was just upping the intensity, because that's the easiest thing to do. It needs to be brought around. You need to move it. The entire process was an effort by the artist to avoid a re-render of the shadow maps. Well, the simple answer is the light has to be moved and the shadow maps need to be re-rendered, because it's not going to look right otherwise. If you just stop and analyze the situation, you'll realize it only takes about two hours of processor time to render new shadows. Everyone wants instant results, though, so they go for the quick fix even if it's wrong. You just can't achieve instant image creation right now. I ask to move a light and the artist wants to avoid a re-render of the shadow maps. They think maybe making the falloff a little different or adjusting the wrap around will fix it. It doesn't work the next day or the next day, and three days later it still doesn't look right. Okay, now you've wasted three days and three iterations of film because you didn't want to stop and spend one or two hours in the first place. Even if it's a whole day, it's worth it.

> **Just give me a sphere that looks integrated, and then put the dog in. Of course the dog won't look right, but it's a quick way of initially setting up lights.**

238

Figure 16.2
A close-up shot of fur benefiting from optimised testing, from the 1999 film *Stuart Little*. "STUART LITTLE" © 2002 Columbia Pictures Industries, Inc. All Rights Reserved. Courtesy of Columbia Pictures.

Outside of the technical aspects, there are some little things that are also important. Steve Rosenbaum taught me that if a supervisor's talking, you should be writing. It instills confidence that all the comments I say will get done. A lot of times people don't write, so I won't even throw all of my ideas out because I know they'll fall through the cracks. They'll just address the big ones. Just because I talk about one thing for 10 minutes and say another thing quickly, it doesn't mean they're not equally important. That little thing I just threw out there will stop it from finalling just like the thing I went on about for 10 minutes. If a supervisor's talking, write it.

You won't remember. You'll say, "Oh yeah, yeah that's obvious," and later you won't remember. It's easier to have it all listed and you just go through and check it off. The supervisor's going to remember and a list makes things so much easier. Another thing is to try not to make excuses. I hate it when you come by and an artist says this didn't work, and this, and that, and this, or that, and it's this big long story. Then I ask what they have to show, and they say nothing. I understand the process. If I ask if you did it and you say you'll have it later, I'll say okay. I'll respect you. You don't need to make excuses.

239

DAVID: *What do you think the role of image-based lighting and global illumination will be in the near future?*

JIM: I studied the hell out of that. I was looking at some of the high dynamic range things. It works for certain instances, but it's not flexible in terms of moving a light. Say you have an environment and you use it to automatically create the lighting, and then you want to stick a little creature in it, like a Stuart Little (see Figure 16.3). Well, when they lit the set, they didn't light the mouse because the mouse wasn't there. So the set's lit well, but it's like when we did the Centaur on *Harry Potter*. Okay, the set's lit, but there's no Centaur, and we didn't even light the set as if the

Centaur was there. If there was a real creature there, the DP would add specials that don't affect the surrounding, but that light him. That's totally omitted in this scenario. So now when we come back to the digital effects house and we're starting to put our creatures into the scene, the VFX supe kind of plays that role. He plays the role of DP. We talked to a guy who's doing a lot of research with HDR (High Dynamic Range) and a ball and eight pictures. He's doing some great research and we talked to him for a while because he had done some really beautiful pictures. We asked, "What if I want to put a creature in and use that?" He said you can do that. So then we asked, "What if I want to give it a little rim?" That's when it got

Figure 16.3
A scene presenting live-action lighting difficulties in the 1999 film *Stuart Little*. "STUART LITTLE" © 2002 Columbia Pictures Industries, Inc. All Rights Reserved. Courtesy of Columbia Pictures.

16. An Interview with Jim Berney

240

really difficult. That doesn't mean it's dead or it doesn't work. I'm just saying there are many more considerations. Even if I duplicate the exact values of the scene, that's not the lighting I want for my subject. It's a great starting place, as long as you can go from there and add your specials and flag lights off. You just need to think it out. We wanted to do something like that on *Potter*, but what had been implemented in the past was what we would have gotten. You set up the ball (chrome reference sphere) in an environment, shoot your pictures, and then take those energy readings. That's your lighting, period. We also needed to be able to sit there and add and manipulate lights.

> **Even if I duplicate the exact values of the scene, that's not the lighting I want for my subject.**

I love the silver balls and the information they provide. I wrote code on *Anaconda* that took the image of the ball, cropped it in as a little texture, focused in on the highlights, and gave you a vector of where the light came from. It didn't give you position, but it gave you the direction it came from. We used distant lights in Renderman, with parallel rays, and the lighting in *Anaconda* took about ten minutes. Those were our lights, period. We never moved them. We did balance the intensities, since the evaluations did not include intensity or color. We could have included those as well, but didn't have time to automate it. It gave you the automatic lights and then I just sat there and balanced it. Most of the lighting was in the shader. We kind of got caught up on things with *Potter*, but I had recorded images on set with two silver balls in each scene. One ball gives you a vector, but with two balls and two vectors, their intersection gives you light position. It's easy. I can code that now, but we just never did. On the set of *Potter*, I shot two balls, but we just never got the chance to code it up. Otherwise, we could have gotten the positions. That actually integrates into the existing pipeline we have now.

DAVID: *In your current position, what do you see as your future technical and creative challenges?*

JIM: As far as technical challenges, I'm still going for that infinite efficiency. I want the speed and I want to get the iterations down fast. That could take what should be a creative job, which is now technical, and make it more creative. That way the artists are artists, and they're not sitting there banging their heads all day on these tools. Another challenge would be to find new ways of managing projects so the hours could come down and people could have lives. That would keep morale up. What we do is great, theoretically. It has so much potential. This is a kick in the ass. Who gets to create three-headed dogs? Then again, if you flash to someone sitting there waiting three hours to see what one light does, then it's not that fun. It's got the potential, but we just need faster tools. Creatively, I want to get off the box. I slowly am and I mainly just use the computer to read e-mail. I want to get in when a production starts so I'll have more input at the beginning on how shots are created and what we're doing. That would involve more on-set stuff.

DAVID: *Do you have any bits of advice for those interested in lighting and compositing as a career?*

JIM: It seems like attitude is everything, and our industry is one where you can't just rest on your laurels. You can't just get settled in. Regardless of how long you've been at it, things are always changing and you have to keep your skills up to date. That's the scary thing, since you can easily get left in the dust if you don't keep your skills current.

> **attitude is everything, and our industry is one where you can't just rest on your laurels. You can't just get settled in.**

There are new kids always coming out of school who are willing to do the hours and learn the new tools. I always like when the artists themselves will take the initiative to actually help improve the process. That helps a lot. Instead of just complaining about it, they ask how they can make it better. A lot of the tools and improvements we have here are because of people who have taken that initiative. Some of the lighting tools that you aren't even aware of happened that way. There are artists whose job it was to get the shot out and they stopped and figured out they could be more efficient if they were able to create a new way. They did it, and we put it in the pipeline.

We're getting close. It's going to be incredibly different five, let alone ten, years from now. People could become less skilled because of what we want. We want faster, easier tools. Okay, if it's faster and easier then you probably don't need people who are as smart and experienced. There will probably be a shift, and there already has been, since ten years ago you needed programmers. Now we're getting

more of a true artist pool and that's a good thing. I think people are tired of banging their head on the box right now. When you look at a movie script and the required special effects, the technical hurdles are always in your head. You ask, "Can we do that and can we do it for the money?" When I talk to directors, I don't even want to hear that. At some point, the director will be able to tell us what he wants to see, and we'll have the tools to quickly figure out a way to do it. There'll be nothing we can't do and it won't cost a billion dollars. We'll have the technology and the speed. Every show we figure one more thing out. Before *Stuart*, somebody figured out hair, and then on *Stuart*, we included hair and made it work with our pipeline. We made a lot of improvements to hair and different hair styles on *Potter*. With cloth, it's the same thing. Five years ago, every CG character was in spandex and shaved. Skin is not perfect, but by the next project with a digital human, it'll start to get perfect and it'll start to get faster and cheaper. Fire is probably not perfect. Water's getting better. Nature is built-up of all these elements that we're slowly nailing down one by one. Fifteen years ago it was marble or something simple. Twenty years ago it was plastic and steel. As we start to add all of these to our list of accomplishments, we'll be able to make whatever we want. Then it'll be completely creative. The question can simply be asked, "What do you want to do?" Maybe we want to go off in some weird galaxy and see some

> **When you look at a movie script and the required special effects, the technical hurdles are always in your head. You ask, "Can we do that and can we do it for the money?"**

> **We had no way of doing flowing, moving, dynamic hair, specific hair styles, or 14 simulated robes at once. We had to budget time and money for all of these tools that we didn't even know how we were going to make.**

creatures and phenomena that only exist as a vision in a director's mind. People could do whatever they want and express themselves any way they want. They wouldn't have to worry about budgetary constraints, getting it done on time, or even being able to do it at all. That's coming around the corner. We're getting there. On *Stuart Little 2* we had to do a bird, so now there are feathers. There's a whole different bag of problems. Now that's done and as long as we don't have fish or something, and the next film is the exact same thing, then that would be relatively cheap to do and we would be able to accurately schedule and budget it. Then you could potentially come down to a 40-hour workweek. Why not? When you sit there and try to figure out a show like *Potter*, it's a huge challenge. We had to do 14 digital kids with flowing robes and hair and this and that. We had no way of doing flowing, moving, dynamic hair, specific hair styles, or 14 simulated robes at once. We had to budget time and money for all of these tools that we didn't even know how we were going to make. So, if you take all of that out of the way, it becomes so much easier. Each show you have less and less to figure out, hopefully, and eventually in ten years it'll all be figured out. We'll continue to optimize, and once it gets completely optimized, it gets less technical and more creative. Then it'll be fun.

242

Appendix

This appendix is intended as an introduction or quick reference to many principles and concepts important to the basic understanding of computer graphics. It in no way presents a comprehensive and complete explanation of the topics, but an elementary discussion of some technical subjects of concern to the technical director. Hopefully, the material presented is sufficient to be useful in your work with computer graphics. You are encouraged to explore the topics in other resources (textbooks, journals, periodicals, online). Many technical references are available with more in-depth information and explanations.

Cameras and Presentation Formats
The Computer Graphics Camera

A live-action camera is difficult to exactly characterize so that it may be duplicated in a computer. For this discussion, I assume the use of a nodal camera in which the pivot point is in the camera's throat at the center of the image plane. The pivot point is the location about which the object rotates or scales. Most software packages use a camera with a local right-handed coordinate system in which the camera looks down the Z-axis in the negative direction. Any real-life camera transformations (translation or rotation) must be converted for the computer world.

The basic parameters typically used to describe a nodal camera for digital effects are:

position – the position in space (tx, ty, tz) of the center of the camera's film plane.

pan (ry) – the rotation around the height axis (y) of the film plane.

tilt (rx) – the rotation around the width axis (x) of the film plane.

roll (rz) – rotation about the viewing axis (z) which is normal to the film plane.

aperture – the horizontal (aperture$_H$) and vertical (aperture$_V$) size of the exposed film plane.

35mm full aperture is .980" x .735" (24.892mm x 18.669mm).

35mm Academy aperture is .868" x .631" (22.0472mm x 16.0274mm).

For more see **http://www.widescreenmuseum.com/widescreen/filmdims.htm**.

Aspect Ratio (AR) – the ratio of width to height of the camera's aperture.

AR = aperture$_H$/aperture$_V$

This aspect ratio is often also the image format of the scanned or rendered image, but it cannot replace the original AR of the live-action camera if the computer camera is going to match.

35mm full aperture AR = 1.333.

35mm Academy aperture AR = 1.376.

full aperture 2k image (2048 pixels x 1556 pixels) AR = 1.316.

2k image (2048 pixels x 1536 pixels) AR = 1.333.

full aperture 1k image (1024 pixels x 778 pixels) AR = 1.316.

d1 image (720 pixels x 486 pixels) AR = 1.4815 pixelwise, but because pixel aspect ration is .9 for television, image AR = 1.333.

NTSC video image (640 pixels x 480 pixels) AR = 1.333. (Note: NTSC television broadcast is 525 scan lines of resolution.)

cineon video image (640 pixels x 486 pixels) AR = 1.316 (scalable to 1k and 2k full aperture).

focal length (f) – the focal length of the lens. Defined: the focal length is the distance from the optical center of the lens where parallel rays entering one side of the lens cross the principal axis on the other side of the lens (see Figure A.1).

interest or target – often used to indicate where the camera should point. Instead of using the rotation channels, the camera can be constrained to a target that the camera looks at.

up-vector – defines the direction up for the camera. Because different sets of rotations can result in the camera pointing in the same direction, it is often helpful to define an up-vector to help better define the orientation of the camera.

Near and far clipping planes limit the range that a camera can see. To save render time and avoid rendering objects unnecessarily, areas closer than the near-clipping plane and farther than the far-clipping plane are not considered by the computer's camera.

curvature (ρ, Greek letter rho) – is an index generated from the effective radius of curvature of the lens. This curvature is generally responsible for the bending of images at their edges.

distortion coefficient – a parameter (or parameters) generated from measurements of the distortion in a calibration grid/image photographed with the lens in question. Each set of lens settings (aperture, focal length, focus) produces a different coefficient, so these measurements generate several curves to characterize the lens. The coefficient attempts to compensate for the effective spherical aberration produced by a changing radius of curvature and/or non-uniform refraction indices of the glass. Spherical aberration causes the blurring of images at their edges. A family of distortion coefficients can be used to compensate for chromic aberration, which is the splitting of light into its color components at the edge of the image. Additionally, live-action camera crews can provide the following parameters.

focus – the distance from the image plane which appears sharply in focus at the image plane after passing through the lens.

f-stop – the size of the light admitting aperture to the camera.

shutter – the angular size (0-360 degrees) of the camera shutter, which affects how long each frame is exposed. The camera in the computer usually expresses its shutter as a value from zero to one (0-1).

speed – the frames per second the camera is shooting. At 24 frames per second with a 180-degree shutter, each frame of film is exposed for 1/48th of a second. With a 90-degree shutter at 24 frames per second, each frame is exposed for 1/96th of a second.

field of view (fov or θ - Greek letter theta) - is the horizontal (fov_H or θ_H) and vertical (fov_V or θ_V) viewing angles the camera allows us to see.

Figure A.1 shows a side-view diagram of the camera image plane. The aperture, focal length, and field of view ($\theta_{V,H}$) are indicated.

The field of view can be calculated from the camera aperture and the focal length of the lens.

$$fov_V = 2*arctan(aperture_V/2*f)$$

$$fov_H = 2*arctan(aperture_H/2*f)$$

Additionally, the equations to calculate 1 of the 3 parameters given any 2 are:

$$aperture_V = 2*f*tan(fovV/2) \quad f = aperture_V/(2*tan(fov_V/2)) \quad aperture_V = AR*aperture_V$$

$$aperture_H = 2*f*tan(fov_H/2) \quad f = aperture_H/(2*tan(fov_H/2)) \quad aperture_H = aperture_H/AR$$

Color Spaces and Image File Formats
Color Spaces

A color space or color model is a way to represent a color with a set of values. The following are several definitions for commonly used color spaces.

RGB – red, green, blue color space is the most common digital representation of colors. The color is defined by the values of red, green, and blue of which it is composed. Colors are usually stored in RGB space.

HSV – hue, saturation, and value is the next most common way digital colors are represented. Hue is an index describing the specific color on the color wheel. Saturation represents the amount of white mixed in with the color. A saturation of zero is absence of the color, which is complete white. Value is the lightness or

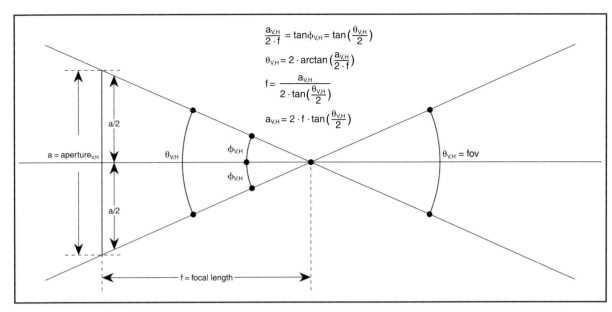

$$\frac{a_{V,H}}{2 \cdot f} = \tan\phi_{V,H} = \tan\left(\frac{\theta_{V,H}}{2}\right)$$

$$\theta_{V,H} = 2 \cdot \arctan\left(\frac{a_{V,H}}{2 \cdot f}\right)$$

$$f = \frac{a_{V,H}}{2 \cdot \tan\left(\frac{\theta_{V,H}}{2}\right)}$$

$$a_{V,H} = 2 \cdot f \cdot \tan\left(\frac{\theta_{V,H}}{2}\right)$$

Figure A.1
Side-view diagram of a camera.

The bit depth of an image is the number of bits used to represent a color value. For example, an 8-bit channel can store a value in the range from 0 to 255, and a 16-bit channel can store a value from 0 to 65535. That means 8 bits resolves a color channel into 255 discrete values and 16 bits resolves a color in 65535 discrete values. Therefore higher bit depth provides more colors to choose from.

Images files may be compressed to save storage space. Some compression methods are lossless, which means they maintain the quality of the original image.

darkness of the color. It is a convenient color space for adjusting color, but colors are typically not stored in HSV space.

HSL – hue, saturation, luminance is similar to HSV, but the luminance describes the lightness or darkness of color, where luminance = 0.3086*red+0.6094*green, and 0.0820*blue.

YUV – a video color space where Y represents the luminance and U and V represent the chrominance (analogous to the hue and saturation).

CMYK – cyan, magenta, yellow, black is the common subtractive color space used for printing color. The colors are mixed to represent the properties of reflected light, because color as seen on a printed page is reflected light. Green and blue make cyan, red and blue make magenta, and red and green make yellow.

Image File Formats

Different image file formats store the pixel information (red, green, blue, alpha, and so on) in different ways. Each was designed to meet the various requirements of particular hardware, software, or image quality needs. There are over 150 commonly used digital image file formats. Of course only a few are described here and listed by their file extension.

.rgb (also .sgi) – stores red, green, blue, and alpha channels with lossless compression at 8 or 16 bits per channel. This was created by Silicon Graphics Inc. as part of their IRIX operating system.

.cin – Cineon format stores red, green, and blue channels uncompressed at 10 bits per channel.

.tga (also .tpic, .vst) – Targa format stores red, green, blue, and alpha channels with lossless compression at 8 bits per channel.

.rla – RLA format created for the Wavefront renderer stores red, green, blue, alpha, and Z-depth channels with lossless compression at 8 or 16 bits per channel.

.tif (also .tiff) – Tagged Image File Format is a very flexible format supporting an arbitrary number of channels and images per file with user definable bit depths and compression schemes.

.jpg (also .jpeg, .jfif) – stores red, green, and blue channels with lossy compression at 8 bits per channel developed by the Joint Photographic Experts Group.

.gif – Graphics Interchange Format stores 8 bits of indexed color, which means a palette of up to 255 different colors are supported.

.iff – an Alias|Wavefront general purpose format that can store an arbitrary number of channels with lossless compression at up to 32 bits per channel.

Compositing Operations

The following is a compiled list describing common compositing operations or terms not fully explained elsewhere in this book.

flip – to mirror the image around the X-axis.

flop – to mirror the image around the Y-axis.

premultiply – to multiply an image's color channels by its alpha channel.

unpremultiply – to divide an image's color channels by its alpha channel.

resize – operation that alters the resolution size of an image.

dilate – operation that increases the size of bright areas while reducing the size of dark areas.

erode – operation which reduces the size of bright areas, while increasing the size of dark areas.

invert – to subtract the channel value from 1 resulting in a negative image.

The following nomenclature is used in these equations for common compositing functions:

A is the first input into the function.

B is the second input into the function.

The subscripts represent the channel or channels used in the operation.

ADD (or PLUS) operation resulting image sums of the values for each channel. Red channel of image A plus red channel of image B and so on.

$$A_{rgba} + B_{rgba}$$

SUBTRACT (or MINUS) operation resulting image subtracts the values for each channel. Red channel of image A minus red channel of image B and so on.

$$A_{rgba} - B_{rgba}$$

OVER operation multiplies image A's color channels by its alpha channel and then adds it to the result of image B's color channels multiplied by the inverse of input A's alpha channel.

$$A_{rgb}*A_a + ((1 - A_a) * B_{rgb})$$

UNDER operation multiplies image B's color channels by its alpha channel and then adds it to the result of image A's color channels multiplied by the inverse of input B's alpha channel.

$$B_{rgba} + ((1 - B_a) * A_{rgba})$$

MIX operation uses a mix value, M, as the fraction of input A added to the fraction 1-M of input B.

$$M * A_{rgba} + (1 - M) * B_{rgba}$$

INSIDE operation multiplies the color channels of A by the alpha channel of B.

$$A_{rgb} * B_a$$

OUTSIDE operation multiplies the color channels of A by the inverse of the alpha channel of B.

$$A_{rgb} * (1 - B_a)$$

ATOP operation is a combination operator taking the result of A INSIDE B and putting it over B.

$$(A\ INSIDE\ B)\ OVER\ B = (A_{rgb} * B_a)* A_a + ((1-A_a)*B_{rgb})$$

SCREEN inverts both images, multiplies them together, and then inverts the result.

$$1 - ((1 - A_{rgb}) * (1 - B_{rgb}))$$

XOR (exclusive or) operation adds A OUTSIDE B to B OUTSIDE A.

$$A_{rgb} * (1 - B_a) + B_{rgb} * (1 - A_a)$$

MAX operation chooses the maximum channel value from A or B for each channel.

$$MAX(A_{rgba}, B_{rgba})$$

MIN operation chooses the minimum channel value from A or B for each channel.

$$MIN(A_{rgba}, B_{rgba})$$

Glossary

The following terms are defined with respect to their use in this book. More comprehensive glossaries of lighting and effects terms can be found in *Visual Effects in a Digital World* by Karen Goulekas and *Film and Video Lighting Terms and Concepts* by Richard K. Ferncase.

Symbols

2D. *See* two-dimensional.

2–1/2–D. *See* two-and-a-half dimensional.

3D. *See* three-dimensional.

A

A.D. *See* assistant director.

algorithm. A procedure or methodology (often mathematical) that describes the steps (sometimes iterative) to reach a solution.

alpha channel (or matte channel). A grayscale image describing the opacity of an image usually with white as completely opaque and black as completely transparent. It is usually included as the 4th channel of a rendered image.

ambient. Describes the uniform non-directional or omni-directional contribution of light to an object or such a contributing light.

animate. Change or motion from frame to frame as in an animated light position or character.

anti–alias. To filter an image to smooth out jagged or stair-stepping edges or lines by color averaging pixels along the edge or line.

aperture. The size of the camera opening exposing the image plane to the environment.

art flat. Artwork painted onto a large canvas or board to simulate areas beyond a movie set such as outside a window or door.

aspect ratio. The ratio of width/height of an image plane.

assistant director. The director's right hand man, running the set and managing the crew.

attenuate. To dampen or decrease.

B

back light. Light striking subjects from behind, often serving to make the object stand out from the background.

background. The part of the scene farthest away from the viewer in front of which the main action happens.

barn door. Hinged panels attached to stage lights to direct or diminish illumination.

beauty pass. In multiple pass photography or rendering, the pass containing the most color and detail. Also called color pass. Other passes may include matte pass, shadow pass, and so on.

blue spill. Blue illumination reflected from a bluescreen and the blue lighting used to illuminate it, which contaminates the subject.

bluescreen. A uniformly colored blue background placed behind the subject being photographed so that a matte or alpha channel may be extracted for only the subject.

blur. An image process that applies a filter algorithm to average a pixel with surrounding pixels.

bounce card. A flat, usually white, surface placed out of the camera's view and used to reflect additional illumination from existing light sources into a scene.

bounce light. Light bounced or reflected off of other objects before reaching the subject, or a cg light used to simulate this phenomena.

bounding box. A box that just contains the object with which it is associated and used to represent the object's limits.

box blur or box filter. A low quality but fast filtering algorithm that looks boxy when the image is scaled. It averages pixels in the horizontal and vertical directions with equal weighting.

bump map. An image mapped to an object in which the color channel values in a given pixel are used to represent a direction and amplitude in which to perturb the surface normal of the object.

C

camera. The device that determines the view captured in the image.

Cartesian coordinate system. A system in which a point is located in space by a set of three coordinates representing the distance along three mutually perpendicular axes, usually labeled X, Y, and Z.

caustics. Technically, the boundaries of discontinuity for transmission or reflection, but commonly used to refer to the patterns of transmitted light through a refractive media, such as water.

cg supervisor. *See* computer graphics supervisor.

chroma key. A matte extraction technique that separates a subject from its background based on a color in the image.

chrome sphere. A mirrored ball placed on set and photographed as reference to later aid in recreating the lighting setup or environment in the computer.

CMYK. Cyan, magenta, yellow, and black color representation.

computer graphics supervisor. The person responsible for the quality and efficacy of the 3D work on a project.

contact shadow. A shadow connected to the object casting it.

continuity. Seamless assembly and natural flow of scenes with respect to time, space, color, and direction.

contrast. The ratio of bright to dark values in an image.

crop. To remove part of an image that falls outside of a selected region.

cukaloris. A panel cut with a pattern to cast shadows of that pattern onto a subject. Also called cookie or gobo. This can be simulated with a texture in a light shader.

D

d1. A digital video format with an image resolution of 720 pixels wide by 486 pixels high.

dailies. The daily screening of the previous days work for review by directors and supervisors.

decay rate. In some software packages, the rate at which the intensity of a light decreases over distance.

depth of field. The region in front and behind the focus plane, which remains in apparent focus through a lens.

diffuse. Describes the direct contribution of light to an object or such a contributing light.

digital effects supervisor. The person responsible for creation of all digital effects on a production.

digitize. The encoding of 2D or 3D data from a physical model or drawing to create an accurate representation in the computer.

director. The person responsible for creating the final realization of the production.

D.P. *See* director of photography.

director of photography. Also called cinematographer. Individual responsible for all lighting and photography on a production based on the vision of the director.

displacement map. An image mapped to an object in which the color channel values in a given pixel are used to represent a direction and amplitude in which to transform that point on the object.

drop shadow. A contact shadow cast from lighting above the object and often simulated in 2D by using an offset portion of the object's matte to darken the shadow area.

dropoff. In some software packages, the rate at which light intensity decreases from the center to the edge of a spotlight's cone.

E

edge detection. An image processing algorithm used to isolate the edges (areas or sharp transition) in an image.

eighteen percent gray. A mid-tone gray representing 18 percent reflectance of light and used to evaluate and calibrate film exposure.

element. An individual image layer or pass, which will be composited with other layers to create the final image.

F

falloff. In some software packages, the rate at which the intensity of a light decreases over distance.

field. Television images are projected onto the screen—odd scan lines first then even scan lines. The even and odd sets of lines are the even and odd fields of the image. An NTSC broadcast is 30 frames (29.97 actually) per second, which means 60 fields per second.

field of view (FOV). The horizontal or vertical angle subtended by the view through the lens.

fill light. A light source positioned to fill in areas the key light does not sufficiently illuminate in the scene.

film grain. The individual chemical crystals in film used to capture the image when exposed to light. As these particles are not perfectly uniformly distributed in the film, motion of the grain is perceived. This noisy imperfection varies for different types of film and exposures.

final. A shot that has been approved as complete by the director.

Flame. A powerful compositing package developed and sold by Discrete Logic. Other versions (distinguished by capability) are called Inferno, Flint, and Smoke.

flash. In compositing, to reduce saturation and contrast in an image to flatten illumination of the subject.

Flint. *See* Flame.

focal distance. The distance from the camera image/film plane at which there is sharpest focus.

focal length. The distance from the lens optical center at which a subject an infinite distance from the lens will appear in sharpest focus. The image/film plane is usually placed a focal length from the lens.

focal plane. The plane at the focal distance in the field of view.

focus. 1. The emphasis of the scene or image. 2. The adjustment on a camera to set the distance that appears sharpest in view.

FOV. *See* field of view.

frame. A single image of a sequence.

frame range. The total number of frames in a series expressed as a start frame, end frame, and frame increment (for example, 5–49 by 2).

frame rate. The rate at which frames are played back to produce moving pictures (for example, 24 frames per second for 35mm film).

Fresnel lens. A glass lens with concentric ripples used to cast a soft, evenly illuminating light beam.

f–stop. The lens setting that defines the aperture. Aperture is focal length divided by f–stop.

Glossary

249

G

gamma. Originally defined as the exponent required to compensate for a computer monitor's nonlinear response to input voltages. This brightness control is a common color correction operation, which brightens the midrange values more than the dark and light ones.

garbage matte. A rough matte to isolate the desired subject from unwanted parts of the image.

gaussian blur or gaussian filter. A good-quality filtering algorithm to smoothly resample an image without aliasing artifacts. It averages pixels in the horizontal and vertical directions with a gaussian (bell–shaped curve) distribution of weighting.

gel. A translucent or transparent sheet of acetate or polyester used to color, diffuse, or otherwise filter light.

gradient. A region of transition from one level of value to another.

grain. *See* film grain.

gray sphere. An eighteen-percent gray colored ball placed on set and photographed as reference to later assist in recreating the diffuse components of the lighting setup in the computer.

green spill. Green illumination reflected from a greenscreen and the green lighting used to illuminate it, which contaminates the subject.

greenscreen. A uniformly colored green background placed behind the subject being photographed so that a matte or alpha channel may be extracted for only the subject.

ground plane. The reference surface in a scene indicating the floor level for animation. Often used to receive shadows.

GUI. Graphical user interface.

H

hardware render. A render utilizing the computer hardware's capability to process and display shaded previews quickly to provide better interactive tools for the user.

harsh light. Lighting that creates high-contrast images with sharp-edged shadows.

hero lighting. The lighting that emphasizes the primary character or focus of the scene.

hi–res. High resolution.

histogram. A chart of the number of occurrences of a certain value.

HLS. Hue, luminance, saturation color representation.

hold–out matte. A matte, either rotoscoped or rendered, for preventing one element from obscuring another element, or portion of the background plate, that should appear in front.

HSV. Hue, saturation, value color representation.

hue. An attribute used to classify color.

I

icon. A small image used to represent a file, window, command, program, and so on.

image plane. The planar area in the camera onto which the image is focused by the lens.

image processing. The manipulation of the pixel values of an image with a computer.

Inferno. *See* Flame.

interest. The focus or target of the viewer or camera.

interlacing. The process of projecting the odd fields of an image and then the even fields so that an entire image is perceived by the eye.

interpolation. Calculating intermediate values between two or more previously determined values.

inverse square falloff. *See* quadratic falloff.

J

JPEG. 1. Joint Photographics Experts Group. 2. An image file format(file extensions .jpg or .jpeg), which uses a lossy compression algorithm to save space.

K

key-frame. A frame at which parameters are specifically set and saved to define any number of animated values, such as position, rotation, scaling, intensity, blur size, and so on. Values for the parameters between key-frames are interpolated by the computer.

key-light. The primary light source illuminating a scene.

L

lacunarity. Basically, the variation in gap/detail size of a fractally generated texture.

lens flare. The photographic artifact created when a light shines directly into the camera and reflects and refracts inside the lens system.

linear falloff. Attenuation directly proportional to the distance from the source. A lower rate of attenuation than real world light.

lookup table. An array of data used to map incoming values to new values, often used in color correction to replace an incoming color value to a desired value.

lo-res. Low resolution.

luminance. Often confused with brightness, it is the weighted average value of RGB channels of an image technically resulting in the sum of 0.3086*red+0.6094*green, and 0.0820*blue.

luminance key. The process of extracting a matte using the luminance values of an image.

LUT. *See* lookup table.

M

maquette. A small-scale practical model used as a 3D reference.

match. *See* matchmove.

matchmove. The process of extracting the frame by frame camera and/or object motion from a live-action plate by hand/eye, so that computer generated elements appear to move properly in the scene.

matte. 1. A surface that reflects light diffusely. 2. Not glossy.

matte channel. *See* alpha channel.

matte extraction. Any process used to create a matte, such as rotoscope or chromakey.

matte painting. A hand-painted image created physically or digitally and used as a background layer to be combined with live-action or CG elements.

money shot. A vitally important shot, either because of its impact on the story, the difficulty of the effects required for it, or the amount of money it will cost to create.

motion blur. The smearing of an object in an image due to its motion relative to the camera. As the shutter exposes the film for a specific period of time, any motion occurring during that period is captured in a single frame.

motion-control camera. A camera whose motion and settings are controlled by a computer-driven mechanical system so that the camera work is precise and repeatable.

MPEG. 1. Moving Pictures Experts Group. 2. A lossy image compression algorithm for storing a sequence of images.

N

nodal camera. A camera whose center of rotation(pivot point) is located at the center of its image plane.

normal. *See* surface normal.

normalize. Linearly convert values to a range between zero and one.

NTSC. National Television System Committee.

NTSC resolution. Commonly used to refer to a video image of resolution 640 pixels wide by 486 pixels high.

NTSC standard. The video signal standard used in North America to broadcast 29.97 frames per second with 525 scan lines of resolution.

P

pan. Rotation of the camera about its vertical axis.

parallax. The apparent difference in position of an object seen by each individual eye.

penumbra. The region of partial shadow between a lit area and a completely shadowed area.

pipeline. A procedure or sequence of steps that defines the process to create a final output.

pixel. From a concatenation of picture element—is the smallest unit in a digital image.

plate. The selected film footage scanned into the computer for use in digital compositing.

plug–in. An additional piece of software that can be integrated to existing software to enhance capabilities and features.

practical effect. Any special effect accomplished in front of the camera, such as an explosion, miniature, and/or animatronic.

proxy. A low-resolution stand–in image or object used to increase interactivity.

Q

quadratic falloff. Attenuation proportional to one over the square of the distance. Closely simulates the attenuation of real-world light.

quality of light. A general term for the feel or mood that a particular light or overall lighting scenario creates (soft, harsh, energetic, scary).

R

radial blur. Filtering that occurs radially from a pixel instead of along the horizontal or vertical axes on which the pixel resides.

ray tracing. A rendering technique that calculates and accumulates the contributions of light beams as they leave the lights, bounce around the scene, and are eventually captured by the camera. Ray tracing can accurately simulate realistic reflections, refractions, and shadows, but at a significant computational expense.

refraction. The bending of electromagnetic radiation (such as light) when it crosses a junction of media with different dielectric properties. For example, light passing from the air through glass or water.

render farm. A set of machines dedicated to the rendering process.

render queue. The list of jobs or frames waiting to be rendered by the render farm. Also used to refer to the software that manages the allocation and assignment of frames and jobs to the render farm.

rendering. The process of calculating an image from the information provided (cameras, objects, materials, lights, and so on).

resolution. The horizontal and vertical number of pixels used to define an image.

RGB. 1. Red, green, blue representation of color. 2. An eight bit image storage format (.rgb extension) containing three (red, green, blue) or four channels (red, green, blue, alpha).

RGBA. Red, green, blue, alpha.

RGBAZ. Red, green, blue, alpha, z–depth channels.

rig. Any geometrical architecture designed to place and control nodes. A lighting rig is a structure for positioning and controlling lights consistently throughout a scene, sequence, or show.

right-handed coordinate system. The coordinate system most often used in computer graphics in which the positive X-axis points east (not literally), the positive Y-axis points upward, and the Z-axis points south. So named because with the right hand opened with thumb extended, the index finger points down X, the palm faces Y, and the thumb points in Z.

rim light. *See* back light.

RLA. A Wavefront raster image storage format (.rla extension) that can store RGBA and Z–depth channels at a bit depth of 8 or 16 bits per channel.

roll. Rotation of the camera along its viewing axis.

rotoscope. The process of creating mattes for each frame of a sequence of images by tracing the object by hand.

S

saturation. The amount of chroma or intensity of a color. Desaturating an image completely creates a gray scale image.

scrim. A wire mesh used to reduce the intensity of a light.

sequence. A series of related shots and scenes.

sequence supervisor. The person responsible for quality and continuity of work created for a particular sequence.

SGI. 1. A computer manufactured by Silicon Graphics, Inc. 2. An eight-bit RGBA image storage format (.sgi extension).

shader. A computer program to describe the physical behavior or appearance of an entity, such as light, surface, volume, and so on. When used for objects, often called a material, or material shader.

sharpen. An image process opposite of blur that increases the contrast of a pixel with respect to surrounding pixels.

shot. A single camera view of action without interruption.

shutter speed. The length of time the shutter is open exposing the film to the scene.

slide map. An image used as a virtual cukaloris and/or filter through which a digital light is projected.

soft light. Diffuse lighting that creates low contrast images.

softness. In some software packages, the rate at which light intensity decreases from the center to the edge of a spotlight's cone.

software render. A render implementing the shaders in a scene to generate an image.

specular. The reflection of the light source in a shiny surface that appears as a highlight.

specular map. An image mapped to an object in which the color channel values in a given pixel are used to represent a direction and amplitude in which to perturb the surface normal of the object.

spill suppression. A process used to remove or attenuate the contamination due to blue spill or green spill.

spline. A curve using control vertices (not necessarily on the curve) to define its shape. Types of splines include Bezier, B-spline (generalized Bezier-spline), non-periodic B-spline, uniform B-spline, NURBS (non-uniform rational B-spline), and Hermite-spline.

storyboard. A series of drawings illustrating the key moments in a scene, sequence, and film.

subject. The person or object being photographed.

surface normal. A vector defined at each point on a surface and oriented in the direction farthest away from that point. In computer graphics, the outward or forward facing surface normal is necessary for lighting calculations.

T

take. The filming of a scene. Each time a scene is reshot is a new take.

T.D. *See* technical director.

technical director. The person in charge of rendering and combining the elements of a computer graphics shot. The definition of this term varies among different studios from a pure graphics programmer to a pure 2D artist.

texture map. An image mapped to an object to define its color and opacity.

three-dimensional. Having dimensions in width, height, and depth. A 3D object can be rendered from different viewing angles.

TIFF. Tagged image file format (.tif) is the most flexible commonly used image storage format.

tilt. Rotation of the camera around its lateral axis.

track. *See* tracking.

tracking. Recording the position (2D or 3D) of a particular feature for every frame of a shot. 2D tracking results in the pixel positions per frame. 3D tracking results in the camera and object positions and camera settings per frame.

tweak. Adjust or adjustment.

Glossary

253

turntable. A render test of a CG object rotated in front of the camera and used to evaluate modeling and textures.

two-dimensional. Constrained to a plane having dimensions in only width and height; can only be viewed orthogonally.

U

UNIX. A common computer operating system developed by AT&T/Bell Laboratories.

V

vector. An amplitude with direction usually defined by an X, Y, and Z value. The amplitude is the distance from that (x,y,z) location from the origin (0,0,0). The direction is the direction from the origin to the location.

vertex. A point in 3D space used to define an edge or curve.

vfx supervisor. *See* visual effects supervisor.

visual effects supervisor. The person responsible for all visual effects utilizing any technique required to best realize the director's vision.

Z

Z–channel. A grayscale image representing pixels distance from the camera. Often black is farthest from the camera and white is closest.

Z–depth image. An image that only contains colors representative of the distance of that particular part of the mage from the camera.

Bibliography

Apodaca, Anthony, and Gritz, Larry. *Advanced Renderman: Creating CGI for Motion Pictures.* San Francisco, CA. Morgan Kaufmann, 2000.

Arnason, H. H. *History of Modern Art, 4th ed.* New York, NY. Harry N. Abrams, Inc., 1997.

Brinkmann, Ron. *The Art and Science of Digital Compositing.* San Francisco, CA. Morgan Kaufmann, 1999.

Driemeyer, Th., and Herken, Tolf. *Rendering with Mental Ray (Mental Ray Handbooks Volume 1).* New York, NY. Springer Verlag Wien, 2000.

Ferncase, Richard K. *Film and Video Lighting Terms and Concepts.* Newton, MA. Butterworth-Heinemann, 1995.

Goulekas, Karen. *Visual Effects in a Digital World.* San Francisco, CA. Morgan Kaufmann, 2001.

Itten, Johannes, and Birren, Faber. *The Elements of Color.* New York, NY. John Wiley & Sons, 1970.

Itten, Johannes, and Birren, Faber. *The Subjective Experience and Objective Rationale of Color.* New York, NY. John Wiley & Sons, 1974.

Index

STEP INTO THE 3D WORLD OF ANIMATION WITH THE PREMIER PRESS *INSPIRED* SERIES!

Inspired 3D Character Animation
1-931841-48-9

Inspired 3D Character Setup
1-931841-51-9

Inspired 3D Lighting and Compositing
1-931841-49-7

Inspired 3D Modeling and Texture Mapping
1-931841-50-0

Filled with tips, tricks, and techniques compiled by the animators of blockbuster films at Hollywood's biggest studios, these four-color books are a must-have for anyone interested in character creation.

Series Editor Michael Ford is a senior technical animator at Sony Pictures Imageworks. He is a certified Level 2 Softimage instructor whose film credits include *Stuart Little, Stuart Little 2, The Perfect Storm, The Mummy, Godzilla, Species II, Mortal Kombat II,* and *The Faculty.*

Series Editor Kyle Clark is a lead animator at Microsoft's Digital Anvil Studios. His film credits include *Star Wars Episode I—The Phantom Menace, Sleepy Hollow, Deep Blue Sea, The Adventures of Rocky and Bullwinkle, Harry Potter and the Sorcerer's Stone,* and *Brute Force* video game for the Xbox.

Premier Press, Inc.
A Division of Course Technology
www.premierpressbooks.com

Call now to order! 1.800.842.3636